MEDIEVAL BODIES

MEDIEVAL
BODIES

Life, Death and Art in the Middle Ages

JACK HARTNELL

W. W. NORTON & COMPANY
Independent Publishers Since 1923

First published by Profile Books in partnership with Wellcome Collection in the UK in
2018 under the title MEDIEVAL BODIES: Life, Death and Art in the Middle Ages

Manufacturing by Versa Press

ISBN 978-1-324-00216-1

W. W. Norton & Company, Inc., 500 Fifth Avenue, New York, N.Y. 10110
www.wwnorton.com

W. W. Norton & Company Ltd., 15 Carlisle Street, London W1D 3BS

1 2 3 4 5 6 7 8 9 0

CONTENTS

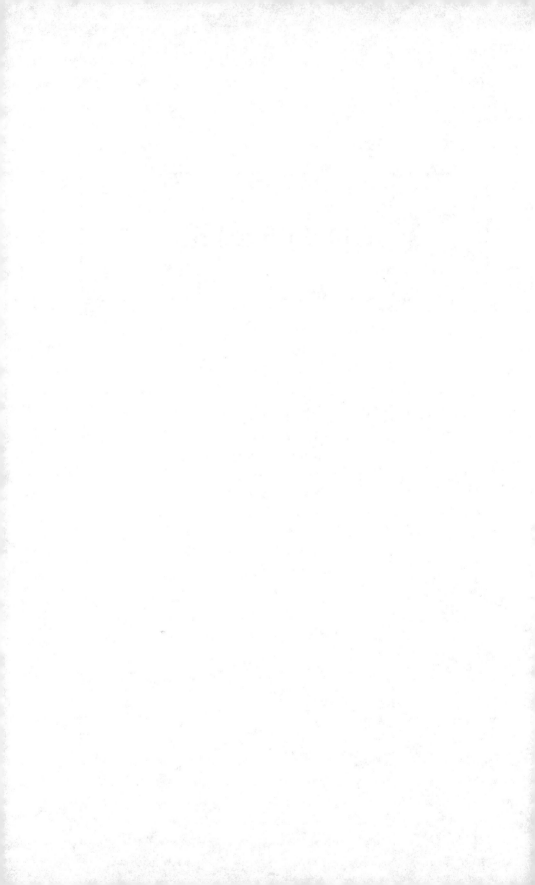

MEDIEVAL BODIES

In 2003 a preserved human head was sold by a dealer in Paris to a Canadian private collection for an undisclosed amount. In itself this was not an unusual event. Human remains, like any other type of valuable historical artefact, pass back and forth all the time in the busy international markets for medical oddities and prized antiquities. But this object, this body, aroused particular curiosity.

It strikes a vivid first impression. Frozen in a dramatic rigor mortis, its head is thrown backwards from the stubs of two shoulders, throat exposed and mouth agape. A large split makes its way down the face from the centre of its forehead, and we see, when it is flipped around, that the entirety of its cranium has been excavated in a hoop about the head. The top of the skull is missing, popped off like the lid of a biscuit tin, and the brain has been removed, leaving only its shrivelled base and a flat stump of spinal cord.

To understand more about this enigmatic cadaver a team of French paleopathologists were given permission to examine the remains in more detail. Subjecting them to a number of innovative medico-archaeological techniques, all sorts of information about the deceased quickly began to surface. They discovered that the figure was male,

originally of Caucasian descent and probably around forty-five years old at the time of death. Short red hairs on the chin and upper lip suggested he had once been of an auburn complexion. And several scans confirmed that his head and shoulders had been preserved using a type of quick-setting, mercury-based metallic wax, injected into the major arteries soon after death to stiffen his pose like a sculptural mould. Most intriguingly, radiocarbon dating estimated that the figure had lived at some point between the years 1200 and 1280: the body was medieval.

For historians like me, such discoveries offer an immediate and enticing gateway onto the past, and not just through the scientific detail of long-dead bones. We know this half-man's gender, his age, even his hair colour, but his remains still animatedly pose all sorts of other pressing questions. Who was he? Where was he from? What was his story? He is a prompt from the past to dig deeper into what we know of the moment in which he lived. And exploring medieval bodies is particularly vital today, because their era continues to be much misunderstood. The centuries sandwiched between the accolades of ancient Greece or Rome and the classical world reborn in the European renaissance are seen as a static and sequestering time, an idea we read in their different names: the 'Dark' Ages or the 'medieval', from the Latin *medium aevum*, a 'Middle Age'. It is a moment often defined by events outside itself, by what it is not, and when we look at medieval artefacts – be they bodies or poems, paintings or chronicles – we have a tendency to emphasise the negative. We draw them into a sceptical and often quite gruesome narrative of the period that has been handed down to us, just the kind of unpleasant moment in history where people might well have ended up with their head split open and injected with metallic wax.

The pervasiveness of this feeling was recently made crystal clear in a visitor survey undertaken by a major London museum during plans to renovate its medieval and renaissance gallery spaces. An average slice of the visiting public was asked by researchers to project themselves into each of the two eras in turn, first the renaissance and then the medieval, and say what they thought they might see or how they believed they might feel about the world around them. Responses to

the renaissance, recorded verbatim by the museum, were bounteous. People seemed genuinely contented, filled with a happy wonder:

> I'm in Florence walking by the river at midday. It's peaceful, I'm smiling. I'm an artist's model and he's sculpting the Madonna and Child.

> The sunshine sparkles, there's a little glade and a little lake. There's philosophy, people sitting round talking about politics, books. Music ... I want to stay and dream.

Sounds lovely. But for the same people, envisaging the medieval world meant that things quickly turned sour:

> There are soldiers, peasants, high castles, muddy lowlands ... Black Death and Plague are all around. It's raining. People are drunk on mead and fighting among themselves. The artists are not respected.

> I'm in a dungeon wearing a potato sack and it's night. It's cold, there are rats. The windows have bars at floor level. I stole some potatoes for your newborn child.

It is a stereotype heard often: that from roughly the years 300 to 1500 most people inhabited a time oscillating between *Braveheart* and *Blackadder*, a world of generalised misery and ignorance, living in piteous squalor only to make war in the fretful darkness. A useless millennium or so. For at least one of the visitors surveyed by the museum this popular view has even gone so far as to warp their historical placement of people and things. The potatoes they envisage stealing – presumably not fluffy, plump roasties, but hard and cold and raw – would in fact only have reached Europe from the Americas in the 1570s, well after the darkness of this supposedly 'Dark' Age is meant to have lifted.

Who or what is to blame for this picture is not entirely clear. In some ways, doing down the past seems a natural reflection of how we wish to see life in the present. To appear enlightened and modern we

need a dark and ignorant past to set ourselves starkly against. Pop culture has definitely taken this up with force in the romanticised figure of a Disney princess, cruelly trapped in her *ye olde* castle, or the bleak violence of nipple-strewn TV dramas like *Game of Thrones*. It is no coincidence that in Quentin Tarantino's 1994 cult hit *Pulp Fiction*, when Ving Rhames's character Marsellus is poised to take gory revenge on a man who has held him hostage, he bitingly tells his hapless prey, 'I'm gonna get *medieval* on your ass.' The era is evoked at once as a historical fantasy and a vicious threat.

Looking back through history, this sense of a nasty medievalism is encountered pretty regularly. In the nineteenth century the idea of a gruesome Middle Ages was a particularly potent fascination for the Victorians, who happily distorted the past to suit their flamboyant taste for the neo-Gothic and the macabre. The idea goes back further still, present in the writing of thinkers during the Enlightenment. In the 1580s trashing the medieval was so widely accepted that the English antiquarian William Camden felt he could skip disparagingly over the entire period when writing his comprehensive, grand history of Britain, offering little more than a paragraph or two: 'I will', he says, 'only give you a taste of the Middle Age, which was so o'ercast with dark clouds, or rather thick fogs of ignorance.' Rather touchingly, medieval thinkers themselves seem to have been the first to conceptualise their age as having a certain middleness to it, stuck between two brighter, more exciting points of history. The Italian author Francesco Petrarca wrote with a mixture of longing and optimistic excitement about a shift of cultural values that he was observing around him in Italy during the fourteenth century and which he hoped might drag the medieval world forward in its wake:

> There was a more fortunate age and probably there will be one again; in the middle, in our time, you see the confluence of wretches and ignominy ... My fate is to live among varied and confusing storms. But for you perhaps, if, as I hope and wish, you will live long after me, there will follow a better age. When the darkness has been dispersed, our descendants can come again into the former pure radiance.

Whenever it originated, this view of the medieval period is unquestionably distorted. Revealing the realities of the Middle Ages from this warped impression has been part of my work for more than a decade and is at the very heart of this book. We cannot patronise this seemingly distant moment in time simply to make ourselves feel better. Rather, in order to truly grasp any aspect of the medieval world we need to engage with it on its own terms. We need to try, as best we can all this while later, to see life as it was understood by our French half-man before his body was frozen in time, indeed by a whole cast of different characters who one by one will fall into focus: a physician treating a patient in sixth-century Ravenna, a Persian poet writing a piece of epic verse in twelfth-century Azerbaijan, a seamstress sewing a garment in the East End of fifteenth-century London, and many more. We need to look beyond caricature to the nitty-gritty detail of life. Or, in the case of this book, the detail of life and death and art. And when we do, we will always discover there is another story to be had beyond that of a backwards, muddy Middle Ages.

Beginnings?

What, then, was medieval life really like? How we start to answer this question depends on where and when in the great span of the Middle Ages we want to look, for the term captures in two short words an enormous period, a whole multiplicity of peoples, cultures, religions and geographies.

A moment so glittering and diverse understandably comes with blurred beginnings and contested endings. We could officially set the medieval clock ticking after the collapse of the Roman Empire, which had dominated and unified enormous swathes of Europe, Africa and Asia for the preceding centuries, kick-starting the Middle Ages in the year 476, when the last of the western Roman emperors, Romulus Augustulus, was deposed by the Germanic king Odoacer, bringing imperial rule to an end in Europe. But in reality this empire had already been in serious decline for some time. We could just as easily

begin talking of the medieval in the early 400s, when northern European tribes started regularly crossing the Rhine to invade Italy, or even a whole two centuries earlier, when the over-expanded Roman world first began to experience political instability and economic slowdown. Yet these early medieval moments can be particularly difficult to pin down for lack of hard evidence: few complete buildings or objects survive, even fewer written sources, and the archaeological record can be sparse. Much of this book, then, by necessity aims at the better-documented, later parts of the medieval narrative, but at this end of the period too, sources are far from bounteous, and a formal full stop for the Middle Ages is equally difficult to find. A move into something resembling the renaissance did not happen overnight. The kind of changing ideas, actions or artworks that signalled to some that a paradigm shift was under way in fourteenth-century Italy might have only come into fashion a full century later in London or Seville, Tunis or Jerusalem. Some two hundred years separate the earliest self-aware critics of the medieval world – people like Petrarca – from the work of sixteenth-century renaissance big-hitters like Michelangelo, Cervantes or Luther, all of whom still lived in a world tangibly buzzing with the influence of the medieval. Historical change is, after all, a human thing. It does not sweep uniformly across regions in an instant.

Nonetheless, a shared classical heritage undeniably binds together the medieval history of the regions on all sides of the Mediterranean, separating them somewhat from the busy parallel stories of the Far East, India, China, subsaharan Africa or the precolumbian Americas. Three principal inheritors of the legacy of Rome come to the fore, each representing a slightly different texture of the medieval bodies that I want to try to trace.

The first is Byzantium, a Greek-speaking, Christian empire which at its height extended throughout Greece and the Balkans, Anatolia, north Africa and much of the Levant. The Byzantines saw themselves less as inheritors of the classical Greco-Roman world than as a direct continuation of it. Their seat of government was Constantinople, a thronging metropolis of architectural sophistication and political

grandeur which had been founded as the easternmost of the Roman Empire's two capitals in the year 330, when Emperor Constantine rededicated a city formerly known as Byzantion in his own name. Byzantine emperors continued for centuries to rule in a direct lineage from Constantine's unshakable Roman roots, and although its territories and influence would slowly shrink, the city itself only finally fell to the Ottoman Turks at the very end of the Middle Ages in 1453, after nearly a millennium of Byzantine control.

Second were those medieval peoples living in western and central Europe, from Scandinavia in the north to Italy in the south, some of whom had actually toppled Rome itself. Unlike the united empire of Byzantium to its east, in the earlier Middle Ages this region was far more fractured and from the fifth century constantly reconstituted its borders. Power shifted between a range of clashing cultural groups – the Franks, Angles, Saxons, Celts, Vikings, Visigoths, Slavs, Magyars, Lombards, Bulgars, Avars – whose kingdoms relied on battlefield successes for both political legitimacy and for military plunder to finance the state. It is perhaps for this reason that their names have since been transformed into some of our more derogatory modern terms: think, for instance, of the Barbarians or the Vandals, both words used in the Middle Ages to refer to actual historical groups. But, their political violence aside, these states were far from filled with the impoverished potato-snatchers conjured up in the London museum survey. Bolstered by an alliance with the Roman Church, from around 800 onwards these polities began to stabilise, making a more conscious effort to encourage learning and culture in the mould of the Roman Empire they had conquered. By the later Middle Ages many had fully concretised into the complex nation-states that would form the backbone of early modern Europe and from there go on to colonise huge swathes of the globe.

The third and perhaps most unexpected of these Roman heirs was the Islamic world. Emerging from the sparsely populated Arabian Desert in the 630s, Muslim peoples clearly had no immediate geographical proximity to the lands of Constantine, Julius Caesar or Plato. But as a combined religious and political force they were to expand with

serious speed, their armies moving so quickly into territories once held by the Byzantine and Persian empires that only a century or so later the caliphate – derived from the term *khalifah* (خليفة), or 'successor', given to Islam's leaders after the Prophet Muhammad – encompassed the Iberian Peninsula, north Africa and most of the Middle East, stretching all the way to modern-day Afghanistan and Pakistan. Like western Europe, the caliphate was far from a unified state. Internal rifts soon turned into full-on civil war and the foundation of several competing medieval Muslim kingdoms. But, unlike its Christian neighbours, Islam was united by a common language, Arabic, and a flourishing literary movement centred around Baghdad saw the mass translation of multiple ancient writings into the Muslim *lingua franca*, preserved by copyists working from languages as diverse as Greek, Syriac, Persian, Sanskrit and Pahlavi. This Islamic world was to fall into a near-constant tension with the rest of Europe, especially after the launch of the First Crusade to reclaim the holy sites of Jerusalem in 1095. Yet, particularly in their early moments of expansion, these Muslim kingdoms thrived through a tolerance of different religions and peoples, and remained a consistent partner of many in the West for trade, commerce and cultural exchange throughout the entirety of the period. Whenever we might think the Middle Ages began or ended, it is the positive interaction between the political spheres of Byzantium, Europe and Islam, not only their opposition, that provides the key to understanding the era as a coherent moment, multiple complex cultures indelibly bound together through a shared Mediterranean past.

You, a Thousand Years Ago

For all the logic of its unifying Roman foundations, if you or I were to be transported back a thousand or so years from the present into the medieval past, we would find ourselves in an uncanny place at once startlingly different from and yet strangely familiar to our own.

Most striking might be its apparent emptiness. Demographically speaking, medieval populations were significantly smaller: there are roughly as many people in the United Kingdom today as there probably were across the entirety of Europe in the Middle Ages. Many of them lived in small towns and villages, the cumulative engines of a largely agricultural economy, and in the absence of jet planes and motorways life might feel surprisingly quiet. At the same time we might visit larger civic centres such as medieval Cairo, Paris, Granada or Venice, whose crowded streets, busy markets and generally condensed living would feel just as bustling as many modern cities. The biggest of these would reach populations of half a million or more and harboured elaborate centres of political power, diverse industries and, later, a university-trained intellectual elite.

Religion would be something we recognise too from modernity, yet it played a much greater role in the fundamentals of medieval life in a way now largely lost. This is not to say, as the caricature some-times suggests, that Christianity, Islam or Judaism was all anyone ever talked about. A good parallel would be the way we think and speak about science today. We do not go around slapping each other on the back and congratulating ourselves on the existence of gravity, con-stantly expressing gratitude and awe that Newtonian physics stops us from floating off the earth's surface into space. Rather, it is a baseline for how we see and understand this world, its past, present and future. Religious tenets like the biblical story of Creation or the potential daily intervention of the Almighty were an accepted but not necessarily all-consuming part of a medieval worldview.

Of course, while I am arguing that we have misjudged the Middle Ages, there is no getting away from the fact that it was in many ways extremely tough. By the standards of the present day, almost everyone in the pre-modern world right up to the 1800s would be classed as living in extreme poverty. Yet medieval people were also aware that, when it came to the shape and fabric of individual living, we are all hostages to fate: our fortunes can rise as well as fall. An illustration from a tenth-century Spanish manuscript shows the image of Fortuna, the Roman goddess of fortune who was also particularly popular with medieval moralists.

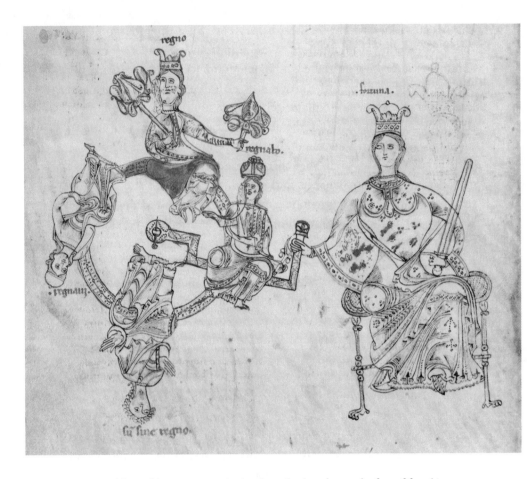

1. The goddess Fortuna spinning her wheel to change the fate of four kings and their rule. The image was added in the eleventh century to a Visigothic manuscript written in Cardeña in 914 by a scribe named Gomez.

Crowned and throned, the stunning Queen of Fate spins her wheel to twist a set of figures to and fro. In this grand image those shown at fortune's behest are four kings. Some are in the ascendancy, while others are having their world flipped completely upside down. Tossed through time, the destiny of each is labelled in Latin beside them: *regnabo* ('I shall reign'), *regno* ('I reign'), *regnavi* ('I have reigned'), *sum sine regno* ('I am without reign'). But one more crank of the handle and everything will

change again. Far from being an exclusively royal hazard, the vagaries of chance were a reality of daily life for all. In the words of the English poet John Lydgate (c.1370–1450):

> *The enuyous ordre of fortunat meuyge*
> *In worldly thynge false and flykerynge*
> *Ne wyll nat suffre vs in this present lyfe*
> *To lyven in reste without werre or stryfe*
> *For she is blynde fykell and vnstable*
> *And of hir course false and full mutable*

> The envious order of Fortune's moving,
> In worldly things false and vacillating.
> None will not suffer it in this present life,
> To live in rest without war and strife.
> For she is blind, fickle, unstable,
> And her course is false and mutable.

Clearly the Middle Ages saw itself as having both winners and losers. Most medieval cultures were indeed heavily stratified in this manner, with divisions between the haves and the have-nots reinforced by patterns of wealth and work. Those who owned land, at home or abroad, had both financial control of its produce – wool, wheat, wood, slaves, iron, furs, ships – and, by extension, political control of the people who wished to live or labour on it. This is not to say that medieval living was entirely constituted of emperors and peasants, two camps polarised at totally different extremities of income: in between was a broad spectrum encompassing all sorts of groups, from busy professionals through to skilled craftsmen and an aspirational merchant class. Yet a king could still expect his comfortable surroundings and ample diet to see him greatly exceed the average life expectancy of a labourer harvesting his royal lands, who might have struggled to make it to forty. The daughter of a wealthy lord might receive a thorough schooling at home, while her working-class counterpart would be unlikely ever to be able to read or write. The son of

an aristocratic landowner could be welcomed through familial connections into the political ruling class or well-funded religious institutions, while the son of a farmer was expected to toil in the fields for his entire working life. Like today, for those who found themselves at opposite ends of Fortuna's Wheel, standards of living could be strikingly different.

Giggles and Disgust

The bodies of these medieval men and women would, of course, have been equally varied, but none would have been that dramatically unlike our own. Contrary to the stereotype, people in the Middle Ages were not necessarily much smaller than us. One recent archaeological study of a group of bodies buried over the course of 900 years in a small rural parish in Lincolnshire reveals almost no difference in people's height between the Middle Ages and the Victorian era, averaging around 5 feet 7 inches for a man and 5 feet 3 inches for a woman. Nor were these people all toothless, crippled or constantly sick. True, they lacked a detailed modern understanding of infection which could have helped fight against large-scale disease events like the Black Death, a quick-spreading bacterial epidemic thought to have decimated nearly a quarter of the global population in the 1340s. Yet the air they breathed and the food they ate would have been free of modern chemicals and pollutants, and potentially far healthier than our own.

What was dramatically different, however, was the way medieval people thought their bodies worked. On the whole, the biological and medical notions of the Middle Ages tend to elicit two types of response. First, giggles. Surviving medieval sources advocate subjecting the body to all sorts of strange happenings in order to cure it, many of which can seem weirdly comical in their wrong-headedness: the application of fresh cow dung to help problematic tear ducts, a combination of vinegar and honey rubbed onto the head to fight baldness, the insertion of peppercorns into the vagina after

intercourse as a contraceptive. But this amusing silliness can quickly shift to a rawer sense of discomfort or even disgust at methods of the past. In the Middle Ages a headache might be treated by puncturing the neck and draining the body of several pints of blood, a concoction of boar's bile and potentially deadly hemlock could serve as an anaesthetic, and a range of ailments were thought to be alleviated by burning multiple points on the body's surface with red-hot metal rods. From a modern vantage point these 'cures' seem worse than useless, even torturous.

This is the true difficulty of getting to grips with medieval bodies: their owners conceived of them through theories that have since been totally disproven to the point of absurdity but which nevertheless could not have seemed more vivid or logical in the Middle Ages. We think of our bodies now as a relatively closed and contented circuit, our skin a clear border between the inside and outside of ourselves. But the human form in the medieval period was considered a far more open and porous group of organs and systems. As a result, an understanding of the world circling around the body was crucial to an understanding of what lay within. Natural philosophers and theorists of the preceding Greek and Roman eras had passed on to medieval thinkers the notion that nature was composed of four primary base elements – fire, water, air and earth – and that the disposition of this quartet could affect the external appearance and internal properties of all things. Each element was also aligned with two further fundamentals, moisture and heat: fire was hot and dry, water wet and cold, while earth was dry and cold, and air hot and wet. Substances associated with each element also contained these inherent properties, and in a direct reflection of these natural surroundings medieval bodies were thought to contain four corresponding viscous internal agents known as the humours: blood, phlegm, yellow bile and black bile. A person's constitution was determined by the equilibrium of these vitalising substances inside themselves, each in turn linked back to a particular element.

This biological system is perhaps not as abstract as it first seems. Some sense of it can still be felt in our own conceptions of health:

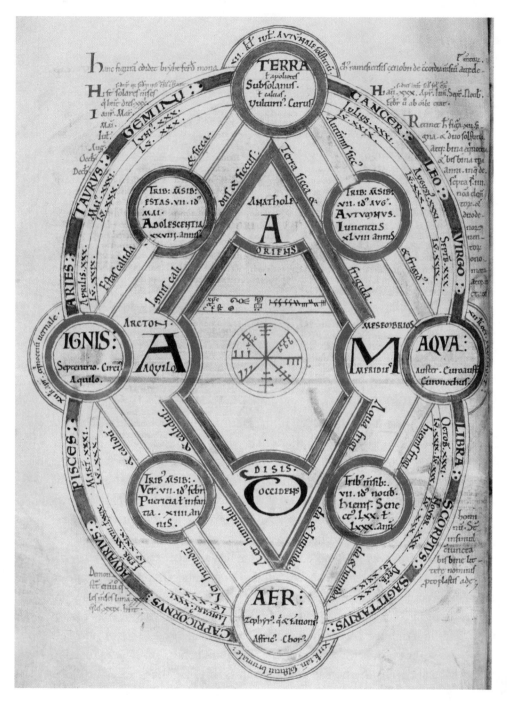

2. A diagram from a book written in the first decade of the twelfth century, known as the Thorney Computus. It shows the macroscopic medieval conception of the world as fundamentally intertwined, outlining the correspondences of the four elements (*Terra*, *Aqua*, *Aer*, *Ignis*) with the months, the zodiac, the winds, the lunar cycles and the ages of man. The first letters of the Latin names for the four cardinal directions are made to spell out the name 'ADAM': mankind thus inhabits the centre of this swirling image.

we often talk of our bodies being 'not quite right' or 'slightly out of balance' when evoking the off-kilter feeling of being ill, a sense that the machine of the body is not tuned quite as it should be. But in the Middle Ages the four humours were at once much more formalised and potentially far more severe than this modern queasiness. Misalignment had the ability to plunge someone into serious ill-health or even death. The primary job of many medieval medics was to prevent or correct a toxic imbalance of these humours through a variety of stabilising treatments. Excesses could be drawn out by purging the body, while tailored prescriptions could use the natural properties of dry, fiery roots and spices or cooling herbs and balms to restore the patient to balanced good health.

This idea did not stop at simple medicines. The grand scope of medieval medical thought took the logic of this link between people and nature to extremes. The time of year could bring natural shifts to the body's balance, each season linked with a particular element: airy spring, fiery summer, earthy autumn and watery winter. Human development over time, too, brought with it elemental change, with different stages of life from childhood through to old age heralding a gradual cooling of the body and a shift in humoral foundation. Even the astrological goings on of the stars and the planets revolving around the earth were drawn into this grand anthropocentric system, with heavenly bodies from Capricorn and Aquarius to the Moon and Jupiter all holding sway over the sensitive make-up of mankind. It is little wonder that, when medieval thinkers came to plot out this intertwined vision of man and the world on the pages of their manuscripts, the resulting diagrams are packed with beautifully dense networks of correspondences and connections. Understanding the body was just one part of an attempt to make sense of the universe in its entirety.

A medical field born of this sort of thinking clearly must have looked and felt quite different from one founded on modern clinical principles of experiment and trial and error. Given that these systems were based so heavily on an inherited and deeply theoretical tradition, long-standing written texts played an important role across large sectors of medieval practice. Upholding the seemingly abstract

concepts that underpinned treatment were many centuries of discourse and debate on the work of ancient and more recent authors, generations of scholars who copied, edited, synthesised, commented on and re-copied a whole range of writings that governed both the scope and specifics of medicine with a strict internal logic. So revered were these texts that they often took precedence over observation of the actual medieval body itself. This goes some way towards explaining why anyone might have kept going with cow dung, boar's bile or bleeding. Consistency in implementing the medicine of their learned forebears was the paradigm of this medical movement, not innovation. Even if a particular method seemed questionable or ineffective – and at times they must have – to find a new route through medieval bodies would have required the overturning of centuries of thought. Change would only arrive on the back of major scientific revolutions, and it would not come quickly. Humorism, inflected with its medieval commentary, was to survive as a stalwart of medical practice well into the eighteenth century.

Histories and Healers

Who would the medieval man or woman have turned to when their bodies began to fail? Although many are peppered throughout this book, it can be tricky to get a proper grip on the different healers that populated this medical world. Most left behind only the lightest of footprints on the historical record, and we are often stuck pondering them from little more than a name scribbled in a margin, the excavated foundations of a hospital or the fragments of a gravestone marked simply *medicus*, 'physician'.

But we do know that, like the Roman era before it, the earlier Middle Ages had no real state-controlled systems of medical qualification and no set path or expected background for becoming a trained doctor. Instead, local schools and institutional clusters taught a much more fluid form of medical curriculum, with particular regions becoming internationally renowned for their strengths

in the healing arts. From the 700s onwards, Muslim Middle Eastern cities were amongst the most important centres for medicine, particularly well known for their ability to enrich the classical European texts they had preserved in Arabic with numerous Asian imports from Chinese and Indian traditions. Specialists in Baghdad, Damascus and Cairo built up extremely detailed and complex bodies of medical writings, as well as developing various new methods in surgery and pharmacy.

These cities' wealthy elites were also among the first to be moved by a sense of charitable giving to endow the earliest large-scale hospital

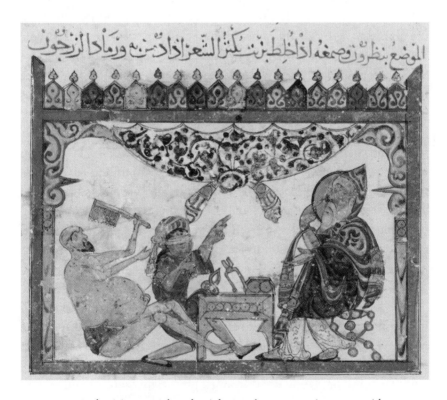

3. A physician, seated on the right, speaks to two patients, one with eyes bandaged and the other with a bulbous stomach. The image accomponies a text on pharmacology originally by the first-century Greek doctor Dioscorides, copied into Arabic in Baghdad in 1224.

complexes. These *bimaristans* (بيمارستان), as they were known, could grow to an enormous size, complete with internal wards corresponding to specialisation and incorporating complementary services such as baths, libraries and teaching faculties. One Baghdadi *bimaristan*, founded in around 981 by the Buyid emir 'Adud al-Dawlah, was dramatically described by one visitor to the city as rivalling its largest palaces in splendour, an expansive network of beautiful buildings open to rich and poor, male and female, and Muslims and non-Muslims alike.

The reach of this Arabic-speaking medical expertise was impressive, stretching west across Muslim north Africa all the way to southern Spain, and practitioners in the rest of Europe benefited greatly from the ability to work at the pinch points between western and Middle Eastern cultures. Both men and women in the southern Italian city of Salerno, for instance, had by the eleventh century accrued a formidable medical reputation. Healing there was helped by Salerno's position as a diverse cultural melting pot, combining the wealth and learning of its local Benedictine monasteries with proximity to both Arabic thinkers in Muslim Sicily and the classical heritage of nearby Greek-speaking territories. So apparently impressive was this multilingual Salernitan healing that wealthy patrons were willing to voyage from far and wide to seek treatment at the hands of its experts. In the 980s a bishop of Verdun named Adalbero even recorded undertaking an expensive cross-continental expedition to Salerno over the Alps from his diocese in north-eastern France, braving long and often dangerous roads just for an improved chance of cure.

The steady growth of this cross-pollenated medicine was cemented in Europe by the emergence of the first universities, founded from the late eleventh century onwards in Bologna, Paris, Oxford, Cambridge, Montpellier, Padua and elsewhere. Rather than specialising in a particular medical field, university-trained physicians were encouraged to slowly accrue as diverse a breadth of knowledge as possible. The best students could discourse encyclopedically on many different aspects of bodily cure, especially those rooted in the sort of textual studies familiar to other more popular subjects like law or theology. But these physicians

themselves were far from diverse. Universities were open only to men, and men of good character and breeding at that, who were expected to subscribe to the moral and intellectual standards of what were largely religious institutions, as well as having the substantial wealth needed to support their studies. Moreover, this type of elite, theoretical and highly academic medicine would not always have been of immediate use when presented with an average actual sick individual: it is hard to imagine how a patient gushing blood from the head or in the throes of a violent fever would have appreciated an extended Latin quotation sourced from the Hippocratic *Aphorisms*, Johannitus' *Isagoge* or Galen's *On the Utility of Breathing*. In reality, such high-ranking university professionals were unlikely to have been the first port of call for many. These figures were very much the tip of the medical iceberg, a relatively small group of well-schooled, well-to-do individuals whose elite bearing and high prices saw them catering exclusively to the upper echelons of medieval society.

Instead, for most medieval people treatment would have been sought from a far broader range of healers sometimes gathered together under the term 'empirics': surgeons, midwives, apothecaries, barbers, dentists, all considered more practically minded craftsmen and craftswomen. Although their work was underpinned by the same fundamental ideas – that the body was founded on balanced humours in deep confluence with the environment around it – these empirics differed significantly from their university counterparts in turning this understanding into practice. Theirs were professions learned not in classrooms but in workshops or in the field, serving as apprentices to more experienced masters in the same manner as young carpenters, butchers, potters or other artisans. Most would not have been literate, yet just as much knowledge was involved in craft as in academia. An apprentice surgeon would have to watch carefully at his master's side for the minuscule subtleties of the knife moving over the skin, of the right way to apply salves and tie complex bandaging, or to pick up a cleverly deployed detail of expert bedside manner at just the right moment to reassure an anxious patient. While the physician's knowledge was safeguarded by the elite Latin language, preserved on parchment in

exclusive libraries, the empiric's livelihood was protected through the keeping of professional secrets within family networks and artisanal guilds. These organisations could grow into powerful social institutions. In large cities such as Paris or Florence medical guilds patrolled the practice of their members while fiercely advocating for their rights and privileges, supporting craftsmen in old age or ill-health, overseeing local government and processing colourfully through the town on feast days with songs and banners. But neither physicians nor empirics necessarily needed to set up permanent practice in these major centres. Many were like the fifteenth-century French surgeon Jean Gispaden,

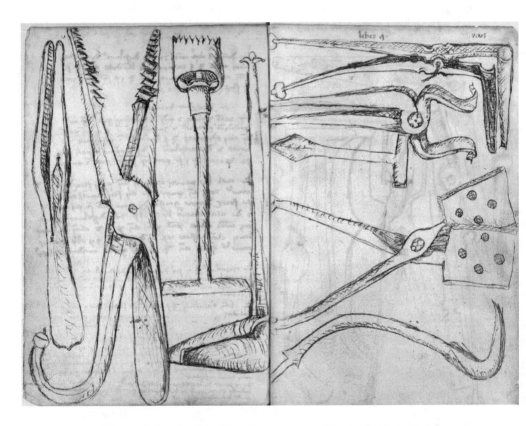

4. The surgical tools of the fifteenth-century travelling healer Jean Gispaden, who sketched them across a series of pages in the back of his notebook.

who journeyed extensively to serve a wider range of clientele. We know of Jean's work through a surviving notebook that he kept, its small, worn pages recording all sorts of details from his practice, and even some careful line drawings of his surgical instruments. These knives, pincers, scissors and other fierce-looking instruments would have travelled with him on his peripatetic surgeries, offering his skilled relief across a large area of the western Alps, trading his training and reputation for a potentially lucrative fee.

With variation, though, came division among these many different types of healer. The literary learning of the universities carried a greater price tag and prestige than the gritty manipulation of actual bodies by surgeons and other empirics. In some centres the two groups were on good terms, working together to heal patients with their parallel expertise. But in others they seem to have inhabited totally distinct and even highly antagonistic social realms. Even today the terminology of modern medicine recalls the fractious diversity of this medieval moment: surgeons still choose the epithet Mr or Mrs rather than Dr, avowing their profession's origins in the world of tangible craft and not the doctoral confines of the academic university.

Folks and Folklore

The patients who frequented these different types of medical expert came from equally diverse backgrounds. Inevitably we know most about the wealthy, whose ample accounts record substantial spending on systems of care. King Edward II of England (1284–1327) employed an international group of at least twelve physicians and surgeons to attend members of the royal household and its extended court, supplying each with valuable medicaments, clothes, valets, a sizeable daily salary and horses (plus hay). Expensive illustrated luxury health books, particularly popular in Italian and French patrician circles, also give us a closer glimpse of this specific class of patron. Lavishly decorating the remedies of their age, these manuscripts are stuffed with large, gilded vignettes of doctors, patients and workers gathering the ingredients

for medical treatments. Often they recommend expensive medicines, rest from overbearing thought, quiet, comfortable surroundings and copious fresh air, all cures aimed at a reader clearly unrestricted by the daily labour of a lower-class existence.

Still, we can try to paint at least a partial picture of more ordinary patients from the surviving records of various medical professionals. The notes of the thirteenth-century physician Taddeo Alderotti, a professor of medicine based in Bologna, record a range of varied house visits, from the grand palazzo of the Doge of Venice to more local, lower-status clients scattered across towns in northern Italy. Practitioners like Taddeo would have customised treatment to suit the pockets of different patients, making up pricey prescriptions of precious spices and minerals for their more comfortable clients while offering simpler remedies made from more freely available materials for the less well-off. The good health of the poor was also aided by an increased attention to public sanitation, which in the later parts of the Middle Ages began to be regulated by local administrators in many European and Middle Eastern cities. Various civic infrastructures were implemented, including regular waste disposal, formalised street cleaning and sewage networks for the supply of fresh water, while the quality of foodstuffs began to be more and more carefully regulated. Depending on where you lived, provision of free medical care might even be made available at the expense of the state, ensuring at least a modicum of treatment for the most needy. These patients, a poorer and more generic sick, are the least likely to make the history books, unless perhaps a botched operation by a surgeon or mistaken poisoning by a dodgy apothecary meant that they featured in accounts of the frequent legal cases brought against healers of the period. Even in the generally well-kept records of larger-scale public hospitals we only tend to hear of these lower-class patients as being placed two to a bed in long wards, waiting to be comforted in their final days.

A great leveller of this medical playing field, however, was religion. Whoever the patient and wherever they were being attended to, almost everyone in the Middle Ages would have upheld a strong belief that their physical health was directly related to their spiritual well-being.

For the predominantly Christian peoples of medieval Europe and the Islamic populations of north Africa and the Middle East, an illness could be understood as stemming from accident, aggression or imbalanced humours, but it might just as likely be an externally presenting symptom of a more deep-rooted, sinful sickness. Medicine's conflation of the body and the natural world fitted quite happily with religious teachings of an ultimate and all-seeing maker who created mankind as the central element of a broader universe. Christian doctrine made clear that disease was one of the many postlapsarian burdens that men and women simply had to bear, meted out at God's behest. And in the views of Judaism and Islam, too, ill-health could stem from ill-living, with rampant epidemics interpreted as divine punishment for wider-scale wantonness.

Yet religion offered hope as well as despair in the medical realm. Just as powerful as the certain sickness of holy transgression was the ever-present possibility of miraculous cure. This belief in a link between spiritual morality and earthly health kept medieval healing in dialogue with much older forms of pragmatic folklore and magical superstition. In the Islamic world, for instance, the old Aramaic practice of harnessing sacred power through ritualised drinking had continued currency in the Middle Ages, prompting the creation of a series of bronze bowls endowed with superstitious healing properties. Inscribed instructions running around the bowls direct the patient to fill it with infusions of different tastes and at different temperatures depending on the effect required. One surviving brass bowl from around 1200, now in the David Collection in Copenhagen, combines engravings of Qur'anic verses wishing for auspicious childbirth with circles and squares of magical numbers, as well as images of poisonous animals, perhaps intended to ward against a sudden or unforeseen death. Imbibing the water from such a vessel was thought to cure disease and fend off future sickness, the liquid imbued with prophylactic powers through contact with the verses and images etched onto its surface.

Seeking religious intervention was thought by virtually all patients to be just as effective as a humour-balancing herb, and

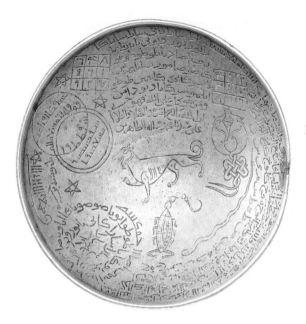

5. A magical brass healing bowl, engraved with Qur'anic phrases and superstitious images, made around 1200 in Syria.

prayers often mingled alongside pharmaceuticals in the pages of mainstream medical treatises. As with the Syrian bowls, the idea that proximity to the holy or fortuitous word could heal was also prominent in Jewish and Christian cultures. Amuletic scraps of parchment carrying the name of God, a saint or short hopeful ditties were sometimes worn around the neck or even swallowed by a patient for protection and speedy recovery. Equally efficacious might be a visit to a pilgrimage shrine to see and touch holy sites or revered remains. This was a more direct form of miraculous cure, where crawling beneath the decorated caskets of saints or sleeping in the presence of sacred spaces might engender the sympathies of the holy who could bring immediate physical aid. Heavenly healing like this was transactional. Good deeds on earth might be traded for instant good health, and pilgrims often left money, candles or wax effigies of afflicted body parts at shrines in the hope of tipping the spiritual economy in their favour. But beyond the miraculous, religious institutions were often also key points of more everyday care. In smaller communities rabbis, priests and imams doubled as local healers, albeit

with limited knowledge, and the emphasis placed on learning and charity as two pillars of the medieval monastery meant that communities of monks also gained a widespread reputation for medical expertise. At once more complicated and more humane than mere superstition, religious healing worked alongside the more secular theories of humoral cure to offer both physical and psychological relief to those in pain.

Beyond Words

This, sketched ever so briefly, is the rough shape of the medieval bodies that this book is poised to delve into. Medicine in the Middle Ages inherited from the classical world a highly developed theoretical and practical framework for understanding health. But it also built up its own uniquely dense socio-cultural and spiritual hierarchies, within which a number of lively competing practitioners and patients jostled for attention. Where exactly the red-haired half-man with whom I began fell within this broad spectrum still remains to be seen. Perhaps evolving technologies will soon provide new ways to examine his preserved body even more closely for further traces of his particular past life. But far from an impenetrable historical fog, the era in which he lived featured numerous exciting conceptions of the human form and how to care for it.

In fact, I think we can push these medieval bodies even further. They were not only the very centre of human existence in the Middle Ages, a malleable whole open to oscillating cycles of sickness and health. They were also a powerful metaphor, a creative body which could be made by healers, writers and craftsmen alike to stand in for almost anything, from the locus of everlasting metaphysical salvation to the recurring machinations of the seasons and the planets. Our routes through this material therefore have to be vast and varied, multiple modes of layered evidence spread across the best part of a thousand years. We will unpack the detail of medical textbooks written by learned authors and comb through the accounts of doctors and records

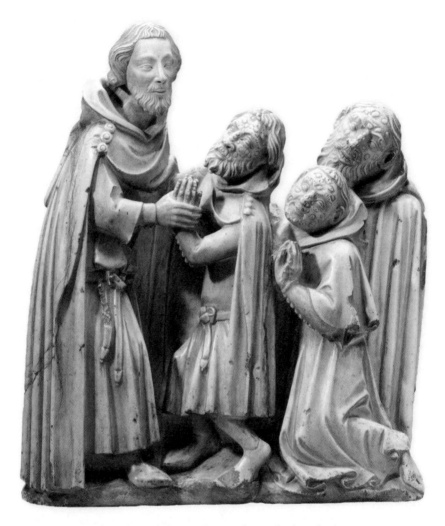

6. A marble sculpture of Saint Elzéar of Sabran healing
three lepers. Elzéar was a Franciscan monk and mystic, whose healing
touch earned him a name derived from the miraculously revived Lazarus
of the Bible. In this scene he is shown curing three beaming lepers,
their faces covered with the rounded buboes typical of the disease.
The piece was carved to decorate the lower sections of Elzéar's tomb
in the town of Apt in southern France around the year 1373.

of institutions. We will consider more lyrical written responses to sickness and cure made by all sorts of medieval people in their poems and prayers. But we will also look to the visual. For artworks and objects are another persuasive body of material that survive from the Middle Ages to communicate a vast range of ideas about how the human form was seen and understood. In an age without diary-keeping, where personal points of view are very few and far between, images offer a powerful inroad when texts fall silent. And they do so with particular emotion and vigour. For all that we can read a surgical treatise or a hospital's ledger for facts and figures, we learn something perhaps more immediate from looking at the carved faces of the faithful who smile as their sculpted bodies are cured by the miraculous touch of a healing saint. Ideas of health and these artistic objects are completely, happily entangled.

Born, bathed, dressed, loved, cut, bruised, ripped, buried, even resurrected, medieval bodies are a path to understanding the very essence of everyday life in the past. In the chapters to come I want to revive them along the very same lines as those laid down by thinkers of the Middle Ages. When a medieval medical author sat at their desk to write a record of their accumulated cures, they would often chose the body's own skeleton to act as their literary form, presenting treatments *a capite ad calcem* – 'from head to heel' – working their way from baldness and the brain down to twisted ankles and splinters in the toes. What follows is just this sort of unravelling, piece by bodily piece: the head, senses, skin, bones, heart, blood, hands, stomach, genitals and, finally, feet. By fleshing out each of these anatomised elements in turn, we can build up a picture of medieval bodies as more than just the sum of their parts, encompassing contemporary attitudes to life and death, pain and beauty. This is the body in its very broadest sense, a jumping-off point for exploring all kinds of aspects of medieval life. The head leads to thought, skin to clothing, bones to burial practice, feet to travel. Because once loosed from the confines of a distant 'Dark' Age, we can begin to see that the lives of these past bodies are not so very far from our own. Skeletal structures of the great medieval cathedrals still stand at the centre of our cities. Anatomised saintly bones survive in relics

and reliquaries preserved in museums and galleries around the world. And a bygone anatomical terminology still lurks at the very heart of our modern language. Far from dead and buried, medieval bodies are alive today.

HEAD

O n the very fringes of the known medieval world lived a tribe of
men with no head. Not that this seemed to bother them. They
were neither deaf nor dumb nor blind. Only, their faces were sunken
into their chests. Their eyes, noses and mouths protruded from their
sternum, and their ears were set frontally, just proud of their armpits.

The Blemmyae, as this race were known, first appeared in the
writings of Roman authors, who thought of them as part of a larger
group of supposedly monstrous peoples dwelling at the north-eastern
edges of the vast, mostly unrecorded continent of Africa. Medieval
authors were equally enchanted by them, and throughout the course
of the Middle Ages layers of detail were added to the Blemmyae's
mythic ethnography. An Old English manuscript from around the year
1000 describes them as gigantically large: *eahta fota lange ond eahta
fota brade*, 'eight feet tall and eight feet broad'. Later, in the twelfth
century, theological authors discussed the Blemmyae's supposedly
monstrous diet, deciding they were cannibals who gorged on mis-
guided wanderers. And by the 1400s a series of romanticised, roaming
histories of Alexander the Great described an encounter between the
ancient emperor and the misfigured tribe, noting that the Blemmyae's

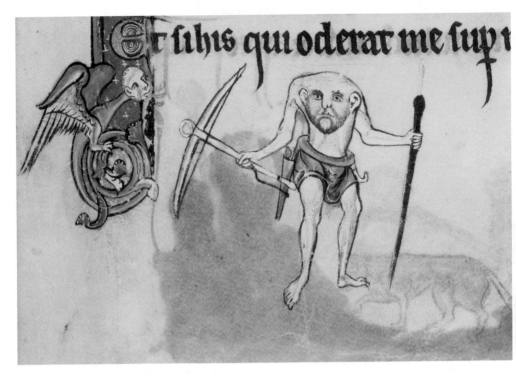

7. One of the Blemmyae, a headless African race, illustrated in the Rutland Psalter, a decorated prayerbook made in England around 1260.

beards sprouted from their groins and could grow down as far as their ankles.

By this period, the hulking forms of the Blemmyae not only populated the texts of medieval works but were also visualised in their margins. Maps in particular – documents which in the Middle Ages were often concerned with plotting history and myth just as much as an accurate cartography – showed the headless figures clustered around the north African coastline with a number of their monstrous fellows. The Panotii, who had ears so large they wrapped around the body like a coat. The Cynocephali, who had human torsos but the heads of barking dogs. The Sciopodes, who were endowed with a single enormous foot, designed at once to carry them hopping at speed and to offer shade from the desert sun by lying on their backs and hanging it over their

heads like a stately parasol. The comic particularities of these different types of almost-men meant that they were often inserted playfully into the vibrant illustrated margins of contemporary books at all sorts of junctures, sometimes even set against each other in monstrous combat. Beneath the bottom lines of one English prayerbook now in the British Library, a Blemmya faces off against another winged grotesque that perches in the curlicue base of an illuminated border. Clutching cross-bow and club, he gestures at his colourful opponent while wearing nothing but a loincloth and a quiver of arrows, his bemused but realistic facial features set firmly into his torso.

We are left to wonder whether perfectly sensible medieval people really believed that such a different and strange race of men actually existed. In a world with no means of mass communication, where cross-continental travel was both expensive and danger-ous, who was to know what lurked at the world's periphery? In the absence of proof, many would indeed have seen these figures as rather fanciful. Yet others may well have taken the popular ancient sources and contemporary tales of far-flung exotic travel at face value, a reasonable explanation of the wider globe. Even today, with modern migration and technology, our knowledge can similarly blur at the brink: the little green men that some think we will encounter beyond the bounds of our solar system are governed not by scientific truth but by the same very human impulses that formed these monstrous medieval races. The Blemmyae, then, sit at an intersection between medieval bodily fact and bodily fiction, giving us a glimpse less into the realities of pre-modern Africa than into the imaginations of everyday folk, their aspirations, their fan-tasies, their fears.

These monsters also reflected broader medieval ideas of what a 'normal' body should be. Set them, for instance, against the way that the bodies of human men and women were described by the famous fourteenth-century Italian physician Mondino dei Liuzzi. Mondino was the first major medieval author to write in any detail about human dissection, a practice that at the time was not yet part of mainstream medico-scientific discovery. In 1316, while teaching at the University of

Bologna, he finished his *Anothomia*, a book outlining various anatomical theories drawn from classical Greek, Roman and Arabic sources and which was to become a much-copied medical stalwart for more than a century after his death. 'We ought to know', he wrote, 'in what ways man differs from the brutes':

> Man, we note, is of upright stature ... for the human body is wrought of matter which is ethereal and airy, and is the lightest among all the animals. Thus it ever strives upward ... he has a most perfect form which he shares with the angels and the intelligences that rule the Universe. Thus all his senses of right are in the upper part of his body ... He is upright so that he may understand.

Mondino is here expressing perfectly two fundamental medieval bodily concepts. First, he argues that mankind's greatest strength is their upwardness, their posturing verticality. Through their two-legged, distinctly skyward-pointing body they literally oversee the rest of the animal kingdom. Other medical authors built on this idea by ranking the body's zones, from its grotty bottom to its sublime peak, all of which we will encounter in chapters to come. Lowest and basest was the fourth zone, containing the taboo organs of the genitals and anus. Third were the machinations of the stomach: important but still with a troubling tendency to grumble and belch without control. Second came the chest, container of various vital organs, including the all-important heart. But chief among the body was the primary sphere of the head, whose brain and multitude of keen sensory organs made certain mankind's place as king of the medieval cosmos. Following this climactic, upward way of thinking, we can see why the location of the Blemmyae's faces mattered so much in medieval minds. Set into their chests, rather than proudly atop the pinnacle of a head, the tribe were marked out as distinctly unhuman: monstrous, physically inferior creatures, robbed of the body's primary quarter.

The second important quality Mondino describes – man's 'perfect form' – casts even greater aspersions on monstrous bodies. Reflecting the dominant religious mindset of Europe at the time, Mondino is here

following to the letter the biblical narrative of Creation, in which Adam was crafted from the earth in the image of God himself. Mankind was a bodily reflection of the all-knowing Almighty. This perfect body, shared 'with the Angels' as Mondino puts it, was therefore also the model of a morally and spiritually good body. So by looking so totally different from normal men the Blemmyae were both anatomically incorrect and ethically questionable. Sure enough, medieval authors were keen to emphasise the deplorable lives of these imagined fringe races, their ungodly physicality given as the reason for their violent warring tendencies and their lack of behavioural understanding. To have no head revealed more than anything a deep-seated and particularly un-Christian streak of sinfulness.

Brains

Stavesacre
Pellitory Root
Sage Leaves
Hyssop Leaves
Betony
Ginger
Black Pepper
Long Mustard Seed
Nutmeg
Galangal
Cloves
Cubebs
Alum
Liquorice Power

Grind them all up and keep until needed.
Mix with vinegar. Gargle.

This fourteenth-century English recipe is a typical medieval medical medley, a concoction of pungent roots, herbs and spices that its author

claimed could cure any form of headache and 'cleanse the brain itself'. What precisely this meant is unclear. The ingredients together might have addressed particular humoral imbalances in the head or perhaps acted as a stimulant to kick the mind into gear. Either way, although medieval people knew little of its actual workings, the brain was considered one of the most important organs in the body, responsible for governing both human intellect and motion.

Neither of these functions, however, was considered to result from the coordinated action of the body's organs. The nuances of the nervous, digestive and circulatory systems were only to be fully explored and explained through technological leaps in later centuries. Instead, actions and emanations such as movement, thought and memory were believed to be governed by an individual's soul. This was, at least in part, the abstract, spiritual force we still associate with the word now, but classical writers had also spoken of the soul dwelling far more literally within the body, enacting different aspects of an individual's will in a more sentient manner. Plato, writing in the fourth century BCE, was among the first to advocate with particular vigour that the most vital, rational aspect of this animating soul was housed in the brain. This was taken up by subsequent thinkers, from the highly popular Roman physician Galen (c.129–216) to the influential compiler and medical scholar Abu ʿAli al-Husayn ibn Sina (c.980–1037), known in the West as Avicenna. Later medieval authors concurred, too, that the brain was a cognitive centre, the primary organ of intellect and reasoning.

An image from a thirteenth-century encyclopedia now in Cambridge's University Library – painted at almost precisely the same time as the Blemmya battling in the English prayerbook's margins – shows the brain in action. It is a simplified figure of the type sometimes included in complicated theoretical texts. Rather than a realistic, textured lump of grey matter, inside the head of a bearded bust we see a scheme of interlinked lines and circles mapped in black and red ink, guiding the reader through the brain's busy make-up. This is an image less interested in presenting the object of the brain than in picturing the processes of thought itself, which in the Middle Ages was theorised as an operation occurring across a series of the organ's sections or 'cells'.

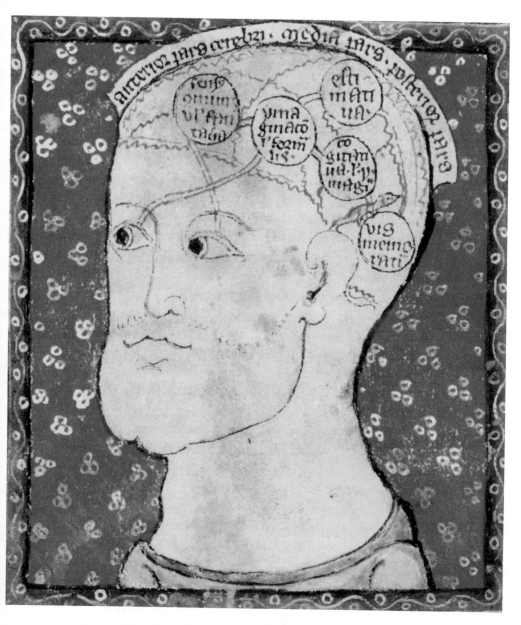

8. A man's head, complete with a diagrammatic outline of his brain, from
a trilingual encyclopedia made in mid-thirteenth-century England.

The first stage of this thought was prompted by the networks of nerves known to run to and from the brain and which suggested that it was responsible for receiving and processing information from the body's sensory extremes. This interpretative function was assigned to two initial cells of the organ, diagrammed here in the encyclopedia by its two left-most circles linked by red lines to the eyes. The first cell, labelled as the *sensus communis*, literally 'common sense', was where the body's communal sensory information was gathered together. This was carried to the brain by a substance known as *pneuma* or *spiritus*, an ineffably light, animating spirit linked to the soul and which ran throughout the brain and body like sentient hydraulics. The second cell, labelled *ymaginatio*, turned this abstract knowledge into tangible thought. Its name is drawn from the Old French word *ymage*, in turn derived from the Latin *imago* – which might translate as image, but also a likeness, idea, echo or ghost – the same word also at the core of our modern concept of the 'imagination'. Images were the building blocks of medieval thought, and these two processes brought them into tangible being within the brain, formed from the body's sensory data. Two further stages completed the process of understanding by further refining and then storing the thoughts already gathered and realised by the *sensus communis* and *ymaginatio*. Sprouting from the second circular cell are two more functions: *cogitativa*, the power of the brain to cogitate or turn sensed images into concepts, and *estimativa*, our estimation, turning images and concepts into judgements upon which we might act. Finally, at the back of the head, is a cell marked *memorativa*, the memory. Believed to be the softest and most impressionable part of the brain, it was here that thoughts would actually be stamped or imprinted, the ultimate repository of this entire elaborate scheme.

Together, this series of shapes presents a route map that allowed medieval writers to elaborate the many complex systems of their brains, from sense and thought to action and recollection. Images like the Cambridge head presented an abstract yet inventive sketch for understanding the processual nuances of the mind. And they also provided a framework for the mental system that contemporary physicians could

use to theorise why the brain failed or fell short. Intellectual difficulties were most often viewed in the context of age, gender or constitution, and the quality of an individual's intelligence was thought to hinge on the speed with which the brain's liquid-like ideas travelled across its cells. As the Syrian scientist Qusta ibn Luqa (c.820–912/13) suggested, the brain substance of brilliant minds passed smoothly and fluidly at lightning pace, whereas a natural thickening of thoughts caused an inherent mental sluggishness in children, 'idiots' and women.

Medieval doctors also keenly recorded the details of more serious mental imbalance. If a patient was suffering from a chronic acceleration of the mind, evidenced in sleep deprivation or an extreme mania, they might recommend various calming measures: medicines made up of soporific plants, massage or the removal of the patient to a quiet atmosphere with calming sounds, running water and softly chiming bells. Speech played a vital part in such diagnoses. The prolific Catalan physician Arnau de Vilanova (c.1240–1311) recorded some of the disorders his patients disclosed to him in conversation, from simple yet exhaustingly repetitive anxieties over eating or falling to more complex bodily dysmorphias – one involving elephant tusks sprouting from the mouth – and even crippling fears of heavy rain or that the end of the world was imminent. Patients' words were used as a key augur of the extent of their mental misfortune, but on the other hand, a silent patient could be just as worrisome. Under-activity in the brain's cells was thought to result in motionlessness or a fully blown catatonic state. These symptoms might be combated through stimulants and shock treatment that ranged from the eccentric to the absurd. The French physician Bernard de Gordon (c.1258–1318) recommended shouting, playing trumpets and bells, plucking the patient's chest hairs and placing a sow and piglets in front of the patient's face to squeal loudly. Needless to say, these treatments were unlikely to have been effective. For all their talk of cells and animating *spiritus*, medieval doctors admitted that they were largely helpless in such cases. Yet it is hard to deny the sophisticated internal logic at work in these early approaches to the brain. It is, after all, an organ whose workings modern science is still some distance from fully explaining.

Madness and Baldness

Beyond the anecdotes of doctors like Arnau and Bernard, the realities of actually living with mental illness in the Middle Ages are hard to unpick. Desperately few accurate or prolonged descriptions survive of medieval people living with chronic mental conditions, and such patients are only really encountered through quite biased accounts, often prone to distortion. The record of a sermon delivered by the Spanish priest Joan Gilabert Jofré in 1409, for instance, evocatively describes his native Valencia as having a host of madmen on its streets: what he called 'poor frantics causing damage to many persons'. Yet Jofré here is not really suggesting that caricatured, aggressive lunatics were regularly roaming around and attacking victims. Far more often it was the disabled themselves who were robbed or mistreated on the streets of medieval cities. Instead, this was a colourful rhetorical exaggeration designed to underline a simple point: safeguarding the mad was a model for safeguarding the entire community. Jofré's sermon in fact drew important support for a hospital in Valencia that was finished a year later, in 1410, perhaps the earliest medieval institution built with a particular focus on psychiatric care.

Less positive accounts of madness surface in the twists and turns of contemporary politics. The case of King Charles VI of France (1368–1422) is one of the most famous records of mental illness to survive from the Middle Ages, his prolonged bouts of instability quickly becoming the stuff of legend. One particularly vivid incident is said to have occurred in August 1392, as the king was riding with his entourage through the shady forests just outside Le Mans. Some say a pauper threw himself in front of the king's horse to beg for alms, others simply that a squire let a spear slip to the ground with a loud clang. Either way, the shock seems to have thrown the king into a semi-conscious, violent rage. For over an hour he attacked his close friends, kinsmen and servants, swinging at them with his sword and killing five before being restrained and falling into a deep coma. When he came round, three days later, Charles wept to hear what he had done. The

king's condition worsened over the next decade, and contemporary historians note him forgetting family members, insisting on running until completely exhausted, throwing furniture around his palaces and trying to break symbols of his coats of arms wherever he saw them. At one point the accounts devastatingly record that he became convinced that his body was formed of fragile glass, obliging him to stand resolutely still and to forbid anyone to touch him for fear he would shatter into thousands of pieces. This chronicling of Charles's slide into illness was not, however, intended as an accurate historical casebook sympathising with the failing medical realities of his mind. The real concern of these writers seems to have been explaining the serious political turmoil that ignited in France as a result of Charles's mental state and which rendered the country unstable for a generation. But we do know that many professionals were enlisted to help relieve the royal brain of its burdens. Physicians intervened with prescriptions of rest and medicaments, while clerics looked to higher powers for Charles's salvation through prayer, sending tiny wax effigies of him to miracle-working pilgrimage shrines in the hope of a cure for both king and country.

Similar tales of dramatic insanity are found in more fictional medieval writings too, but, unlike contemporary sermons and political histories, these dramas and poems tend to show madness ignited not by ill-health or sudden trauma but by the sorrowful pain of unrequited love. One of the most reproduced Middle Eastern poems of the period, the Persian tale of fated lovers Layla and Majnun (مجنون ليلى), depicts a love-struck form of insanity known by Sufi Islamic authorities as *divanagi*, 'love-madness'. Widely popularised by the twelfth-century Azerbaijani author Nizami Ganjavi, the story tells of a young woman, Layla, and her schoolfriend named Qays, who falls passionately in love with her. So maniacal and all-encompassing is his adoration that he quickly earns the epithet *Majnun*, the 'madman' or the 'possessed', a term hooked around the same Persian root as the word for demon, *jinn* (جن). In a tragic turn typical of medieval Romance, although Layla reciprocates Majnun's affection, she finds herself betrothed and married off to another more appropriate suitor. Stricken with the impossibility

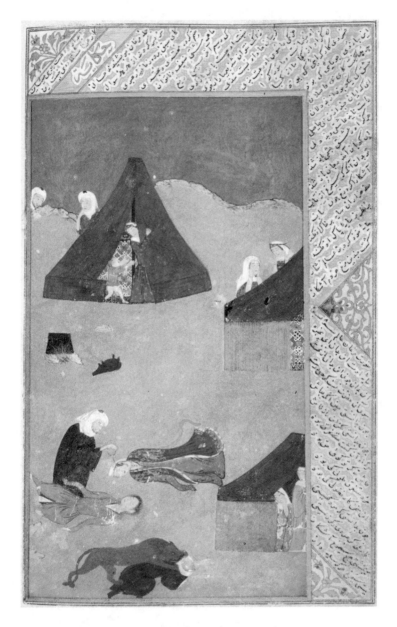

9. Layla and Majnun fainting at their final meeting, in a copy of Nizami
Ganjavi's *Khamsa* (خمسه). The image is included in an illustrated
miscellany made in Shiraz between 1410 and 1411 for Jalal al-Din Iskandar
ibn 'Umar Shaykh, who at the time ruled over much of Iran.

of his love, Majnun wanders into the desert, where he is comforted by wild beasts and writes ephemeral verses of poetry into the sands with a stick.

Layla and the wandering Majnun's love remains unfulfilled until their heart-broken deaths years later, able only to snatch the occasional meeting to exchange verses chastely from a distance. One of these poetic encounters, the last time the lovers see each other alive, is captured in sparse but dramatic detail by the illustrator of a luxurious album of poetry made between 1410 and 1411 for Iskandar Sultan, the governor of Shiraz. In a rectangular window framed by the diagonal lines of the poem's text, the two lovers have fainted at the sight of each other amid the tents. Their bodies are withered and floating, the flowing cloth of their elaborate garments billowing out as they fall to the desert floor. The wild beasts that Majnun has befriended in his isolation protect the couple, while his elderly attendant bends over the body of Layla and uses a pointed metal container to apply a remedy to her face, a herbal treatment in the same tradition as the revivifying ointments recommended by Bernard de Gordon. Love, the poem suggests, could transform from acute mental imbalance into an actual physical illness. In other images of Majnun, this fully realised lovesickness has caused his body to waste dramatically. He is pictured hopeless and emaciated, his constant pining rendering him a skeletal hermit.

Insanity was thought to be evident in the body in this way. In fact, a person's mental state could be reflected in all things, from the expression of the face to the quality of the skin. Common among contemporary biographers and medics alike was the practice of physiognomy, the idea that physical stature or facial features could act as a shorthand for intelligence, nobility or more negative character flaws of the mind. Hair, in particular, held a prominent place in the medical compendia that circulated throughout the later Middle Ages and was endowed with just this ability to indicate certain characteristics of the person beneath. Majnun is described as having a shaggy and unkempt mop, his wild locks a sure-fire sign of his crazed disposition. But simply having red hair could be thought of as suggesting a quickness to temper. Thick or knotted hair came with

an inherent brutishness. And a lank, sparse blonde could indicate deviousness or deception. Such hirsute distinctions were clearly in the mind of Geoffrey Chaucer (c.1340–1400) when introducing the corrupt character of his pilgrimaging Pardoner in the *Canterbury Tales*:

> *This Pardoner hadde heer as yelow as wex,*
> *But smothe it heeng as dooth a strike of flex*
> *By ounces henge his lokkes that he hadde*
> *And therwith he his shuldres overspradde*
> *But thynne it lay by colpons oon and oon*

> This pardoner had hair as yellow as wax,
> But smooth it hung, as does a bundle of flax.
> In small pieces hung these locks that he had,
> And over his shoulders it spread,
> But thin it lay in strands all one by one.

The Pardoner's cloying, straggly hair confirms his effeminateness but also presages an unscrupulous personality, a clue that any knowledgeable reader would recognise. Sure enough, we later learn that he is willing to preach hypocritically and irreverently falsify papal papers, abusing the duped faithful for profit. If only they had looked more closely at the clues hiding under his hat.

This seemingly arbitrary connection between character and hair was in part due to the process by which hair was believed to grow from the head. Medical writers theorised that as certain humoral fumes left the body through pores in the skin they condensed, forming small individual hairs that protruded from the surface. No such strands could grow where these membranous gaps were few and far between – the thicker skin of the palms or the soles of the feet – but where the pores had space to breathe, hair could grow much more plentifully. Heat was also thought to be congenial for hair growth, and, given that hot air rises, it was seen as only natural that the top of the head should sprout the thickest, bushiest locks. According to humoral theory, men had hotter bodies than women, and so it also made sense that they were the

hairier sex, although this same heat was in danger of drying out their pores completely, leaving them more prone to baldness.

A lack of hair on the heads of women, on the other hand, was seen as deeply unnatural. Standards of beauty in the Middle Ages varied dramatically from place to place and across the centuries, but in their definitions of good looks medieval authors often repeatedly turned to certain key tropes: the whiteness of the skin and redness of the lips, a thin waist and small breasts. At times a large, long forehead seems to have been fashionable, with women plucking their eyebrows and the peak of their hairline to exaggerate its size. Predictably, contemporary moralists were not happy with such seeming vanity, but a group of recipes found in the *Trotula* – a popular medieval compendium of women's medicine probably gathered in Salerno in the twelfth century – lists a variety of cosmetic treatments to improve the hair. Its smell could be helped by washing it with cloves, or it could be thickened with warm saltwater. Colouring with a cornucopia of natural ingredients is also suggested: walnut oil, vinegar-cooked myrtleberry flower, ants' eggs with yellow sulphide, or honey-infused white wine. Initiating such a transformation, however, was no simple make-over. Through the physiognomic lens of the day it had the power to affect the way others perceived the very temperament of your inner person, chaste or louche, beautiful or ugly, sane or mad.

Beheadings

If the head was the locus of human rationality, sanity and personhood, it is unsurprising that a vivid means of social control in the Middle Ages was to chop it off. The novels of nineteenth-century neo-Gothic writers like Walter Scott were set in a fantastical medieval Europe where such executions were glamorous and ten a penny. But beheadings were far less frequent in the medieval period than the brutality of most histories written since would have us believe. Death by hanging, with its comparatively unbloody results, was one of many more typical and tolerable forms of punishment. So when beheadings did occur, we

have to see them as an act of deep symbolism, able to function at once as violent judgement and potent sign. They were as much a continued threat to the living as social recompense for the dead.

Political thinkers often bound together conceptions of the body with conceptions of the state. The Englishman John of Salisbury (c.1115–1180) was one of several authors to espouse the idea of the Body Politic, a corporeal metaphor for society with individuated functioning parts. Peasants, Salisbury wrote, were presented as the feet of this state-body, toiling over the soil in service of its upper members. Registrars and treasurers formed the stomach, busily digesting the state's bureaucracy and finances. The active knights of the realm were the state's arms and hands, the government its beating heart, and the judges its eyes and tongue, seeing and speaking justice. But above them all was the king or prince, literally the 'Head of State', with dominion over all these bodily peoples just as the head reigned over the body. Like the human form, this Body Politic functioned successfully only when its constituent parts worked together as a cohesive whole. Should the treasurers become greedy and overfeed its stomach, the system might become bloated with corruption. Likewise, if judges too regularly turned a blind eye or peasants refused to keep the state moving forward, this metaphorical body would begin to atrophy and, eventually, collapse dead.

Occasionally, medieval people decided that it was high time the entire structure was prematurely decapitated. Unsatisfied with the rule of the thirteenth-century English king Edward I, leaders of the long-discontented provinces of Wales sought to remove him and instate themselves to rule atop the country's shoulders. In 1282 Llywelyn ap Gruffudd, then Prince of Wales, put paid to a thin treaty of peace that had papered over the two regions' political fractiousness and waged a series of military campaigns against Edward's forces. But things did not go according to plan for the Welsh. In a decisive skirmish on 11 December, Llywelyn's forces were overcome and he was separated from his men, surrounded and killed. In a horridly poetic extension of the metaphor that so defined the rebellion in the first place, the English then took Llywelyn's body and beheaded it. His transgressions against the Body Politic were made as visible as possible. The severed head was sent to King Edward in London, where it was

mockingly crowned in a wreath of ivy before being paraded through the streets and set onto a spike on the walls of the Tower of London. Despite the stereotype, this was not simply a random dismemberment meted out at the whim of a megalomaniacal ruler. Rather, this was a calculated act designed to perpetuate certain myths of rule and power. The message was made clear and painfully public: cross the king at your peril. The very reason that such flamboyant and fantastical beheadings haunt fictional medieval tales so often is precisely because the few that actually did take place were doing their job, propagandising for the crown and governing by threat.

Images also helped to spread this fear of a potentially vengeful state. Decorated editions of political chronicles were often laced with complementary depictions of extreme violence. The *Chroniques*, an early account of the Hundred Years' War between England and France written by the historian Jean Froissart (c.1337–1404), often contained luxurious illuminations depicting the fates of various double-crossing characters on both sides of the conflict. Take Olivier de Clisson, a Breton aristocrat who made the mistake of siding with the English. He was captured and decapitated by the French, his headless body humiliatingly strung up outside the city gates of Paris for all to see. The image in Froissart's book is no less of a warning. Olivier is shown blindfolded and dressed in white, poised to follow several others whose slumped, headless bodies already sit at the foot of the scaffold before him, gushing blood. Perpetually suspended in his last, dramatic moment, it would not be hard for readers to imagine themselves in his situation, prompted to think carefully about their own dealings with a state that could so easily end life with nothing more than the swipe of a sharp sword.

Set alongside such gory instances of violent retribution, mercy became an equally powerful tool in a medieval government's arsenal. In 1285, only three years after Llywelyn's execution, an inhabitant of Norwich named Walter Eghe was caught in possession of stolen goods and sentenced by a jury to hang, but upon being cut down from the gallows he was somehow found to still be alive. Claiming his survival as an act of God, Eghe fled to the city's cathedral, where he sought official sanctuary from the law. Visiting the city some months later, King Edward

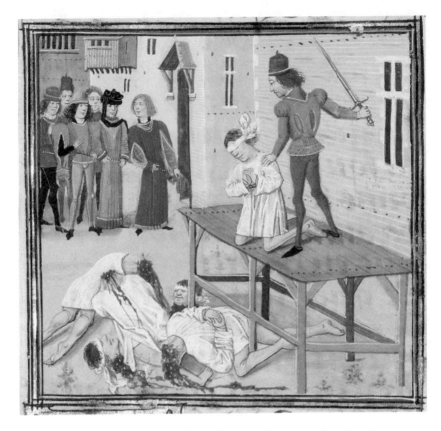

10. The beheading of Olivier de Clisson, from an illustrated copy of Jean Froissart's *Chroniques*, made for the Flemish courtier Louis de Gruuthuse in Bruges around 1475.

— the same ruler whom it would be so easy to caricature by his ruthless command to wreath Llywelyn's bodiless head in ivy — took the case as an opportunity to show his royal beneficence. He officially pardoned Eghe of his crimes and decreed he should be protected from serving further penance, demonstrating his power to preserve life just as he could inflict death. Medieval rulers had little need for the inflexibilities of regulated conviction enforced equally across entire populations through the rigours of objective justice. The ability to hold the lives of wrong doers in their hands was an extremely effective and self-affirming way to govern. Such punishments formed a campaign of propaganda that threatened with one

hand and offered salvation with the other, the eloquent spectre of losing one's head a persuasive way of keeping citizens in check.

The Saintly Caput

One group of medieval individuals had a proven capacity to bear such extreme bodily punishment unflinchingly, able to transform whipping, the slashing of skin, dismemberment, burning, drowning, even the drastic act of beheading, into propaganda for their own cause. These were the saints, ancient and contemporary religious figures who had led exceptionally virtuous lives and often undergone torturous persecution for their faith. Officially elevated from the ranks of mere martyrs by the Church, they were firmly enshrined in the hierarchy of the faithful, their stories constantly told and retold as part of the tapestry of medieval daily life.

Theoretically, the saints had already achieved one of the fundamental goals of religious worship sought by all medieval Christians. Upon their deaths, rather than following the normal operations of Christian salvation and patiently awaiting the lengthy limbo of Purgatory or facing the disgraceful torments of Hell, their overwhelming piety and ultimate devotion saw these canonised individuals assumed immediately to Heaven. There they dwelt directly alongside God, functioning as the most potent of intermediaries for people still on earth. Addressing one's prayers to these idealised intercessors, perhaps also via physical contact with the residual relics they left behind – either their former possessions or actual skin and bones – assured the most direct route to the beneficent mechanics of the divine. These figures were lynchpins of Christian society, known and venerated by rich and poor alike.

We hear about the saints mainly through their much-replicated written narratives, a literary genre known as their *vitae*, their 'lives'. Starting as small accumulations of blessed tales surrounding a particular individual's early cult, over the period of decades or centuries these biographies were embellished and expanded to encompass extensive stories of a saint's time on earth, as well as diverse lists of their

superhuman, miraculous feats and accounts of their pious deaths. Much importance was placed on these final martyred moments, especially the degrees of torment a saint could tolerate in the name of the Christian cause. By the end of the Middle Ages, particularly in German-speaking areas of central and eastern Europe, a logic had cemented itself whereby the more extreme and horrible a saint's martyrdom, the more impressive and devoted was their saintly patience in enduring it. Across panel paintings and manuscript pages, sculpted altarpieces and metalwork miniatures, a saint's body could undergo all manner of horrendous and bloody tortures. These images may seem gruesome, obsessive even. But look at the faces of these saints and we see their punishments borne with a calm, dignified, even smiling disposition. They appear anaesthetised by the prophetic knowledge of what this violent demise will earn them in the eternal afterlife.

These ritualised deaths were so prized by their followers that they often came to define the saint in question. The medieval *vita* of Apollonia, a Roman martyr of the third century, recounts that the saint was put to death by burning at the stake, but not before a beating that saw all of her teeth broken or, in some accounts, violently torn from her gums. This grim end gave the saint something of a devotional speciality in the eyes of the faithful, who happily enshrined her as the patron saint of dentistry. And upon seeing a robed figure in a church clutching a pair pincers in her hand, a well-versed Christian viewer would know it immediately to be Apollonia, the instrument used to pull out her teeth reworked as her identifying symbol. A man with a rock lodged in his head would similarly become Saint Stephen, stoned to death in first-century Jerusalem. Another, with no eyeballs, could be Saint Lucy, blinded and martyred in third-century Sicily. A woman holding a wheel was identified as Saint Catherine, a fourth-century princess from Alexandria who was sentenced to death by being bound to a cartwheel and bludgeoned. Saints and the objects of their martyrdom were totally intertwined, forming a morbid religious shorthand used when depicting their holy ranks, lined up amid the heavenly clouds.

So busy was the constant evocation of the saints as the protectors of medieval people that the detail of their lives could become blurred

into myth in just the same manner as the headless Blemmyae. Narratives and attributes did not always need to match directly. The image of a delicate young woman stretched violently across the spokes of a wheel seems to have caught medieval imaginations and become Catherine's famed attribute even though, if we follow the narrative of her *vita*, the great cartwheel in fact cracked beneath her heavenly body, proving her divine favour. Catherine's executioners were instead forced to turn to the most final of all punishments and behead her. But even this dramatic act was not enough to defeat some saints. Saint Denis, the third-century bishop of Paris, was beheaded on the city's highest hill, modern-day Montmartre, literally the 'mount of martyrs'. Yet, according to medieval accounts, as soon as Denis's severed head hit the ground, his headless body simply rose up and grasped it. Carrying the head, he walked a full six miles north before finally collapsing at the site of what would become a church and eventually a cathedral, named in his honour. These animated headless saints are known as cephalophores, 'head bearers', seemingly reanimated by the sheer will of their heavenly devotion. And just as important as their miraculous wandering was the speech that could amazingly continue to flow from their disconnected mouths. As Denis walked the last leg of this journey, his disembodied head continued all the while to preach, bringing a host of converts to the Christian cause in his final, revivified moments.

Controlling the remains of these severed heads was particularly important for religious authorities. Such relics grew to become deeply fetishised objects at the cornerstone of the cult of saints, able at once to bring spiritual succour to the faithful and potentially lucrative funds to the Church in the form of charitable donations. The New Testament narrative of the biblical protomartyr John the Baptist, for instance, records the complicated story of his death, decapitated for his faith at the behest of Herodias, wife of Herod, the ruler of Galilee. John's head was triumphantly presented on a platter, and this unforgettable decollation enshrined the *caput*, as it was known in Latin, as a potent symbol of the Baptist. By the Middle Ages John's intact cranium had gathered many supposed resting places. Some clerics claimed it lay in the Great Mosque at Damascus, where a shrine was still kept to it on the former

11. A *Johannisschüssel*, the decapitated head of John the Baptist on a
platter. The oak head was carved by the artist Dries Holthuys in Xanten,
Germany, around 1500. Its lustreware majolica plate comes from the
Valencia region and was made half a century or so earlier.

site of a grand Byzantine church. Others thought it was the property
of Amiens Cathedral in northern France, where a version of the relic
had been taken after the Fourth Crusade of 1204 and set into an enor-
mous golden reliquary. But regardless of which relic one saw as the
most authentic, interaction with John's head was fundamental for the
medieval Christian faithful, offering a unique sense of heavenly com-
munion by coming face to face with the saint himself.

So strong was the power of John's head that even communities
without direct access to his saintly skull sought to venerate it, not

directly through relics but vicariously through the skill of medieval artisans. In many northern European towns sculptors were commissioned to create *Johannisschüsseln*, evocative likenesses of the Baptist's severed features. One such piece, made for the cathedral of Xanten in the west German Rhineland, is typical of this tradition, bringing to mind the Levantine surroundings of John's decapitation by setting a sculpted wooden head onto an exotic Moorish plate, fusing the saint's likeness with an authentically Middle Eastern ceramic form. These were deeply revered objects that activated many ideas associated with the medieval head, from execution to memory to morality, elaborate spiritual stage props that extended the awe-inspiring presence of the Baptist into people's everyday existence. They were placed on cathedral altars, carried about the town during religious processions and used as a stand-in for the real thing in religious plays, complete with streaming artificial blood. People even prayed to them for relief from head-related ailments like headache and throatache, forging a literal link between the saint's suffering *caput* and their own. In so doing the sculptures, in a strange sort of way, were reaching at something beyond even the pained figure of Saint John: they recalled the head's place as the powerful summit of the medieval body, at once medical and mindful, punitive and peaceful.

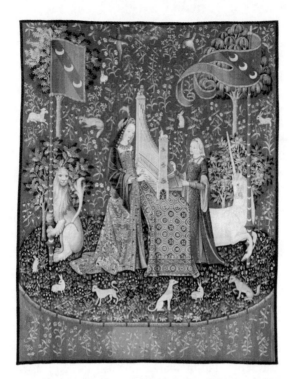

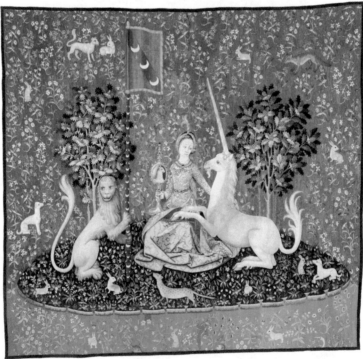

12. Two of a set of six tapestries of a young woman, a lion and a unicorn depicting the senses of taste, smell, sound (top), sight (bottom) and touch, all made in Flanders towards the end of the fifteenth century.

SENSES

Watching the six large tapestries being hauled into place on the walls of the museum's Grande Galerie in the spring of 1883, Edmond du Sommerard probably stroked his extensive beard and breathed a sigh of relief. It had, by all accounts, been a difficult negotiation.

The wall-hangings, sumptuous, enormous rectangles of colourful wool and silk made in Flanders in the final years of the fifteenth century, had first been discovered forty years earlier, in 1841. The writer and Inspector-General of Historic Monuments, Prosper Mérimée, had found them at the Château de Boussac, an imposing renaissance mansion in France's central region of Limousin. But it was hardly a grand enough residence for works that, half a century later, would rival the Mona Lisa as one of Paris's star museum attractions. Mérimée was horrified to discover that several parts of the extremely rare tapestry series had already been cut up by the local administrators of the château and used to cover carts or furnish the house as carpets and doormats.

By 1882 dwindling funds had forced the town of Boussac to put the tapestries up for sale. The remaining pieces were found damp-stained, nibbled at their corners by an undiscerning mouse, but their value was

still clear to those in the know. The notorious rumour mill of Paris's flourishing antiquities market started firing on all cylinders. Hushed conversations over account books spoke of substantial private offers, upwards of 50,000 francs, double the price for which the château itself had recently been purchased. Speculation was mounting, too, that the tapestries had caught the eye of a mega-collector, perhaps the wealthy banking scion Alphonse de Rothschild, and were poised to be vacuumed up into the private market, disappearing from public view for ever. It was only after heated talks and the intervention of the French state that Boussac agreed instead to sell the tapestries to the Musée de Cluny in Paris for a more modest sum of 25,500 francs.

The museum had been the brainchild of Edmond du Sommerard's father, Alexandre, an influential figure in the revived taste for the medieval among the cultural movers and shakers of the capital. By 1833 his collection of medieval and renaissance objects had become so large that he was forced to move them to bigger premises in the extravagant late medieval mansion known as the Hôtel de Cluny, just a short walk south from the Cathedral of Notre-Dame and the Île de la Cité. But Alexandre made it clear that his pieces should not be cloistered away for ever. Upon his wishes, after his death in 1842 the Hôtel was converted into a public museum, so that Parisians of all classes could be transported back into France's medieval past. His son Edmond, the museum's first director, restored and refigured the building, extending it to include a new long salon upon whose walls the tapestries were finally hung.

More than a century later these intricate textiles are still on public display at the museum, now known as the Musée national du Moyen Âge, where they were carefully restored in 2013. Yet although the softly glowing lustre of their rich coloured cloth has been revealed for the first time in over 500 years, people are still puzzling over what precisely they depict. Each tapestry carries an intricate design featuring a young woman, a lion and a unicorn. They vary slightly in size, presumably to match the medieval walls they would have originally decorated and insulated, but across all six pieces the same trio adopt different poses and positions in a fantastical circular green garden. Their surfaces are

everywhere puckered with sprouting wild flowers, hiding frolicking miniature creatures and supporting stout trees of crisp, bushy leaves laden with different varieties of blossoms and fruit. This cornucopia would have been quite a showcase for the immense technical skill of their Flemish weavers, who would have painstakingly transformed the designs from painted cartoons into woven cloth. The woman herself, though, is enigmatic. Sometimes standing and sometimes seated, sometimes aided by a younger maid and other times alone with her beasts, she gestures back and forth between tasks in a language of subtle signs, a pointed finger here, a soft caress there. The heraldic flags that feature prominently throughout the series feel like they might offer a clue to who she is, or to the tapestries' original commissioner, but the specific symbolism of their three crescent moons has been lost over the centuries. We have no immediate access to what this young woman is saying or doing or thinking, or to the scene of the action itself: her island is enclosed, floating in a deep-red vegetal background some distance from any world that the viewer inhabits.

One thing does seem to be clear about the tapestries, however. Across the first five compositions the woman treats the lion and unicorn to the music of her harmonium, feeds her parrot and a monkey from a bowl of berries, sniffs a wild flower, tenderly touches the unicorn's horn and plays with a mirror: displays of hearing, taste, smell, touch and sight. Classical and early medieval authors had once worked with a much more open understanding of what constituted a sense, including the brain's faculties such as memory and the imagination, or extreme feelings like anger and divine love. But by the later Middle Ages the traditional 'Five Senses' had solidified as the five fundamental forms of sensory interaction that could take place between bodies and their immediate environment. To explain the working of these senses, thinkers of the period sought to understand the base matter behind each and how it moved throughout the world: how a flower's perfume might be borne on the wind, or how sounds made their way through the air. But, crucially, to get to the heart of sensation they needed to know how these sensory signals were received by the body itself.

Seeing Sight

In one of the largest of the Cluny tapestries the young woman turns a gilded mirror towards the smiling face of her unicorn, casting his image back in miniature towards the viewer. Among her elaborate surroundings, flashing the face of her companion seems a small act for the woman, nothing more than a twist of the wrist. But in inviting the unicorn to see its own reflection in this way, she also asks us to consider the very mechanics of looking itself.

Two contrasting theories of sight jostled for primacy in the Middle Ages, both of which understood the sense to function through the exchange of light. The first took up the notion that the eyes fundamentally functioned as receptors, accepting visual rays that were cast outwards from all objects in the world and conveying this sensory information back to the brain via the optic nerve. Supporters of this theory of intromission, as it was known, ranged from Aristotle to Ibn Sina, who strongly upheld the idea in his *Danish-nama-yi ʿAlaʾi* (علائى دانشنامه, commonly called 'The Book of Scientific Knowledge'). 'The eye is like a mirror', he argued, 'and the visible object is like the thing reflected in the mirror'. The second, competing idea of vision also developed from classical writings, especially the Greek theoretician Euclid and the Roman writer Ptolemy, but conceived of sight as functioning the other way round. It was not objects that projected light, they argued, but the eye itself that expressed rays outwards until they alighted upon an object. Sight in this mode was an almost tactile process, with invisible emissions from the eyes feeling their way through space to illuminate the world with their diaphanous touch.

Medieval writers continued this nearly millennium-long debate about vision's directionality until the 1260s, when the English theologian and author Roger Bacon (c.1220–1292) intervened to suggest that, in a way, both camps might be right. In a subtle synthesis of the two visual traditions Bacon's highly influential book on the philosophy of optics, the *Perspectiva*, argued that the optic nerve did indeed relay sensations of the eye to the cognitive faculties of the brain, but that it could both send and receive information. Sight, therefore, could be

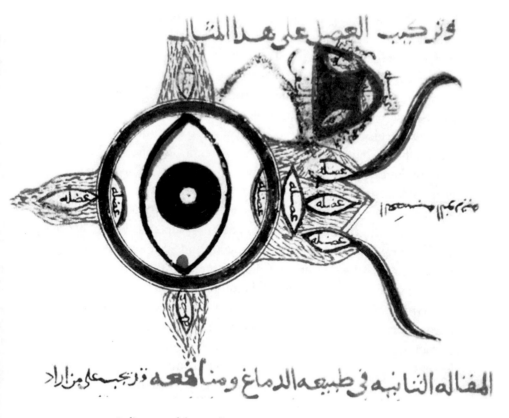

13. A diagram of the eye from an Arabic treatise written by the
Nestorian Christian scholar Hunayn ibn Ishaq, itself a ninth-century
translation of Galen's even older treatise on ocular remedies.

based in both objects and bodies, and natural philosophers of all stripes
appeared convinced that visual rays moved both into and out from the
eyes in two directions, not just one.

Medieval opinion was similarly fluid about the physical make-up
of the eye. On the one hand, its theoretical anatomy had been rela-
tively consistent for centuries. When physicians described it in their
treatises, they spoke of a circular organ with a lens at its centre, a core
that was surrounded on either side by different layers of variable vis-
cosity and hardness. Many of these live on, refined and sometimes
relocated, in today's optometrical terminology: the aqueous humour,

retina, cornea, sclera, conjunctiva and so on. For the everyday medieval medic, though, ocular anatomy was thought less important than an understanding of how the four bodily humours were constituted within the eyes. A healthy eye was thought to be humorally cold and wet, and if swelling, irritation or bleeding occurred, cures sought to return it to this natural condition. Failing vision or infected eyes required treatment with pharmaceuticals of the appropriate humour, especially recipes that included earthy plants such as fennel, onion or garlic. Other more serious conditions were less well understood by medieval physicians and surgeons, who located them in various parts of the eye and attributed them to different causes. Cataracts, for instance, sometimes described as the unwanted gathering of cloudy vapours, were only considered curable in their early stages if at all, and a patient was normally prescribed herbal eye drops or minor surgery to the cornea with thin needles, which almost certainly did more harm than good.

Given the inevitably mixed success of such interventions, it was not uncommon for people to fall into blindness. In the Middle Ages this term did not necessarily imply a total lack of vision: without glasses or contact lenses many of us today might too have found ourselves in this medieval category. Some help was on hand. By the early 1300s readers in western Europe began to use Arab-style reading aids, often in the form of polished 'reading stones' made of the mineral beryl, whose green lustre was thought particularly efficacious for good vision and whose curved lenses could magnify their texts. But for the more seriously poor-sighted or totally blind the only real recourse was to the charity of their immediate family or, for a lucky few, the religious arms of the state. The thirteenth-century poet Rutebeuf, writing satirically in Old French in around 1260, listed the blind among the regular denizens of Parisian street life:

> *Li rois a mis en i repaire,*
> *Mais ne sais pas bien pour quoi faire*
> *Trois cens aveugles route a route*
> *Parmi Paris en vat trois paire*
> *Toute jour ne finent de braire*
> *'Au iii cens qui ne voient goute.'*

The King has set in one spot
Although why I know not,
Three hundred blind, road by road
Going though Paris in groups of three,
Everyday not ceasing to bray
'Give to the Three Hundred who cannot see.'

These 'Three Hundred' were the eponymous residents of the Hôpital des Quinze-Vingts — literally the hospital of 'fifteen twenties' — a religious institution and charitable living-quarters recently founded to care for three hundred blind people by the French King, Philip Augustus. Making their way conspicuously through the streets in groups of three, sometimes led by sighted guides, the Quinze-Vingts would each day implore people to give alms to support their communal upkeep. Many, however, complained about their presence in the city and continued to view these blind beggars as something of an urban pest, ripe for victimisation. In 1425 an anonymous Parisian chronicler records an 'entertainment' in which four blind people were put in a park with a pig, handed clubs and told that if they killed the pig they could eat it. The crowd watched on, apparently in enjoyment, as the blind men nearly beat each other to death.

Such unpleasant harassment of the visually disabled, however, also coexisted alongside overwhelming praise for those who had the patience and faith to endure a lack of sight. The Mamluk Egyptian philologist and historian Khalil al-Safadi (c.1297–1363) dedicated two large treatises to the biographies of more than four hundred famous blind and one-eyed men who had overcome their disability to forge careers as great theologians, scholars, doctors or poets. In spiritual narratives, too, admiration of the blind's achievements was even more profound. Christians, Jews and Muslims alike all framed a lack of sight as a trial of an individual's morality. Those who suffered through such a test would be rewarded for their continued faith in the afterlife, and without the fruits of the human world to bother them they were also thought to be endowed with a potential to see deeper, more divine things. Uncluttered by earthly vision, they might instead learn to look

with what the English mystic Margery Kempe (c.1373–1438) called the *'syght of hir sowle'*, an ability to glimpse with clarity the transcendent workings of God which lay behind all things.

Sniffing the Past

The exploits of the mysterious woman in the Cluny tapestries, then, are designed to prompt the viewer into both recollection and projection, mapping onto her five sensory games all sorts of ideas which lay behind the senses in the Middle Ages. Even today, when engaging with these pieces we cannot help but begin to imagine that we too are part of the picture, and this is intentional. Like many images of the medieval body, the tapestries deliberately encourage us to coexist with the depicted beholder. Seeing the young woman flashing a mirror to her unicorn companion, we are perhaps reminded of our own good luck in having eyes healthy enough to take in its vibrant scenes. We take her experience as our own and begin to sense what she senses.

At the same time it is, of course, impossible to actually reconstruct these medieval senses with any real precision. Sensory experiences are individual and subjective, making them extremely difficult things to describe or to share. Smell, for instance, is both particularly evocative and particularly personal. You and I, sniffing the same rose, even at exactly the same moment, cannot truly know for certain that our sensations match. And the words to which we might turn in comparing our experiences also fall short. There are various strategies. We might resort to the scientific or biological to elucidate: 'That wine has a rusty, composty smell to it.' We might borrow from other senses: 'That cheese smells sharp and bright.' Or we might rely on a shared set of undeniably abstract cultural concepts: 'That perfume is *so* 1980s.' But each type of sensory description is beset with a seemingly endless range of subtleties and specifics. In the mêlée of modern language we might talk of a whiff, a scent, a puff, a waft, a stink or a fragrance, all of which denote subtly different things in subtly different contexts, their meanings ever-shifting like the gusts of air on which they arrive and

14. A gilded-copper censer or lamp from the mid-fourteenth century, made in northern Italy.

15. A brass and silver incense-burner made in Mamluk Syria, c.1280–1290.

leave. This is the problem of what historians call sensory archaeology, the difficulty of bridging the millennium-long gap between an original medieval description of a sense and our own bodies in the here-and-now. We know that medieval thinkers theorised the action of smelling much like the action of sight, with scents travelling on the air to the nose and from there via the body's animating spirit backwards to the brain for comprehension. But recapturing these past smells is inevitably an oblique act, sensed only through thick phenomenological clouds.

Thankfully, objects can help with this olfactory conundrum. The two intricate metal items above were made only around eighty years

apart on opposite sides of the medieval Mediterranean. Both are delicate pieces designed to contain burning incense and spices to perfume their surroundings. But they give access to two quite different cultural contexts for medieval smell.

The object on the left, the more ornate and larger of the two, was crafted in northern Italy, perhaps in the fourteenth-century Milanese workshop of the much sought-after sculptor and painter Giovannino de' Grassi. It is a small but extremely detailed gilded-copper lamp, designed to diffuse both the glowing light and the sweet smells of the burning incense inside through six windowed openings. Men in biblical dress stand in front of these niches, with miniature angelic figures interspersed between them, both of which suggest that the piece was designed to be used in a Christian context. Smell was a fundamental part of medieval Church practice, and both the western Catholic and eastern Orthodox liturgy regularly called for incense to be burned in processions or to accompany particular moments of observance. Sweet smells themselves are frequently mentioned in biblical texts as key indicators of sanctity, and holy relics were almost always recorded as giving off a miraculous perfume, echoing Christ's body, which, according to the Gospels, was anointed with scented oils after being taken down from the cross and prepared for entombment.

Smells were also used to dramatic effect in saintly *vitae*, with unexpected scents suddenly appearing in the hagiographic narrative to emphasise the theatrical turns of sanctity. In the life of the ninth-century Byzantine saint Irene of Chrysobalanton we read of the terrifying moment the saint is visited by a demon while praying in the room of her convent in Constantinople:

> Then the demon stretched out his hand and kindled a stick against the lamp-wick. He dropped it around the neck of the holy woman, and it burned up as if fanned, violently inflaming her whole hood along with the scapular and the shift, and began even to lick her flesh. It went over her, scorching her shoulders, her breast, her spine, her kidneys and her flanks.

Smelling the fire, one of Irene's fellow nuns soon traces her way to the source of the stench, where she finds a terrifying but wondrous sight: 'Irene all in flames but standing immobile and unwavering and unconquered, paying no heed whatever to the fire.' Promptly extinguished, the scorched Irene claimed to have felt little pain from the flames. And as her burns were treated, pulling away the fragments of garment now welded to her skin, the pungent, sickening smell of smoke and scalded flesh suddenly transformed into a gorgeous fragrance emanating from Irene's holy wounds. Deliberately contrasting a suffocating reek with an angelic perfume, the *vita* relishes this luscious new saintly aroma, calling it 'incomparably more fragrant than any perfume and precious scents, filling the whole convent for many days'.

In his lamp Giovannino de' Grassi would have had similar sanctified smells in mind when he chose to surround its flame, emanating perfumed smoke, with religious figures. A jungle of gilded corkscrew vines, rolled leaves and opening flowers further evoke the abundant scents of nature, weaving their way around a micro-architectural structure that culminates in a series of pinnacled towers and battlements. Atop them all is an open spire, from which the whole ensemble would have hung or been swung by hand in procession from a short chain. These architectural flourishes were in part an allusion to the great churches and cathedrals in which such objects would have been used. But they also refer to the ultimate Christian city, Heavenly Jerusalem, the beautiful realm of the Eternal. More than just a sight to behold, heaven was also the olfactory seat of perfection, a lofty perfumed place full of saints, spirituality and, in the words of the fouth-century theologian Saint Augustine, 'a fragrance which no breeze can disperse'.

The second incense-burner looks quite different from Giovannino's. Made by an unknown craftsman in Mamluk Syria, a set of thin sharp tools would have been used to pierce patterns through its delicate brass and silver surface, allowing the smoking incense inside to waft through its small, sieve-like shell. Yet, like the Milanese lamp, its considered form also hints at the bigger ideas caught up with the medieval sense of smell. Christianity and Islam shared a conviction that the afterlife was a sweet-smelling place: the Qur'an calls Muslim paradise *jannah* (جنة),

a place most often evoked as an abundant, scented garden. At many moments life in the Middle Ages would have smelt rather pungent. While bathing seems to have been a more popular pastime than in the pre-modern centuries that followed it, people still tended to have only a few sets of clothes, which they washed and changed infrequently. The Garden of Paradise, by contrast, was completely unfettered by malodour, filled instead with gently flowing waterfalls, fruit that never rotted and rivers of honey and milk that always stayed fresh and fragrant. The *houris* (حورية), heavenly maidens who inhabited these gardens, were even said to be somehow formed of perfumed substances like saffron, musk, camphor and ambergris, precisely the sort of spices that would have been burned in the small Syrian lamp.

The imagery that appears on this little sphere also affirms such heavenly pleasures. The lamp's surfaces are decorated with seven cross-legged figures seated in seven roundels that represent the seven planets: Mercury, Venus, Mars, Jupiter, Saturn, Earth and the Moon, at the time considered a planet in its own right. Above them, a central roundel is filled with the perforated rays of the sun, the whole scheme a reflection of the advanced state of contemporary Muslim astronomical science, which had for some time carefully studied the motions and meanings of these celestial bodies. The internal machinery of pieces like this were even more intricate than their surfaces. It contained a small bowl of lit incense set into a gimbal, a series of rotating rings which gyroscopically allowed their contents to remain upwards regardless of the position of its decorated metallic shell. This meant that the small ball could be rolled playfully back and forth without upsetting its contents. We might imagine it quietly zipping across a table, perhaps passed from guest to guest at dinner, or along the carpeted floor of a travelling tent with the incense's sweet fragrance underscoring conversation.

Such smells, like their silver container, were a clear symbol of opulence and excess. The spices it was filled with – cloves, cumin, myrrh, jasmine, rose, camomile – were often pricey imports. But such scents were also valued for certain scientific properties that might have been particularly useful while eating or on the move through new lands.

Disease was understood in the Middle Ages to be spread and received in part through polluted vapours or *miasma*. Good smells could counteract this bad air, cleansing as well as scenting their surroundings. Like its Christian counterpart, then, this burner was laden with multiple inferences, from heavenly symbolism to earthly expense, its miniature planets revolving like the heavens as it was passed around, swirling spices softly about the room.

All Ears

Teresa de Cartagena defined her deafness as separating her from the world. She was able to see the richness of things, to smell them, to touch them, but without her ears she still felt disconnected from people:

> *Ya soy apartada de las boʒes humanas, pues mis orejas non las pueden oýr. Ya tiene silençio mi lengua plaʒera, pues por esta causa non puede fablar.*

> I am cut off from human voices, for my ears cannot hear them. My gossiping tongue is silenced, for because of my deafness it cannot speak.

She had lost her hearing young while growing up in fifteenth-century Burgos, in northern Spain, and later in life became one of the earliest women to write about her deafness in a short treatise named the *Arboleda de los Enfermos*, the 'Grove of the Sick'. Ears in the Middle Ages were described as functioning through a narrow network of thin tubes that protected a small hair-lined well of stationary air that absorbed the resonance of incoming sounds. Following the familiar pattern of the body's sensory organs, this sound was then conveyed to the brain by the *spiritus* for comprehension and judgement. For Teresa, lacking the ability to engage with this complex process was bittersweet: sad because it set her at a remove from many aspects of life, yet truly joyful because she felt living in silence opened her up to a series of sounds normally beyond human perception.

In his treatise *De institutione musica* ('The Fundamentals of Music'), the sixth-century philosopher Boethius introduced an influential three-fold classification of sounds that was to hold strong currency across the period and well into Teresa's day. First there was *musica instrumentalis*, the sounds and songs of voice and instrument – string, wind, percussion – which people heard all the time in their normal earthly experience. Then there was *musica humana*, a more complex form of spiritual music. This was inaudible to men and women, but was constantly playing out as a series of resonant harmonies between the body and the soul. Even more refined was *musica mundana*, a phrase taken from the Latin *mundus*, the music of the world. These were sounds that set the medieval understanding of music into permanent dialogue with the study of philosophy and mathematics, the cosmic mellifluence of the spheres. Again, this world-music was beyond the audible grasp of mankind, but it was continuously resounding in the eternal movement of the planets and the changing of the seasons. It was almost theoretical sound: the underlying vibrations of God's constantly humming universe. In Boethius' paradigm, it was this trifold music that bound together song, man and the world, held in heavenly unison through polyphonic sympathy, and it was to the more sacred strains of this resonance that Theresa felt she was uniquely attuned. Deafness, like blindness, granted special access to the divine.

Given this conceptual, almost spiritual foundation for sound as at once audible and inaudible, it is unsurprising that the strongly religious culture of the Middle Ages felt able to locate a certain special sanctity in music. This was especially the case in sacred space. Synagogues, mosques and cathedrals, particularly those built at great expense on staggeringly large scales, were exceptional in comparison with most normal dwellings both architecturally, in their large size and vibrant decoration, and also acoustically, in their remarkable capacity for resonance. Average living-quarters would have mostly been uninsulated spaces whose thin timber walls would have left noises from adjacent rooms flat, dull and dampened. Religious architecture, on the other hand, often deliberately amplified and reverberated sound. Walking into the 184-foot-tall domed space of Hagia Sophia, Constantinople's

16. The interior of Hagia Sophia, Constantinople, originally built as the Byzantine Empire's first Christian cathedral by Justinian I in 537 and later converted into a mosque under the Ottoman sultan Mehmet II in 1453.

capacious fifth-century basilica church – later converted into a mosque under the Ottomans – a visitor would have encountered an other-worldly sonic space the likes of which they had probably never heard before, packed with echoing speech, the noise of footsteps bouncing repeatedly off the high walls and, of course, song. The German abbess and composer Hildegard von Bingen (1098–1179) went so far as to chastise officials who kept music separated from such spaces of spiritu-ality. As she wrote in a letter to her archbishop: 'Those who, without just cause, impose silence on a church ... will lose their place among the chorus of angels.' In addition to smelling good, Hildegard imag-ined that heaven had a profoundly holy, choral tenor to it. Whether filled with the well-established melodic lines of unaccompanied Chris-tian plainchant or the Qur'anic verses intoned by imams before their congregation, these earthly spaces could have their vast expanses elec-trified through sound.

The loudest of these sacred sounds – in fact, probably some of the loudest man-made sounds a person was likely to encounter in the Middle Ages – were the chimes that regularly rang out from medi-eval belfries. Bells and their ringing were an important part of life, regulating the working day, and they were particularly important for Christianity from its very earliest origins. By the ninth and tenth centu-ries large cast-bronze bells became more and more common, carrying their sound for miles around and calling people to worship. These were complex objects and required a significant level of technological ability to successfully melt, shape and tune their metal. They were often cast on-site during a building's construction, sometimes in sunken pits sym-bolically located at the very centre of a half-completed religious site, and from this auspicious birth an institution's bell would continue to play a keen role in both promoting its faith and literally protecting its faithful. Loud, cacophonous sounds were thought to have an apo-tropaic effect, helping to drive away unwelcome spirits. As a result the names of saints were sometimes cast into a church bell's rim, extending a sonic aura of goodwill and protection from the heavenly individual to anyone who heard its distant peal. One bell from the mid-1200s, donated to a church in the Italian town of Assisi by Pope Gregory IX,

proudly proclaimed its multiple purposes in first-person poetic verses cast into its side, its efficacy intoned in repetitive lines like the slow chiming of the bell itself:

SABBATHA PANGO
FUNEREA PLANGO
FULGURA FRANGO
EXCITO LENTOS
DOMO CRUENTOS
DISSIPO VENTOS

I DETERMINE THE SABBATH
I LAMENT FUNERALS
I BREAK LIGHTNING
I ROUSE THE LAZY
I TAME THE CRUEL
I DISPERSE THE WINDS

Even without their resonating holy sound, bells were potent objects. If broken or cracked, they might be interred in holy ground like the dead. And they could be taken prisoner, used as political pawns in larger cultural clashes. In the year 997 the Muslim ruler of the southern Spanish caliphate of Córdoba raided and destroyed the major Christian pilgrimage centre of Santiago de Compostela. But instead of melting down the grand church's bells for their valuable raw metal, they were held captive, hung as symbolic booty in Córdoba's own Great Mosque.

The tunes and patterns to which these church bells were played was something their ringers would have learned by ear. Indeed, before the ninth century sacred and secular music alike would not have been recorded in writing but transmitted orally, committed to memory through experience and repetition. It was only in the twelfth and thirteenth centuries that an increasingly complex system of notation began to develop that preserved these musical traditions more precisely. Work by the Troubadours, the composers of playful, lyrical love songs in southern France and northern Spain, began to be notated on pages

17. An Exultet roll from Bari in southern Italy made around the
year 1000. Like all such rolls, this example combines images and text set upside
down from each other, to be read by a priest facing in the opposite direction to his
audience. In the upper image we see an Exultet roll being used in just this way.

packed with staved lines. And to standardise the emerging church prac-
tice of polyphonic prayer, enormous choir-books were transcribed at
a size big enough for several clerics to gather around and sing. These
earliest written melodies lacked the clearly specified speeds and dynam-
ics of modern sheet music, but they at least conveyed intervals between
consecutive notes and the relationship of tunes to their accompanying
lyrics. Even so, memory was key, and much of this music's nuance was
still expected to be known in advance by the skilled singers and instru-
mentalists who performed it.

This emerging style of musical notation has left a number of
remarkable material remnants, from illustrated manuscripts of song
decorated in bright, vivid colours to single stanzas of music etched onto
the flat blades of carving knives, intended for singing at the dinner table.
One group of Italian songs are particularly unusual in their format, not
bound together on pages in the manner of a normal codex book but
stitched into long continuous reams of parchment. Known as Exultet
rolls, after the sung Easter prayers they contain, these long pieces of
parchment – sometimes more than seven metres in total – juxtapose
lines of Latin text, musical notation and rectangular images illustrating
moralising scenes spoken of in the songs stretched across their width.
The orientation of these scrolls seems topsy-turvy: the words and music
face in one direction, the images completely in the other. But this was
a deliberate flip. As the officiating priest sang the extended prayer from
the roll's text he would allow its end to flow forwards and over the edge
of the pulpit on which he stood. While his song rang forth, the reversed
images would slowly unfurl, appearing the correct way up for the
observing congregation in front of him, giving continuously flowing
visual form to the prayer as it unrolled for metres on end. Sound and
image here combine to create an amazing multi-sensory performance,
reliant on both the keen eyes and ears of the faithful.

Mouth, Tongue, Teeth

Like the eyes, the medieval mouth was considered a two-way street in sensory terms. Medical authors knew that in one direction it absorbed the raw information of taste before sending food onwards down the gullet to the stomach. And in the other, the mouth was outwardly communicative: it spoke, projecting sounds direct to the receptive coiling pathways of others' ears. It can be hard to guess exactly how this medieval speech sounded. Its precise phonetic patterns have inevitably been lost in the intervening centuries, along with the native speakers of its many historic tongues. But by deconstructing written dialects of different languages from different regions, we can begin to piece together the contrasting cut of syllables, stresses of vowels and other sonorous nuances of their words.

Speakers from some places, we intuit, would have sounded soft and sweetly tongued, others much more precise and guttural in their tone. Medieval sources themselves commonly comment on vocal differences from country to country, setting the pleasant subtleties of certain accents against the incomprehensibility of others. Germans said that eastern languages sounded mangled and harsh. Egyptians thought it was easy to identify non-native Arabic speakers by their flat, European tone of voice. And the pace of language was apparently just as noteworthy. The journal of the Franciscan missionary William of Rubruck, who in the thirteenth century travelled thousands of miles from his native Flanders to Karakorum, the capital of the Mongol Empire, recorded with surprise that the priests of the 'Saracens' – a somewhat derogatory catch-all for Muslim Arab peoples – sat 'all mute in manner' and he could not 'provoke them unto speech by any means possible'. In comparison, some European dialects were criticised by contemporaries for their strange and busy noisiness. The historian Ranulph Higden (c.1285–1364) tried in his writings to explain the confusing tripartite heritage of medieval England's many divergent accents, but even he had to conclude that the language was a corrupted and somewhat ugly one:

Englisch men, they hadde from the begynnynge thre manere speche, northerne, sowtherne, and middel speche in the myddel of the lond, as they come of thre manere peple of Germania, notheles, by commyxtioun and mellynge firste with Danes and afterward with Normans, in meny the contray longage is apayred, and som useth straunge wlafferynge, chyterynge, harrynge and garrynge, grisbayting.

English men, they have from the beginning three manners of speech — northern, southern and middle speech in the middle of the land — as they come from three manners of people from Germany [the Jutes, the Angles and the Saxons]. Nonetheless, by intermingling and mixing, first with the Danes and afterwards with the Normans, in many the country's language is damaged, and some use strange babbling, chattering, snarling, clicking and grinding of teeth.

Other peoples were praised for the unusually high quality and texture of their speech. Early Muslim travellers, journeying deep into the Arabian desert in the eighth century, came across remote Bedouin communities whose quality of Arabic they described as amazingly uncorrupted, untainted by city life and held up as a purer, more poetic form of the language.

Individual speakers were also admired for their silver tongues and beguiling rhetorical mastery, especially influential teachers and preachers — Muslim, Jewish and Christian alike — who acted as the professional mouthpieces of God. Saint Anthony of Padua (1190–1231) was one such revered speaker, his oratory praised for its clever constructions and musical rhythms as they fell upon the ear. One contemporary biographer claimed that, when Anthony addressed a crowd of pilgrims in Rome who had gathered from different points across the globe, the saint's speech was so glorious that each member of his multi-ethnic audience miraculously heard his emotional preaching in their own mother tongue. A short time after his death Anthony's holy jawbone, seen as the anatomical foundation of his impressive oratory, was preserved as a relic, its elaborate precious metal reliquary posthumously reconstructing a head and shoulders of gold and silver around the saintly mandible

18. Reliquary of the jawbone of Saint Anthony of Padua, made in 1349 and embellished with many later additions being processed around the city's streets.

that had once spoken so mesmerisingly. Many pilgrims seeking spiritual countenance flocked to see the remains on display in Padua Cathedral, and they were certainly impressive to behold. The reliquary, embellished many times over the centuries, includes an enamel base mounted on three seated miniature lions, a gilded halo interspersed with angelic figures, and a sparkling tiara and necklace studded with pearls, jewels and glass cabochons. At its face, the relic itself was mounted within a domed piece of clear rock crystal so as to make it as visible as possible to onlookers.

But the interaction of medieval congregations with objects like this often went well beyond mere looking. Visiting a saint's shrine could be a distinctly oral experience too. Touching and, especially, kissing holy remains were thought to give even more direct access to the divine than simply appearing before them, and following this osculatory logic all sorts of objects became targets for pilgrims' puckered lips. Byzantine icons had their painted surfaces worn away by over-zealous kisses, exposing their subcutaneous wooden structures. Muslim and Jewish shrines were described by contemporaries as sporting large tomb slabs set into their floors, ideal for kneeling down and kissing. And surviving manuscripts of most religious persuasions exhibit similar signs of wear, their likenesses of holy figures or the ornamented text of holy names now smudged and watermarked, sometimes even completely destroyed by repeated kissing of the parchment. The mouth was a key point of contact for the sacred to flow back and forth.

Unlike the lips, the tasting tongue was less a place to signal the passion of religious experience than an organ through which to read the imminent onset of illness. Like all of the senses, one's taste could be knocked off-balance by humoral misalignment, indicated perhaps by a constant bitterness, inflamed tongue pores or a suspicious discoloration to its underside. Medical authorities recommended seeing to such maladies by rubbing the tongue with small packages of spices, including iris stems and aniseed. Even when healthy, the tongue could be used as a conduit for healing the rest of the body. For cases of witlessness or muteness one ninth-century English manuscript advises that medicines should be taken into the patient's mouth and the sign of the cross made under the tongue before swallowing. And if such prescriptions called for particularly bitter or pungent spices, it was no matter: they could always be followed with one of the prominent remedies recommended in later medical compendia for curing bad breath, including drinking perfumed wine or keeping a laurel leaf under the tongue. Were a patient wealthy enough, they might even swallow small pieces of gold and ground jewels, transmitting material expense into medical efficacy on the tongue.

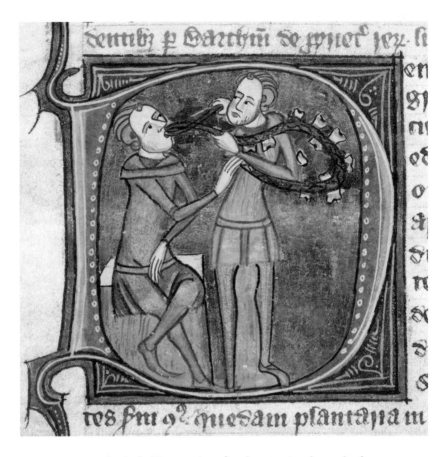

19. A dentist holding a string of teeth, removing the tooth of a
patient with a pair of pliers. The image illustrates an entry on
dentistry in the *Omne Bonum*, an encyclopedia written by the English
author James le Palmer in London around 1360–1375.

As well as the evidence of these cleansing gargles, archaeologi-
cal remains from the Middle Ages suggest that levels of oral hygiene
were significantly better than we would expect from the stereotype of
a blackened medieval mouth, although differing diets meant standards
would have varied significantly from place to place and between social
classes. With greater amounts of expensive imported sugar in their
food, the wealthy might have been prone to problems caused by an

excessively sweet diet, whereas it was the coarseness of the cheap flour in a peasant's loaf of bread that would have caused them longer-term tooth trouble. Dental advice was of some concern for university-trained physicians, but more often it fell to the practically minded surgeons and barber-surgeons or specialised dentists found in most large medieval towns. Providing that one visited a practitioner who had received a sensible training – as opposed to a masquerading charlatan or quack doctor – these healers were likely to offer at least some sound advice. Those with sensitive teeth were told to avoid eating hot and cold food in close succession, and that washing the mouth with appropriate concoctions could help ailing gums. In extreme cases, though, difficult teeth had to be removed and the cavity treated with herbs and spices, especially peppercorns, which were thought particularly efficacious for the mouth. In removing a painful tooth, authoritative texts stretching back as far as antiquity claimed that the goal was to expose and extract the 'tooth worm', a tiny creature that they held to be responsible for dental pain. But by the early modern period it was generally agreed that what remained after tooth removal was in fact a stub-like nerve which, devoid of its covering, could sometimes take on a surprisingly worm-like appearance.

A healthy, beaming smile seems not to have been a particularly pivotal aspect of beauty across Europe and the Middle East in the Middle Ages, certainly not as important as it is today, and it is rare to find smiling figures at all in medieval images. Still, the quality of medieval orthodontics meant that, for those who could afford it, removed teeth could be easily replaced to ensure a tooth-filled grin. The surgical author Abu al-Qasim al-Zahrawi (936–1013), a prolific and influential writer working in Muslim Spain and well known in the Latin-speaking world by the name Albucasis, offered complex procedures for replacing extracted teeth with prosthetic originals. These were often formed of carved animal bone and tied in place next to their neighbours with thin gold thread. What happened to the original teeth thereafter seems to have been the dentist's business. An illustration from an encyclopedia assembled by the English author James le Palmer in the mid-fourteenth century shows a dentist at work, bending over the patient with grim

20. The sixth and final Cluny tapestry, showing the young woman and her beasts in front of a tent featuring the mysterious phrase: *A MON SEUL DESIR*. Its meaning is yet to be fully deciphered.

concentration and a pair of black pliers, originally painted silver but now tarnished by time. Around his shoulder he seems to clutch a necklace from which hangs a series of enormous exaggerated teeth: at least someone benefited from the nefarious workings of the tooth worm.

We can only hope for her sake that the woman in the Cluny tapestries who feeds sweet, tooth-rotting berries to her parrot and monkey did not try too many herself. Repeated overindulgence would have been a swift road to visiting a dentist like James le Palmer's, perhaps even one similarly dressed in the rich bounty of the mouth. Still, this was just the sort of connection that the Cluny tapestries were designed to encourage in their medieval viewers, bouncing back and forth between the young woman's sensory experiences and their own. The five pieces in effect define and individuate the five different ways in which a single body might perceive information from the world around them through the senses. But at the same time, in having the same set of recurring characters play out the full quintet of human sensations in turn, the tapestries also serve to bring human sensory experience together. These were, after all, objects to be seen not one by one in isolation but as a unified group, enveloping the viewer around the wide walls of a single room. United as a set, they layer the senses one atop the other just as they were layered in everyday medieval life. The sixth and largest of the Cluny tapestries gestures towards just this sort of sensory unison. It remains the most mysterious of the series. The young woman is again centre stage atop her floating island full of trees and plants, this time standing before a tent, in the middle of taking – or perhaps replacing – a golden necklace from a box held by her faithful maid. Across the top of the tent's entrance an ambiguous motto is emblazoned: *A MON SEUL DESIR*, 'to my sole desire'. What this desire was remains only for her to know. But surrounded by beasts drawn from her previous five scenes – the monkey, dogs, rabbits, birds and, of course, her lion and her unicorn – we can presume that, whatever this ultimate pleasure may have been, it was only to be truly reached and enjoyed to the full through the combined perception of the body's five senses.

SKIN

Skin encloses and enshrines the body's complex internal workings in a way that makes them both safe and mysterious. But it also faces outwards, projecting issues of identity and race forward from the surface to create a public façade of the person it simultaneously secures. In the Middle Ages both of these ideas – safeguarding a secret inner life and forming an external social character – were prominent conceptions of the body's outer layers.

Beneath Bodies

A figure stands proudly in a blue box in the middle of a manuscript page. His body is hairless and naked, and a light wash of rosy paint tints his head and thighs a flushed prickly pink. The lazy curve of his posture projects a certain easiness, a sense of calm, and he seems to be looking vacantly outwards, staring into the empty space immediately to his left. But on closer inspection we realise that he cannot be gazing distractedly into the middle distance, for this man has no eyes or eyelids, only a pair of empty sockets. In fact, his body sports no outer layer at all: his skin

21. A man carrying his skin on a pole in a manuscript of Henri de Mondeville's *Chirurgia*, copied in Paris in 1306.

is folded in two like a piece of stiff fabric, sloughed over a long stick he carries at his shoulder. Among its flaps and folds, the shapes of his arms and legs are still distinguishable by their intact hands and feet, as is the body's once full head of hair, which spirals out, corona-like, in strange black weaves from his scalp.

From what we have seen of the saints – their severed heads and other violent punishments – we might assume that this is a devotional image of a martyr from a religious text. It certainly resembles contemporary depictions of the ill-fated Saint Bartholomew, skinned alive before being crucified as part of his torturous test for sanctity. Yet this is not a holy figure, inventively presenting his pelt to the reader. Neither is this man part of the medieval tradition of playful marginalia, much of which happily punned on such grotesqueness: fantastical images of

giant snails battling with knights or miniature rabbits using knives to skin each other alive at the page's edge. This naked man boldly spans an entire column of text. He is front and centre, no comedic sideline clinging to the border.

He features, instead, as part of a book called the *Chirurgia*, the 'Surgery', written by the French master surgeon Henri de Mondeville in around 1306. Mondeville was a highly respected figure, a teacher in both French and Italian universities, and with his book he was seeking to raise the rather lowly status of his profession. Detailed, expensive, high-quality illustrations were normally the preserve of religious texts and intellectual treatises written for a class of well-healed elites by more socially assured medieval authors. Until books like the *Chirurgia*, surgeons were not counted among such illustrious company: their craft was not a literate one, and they tended to fall, along with other practical empirics, towards the bottom of medicine's pecking order. Pushing back against this status quo, Mondeville sought to present an ambitious theoretical underpinning for his vision of a learned surgery, a rigorous intellectual guide to various elements of the craft covering multiple aspects of anatomy and surgical cure, from leg amputations and wound cautery to the lancing of boils and embalming of cadavers. This was complemented by a set of thirteen diagrams that both elevated and elaborated the text, one of which was this flayed man. An accompanying caption in Middle French beneath the figure explains his specific function:

le 4 figure. un home escorchie portant son cuir sus ses espaulles o un baston et la pert le cuir du chief eschevele, le cuir des mains, et des pies et la char lacerueuse et glandeuse qui est par le cors et la blance qui est es mamelles et es emuptoires, et par la fixeure du ventre apert la gresse le sain loint.

The fourth figure, a flayed man carrying his skin over his shoulders on a stick; the skin of his head with hair, the skin of his hands, and his feet; and the lacerated flesh that is on the body, and the white which is the breasts and the emunctories [organs that carry off waste], and by the opening of the stomach the fat and the lard.

Heading a section on the anatomy of the skin, the figure shows the detail described by the text: the red tone of the flesh, the hair of the head and the whitish hue of the subcutaneous fat.

Although simple, a much-reduced diagram like this could suffice when visualisation of the inaccessible bodily interior was needed. As Mondeville's contemporaries often attested, looking beneath the surface of a painted figure was, after all, far easier than looking beneath the skin of a real medieval body. In the modern era, by the time we reach adulthood we will probably have seen various types of X-rays and scans – either real or cluttering the sets of TV crime dramas – which suggest relatively clearly to us the shape of things beneath our skin and the skin of others. The same was not true for audiences in the Middle Ages. Although skin was thought permeable, absorbing the humoral surrounds of climates and seasons, it was still an opaque barrier whose contents were not entirely clear, visually speaking. Most major medical centres heavily restricted the actual anatomical dissection of bodies. The practice had always rubbed up against a whole host of extremely uncomfortable social questions. Was it right to do such violence to a dead body? And whose body should be chosen to undergo such trauma? The answers from the earlier Middle Ages came loud and clear: 'no' and 'not mine'. Contemporary religious doctrines of all three cardinal faiths spoke at length of things like posthumous judgement, heavenly resurrection and the ultimate unification of body and soul. If your body was cut to blazes by a group of medics before you were interred in the grave, little would be left to rise again for eternal salvation. Maintaining a corporeal coherence, even after death, strongly mattered to many medieval people.

At just the same moment that Mondeville's *Chirurgia* was being illustrated, however, an alternative approach was beginning for the first time to gain traction. In 1286 the Italian chronicler Salimbene da Parma recorded that civic authorities in northern Italy had, unusually, allowed an internal examination to go ahead on the body of a man. There were extenuating circumstances: he had died from an unknown disease that was sweeping rapidly across the region, and authorities suspected that the epidemic had somehow spread to the human population through

the region's chickens. A doctor from Cremona was ordered to investigate and opened the bodies of several affected hens looking for clues, where he discovered that many of the animals carried an unusual and distinctive abscess on their heart. The dead man's thorax was opened too and, sure enough, his heart showed matching marks, confirming in the authorities' minds a link to the chicken epidemic. One local doctor was so alarmed that he launched a pamphlet advising against eating either the birds or their eggs, citing as evidence this insightful early autopsy.

In the wake of such crude yet seemingly successful investigations a professional interest in the results of dissection seems to have very slowly begun to grow in the region. In the years that followed, judges in a handful of Italian legal cases began to order some of the earliest bodily post-mortems of the Middle Ages. Doctors started testifying in trials based on both external and internal assessments of cadavers, their results slowly becoming considered a new type of important admissible evidence. In 1302 a man named Azzolino degli Onesti was found dead, possibly poisoned. But it was only after his body was publicly opened by a number of physicians and surgeons that serious internal bleeding was discovered near his heart. The examining doctors took this as an indication of a natural death, not murder, and Azzolino's suspected poisoners were exculpated. Still, investigations like this were extremely morally difficult. Italian funerary tradition had long called for the dressing of the deceased and the exposure of their face in procession to the grave, something that was clearly violated by deconstructing the corpse piece by piece. Few wished for their loved ones to undergo such treatment unless absolutely necessary. Yet increasingly it seemed clear that dead bodies contained within them some sort of empirical truth, a series of clues and causes that lay hidden beneath the skin.

While fourteenth-century courts might have been adjusting to the occasional presence of post-mortem evidence, the academic medical establishment on the contrary remained largely unmoved. Some initial dissections, undertaken for teaching purposes, did appear around the same time as these trials: for instance, the Bolognese anatomies of Mondino dei Liuzzi recorded in his *Anothomia* of 1316. But these

occasions were not anatomies as we might consider them today. More than anything, they were ritualised events in which the body was opened only to affirm the supremacy of the grand classical tradition. Important treatises by important masters were intoned aloud by important physicians, and the disassembled body was simply used to illustrate them. These were performances of medical texts, not actual exploratory anatomies. An image accompanying a later printed copy of Mondino's own treatise gives a sense of how the medieval dissection scene may have unfolded. A cadaver is set out on a makeshift wooden table, surrounded by an audience of academic students and fellows who debate around the corpse. Sitting behind at a tall cathedra, looking not unlike a priest at a pulpit, is the figure of the *lector*, a high-ranking academic who was responsible for reading aloud the chosen part of the Latin text about to be verified against the corpse, while below two figures among the group of dissectors lean over the cadaver. One, the *sector*, holds a long knife in hand. Judging by his lack of academic robes, he is probably a surgeon, poised to make the first incision as specified by Mondino from sternum to pubis. Beside him, directly above the head of the cadaver, stands the figure of the *ostensor*, the most senior figure on the dissection floor, responsible for translating and elaborating on the *lector*'s Latin for the comprehension and guidance of those gathered around him. Apart from these two figures, almost everyone else completely ignores the corpse.

Given the social taboos involved, an extremely cautious practicality also governed much of the detail of these dissection events. Anatomies were scheduled to happen once a year, although they often took place far less frequently, and dissecting a body only ever happened in the cooler winter months, meaning professors and students were not forced to share small makeshift anatomy theatres with a quick-rotting cadaver in the summer heat. The bodies to be examined were also mostly restricted to those of recently executed criminals, pledged to the university under strictly defined terms by the city administration. These could be either male or female: in fact, the female body, with its added capacity to bear children, was thought the more physiologically interesting of the two. But they were largely bodies of foreigners

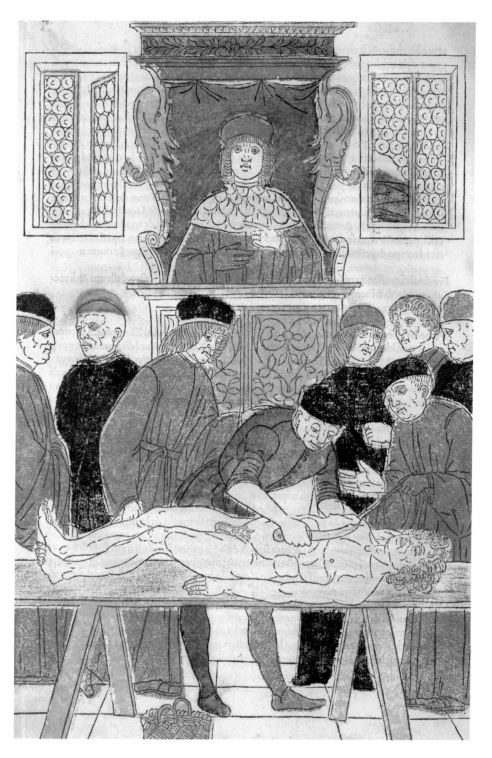

22. A dissection scene, presented in the *Fasciculo di medicina*
('Little Bundle of Medicine'), a medical miscellany printed at
the very end of the Middle Ages in Venice in 1493/4, but which
preserves Mondino's *Anothomia* alongside this image.

or people born at least a significant distance from the city: universities in these small Italian communities tried wherever possible to avoid worrying the local populace by carving up their own. Couching the event in such regulations was intended to reduce anxieties of this sort, but these dissections did not always go smoothly. In 1319 a Bolognese medical maestro named Alberto de' Zancariis and his students gathered near the city's university in the small Cappella di San Salvatore to undertake the anatomy of a body that had been illegally disinterred from a nearby graveyard. The event shocked the town, and a trial sent several of Alberto's tutees to prison for grave-robbing.

Stories like this troubled the medieval imagination deeply, and laws were often tightened or at least reasserted in response to such unorthodox and disrespectful cases. Nonetheless, over the following two centuries academic healers from Montpellier and Florence to Lerida and Vienna became increasingly eager to display their knowledge of the body's interior. More and more often, doctors were carefully peeling back its skin to look beneath.

Surface Qualities

Medieval medicine thought of the skin as being made up of two symbiotic layers: an outer layer, called the 'skin proper', and an inner, muscular layer, called the 'panicle'. Together these offered doubled protection for the body's internal workings, and they had many combined characteristics. Mondeville described the twofold structure as:

nervosum, forte, tenax, mediocre in duritie et mollitie, flexibile, multum sensibile, tenue temperatum in complexione, totum corpus in parte exteriori circumdans

nervous, tough, resistant, medium-hard, flexible, very sensitive, thin and temperate in complexion, encompassing the entire surface of the body.

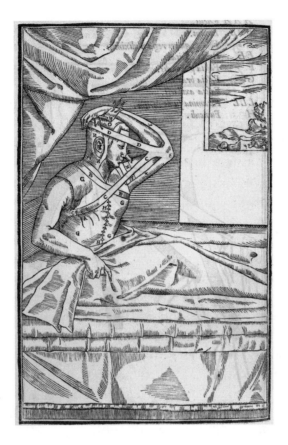

23. A later illustration of fifteenth-century rhinoplasty technique, where a graft of skin is taken from the forearm and encouraged to grow over the missing nose. This image is from the Bolognese surgeon Gaspare Tagliacozzi's treatise *De curtorum chirurgia per insitionem*, printed in Venice in 1597.

Such detailed knowledge of the skin's many vagaries was especially important for surgeons, who were frequently called upon to breach its surface. Amputations necessitated the stripping back of skin to access and saw through bone. Incisions or counter-incisions into the skin could be made to enlarge entry wounds for the removal of foreign bodies or to relax separated body parts. The frequently prescribed practice of phlebotomy called for the partial puncturing of the skin to let blood flow. And of course there were plenty of complaints and

treatments that concerned problems with the skin itself. Liniments and oils were used to treat rashes, burns, pimples, scabies and even freckles, while growths or ulcers were cut from the skin's surface with thin, sharp knives.

From the 1400s onwards surgeons also contributed to a growing market in plastic surgery, a collection of cosmetic operations whose roots lay in Byzantine medicine and techniques imported from the Indian subcontinent a millennium or so earlier. The fourth-century author Oribasius discussed repairing the tip of the nose with an H-shaped flap of skin taken from the cheek, and in the fifteenth century rhinoplasties were still being undertaken along similar lines. These were particularly popular operations for those who had been disfigured in violent accidents or on the battlefield, and they would become especially important for victims of Europe's first major outbreak of syphilis in the 1490s, a disease which in its advanced stages can cause partial or total collapse of the nose's bridge. The operation received medieval renown in the hands of the Sicilian surgeon Branca Minuti and his son Antonio, who advocated taking skin for the replacement nose not from the cheek but from the arm. This left the patient with fewer scars on the face, but did mean they had to be bound into a complex series of straps to hold their elbow up to their mouth for several weeks while the graft gradually grew out of their shoulder.

Skin, though, was more than just a site for physical imperfections and surgical manipulations. Signs of a whole host of flaws could be found in its colour, temperature and texture, and, like hair, it was an important interface for uncovering underlying issues lurking below the surface. Examinations of the skin by a doctor might expose flaws in diet or humoral balance, but they could also highlight defects in a patient's moral or spiritual integrity. Leprosy, for instance, was one of the most discussed diseases in the medical literature of the period. Its sufferers were clearly identifiable from the scarring and cracking of their skin in unpleasant characteristic lesions. Yet the disease was also thought by many authors, medical and otherwise, to penetrate far beneath the panicle into the more subjective recesses of a person's character. The leper's corrupted body was seen as the result of a corrupted internal

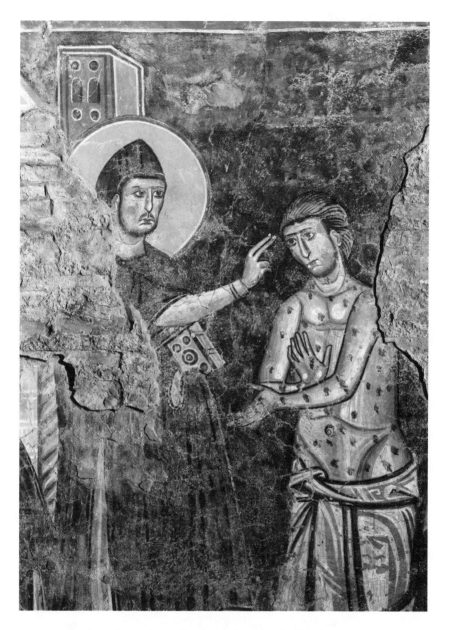

24. An eleventh-century wall-painting from the church of San Crisogono,
Rome, showing Saint Benedict of Nursia healing a leper. The
dark black spots all over the half-naked sick man evoke the lesions
which appear on the skin of patients with the disease.

morality, and this led to serious stigmatisation, particularly anxieties over contagion and the unfounded fear that lepers might attempt to tamper with water supplies and infect entire unsuspecting populations with their disease. We know now that the chances of catching leprosy are extremely low, and that the disease is passed only by prolonged, close contact with a contagious individual over many weeks or months. But in the Middle Ages the advice of one ninth-century commentator on the Qur'an would have rung far more true: 'One should run away from the leper as one runs away from a lion.' Others, however, took a kinder view. They interpreted leprosy less as divine retribution than as a test of the patience and compassion of others. No doubt influenced by the sympathetic mentions of lepers in Old and New Testament sources, authors such as Gregory of Nazianzos, a Byzantine theologian and the fourth-century patriarch of Constantinople, chastised those who refused to understand the subtleties of this surface disease. 'The timid are misled by foolish talk', he wrote. 'Look at physicians and the example of those who take care of these sick, of whom not one has fallen into danger through visiting them. Do not despise your brother. He is your own member, though this calamity has deformed him.'

Clashing Colours

It was not just marks of disease on the skin that so polarised medieval opinion. Discussions of the body's surface also unveil a range of complex positions on issues of race.

Occasionally in the Middle Ages we hear of miraculous stories in which skins of different hues came together, just the kind of social tolerance advocated by people like Nazianzos. Such a case appears during a fantastical surgical operation recorded in the hagiography of Saints Cosmas and Damian, two third-century brothers whose distinguished physicianship and pious martyrdom to the early Christian cause saw them enshrined as the patron saints of many medical professions. In the accounts of their holy lives we hear of a churchman from Rome whose leg is being ferociously eaten away by an unnamed infection or cancerous

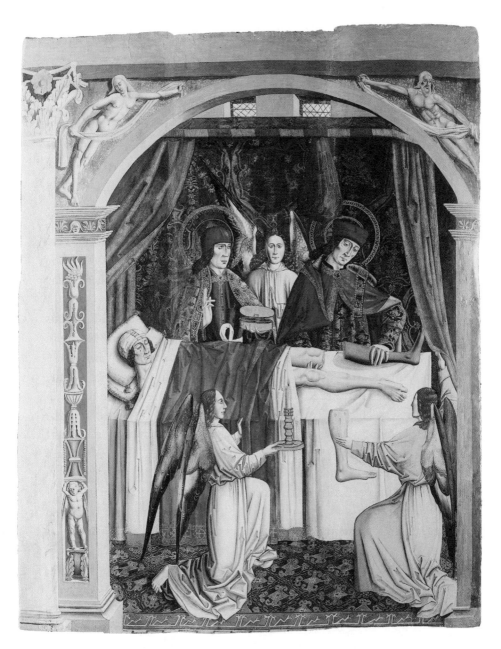

25. Saints Cosmas and Damian performing the miracle of the transplanted
leg in a painting by an anonymous Spanish artist made around 1495.

disease. Praying to Cosmas and Damian for help, he falls asleep one night and dreams that the brothers appeared to him bearing ointments and iron surgical instruments to remove the disease-ridden limb. The pair amputate the leg and transplant it with that of an Ethiopian man who had been buried on the same day in a nearby churchyard. Awaking the following morning, the man finds himself to have been painlessly healed and his leg replaced, his dream cure become reality. The author of this short tale does not reflect or even comment on how radical this transgressive bi-racial transformation must have appeared to contemporary audiences, focusing instead on an uplifting sense of spiritual triumph.

Medieval race relations, however, were generally far more malicious than this pious narrative suggests. It was not that people were unaware of other ethnicities. At least in large port cities one could come into contact with a wide variety of diverse travellers from across the Mediterranean and beyond. Pilgrimage routes from east and west to the Holy Land as well as busy trade in exotic and quotidian materials both necessitated frequent cross-continental exchange. But the rapid expansion of Islam out from the Arabian Gulf was met with an equally fierce response from powers in the West. What followed was one of the most sustained periods of intercultural conflict before modern times, an aggressive and bloody collection of religious wars. From the end of the eleventh century choreographed campaigns and counter-campaigns of Crusade and Jihad saw peoples systematically pitted against each other, religion against religion, race against race.

Differences in skin colour soon emerged as a key way of identifying, denigrating and demonising one's enemies. Theories had been circulating for some time in Middle Eastern medicine that the bodies of north-western Europeans held within them several fundamental humoral failings. The geographer and historian Abu al-Hasan al-Masudi (c.896–956) opined that:

> As regards the people of the northern quadrant, the power of the sun is weak among them because of their distance from it ... the warm humour is lacking among them. Their bodies are large, their natures gross, their manners harsh, their understanding dull, and

their tongues heavy. Their colour is so excessively white that it passes from white to blue. Their skin is thin and their flesh thick.

Later Muslim propagandists happily carried these long-standing medical criticisms into their twelfth- and thirteenth-century conflicts. They presented their enemy's physical differences as intellectual flaws: the strange whiteness of the Europeans' clean-shaven skin and the unsettling blueness of their eyes were transformed into evidence of incompetence on the battlefield and an essential cowardice. For their part, Christian propagandists on the other side of the conflict seemed even more consumed with skin colour and constitution as tools for emphasising difference. Illustrations in books of western Crusader history took every opportunity to portray enemies of Muslim or African origin as visually distinct. Their foreign styles of dress were emphasised and their skin darkened to underline what was seen as a basic physiological difference.

Among other things, these European artists were echoing a prominent Christian association of blackness or darkness with acts of sin. If Christ, according to the Gospel of Matthew, was *lux mundi*, the light of the world, then those who opposed him – Satan, spirits, demons, heathens – should be presented as his antithesis, shrouded in shadow, both morally and literally. In making his first call to Crusade in 1095, Pope Urban II supported his order to recapture Jerusalem from Muslim hands with a long roll of racial invective, suggesting that followers of Islam were cowards and that this was inherent in their breeding, humours and skin. Unintentionally echoing al-Masudi's words, he railed that: 'It is a fact well known that every nation born in Eastern climes is dried up by the great heat of the sun. They have less blood in their veins, and that is why they flee from battle at close quarters. They know that they have no blood to spare.' Part aggressive propagandising, part pseudo-eugenics, this sort of thinking incorporated for the Crusaders a warped yet useful medical logic into a visualisation of their dark-skinned foe as a violent, savage and impure 'other'. Ironically, both Christian and Muslim agitators alike were using the same theories of human biology to emphasise each other's skin as dangerously different.

26. Caricatures of Richard I and Saladin jousting in the margins of
the Luttrell Psalter, painted around 1320–40 in Lincolnshire.

These caricatures ran deeper than mere wartime advocacy. In the distinctly un-diverse and religiously conservative environment of most medieval societies, a general racial stereotyping could quietly leak into many parts of everyday life. The Luttrell Psalter, a personal religious book made for the wealthy Lincolnshire landowner Geoffrey Luttrell between 1320 and 1340, contains a revealing miniature scene at the base of one of its pages. Jousting across the bottom of the parchment on horses draped in exaggerated finery are two stalwarts of early Crusader history. The figure on the left is identified by the rampant heraldic lions on his shield as Richard I of England (1157–1199), the *Cœur de Lion*, or Lionheart, master tactician of the Third Crusade in the 1190s. On the right, dressed in far more exotic armour and a helmet of shimmering gold leaf, is Sultan Salah ad-Din Yusuf ibn Ayyub (c.1137–1193) – known in the West as Saladin – the founder of the powerful Egyptian-Syrian Ayyubid dynasty. The scene is entirely fictional. The two men never met in person, fighting battles only by proxy through their respective royal armies, and by this stage in the fourteenth century tales of these leaders and their Crusades had become as much a romanticised literary genre as a genuine chronicle of military events. Yet there is little doubt as to who, a century and a half after the fact, is being presented in the margins of Geoffrey's manuscript as the victor. Richard's lance

slams forward, knocking Saladin off balance and thrusting him back in his saddle. It is as if he is about to topple to the ground and be trampled beneath his horses' hooves. And in the clash his ornate helmet has been thrown back off his head, allowing the artist to expose the Sultan's most alarming features. Here, just like Pope Urban's description, his eastern skin is so dark, so 'non-white', that it is coloured a deep shade of blue, making him seem even more alien than the caricatured head of a black Muhammad emblazoned on his shield. For all the strange webbed flourishes of his horse's caparison and the intense bright-red scales of his chainmail, the most vivid marker of Saladin's otherness remains his uncanny, discoloured skin.

Written on Skin

Skin did not necessarily need to be attached to a body for it to convey equally powerful meaning. When it came to writing a book – be it a chronicle of Crusader history, a treatise on surgical cure or any other topic – medieval authors had a choice of materials. Those working in the Islamic Middle East and north Africa mostly turned to paper, a technology they had borrowed from contact with Chinese cultures as early as the eighth century. But in western and central Europe a far more common carrier of knowledge and imagery was parchment, dried and treated animal skin that had been transformed from a living, breathing surface into a flat, clean page.

In the earlier Middle Ages the making of parchment was largely undertaken in the scriptoria of monasteries or the courts of royal ruling dynasties. These centres sheltered the few authors of the era who were concerned with creating long-lasting books, either intellectual tomes on religious and scientific themes or more practical permanent records of the state, its laws and its finances. But by the thirteenth century preparing the skin had become the job of professional parchment-makers, commercial producers from whom scribes and illustrators might purchase single sheets or bound gatherings to begin turning into a manuscript. The shops of these artisans were clustered at close

27. Brother Fritz the Parchment-Maker, scraping down a stretched skin with his
lunellum in the final stages of making parchment. The image comes from the
so-called Housebook of the Twelve-Brothers, a tome listing members of a charitable
foundation for retired craftsmen in Nuremberg, Germany, made around 1425.

quarters in the literary districts of larger medieval cities, sometimes
stretching the length of several streets. This was, in part, to concen-
trate their resources and expertise, for making parchment had multiple
complex, carefully planned stages, relying on niche skills and expen-
sive ingredients.

First, the skin of an animal had to be purchased. This was to be as
high-quality and unblemished as possible, as well as of an appropriate
size, colour and animal for the book under commission. A calf, say,
with darker hair or a patterned hide would produce large parchment of

a mottled yellowy-brown colour, while a lamb with lighter wool would produce a smaller but brighter piece. The skin would be washed, left under running water for a day or so, before being suspended for longer periods in subtly corrosive alkaline substances: dehairing liquors, quicklime, even urine. These substances caused the cells in the skin to partially rot and degrade, allowing the hide's hairs to work themselves loose and fall out, leaving a continuous, flat surface. The parchment-maker would then transfer the skin to a stretching frame, making sure it did not dry out, and carefully scrape it down with a curved knife called a *lunellum*, a crescent or 'moon-shaped' blade. An illustration from 1420s Nuremberg shows a parchment-maker, Fritz Pyrmetter, in the midst of this process. Fritz's patronym is almost certainly a nickname that riffs on the German term for parchment, *pergament*, itself taken from the Latin *pergamina*, 'stuff of Pergamum', the ancient Hellenistic city supposedly first famed for its bulging libraries of parchment books. Bearded and dressed in a simple tunic, Fritz works in much the same way as his forebears of the same name, running the wide blade back and forth over the stretched parchment, its curved ends making sure that his swift strokes do not nick the taut skin.

However careful a parchment-maker was in this work, natural imperfections in an animal's skin meant small slits in the parchment could still emerge. To stop them becoming larger circular holes during the stretching process, these tiny ruptures were swiftly sewn up with needle and thread, just like the living work of the surgeon. Such repairs can still be found in many medieval books, small sutures which have kept the page intact for centuries. Some use plain thread to blend into the parchment's pale surface while others work in deliberately colour-ful and decorative patterns, emphasising the skilled needlework of their makers. And when the holes were too small to bother stitching, they could also provide amusement for a book's author, who might doodle around these blemishes to create animals or faces, discreet remind-ers of the surface's original life. Either way, the parchment-maker would have constantly tightened the frame's pegs as he scraped away any final surface blemishes, reducing the sheet to a smooth and shiny layer. Dry parchment has the texture of a thin piece of plastic rather

28. Small holes in a parchment page transformed by a
twelfth-century scribe, who has taken a moment out from
transcribing Saint Bernard of Clairvaux's commentary on
the Song of Solomon to doodle them into a face.

than soft, floppy paper. Whether rolled up in a continuous series of
stitched membranes or trimmed into rectangular folios for binding into
a codex-form book, its simultaneous flexibility and rigidity meant it
was extremely resistant to folds, creases, scratches and stains, an almost
indestructible writing surface.

Given all of the work necessary to provide just a single spread of
pages, it is not hard to see why medieval books were considered such
laborious and luxurious items. Large multi-volume codices, some
stretching to five hundred folios or more, might contain the skins of

several entire herds and require months of labour before a single word or illustration had even graced their pages. One luxury book, made for the Bishop of Westminster in the early 1380s, is recorded in episcopal accounts as costing four pounds, six shillings and eight pence for its parchment alone. To put this in context, the book's extremely skilled scribe, one Thomas Preston, was paid a total fee of four pounds plus expenses – almost the same amount – for the whole two years he spent writing it. Indeed, parchment's expense is not only an issue for the distant medieval past. The United Kingdom's laws were still being recorded on parchment until early 2017, when Members of Parliament voted to cut costs and move to a cheaper system of bound paper. To its critics, parchment was an archaic and outdated remnant of muddy medieval governance, ripe for modernisation: a sarcastic headline in the *Daily Mirror* blared, 'MPs just spent two hours discussing whether to keep wasting £80,000 a year printing laws on calf skin.' Yet Paul Wright, the general manager of William Cowley, the UK's last surviving parchment-maker, retorted that it is only because of parchment that

29. The Acts room in the Palace of Westminster, containing thousands
of parchment rolls on which British laws have been recorded for
over five hundred years. The oldest Act stored there dates from 1497,
and pertains to apprentices in the Norfolk wool industry.

the libraries of the Palace of Westminster still hold the original text of laws stretching back to 1497 and the reign of Henry VII. As Wright put it: 'You can roll parchment up and leave it on a shelf or in a cave for 5,000 years. But you won't find any paper manufacturer who will guarantee longer than 250 years. That takes us back to about 1750, and the rest of history we can kiss goodbye.'

Second Skins

If physicians and surgeons treated diseases of the skin and parchment-makers processed it into flat surfaces for writing, a third group of medieval craftsmen and women used their skills to protect the skin from the elements, clothing the body in virtuoso crafted textiles. Unlike the fixity of one's colour or complexion, clothing provided medieval wearers with a changeable skin that could be made far more malleable to mark a range of different identities. However, the actual works created by tailors and seamstresses, weavers and embroiderers, are among the rarest of objects to be passed down from the Middle Ages. Tunics, trousers, robes, dresses, gowns, jackets, capes, undergarments, these are all things that were particularly prone to the wear and tear of daily life. Their organic dyes and fabrics began to degrade from their very first moments of use, and the vast majority of medieval textiles have avoided such decay only from having been kept in the most parched, consistent conditions, excavated from dry desert sites, often in Egypt, or uncovered in the untouched, sealed tombs of churchly catacombs.

Those which do survive, especially from the earlier Middle Ages, seem mostly to have been crafted in what were the highly prized styles of Byzantine and Islamic ateliers. Cotton, linen and silk garments were a speciality of the Middle East, with raw textiles imported there to be worked into remarkable clothes from the environs of Spain, Sicily or Syria, all regions rich in both agriculture and sericulture, the cultivation of silkworms. A woollen child's tunic from the fifth or sixth century, now in the Victoria and Albert Museum in London, shows the kind of

detailed work such garments could entail. It is a burial shirt, designed to wrap around the body in the tomb, and although now dirty with age, it would have cleanly enshrined the deceased, a final formality for the person now passed. Made from a single piece of uncomplicated, uncoloured cloth, it lent a certain simple smartness in death, folded at the top and sewn down each side with linen thread. Yet subtle embellishments can still be found at its collar and waist. A series of intricate woven patches and bands of repeated motifs decorate the body with circular patterns, spiralling vines and abstract shapes, while tiny heads, flowers, birds and animals come together to add a delicate sense of personality to the fabric and the wearer.

The idea that clothes might reflect their owners was important in life as well as in death. They often declared national, political or religious allegiance. Sometimes this was extravagant and overt. Soldiers on the battlefield indicated which side they were fighting for with badges on their uniforms, plumes in their helmets or the bearing of royal symbols on their armour. Monks and nuns might indicate their particular religious fidelity through certain colours and styles of robe, an identity they could have stripped from them if they transgressed their order's rules and were defrocked. But at other times indicators of dress were more subtle and coded. In civilian life social hierarchies were frequently enforced by the expense and turnover of high-quality clothing. For the few who could afford them, fashionable details such as short-cropped surcoats, sleeves with oak-leaf frills, close-fitting bodices with variable necklines, caped hoods with long tippets, or double-horned head-dresses marked one out as a participant in the speedy turnover of chic styles. In such a loaded sartorial atmosphere various regional caricatures abounded. Scandinavians were associated with the pricey furs they traded. The Chinese and Persians were praised for the delicacy of their patterned silks. And western travellers to the Middle East tended to roll together criticisms of non-white skin with brightly coloured, 'exotic' clothes, disliking in particular the turbans worn in most Islamic cultures and the gaudy dyes of uniforms at the Mongol court.

Yet, for most medieval people, deciding what to wear was often not much of a choice at all. Not only were many bound by the practical smocks

and uniforms of more workaday professions, but from the twelfth century onwards in various provinces on all sides of the Mediterranean an extensive framework of legal codes sprang up which governed expenditure and dress. These sumptuary laws, as they were known, were enforced by local government and confined appropriate styles and fashions to particular types of people. This was, in part, a method of safeguarding local makers, imposing penalties on people wearing foreign fabrics and offering protectionist support to markets closer to home. Textiles could be big business in major centres like Lucca or London, and unlike some niche medieval crafts these specialists formed a substantive workforce of both men and women, reliant on the industry's success. With such help from the state, making clothes could be quite lucrative. Thomas Carleton, one of the most successful textile-workers in England, was appointed embroiderer to the household of King Edward III from 1368, and his surviving account books show him in the process of scaling up his business to include a number of different properties throughout the city, each with a small shopfront decorated with folding shutters that doubled as a flip-down counter for selling wares.

But sumptuary laws could also be more controlling, even sinister. On the one hand, they quite reasonably sought to keep the peace, clothing-wise. In 1375 the codes of the town of Aquila in central Italy insisted that nobody wear 'pandos curtos ut eorum genitalia remaneant discoperta', 'trousers so short that the genitals remain uncovered'. Fair enough. But they often also tried to enforce codes of morality through social supervision, fending off what lawmakers saw as an unpalatable sartorial contamination between high and low social ranks. In Nuremberg, peasants wearing pearls or modish slashed shoes would be met with a hefty fine, while in Mamluk Cairo non-Muslims were required to wear particular colours to emphasise their difference: Jews in yellow and Christians in blue. Prostitutes, too, were banned from wearing certain fabrics in nearly all major cities, both East and West, for fear they were mistaken for ordinary folk. Their hoods were restricted to black or yellow-coloured cloth and at times were even trimmed with small bells to warn of their approach.

A concern for the particular dress of sex workers exemplifies just how closely medieval ideas of clothing the skin were bound to concepts of wantonness and sin. Not that prostitutes were always demonised for their profession. Surprisingly perhaps, religious authorities sometimes advocated a tolerance of sex work, at least in heterosexual encounters. Jewish writers turned to scripture to point out that several biblical women, the likes of Rahab or Tamar, had been prostitutes and yet were still held up as model heroines of the faith. Christian Church Fathers also saw sex workers as something of a social necessity: as Saint Augustine wrote in his first book *De ordine*, 'On Order', if society was to do away with prostitutes, 'the world would be convulsed with surplus lust'. Muslim writers even equated a sex worker's fee to a justly earned dowry. Yet the real social danger of a medieval prostitute was not her finances: it was her all too easy ability to shed her clothes and expose her skin beneath. In spite of their seeming tolerance, these same religious thinkers often expressed the predictable view that the easy nakedness of prostitution implied easy morals. The idea that nudity was tantamount to an insatiable lust had been posited from the very beginning, quite literally. Adam and Eve, enjoying prelapsarian bliss and bounty in the Garden of Eden, thought nothing of having their skin on show. It was only after eating from the Tree of Knowledge that, to quote Genesis, 'the eyes of both were opened, and they knew that they were naked. And they sewed fig leaves together and made themselves loincloths', the first clothes. Such freighted, problematic nudity recurs at various moments in holy texts, always framed as acts of invasion and shame: Noah was discovered naked and drunk by his sons, the heathen Babylonians were humiliated for their free nudity, and saintly bodies were often forced to suffer the ultimate indignity of undress as they went to meet their heavenly demise. Clothes carried with them an inherent morality, and for civic regulators, policing dress was part of policing the ethics of the faithful.

Keen to set an example in this regard, religious authorities thought extremely carefully about what they themselves should wear in front of their flock, especially the ways they should dress to encounter the

majesty of the Holy Word. Christian clergy, in particular, among the most powerful figures in European society at the time, commissioned extravagant and symbolically potent liturgical vestments that remain some of the best-preserved specimens of medieval embroidery from the period. As with the pages of parchment books, it was often the habit of subsequent generations of users to cut and crop these garments from their original shapes, sometimes lifting entire scenes from pieces of clothing to reformat them into new robes. Yet even in fragments they still retain something of their former power. Take the so-called Marnhull Orphrey, a fourteenth-century band of embroidered religious scenes that would once have decorated the clothes of a priest. In faded yet extremely fine silken thread it depicts the punishment of Christ: in one image he is flagellated by a pair of figures brandishing whips, while another presents his haranguing and taunting when carrying the cross to Golgotha. These images themselves play on the social role of dress. Christ is shown nearly naked, his dignity covered only by a silver loincloth, while his assailants wear exotic and elaborate clothing, boldly coloured, with clashing patterned leggings and ochre coats. The hues of these textiles underline the stark difference in humility between the parties. But Christ's nudity also serves to highlight the lucid resplendence of his skin itself. Embroidered in pale, gleaming silk thread, it is fetishised as a patch of pure whiteness that contrasts with the deliberately darkened skin tones of his miniaturised assailants.

Like the blue-faced Saladin being thrown from his horse across the bottom of the Luttrell Psalter, the spiritual blackness of the sins these non-believers perpetrate against Christ is transformed into a literal blackness worn on the skin of their face, hands and feet. An expensive, luxurious piece like this would have amplified the high authority of the cleric who wore it, at once showcasing the Church's clear opinions on race and dress. And at the same time his body would have also added a final element of animation to the scene. The figures are set not against a simple yellow silk but against a background of metallic, gilded silver thread. As the priest moved through the actions of officiating the Christian ritual, his garments would have caught the

30. Two scenes from the Marnhull Orphrey, showing Christ carrying the cross and the flagellation, probably made in early fourteenth-century London.

light streaming through windows or flickering from candles, making its threads glitter and shimmer. The cross, the whips, the flecks of blood on Christ's body would have all sparkled as the priest embodied the orphrey, its heavy inanimate fabric coming to life as a second liturgical skin.

BONE

It was known long before the Middle Ages that bones formed the body's foundation, a structural framework around which everything from muscles and nerves to veins and flesh was wrapped. Early medieval authors described most sections of the skeleton relatively thoroughly in their treatises, individuating the bones and their different functions: the ribs fortified the chest, the skull protected the soft brain beneath, the clavicle – from the Latin *clavicula*, meaning 'little key' – locked the arms to the chest at the shoulder. Still, there was not always certainty as to the tally of bones the body contained. A few writers stumped for a total of 229, while some maintained that males had 228 bones, two more than females, who had 226. Others thought specifically that men had one rib fewer than women, a single bone missing in an echo of Genesis, which told of God creating Eve from Adam's side.

The confusion was the result of a practical problem. To see bones as a clean, white and easy-to-count skeleton first required the removal of the tough tendons and ligaments that bind the muscles to them. This was, and still is, a time-consuming business. Limbs and other body parts have to be carefully boiled to loosen the fibres of these fleshy elements and encourage the core to slip out like a freed lamb bone

from a stewed shank. In the medieval period, opening up the body was fraught enough without brewing up such controversial casseroles. Besides, getting to the bones by boiling also had the obvious drawback of destroying most of the cadaver in the process, rendering the corpse unacceptably despoiled and, ultimately, unobservable. It was only later, in the early modern period, that the construction of anatomical teaching skeletons rose to prominence, and even then the bones of a dissected corpse tended to have its flesh not boiled but slicked away, using aggressive corrosives such as quicklime.

Bones, then, were somewhat frustrating things, clearly important but unattainable and interior beneath the skin. This also had the effect of limiting their appearance in medical images of the time. When they do feature, they feel familiar but slightly skew-whiff. The skull is there, but with only some of the jagged suture lines that run outwards from its centre. The squared-off jawbone is sometimes shown correctly as an independent piece, but more often is fused with the cranium to form one strange giant bone-head. The pelvis, too, has a tendency to be shown warped and curvy, as if combined with the sacrum into a single semi-circular unit. And piano-key spines extend from the neck to the coccyx with the ribs flourishing outwards, but often without individual ver-tebrae, appearing just as a single wobbly line running down the back. Sometimes an effort is made to echo the interiority of the skeleton, so hard to see in reality, by displaying the bones as an interconnected framework sitting verifiably within the body. Layers of painted muscle and flesh are built up around the skeleton in recessing bands of deep marbled purple and lighter red. But more often depictions dispense with any sense of realism altogether.

An image from 1488 copied alongside the writing of the Persian author Mansur ibn Ilyas (c.1380–1422) shows just such a schematic view of the bones. The figure is strangely warped, with a flat, seemingly reversed, heart-shaped head, in which the eyes and nose face upwards towards the top of the page. Those in search of an ignorant Middle Ages might quickly write this off as an error, the work of an illustrator who had no idea what a skeleton really looked like. Yet if we look a little more closely, we realise that this is in fact a dorsal view. Like its western

31. A diagrammatic skeleton explaining the detail of the bones in the body, from a copy of the *Tashrih-i badan-i insan* (تشريح بدن انسان, 'The Anatomy of the Human Body'), by the Persian author Mansur ibn Ilyas, completed in December 1488.

counterparts, this image pictured the skeleton from behind: the elbows and the palms face the viewer, laid on their front, and the head is tipped backwards at an extreme angle so that the upper vertebrae of the spine can be seen in their entirety. The interest for those reading Mansur was clearly not in seeing a skeleton presented with perfect accuracy. After all, any healer experienced enough to be reading a dense and theoretical book like this would be more than familiar with the detail of real human bodies. Rather, what they wanted from such an image was a different kind of knowledge. Littered around the stylised outlines of the bones are tiny sections of explanatory text, listing their names and differentiating their functions. This is the skeleton as a presentation device, designed to make the detail of the bones more memorable. It conveyed terminology, an intellectual framework for medical understanding, built up around the body's bones.

More practical medicine took a different approach to the bones. Medieval osteological health had a well-established repertoire, particularly the work of surgeons who could offer practical expertise in the case of bruises and breaks. Dislocations and their healing – what the influential Italian surgeon Teodorico Borgognoni (c.1205–1298) referred to as 'the joining of the disjointed' – were thought to be best addressed by the firm manipulation of the affected limb under traction, with stretching force applied to the area, either by hand or using a number of innovative devices. For hip dislocations the lower legs would be bound together at the shins and a small animal-skin bag inflated between the thighs, popping pelvic joints back into place. For the spine, elaborate wooden racks would be used in conjunction with the surgeon's body weight to palpate or stretch the patient. Such stretching alone would probably have provided little long-term help but may well have lessened the pressure on crushed nerves and reduced the spasming of over-extended muscles, giving the patient some genuine relief.

Even more successful was the resetting of fractured or fully broken bones using braces and tight bandaging to immobilise and realign limbs, followed by the application of various salves and medicaments to help the bones heal. We get a good sense of these methods in an assorted book of medical, religious and magical texts written in Greek around

32. Two pages from different parts of a medical book
written in Greek around 1440 by the healer John of Aron. On the
left are different positions of bandaging on the face, and on the right
is the torsion of the body to relieve pressure on the joints.

the year 1440 by a little-known practitioner named John of Aron
(Ἰωάννου τοῦ ἀρο). The parchment of the manuscript has not survived
particularly well, scuffed and stained across its surface, perhaps suggest-
ing frequent consultation. Nevertheless, one of the pages still clearly
shows a series of nine faces diagrammed side by side, each wrapped in
different snaking webs of brown bandage. Their different configura-
tions are designed to secure a range of damaged bones, each named by
shape and style: περικεφαλαία ('around the head like a helmet'), πλήξ
('entangled, around the face'), ῥόμβος ('rhombus-shaped'). Another
illustration from the same book shows a more elaborate bone-setting
scene in action. The patient is stretched out face down on a traction

machine, while two assistants tighten the rack at either side. The whole affair seems rather grand, taking place beneath an ornate canopied archway, its hanging lamps and patterned dome invoking the mosaic decoration of a luxurious bathhouse. It must be warm, for the assistants are naked and the attendant physician wears only a towel around his waist as he manipulates the patient's back with a plank.

Healing techniques like this were not restricted to human bones. The fourteenth-century veterinarian Abu Bakr al-Baytar, a specialist working in the royal court of Mamluk Egypt, developed detailed processes for the construction of large-scale splints that could be administered to horses or cattle with broken bones, as well as ingredients for curative remedies and painkillers to be given in far stronger doses than to men and women. Animal medicine like this was not often recorded. Farmers, almost all of whom would have been unable to read and write, had little need to document in long-winded detail the husbandry that they had already been practising for generations, passed on by observation and oral tradition. Instead, such veterinary writings were normally the preserve of the keepers of high-end beasts like al-Baytar. Healthy stable and working animals were of vital importance

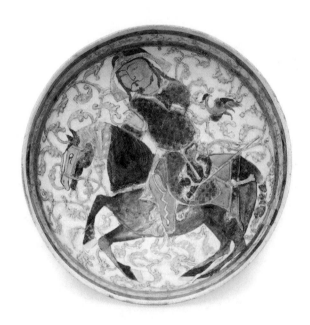

33. A bowl probably made in twelfth-century Iran by a Seljuk ceramicist, showing a prince hunting on horseback with birds. Such creatures were just the type of high-status animals that the Mamluk veterinarian Abu Bakr al-Baytar would have treated.

to the smooth running of various matters of state, from processions and festivities to diplomatic travel and war. Instructions for complex surgeries on animals were therefore valuable things, laden with intriguing details that tell of surgical incisions for accessing the bone, as well as injections of immobilising substances to stop animals struggling and techniques for cauterising openings after surgery. Other books list recipes for extremely viscous pastes that could be used to still, stiffen and protect more subtle fractures, even in the difficult case of a broken wing sometimes sustained by the large hawks used by the aristocratic elites for hunting. Given the immense popularity of the sport in wealthy circles across the Mediterranean, knowledge of how to heal the bones of birds could be just as important, and just as lucrative, as operations on human patients.

The Site of Bones

Set diametrically against these more hopeful concerns of healers, who thought they could tend to and revive the living skeletons of both man and beast, was the near-constant presence of the bones in medieval cultures of death. This was their most blunt and by far their most prominent role in the Middle Ages, a marker of people's intimate and public relationship to the realities of living and dying. Where the bones finally came to rest could be extremely important, a site of sadness, joy, memory and spiritual exchange between the dead and the living.

For most in the period, designating where one wished to be buried was something undertaken while still alive, sometimes long before reaching old age or sickness. Honouring such wishes was thought particularly crucial. We can see this most easily in the cases of several high-status individuals. Given their extreme wealth and their ability to travel, it was not uncommon for a king or queen, sultan or emperor, to die some distance from the pivotal political centre of their realm. And as their bodies could hold substantial dynastic currency for both their followers and their nation, a royal's successor could find themselves with the difficult job of transporting posthumous remains some

distance to a place appropriate for a sufficiently momentous burial. Moving corpses across continents, though, was not easy. After the death of the Carolingian King Charles the Bald in the Alpine town of Avrieux in 877, his body was gutted and stuffed with aromatic preservatives, salt and wine to facilitate its intact return to the Cathedral of St Denis, some 600 kilometres away on the outskirts of Paris. Alas, so strong was the body's nauseating stench that the King's party could only take him as far as nearby Nantua. It was only seven years later that what remained of his body was disinterred and returned to the capital by a particularly devout and adventurous monk. While such removal was streamlined somewhat over the centuries, it still remained a momentous undertaking. When King Louis VIII died in the Auvergne in 1266, his followers were presented with a journey of similar complexity and distance. This time the corpse was salted, wrapped in waxed cloth and sealed into a stitched-up cowhide to save the noses of those who bore his bones.

This dedication to the place of death was particularly integral to all three of the predominant faiths of the Middle Ages. In religious terms death was seen not as a finite end, but rather as an important crossing point into another realm, from one earthly stage of life to another less tangible one. This was most discussed in Christianity. Earlier Greco-Roman practice from which the religion stemmed tended to emphasise individual biographies of the deceased through familial ancestries: men and women might have died, but their links to kin and clan remained. The New Testament reframed this as more of a spiritual persistence. The powerful animating soul, medieval theologians agreed, lived only temporarily within the body, and while death marked the cessation of a person's perishable earthly form, this was but a single moment in the soul's longer journey. This continuity would only end upon its very final reckoning at the moment of an imminent and apocalyptic Last Judgement. There were two exceptions. If in life you had committed an unforgivable level of mortal sin, your soul would be condemned immediately to hell on departure from the body. Likewise, if you had been astoundingly saintly, through good deeds or holy martyrdom, your soul would leave the dead body to rise directly to heaven. For most normal folk, however, death marked the soul's shift into a rather more

34. Sculpted scenes above the western door of the Cathedral of
Conques in southern central France, finished around 1107. It offered
a powerful vision of the Last Judgement for the faithful to see every
time they entered the church, with a large central image of Christ
judging the good on his right-hand side and the bad on his left.

complicated state of limbo, awaiting its ultimate sentencing until the
End of Days, whenever that might be.

It was only after the influential writings of thirteenth-century
theologians such as Thomas Aquinas (1225–1274) that this concept of
purgatory was fully fleshed out by the medieval Church, and their ideas
made clear that earthly bones could have a serious impact on this inter-
mittent realm. While alive, living the life of a good Christian would
begin a favourable process of judgement. Living well, spiritually speak-
ing, involved not only faithful prayer and Christian good deeds but also
engaging materially in churchly pursuits, pilgrimage, crusade or the
patronage of sacred objects and spaces. But, once dead, the continued
well-being of your eternal soul was entrusted entirely into the hands
of the living. Each time they invoked your name in prayer, your purga-
torial sentence was shortened and alleviated. Some wealthy individuals
sought to amplify this spiritual support by striking deals for posthumous
remembrance. They founded and funded whole religious institutions

— monasteries, convents, abbeys, cathedrals — writing into their char-
ters that an entire foundation's religious inhabitants would, in exchange,
pray for their munificent benefactor daily for generations to come. In
particular, the existence of miraculous relics had long proven a lingering
connection between the body and the soul, even after its departure, and
thus this alleviating power of prayer was thought all the more potent at
the graveside. For both rich and poor the site of bones acted as a sort of
bodily antenna for sending spiritual countenance to the abstracted soul.

Unlike this rather detailed account in Christian scripture, discussions
of the appropriate way to treat a body and its burial place after death are
not much mentioned in the Qur'an. Medieval Islamic thinkers were forced
to build up their own recommendations in a series of advisory manuals
on the burial of bones. Especially popular was the tenth-century Afghani
author Husayn al-Baghawi's *Masabih al-Sunna* (مصابيح السنة, roughly
translating as 'The Lamps of Prophetic Teaching'), which included,
among other details, the commonly held Muslim belief that burial should
follow quickly after death, preferably within a day, a practice still upheld.
For Islam's early communities this would have been an important prac-
tical measure. A dead body would not stay untroubled for long in the
intense desert heat of the Arabian Peninsula or other temperate Islamic
lands and so was placed quickly into a grave, dressed only in a simple
shroud and leant on its right-hand side so as to orient it towards the *qibla*
(قبلة), the sacred direction of Mecca. But there was also a spiritual haste.
A person's soul was thought to depart the body with speed upon death,
creating a metaphysical divide between material and spiritual worlds that
was to be resolved only when the soul was reunited with an idealised
version of the body after the Day of Judgement, or *Qiyamat* (القيامة).
Archaeological evidence suggests that such burial traditions were being
followed by Muslim populations across the Middle East and even as far
west as Nîmes in the south of France, where Islamic Umayyad communi-
ties briefly settled in the early eighth century after their armies advanced
northwards over the Pyrenees from Muslim Spain. Here, bodies were dis-
covered correctly dressed and oriented, with their hands laid so as to cover
their face, a poignant gesture of the bones in perpetual holy deference
and grace.

The final resting places of medieval Jews can be even more complex to uncover and interpret. Jewish communities lived as minorities across the entirety of the Middle Ages, their lives exclusively taking place under the rule of other faiths. Following the advice of the Old Testament book of Proverbs that 'the rich and poor meet together in death' – a reminder that material goods are of use only to the living – they often left little in the way of ostentatious or symbol-laden tombs and grave-markers over the bones. This material sparsity is further compounded by the extensive periods of persecution Jews underwent across Europe at various points in the period. Ostracised from Visigothic Spain in the seventh century, massacred in Germany in the eleventh as an off-shoot of the First Crusade, expelled from England altogether in a royal edict of 1290, to name just the more major instances, Jews rarely had the political freedom to bury their dead in the manner they wished. And even when they did, medieval Hebrew texts outlining funerary customs tended to focus on instructions for mourners. They called for a certain juxtaposition, counselling expressive grief in private but deliberately internalised, restrained quiet in public: tearing one's clothes and garments at the bedside of the deceased, but heralding a death to the world only by hanging a small cloth outside the house and opening all of its windows. Attitudes to the corpse itself were similarly contrasting, at once an object of extreme deference and potential pollution. Touching dead bodies directly was considered irreverent – something especially to be avoided by the *kohanim* (כהנים), the priestly class – apart from when ritually washing the deceased for burial, anointing them and enshrouding them in linen sheets and clothes. Once wrapped, the body would be taken to the nearest cemetery that permitted Jews, often a significant distance outside of urban centres, and interred in a coffin or on short wooden planks. The grave was normally marked only by a simple stone slab with the name of the person buried beneath, but preserving the body in good corporeal order like this would have kept in line with Jewish teachings of a conceptual, mystical messianic time known as *ha'olam ha'ba* (העולם הבא), 'The World To Come'. At this future moment the dead would rise from their graves for a redemptive return to the Land of Israel, the bones reanimated for an eternity in an age of paradise.

In practice, these three religious frameworks for death and burial varied dramatically between different communities and across the centuries. And there were also many points of exchange between them. Jews passed to Christians the tradition of anointing the corpse, Christian kings could be buried in shrouds of expensive cloth woven by Islamic textile-workers, and Muslim cemeteries could stand side by side with Jewish graveyards at a city's limits. Rather than something to shy away from, this cross-pollination could be proudly worn as a sign of medieval multicultural sensibilities. In twelfth-century Sicily, a kingdom where the faiths enjoyed comparatively cordial relations, language at the graveside reflected the shifting sands of these religious worlds. A large stone slab discovered in Palermo at the church of San Michele Archangelo records the death of a woman named Anna. It is most likely the end of a sarcophagus commissioned for her by her son Grisanto, a Christian cleric of Sicily's Norman king. At the square gravestone's centre sits a simple mosaic cross, colourfully formed from inlaid red, green and blue glass, around which four distinct carved inscriptions unfold in turn. Together, these quarters of text mourn Anna's passing, each in a different tongue: Greek, Latin, Arabic and Judeo-Arabic, Arabic words written in Hebrew letters. Calling out in a polyglot chorus from her grave, they prompt the visitor to memorialise Anna's life and invoke good wishes in her name, all speaking versions of the same refrain, 'Here lies Anna, mother of Grisanto, buried in this Church in the year 1148':

✝ תופית אנח אם אלקסיס אכרסנת קסיס אלמלך אלמעטם עאל ✝

✝ XIII KALENDAS SEPTEMBRIS ✝ OBIIT ANNA MATER
GRISANDI ET SEPULTA FUIT IN MAIORI ECCLESIA
SANCTE MARIE ANNO MCXLVIII

✝ ἐκημήθη ἡ ἐν μακαρίᾳ τῇ λήξῃ Ἄννα ἐν μηνὶ αὐγούστου κ΄. καὶ
ἐτάφη ἐν τῇ καθοληκῇ καὶ μεγάλη ἐκκλησίᾳ ἔτει ϛχνϛ΄ ✝

✝ توفت انّه ام القسيس اكريزنت قسيس
الحضرة المالكية الملكية العالية العلية العظمة السنية القديسية ✝

Stones over Bones

If these funerary customs and linguistic memorials directed the voices and actions of the bereaved at the site of the grave, what of the dead themselves? Could they be reanimated? How was their presence felt beyond putrefying flesh and emerging bone in the ground below? Medieval craftsmen offered a powerful response to these questions by creating tombs and grave monuments designed to extend an individual's presence long after their mortal demise.

Given that graves were sites for transactional mourning, where the pious actions of visitors could directly affect the quality of the deceased's eternal salvation, a certain spatial politics began to play out in the placement and embellishing of these sites of death. In small villages and larger cities alike, most people would have been interred in communal burial space within cemeteries dedicated to their respective faith. There were unfortunate exceptions. The poorest might struggle to meet the cost of interment in sacred ground, their burial falling instead to the charity of others, who would, in turn, receive serious spiritual recompense for taking on a pauper's debt. And those who were thought to have died from particularly contagious sicknesses – plague, for instance, or sometimes leprosy – would normally be removed from the bulk of the population and end up in mass graves mostly outside city walls. At the other end of the social scale, at least in Christian societies, more aspirational citizens like nouveaux riches merchants, local aristocrats or high-ranking clergy could fund particularly prestigious burial inside a church, jostling for the choicest spots in proximity to the sacred space of the high altar. They were, in effect, peacocking for the all-important purgatorial prayers. Indeed, those at the very highest levels of society might side-step such concerns altogether: they commissioned additional wings to buildings or endowed entirely new foundations where their family's dead might be repeatedly interred. Such elaborated spaces effectively became dynastic necropolises, a corporeal red carpet displaying a family's unbroken lineage and justifying the continued and undeterred reign of their

living relatives. Such substantial monuments – the sculpted tombs of the English royalty in Westminster Abbey, say, or the domed mausolea of Mamluk sultans in Cairo – would have been monumental projects, sustaining the political clout of ancestral bodies well into the future.

As well as prominent placement, the status of the medieval deceased was also conveyed in the material abundance of their tombs. The wealthy in life remained wealthy in death. Gilded metals, jewels or beautifully patterned stones all elevated the body's immediate surroundings, redirecting onlookers to think more about the glittering legacy of the deceased than their body interred within, slowly turning to dust. Some relied on sheer staggering presence. The princes of various Persian dynasties deliberately ignored contemporary Islamic prohibitions against ostentatious funerary structures by erecting extremely tall and pointy brick mausolea. One such structure still stands in the ruins of the Persian city of Jorjan, now in northern Iran, a towering 53-metre-high turret built in the year 1006 for a Ziyarid emir named Qabus ibn Wushmgir, whose name is commemorated in circular kufic inscriptions that wrap around its circumference. Others turned to intricacy and more emotive imagery to move the viewer. The fifteenth-century French dukes of Burgundy, Philip the Bold and John the Fearless, found final resting places in a pair of elaborate personal monuments whose central sculpted tombs were each supported by a throng of miniature alabaster mourners. Each of these tiny figures is dramatically hooded and strikes a different sensitive pose, frozen in multiple actions of grief that might have been experienced by those beside the grave. Perhaps the most materially minded of all were the emperors of Byzantium, who for nearly seven hundred years followed the example of Constantine the Great and chose to be entombed in large marble sarcophagi within the ancestral necropolis of the Church of the Holy Apostles in Constantinople. These rulers do not seem to have been particularly interested in complex carvings or affecting decoration. They focused instead on the multitude of different properties to be found in one particular

35. The towering 53-metre-high mausoleum of the Ziyarid emir Qabus ibn Wushmgir, built in 1006 in the Persian city of Jorjan, now in northern Iran, near the border with Turkmenistan.

stone's coloured seams. Their sarcophagi were hulking, impossibly heavy caskets, carved from marbles of all possible hues and shades: rich green Thessalian marble, rosy and speckled Sagarian marble, colourful Hierapolitan and Proconesian stones and, most prominently, a rich purple porphyry. So strong was the significance of this purple marble as an indicator of imperial status that one emperor even took it as his name, Constantine VII Porphyrogennetos (905–959), literally 'born-in-the-purple'.

Not everyone, however, would have been satisfied with the style of these unembellished Byzantine boxes. Likeness and recognition at the grave were also thought important, especially in western Europe.

Those who could afford it commissioned images of themselves to appear somewhere within the ensemble of the tomb, often a highly romanticised vision of their own body. Effigies like this began to be included at burial sites from the very early Middle Ages, starting as relatively simple figures sunken into slabs commemorating the aristocracy or clergy, evoking in front of the mourner the literal presence of the person for whom they might be praying. But these soon grew into ornate likenesses of the dead, recalling their earthly deeds. Sculptures atop royal tombs could be proudly decked in the full regalia of state, complete with golden crowns and enveloped in silken gowns, capturing the trappings of their earthly status in perpetuity. And dynamics of posture and pose, too, could be important in these monuments, used to emphasise both status and personal character. Popes and archbishops, for instance, usually appear poised in the action of blessing or are frozen in time crowning kings, one of their most respected social roles, whereas in the tomb of the warfaring nobleman William Marshal, Second Earl of Pembroke (1190–1231), now in London's Temple Church, his effigy writhes into a twisted position as if he is poised to jump to his feet, his hand on his hilt, only just stilled at the moment of drawing his sword. The tomb immortalises the earl's place as a bold leader of men, presenting him in constant vigilance, ready and able to do battle even after death.

Nor did medieval tombs shy away from dealing with the raw ugliness and finitude of the deaths they marked. Skeletons abounded, fleshless skulls and bones picked out in brass monuments or on tombstones, suggesting that, whether because of their reassuring belief in an afterlife or an ease born of familiarity with the reality of mortality, medieval people were far less anxious about cohabiting with the visual ephemera of death than we perhaps would be. Some monuments, though, took this to the extreme. The body of Alice Chaucer (1404–1475) lies in the small church of St Mary in Ewelme, a picturesque town nestled in the Oxfordshire hills. Alice was part of a wealthy dynasty, the granddaughter of the famed poet Geoffrey Chaucer, but in her own right was an unshakable and adept political

operator. She had taken a series of three husbands, each of them one rung further up the social ladder than the last – a lord, then an earl, then a duke – all of whom predeceased Alice, leaving her with a substantial fortune and expansive landholdings which she managed with rigour. The spoils of this social intelligence are best evidenced in the expensive and unusual tomb she had commissioned for herself shortly before her death. Atop this funerary monument a carved alabaster effigy of Alice lies prone on a sculpted pillow supported by angels. She smiles peacefully, wearing a rich cloak and small coronet that indicates her lofty position as duchess. Around her left forearm is a small band that proudly signifies her acceptance into the Order of the Garter, the highest chivalric honour that could be bestowed by the king and which at the time was almost never granted to a woman. She is laden with the symbols of her living achievements, the frills of finery and office. But beneath this idealised figure astute viewers could peer through a small architectural grille to see a quite different alabaster image of Alice that she also had commissioned. Laid out on an intricately carved funerary shroud is her decaying corpse. The body is grotesquely stiffened, its plump flesh so drained of life as to resemble a thin canvas stretched across a rack of bones, made painfully visible beneath. Her nose is missing, her breasts have withered completely flat and her naked jaw is drawn open in rigor mortis. The only concession to worldly concerns of appearance is her stiffened right hand, which clutches the shroud across her pelvis, covering her modesty.

This seems a surprising image for Alice to have chosen to be presented to the world, especially when set against the idealised figure above. Yet such a comparison was precisely the point of a tomb like this. The lower effigy sets up an elegant contrast, a binary in death between Alice's two bodies, earthly success set against earthly decay. And in so doing it reminded the viewer of the constantly pivoting status of any such medieval tomb: at that very moment Alice was both a humble, wasting bag of bones and an abstracted soul awaiting heavenly judgement. It was only through a visitor's presence at her

36. The two effigies from the alabaster tomb of Alice Chaucer
(1404–1475) in St Mary's Church, Ewelme, Oxfordshire.

side, revelling in her material legacy and praying by what remained of her, that she might eventually achieve ultimate salvation in heaven.

Working the Bones

Alice Chaucer's grisly tomb was only one of a much larger group of late medieval artworks that sought to seize back some aesthetic potential from the tough realities of life in the Middle Ages. Take the opening stanzas of the Middle English poem *The Dance of Death*, by John Lydgate, the same author who wrote so eloquently about the cruel spinning of Fortuna's Wheel. Writing in the early fifteenth century, his work formed a central part of an emerging late medieval interest in the macabre. There was, the poem's first lines suggest, both a frequency and a universality in the way people saw death:

> *O ʒee folkes / harde herted as a stone*
> *Which to the world / haue al your aduertence*
> *Like as hit sholde / laste euere in oone*
> *Where ys ʒoure witte / Where ys ʒoure prouidence*
> *To see aforne the sodeyne / vyolence*
> *Of cruel dethe / that ben so wyse and sage*
> *Which sleeth allas / by stroke of pestilence*
> *Both ʒonge and olde / of low and hie parage.*
> *Dethe spareth not / low ne hye degre*
> *Popes kynges / ne worthi Emperowrs*

> O you people, hard-hearted as a stone
> Who to the world devote all your attention
> As if it should last forever and anon.
> Where is your reason? Where is your wisdom?
> To see afore you the sudden violence
> Of cruel Death, who is so wise and sage,
> Who slays all by stroke of pestilence

Both young and old, of low and high descent.

Death spares not low nor high degree

Popes, Kings, nor worthy Emperors.

But rather than presenting his poem exclusively as a mournful lament of his time, Lydgate goes on to extract broader moral ammunition from this supposedly ghastly situation. The piece continues as a tragicomic rumination on the power of dying, phrased through a series of unfolding dialogues between people of different social status – from an emperor and king down to a labourer and a child – with a strange, skeletal personification of Death, who beckons them in turn to dance. Nobody can avoid Death's hand. Mankind is *'nowght elles but transitorie'* ('nothing else but transitory'), all eventually turned *'to dede asshes'* ('to dead ashes'). But there is a certain frivolity to Lydgate's touch. While undeniably dark in tone, he laces a subtle social commentary throughout the responses of his highborn and lowly characters, all keen to turn down Death's worrying invitation to dance – to die – as quickly as possible. When the figure of the Sergeant, for instance, is requested to join, he replies with pastiched pomposity that Death should not dare challenge an officer of such high state to engage in something so shallow. The Astronomer tries to forecast a reason in the stars not to join the deathly revellers. The womanising Squire only agrees to follow Death's lead once he has had the opportunity to bid farewell to his 'ladyes'. And the King ends up admitting to Death that he actually does not know how to dance at all.

Lydgate's poem was based on the most famous and perhaps the earliest example of this genre, a French *danse macabre* that he had seen in 1426, when visiting Les Innocents, the largest cemetery in medieval Paris. This was no quiet, austere burial ground but a busy and unashamedly communal space, a site for mass graves of the poor and host to larger public events for the people of Paris, from markets to feast-day processions. Lydgate had found the poem there not written in a book but painted as a mural that grandly stretched across several walls of the cloister-shaped charnel houses that flanked the edges of

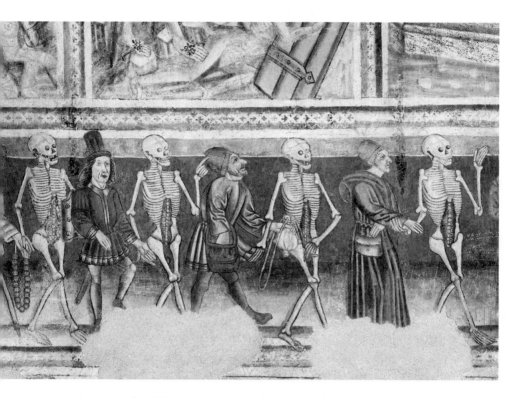

37. A detail from a Dance of Death painted on the walls of the
Church of the Holy Trinity in Hrastovlje, Slovenia, by the artist
Janez iz Kastva at the end of the fifteenth century.

the cemetery. Inside these half-open buildings the rafters were packed
with the skeletons and skulls of Les Innocents' longer-term residents,
excavated to clear space for new bodies in the central burial ground
itself. But directly below these bones, along the charnel houses' inner
walls, the poem and an elaborate illustration of Death's dance played
out. The late eighteenth-century modernisation of Paris saw Les Inno-
cents destroyed, but we get a good sense of the mural from several
others painted around the same time, and which proved especially
popular on the walls of churches in central Europe and the Baltic. Frol-
icking skeletons hop and spin along the brickwork, reaching out their
hands to grasp the anxious caricatures of the poem, a continuous band

of men and women, arms interlaced, each dragged along in the steps of Death's final dance.

Some medieval objects went even further than these murals in their playful intertwining of death and skeletal bones. Baldassare degli Embriachi, a fourteenth-century Florentine sculptor, achieved remarkable success crafting a wide range of luxury objects whose outsides were actually formed from decorated animal bone itself. Their trademark styles contrasted inlaid pieces of wood, horn, hippopotamus teeth and cow and horse bone, combined into intricate patterned panels and tessellated figural vignettes. Hundreds of objects survive from the Embriachi workshops, which relocated from Florence to Venice in the 1390s: small crucifixes, rectangular boxes, circular caskets, figural triptychs, a doubled chess and backgammon board, even enormous pinnacled altarpieces, all formed from this same boney style. But the Embriachi were in turn trading off the popularity of other small objects carved from an even more luxurious material, ivory, thought similar in look to bone but far more expensive. It was valued by high-status patrons and artisans alike and represented an obvious luxury. Whether imported from African elephants or the tusks of walruses on the arctic edges of northern Europe, it was the material stuff of the extremes of the known world, only reaching the central Mediterranean after travelling substantial distances. We know, therefore, that macabre imagery fixating on skeletons and skulls in the same deathly manner as Lydgate's poem was no mere joke when we find it carved from this valuable material. One such sculpture, made towards the end of the fifteenth century, was perhaps designed to sit at the end of a string of rosary beads. At first glance it appears to show a simple scene of young love in miniature, a couple caught kissing, the woman rebuffing or perhaps encouraging the man's wandering hands at her chest. But upon flipping this little object around in our fingers, we discover a remarkably different type of image. A triumphal skeleton is poised tall as if he has just emerged from the grave itself. His flesh is half gone from his body, the creamy white of the ivory tusk standing in perfectly for the bleached pallor of his human bones, and he holds a banner emblazoned in French, *EN VOVS MIRES TES Q IE SUI SERES*,

38. A carved ivory rosary bead showing a kissing couple
and a skeleton holding a banner, made at the very end of the
fifteenth century, probably in northern France.

'recognise in me what you will soon be'. The jarring switch from the
follies of youth to galloping death, and back again should you wish to
give the bead another spin, brings both a sense of gallows humour and
a serious jolt: life is fleeting, live it well.

To the modern mind such trinkets, like the buildings at Les
Innocents, packed with skulls and bedecked with the splayed skeletal
remains of cadavers, feel rather graphic and unrelenting. Whether
crossing through town or simply looking down at a rosary, the vio-
lence and impending doom of medieval bones seem to have met the
eye uncomfortably often. But mediated by a firm belief in the after-
life, as well as a far more proximate relationship to the realities of
death, these representations would not have had the same shocking
impact on their original owners as they have on us. True, there is no

doubt that the bones were morbid things, irrevocably associated with death, the pain of grief, the sorrow of mourning. But to see this as a gruesome medieval obsession is wrong. More apparent to medieval men and women would have been the sophisticated range of ways one could approach bones. Fearful yes, but also respectful, hopeful, even playful.

<div style="border: 1px solid black; text-align: center;">

HEART

</div>

On 17 August 1308, from her bed in the central Italian monastery of Santa Croce in Montefalco, abbess Chiara Vengente breathed her last. The precise cause of her death was not recorded by the nuns who had gathered around her, hoping to ensure the safe passing of a woman who had acted as their spiritual guide for some eighteen years. But one thing was clear to sisters Francesca, Illuminata, Marina, Catherine and Helen as they stood at the dying abbess's side. Christ was in Chiara's heart. Of this she had been particularly insistent as her health declined, often pronouncing that she felt him in there, nourishing her. So when, after her death, Chiara's body seemed miraculously to resist the intense heat of Italy in August, refusing for a full five days to decay, rot or succumb to even the slightest malodorousness, the sisters decided to take their abbess at her word. They cut her open, removed her heart and put it in a box.

The nuns were unlikely to have been able to navigate particularly precisely inside Chiara. Some may have previously embalmed sisters past with apothecary's herbs and spices. But like most untrained venturers into the body's innards, they would probably have known little more than an approximation of where Chiara's heart was and roughly

what it might have looked like. We do not know if they even expected to find anything particularly special within their abbess's uncorrupted body. Rather than a precise anatomical intention, they seem to have been following more other-worldly instincts.

The next day, after evening prayers, Sister Francesca felt compelled to return to the box. For some reason she was not satisfied by the first impromptu post-mortem and, intent on searching ever deeper inside Chiara's increasingly holy remains, she cut the heart in two with a razor to examine its contents. It was at this moment that Francesca realised that the sisters' searches were to have deep spiritual reward. Inside the heart she found a tiny sculpted image of Christ on the cross and, alongside it, a whole collection of miniature objects associated with the Passion, from the nails hammered into Christ's body and the whip of his flagellation to the lance of the soldier Longinus which had pierced deep into the crucified Christ's side. But these miniatures were not crafted from traditional artists' materials, from metal, wood, ceramic or ivory. They were wrought from the flesh of Chiara's heart itself.

The miraculous organ and its contents were immediately brought before Church authorities. Some were sceptical, but a small cult of devotees formed who were certain that Chiara's heart had been singled out by holy forces, a sign of her exceptional religious steadfastness and foresight. In the decades and centuries that followed, paintings were commissioned to adorn the sisters' church showing Christ himself planting a life-size cross directly into Chiara's chest. Prints were made of the heart and its contents, in order that word might spread of the miraculous occurrence. Finally, after several failed attempts, in 1881 Pope Leo XIII confirmed Chiara's canonisation as a saint of the Catholic Church. Her heart, complete with its muscled crucifix, sits today inside a large, ornate metal reliquary on the church's high altar at Montefalco. Blackened over time, it is still preserved without rot or decay. Whether this was granted by some heavenly consent or a more natural process of desiccation is a decision for the beholder.

Of all the places where Christ could dwell within Santa Chiara da Montefalco's body, why did it make sense to the sisters of Santa Croce, indeed to the saint herself, that he might have miraculously

materialised within her heart? What was it about the organ that enticed sister Francesca to slice deeper into its chambers? And what else could this central, vital body part prompt in the minds of medieval people?

Healing the Heart

At the very simplest level, the heart is the internal organ whose presence in the body we can sense most acutely. Beating away inside our chests, it is one of the only things from the inside of ourselves that we can actually feel. Our stomachs might occasionally clench or let out an embarrassing gurgle, but this is nothing compared with the pumping of the heart in the chest, its pulse sounding loudly in our ears after sudden excitement, during intense exercise or in response to overwhelming fear. The insistent nature of this internal animation meant that, even in an age before sophisticated scanning of the interior, medical practitioners still placed remarkable importance on the heart and its functions.

The heritage of the classical Greek and Roman worlds played an influential role when it came to understanding the organ. Particularly pivotal were the writings of Aristotle, who in a treatise titled *De anima*, 'On the Soul', followed Plato in claiming that it was not the spontaneous action of the body's organs that controlled human movement and intellect but the governing force of the soul. But, unlike Plato, Aristotle did not locate it in the brain, arguing instead that the sentient soul dwelt within the heart. It was from there, not the head, he thought, that all human animation and desire emanated, a producer of both motion and emotion. Apparently following the evidence of dissected early-stage chicken embryos, the ancient Greeks also considered the heart to be the first organ formed during the development of a human foetus in the womb. And later, writers such as Galen and Ibn Sina expanded these theories to argue that it was also the source of the body's healing power and generative growth. For medieval thinkers in the Aristotelian mould, the heart was considered by some distance to be the body's principal and most powerful part, its theoretical core, a proxy originator of action and understanding.

Despite this significant position as the house of the human soul, however, the heart played only a relatively small part in the actualities of medieval medical practice. It was certainly depicted in medical treatises. A thirteenth-century English miscellany shows it nestled among the text of the page alongside various other bundles of internal organs, the red lobes of its lower ventricles contrasted with the feathery whiteness of the upper atria and the long tube of the vena cava. Nonetheless, the heart tended to feature in such books only tangentially to treatments that were really focusing on other bodily concerns, like the general functions of the abdomen or the processes of a fever in which the heart was thought to play a small part. Even within these writings the heart's precise shape, size and function fluctuate: some described it as round, while others conceived of it as more oblong and others still thought it triangular in its features, pointy like a pyramid.

One thing theorists did agree on was that the heart was of great consequence for bodily heat. The fiery core of the body, it was likened to a glowing internal sun from which other organs might receive their nourishing warmth. With warmth and coldness fixed as one of medieval humorism's key dichotomies, the heart was also hugely significant for the overall humoral equilibrium that the body needed to maintain. If its complexion was to fall into imbalance, the body was at particular risk of dangerous failure. Signs of such impending disaster included both an overly rapid pulse or a deathly weakening of its beat, and heart murmurs and tremors were known to potentially signify an impending cardiac arrest. As well as being heralded by these physical symptoms, attacks of the heart were also conceived of as deeply emotive things, brought on by extreme changes in mood, especially shock or quickening anger. In these instances medics knew there was little that could be done to relieve a patient. Some curative substances from the physician's toolkit were occasionally recommended to treat an ailing heart, from valuable gold and pearls to more mundane herbs and spices, especially sweet and pungent plants and syrups made from sugar and violets. Yet on the whole these measures were deemed of little use. The doctor was thought extremely lucky if they managed to revive such a stricken victim, and lists of heart

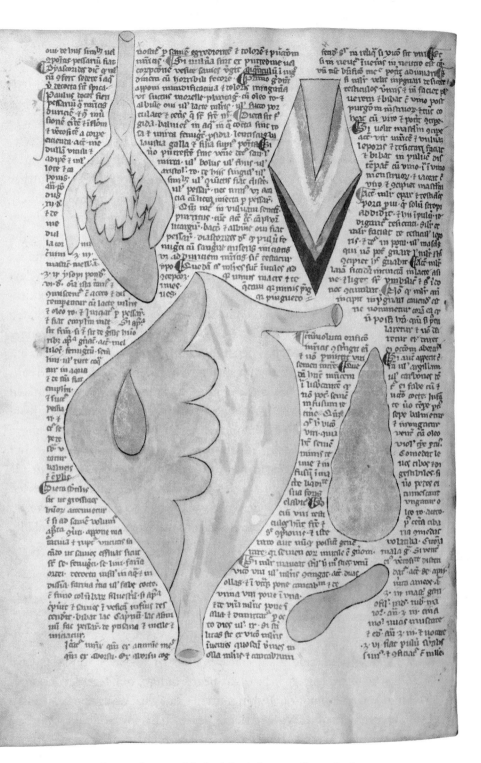

39. An image of many of the body's vital organs, from a Latin
medical manuscript made in thirteenth-century England. The
heart is shown in the upper left, surrounded by text.

cures in medical compendia read in a distinctly melancholic tone, as if to suggest that the patient was already lost.

This paucity of effective heart medicine was, in essence, down to the now familiar dominance of classical texts such as those of Aristotle, Galen and Ibn Sina. These writings claimed to understand the heart's semi-spiritual contents in totality and consequently dampened further attempts to search out the detail of its actual inner mechanics. Virtually no systematic explorations of the heart appear to have been undertaken in the period, and little was known of its specific functions: neither the independence of its ventricles nor the doubled pattern of its pumping. It was not until investigations in the seventeenth century by the English anatomist William Harvey (1578–1657) that the heart was even understood to be part of a looping circulatory system in which blood rotated around the body. Prior to this, the obvious bodily sensations of beating and bleeding meant that physicians had quite easily traced blood leaving the heart, transported outwards through the extending arteries and capillaries towards the body's extremities, but they had not yet rounded the circle and traced the heart's veinous and arterial tracks back from the limbs to the pump. This one-way thinking prompted a far more open conception of the organ as porous and permeable. It was not shut off neatly in a sealed circuit from the rest of the body or the outside world. Rather, matters of the heart were thought to be equally affected by external influences as concrete as a lance or as conceptual as love, an idea that was to have a profound impact on all sorts of bodily thinking, from the anatomical to the poetic.

Heartfelt

Modern language is deeply suffused with the long-standing association of the heart with emotional states. We talk of a heart fit to burst, learn things by heart, engage in heart-to-hearts or have our heart set on something. If we are emotionally committed to an idea, we can be heartfelt in our expression of it. We experience heartache, a form of pain somehow both physical and emotional at once. And when expressing negativity

we can be heartless, do things only half-heartedly or express a change of heart altogether. Many of these terms are filtered through Europe's dialects past. We might take on the emotional posture of 'courage', itself from the Old French for heart, *coeur*. Likewise, the kindly word 'cordial' stems from the Latin for heart, *cor* or *cordis*, from where we also get the verb 'record', our heart literally the inscribed register of our emotions. Even the very concept of something having a 'core', evolved from the same Latin roots, suggests the heart to be at the very centre of all things.

This expressive language of the heart, so fruitful and evocative in its variations, was well known and much used by medieval thinkers. Authors in particular agreed that of all the different emotions to which the heart might align, love was its predominant and most forceful domain. The tenth-century Jewish physician and poet Moses Ben Abraham Dar'i, for instance, revelled in the idea of the heart as not just a passive agent but an alert and active romantic force. Reflecting a much-invoked hierarchy of sensory affection, his Judeo-Arabic verses played with the notion that, although sight was the sense through which one might seek out one's beloved, it was the heart that ultimately guided love:

ולסאילי ען כשף אסם חביבי

נאדיתה פי קלב אעמש תתצרו

אן אלעיון אדא תנאקץ נורהא

צארת עיון אלקלב דאים תבצרו

To the one who asks me to reveal the name of my beloved,
I cry out: 'You suffer from a blind heart!'
For when the light in one's eyes grows dim,
the eyes of the heart will always begin to see.

We can observe this same pairing of hearts and eyes in various poetic movements of the period, especially the Troubadour romance lyrics penned in the Old Occitan language of central and southern France. One such author, Giraut de Bornelh, writing in the 1180s, was clear that he too saw the heart as the true sentinel of feeling:

Tarn cum los oills el cor ama parvenza
Car li oill son del cor drogoman
E ill oill van vezer
Lo cal cor plaz retener

So through the eyes love attains the heart.
For the eyes are the scouts of the heart,
And the eyes go searching
For what would please the heart to possess.

From the late eleventh century onwards, poems and songs in this tradition helped shape an entirely new vision of medieval love. Contrasting with wanton lust or more casual styles of ill-intentioned encounter that easily left lovers spurned and dejected, this model of affection was billed as distinctly honest and wholesome. It has been dubbed 'courtly love', a highly conventionalised amorousness which over the course of the later Middle Ages rose to widespread popularity. Whether following the dramatic tales of daring courtiers or the twists and turns of separated, longing lovers, the literature of this chivalrous romance often followed predictably chaste yet ardent patterns: couples spy each other from a distance and long for each other from afar, the man attempts to woo the lady with his dramatic heroism, and she finally consents, consummating their secret tryst. In Europe, the Troubadours and their German counterparts, the Minnesänger – literally 'courtly love singers' – found themselves chroniclers of this burgeoning aristocratic culture. It attached great importance to the rituals and niceties of courtship, and above much else it set at its core the different romantic movements of the heart.

A songbook made in Zürich some time between 1300 and 1340 for the Manesse family, a dynasty of prestigious merchants, shows just how high up the social ladder this poetical interest in matters of love and the heart went. At over 400 pages long, the book represents the most complete and comprehensive collection of ballads in the medieval German dialect of Mittelhochdeutsch, containing almost 6,000 verses from the work of 140 poets. Intriguingly, these texts are not arranged

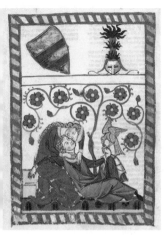

40. Three portraits of courtly love poets from the
fourteenth-century Codex Manesse: on the left Herr Konrad von
Altstetten, in the middle Graf Albrecht von Heigerloch,
and on the right Herr Ulrich von Lichtenstein.

chronologically, or according to a particular poem's popularity. Instead
they follow their authors' social rank, from the writing of kings, dukes
and counts all the way down to minstrels, Jews and mere commoners.
At the top of this pecking order is the Holy Roman Emperor himself,
Heinrich VI (1165–1197), who in his youth wrote a series of romantic
poems that open the book and which marvel for the reader at the sheer
heart-rending power of love. No amount of wealth or political might,
Heinrich claims, can compare to the sensations aroused in him by his
beloved:

> *Ich mich ir verzige,*
> *Ich verzige mich e der crone …*
> *Si hat mich mit ir tugende*
> *gemachet leides vri*
> *Ich kom nie so verre sit ir iugende*
> *Ir enwere min stetes herze ie nahe bi*

Before I give her up
I would give up the crown ...
She has with her force
Let my sorrow free,
I have never since youth been so far
Without my faithful heart near by.

As well as such dramatic stanzas, the spoils of these many German love songs are visualised across the codex's decorated pages in the form of miniature author portraits showing each of its romantic poets in turn. Some, such as the chivalrous Herr Konrad von Altstetten, lounge in their lovers' arms beneath suggestively flowering trees after what we can only presume has been a rather successful poetic recital. Others are shown in the midst of dramatic heroic action. Herr Ulrich von Lichtenstein appears armoured under the crest of Venus, a full-scale figure of the goddess mounted atop his helmet as he rises forth from the froth of the waves above a pair of battling sea monsters. The accompanying poem tells us that, as Herr Ulrich travelled to meet his lady love through northern Italy and Austria towards Bohemia, he battled victoriously no fewer than three hundred times. Knights, kings, even emperors, it seems, found the heart a compelling meta-phor for the twin pillars of courtly love: an enduring, softer sense of romance and a more overtly masculine, aggressive performance of passion.

On the other side of the same coin, as an active symbol of the body's spiritual feelings and emotional states, a heart could also betray its owner by exhibiting moral flaws that might otherwise have escaped notice. A tale from the *vita* of Saint Anthony of Padua – he of the silver tongue and golden jaw reliquary – records his attendance at the burial of a rich man in Tuscany. All of a sudden, in the middle of the funeral cortège no less, Anthony received divine inspiration that the man on his way to the grave was unfit to be buried in sacred ground. Crying out, calling a halt to the procession of the corpse, the saint proclaimed that the man's soul was damned and that the body itself, if searched, would be found to hold no heart within it. We know from the historical

record that Tuscan funerary rituals like this had long been a part of the social pageantry of local rule and order, holding profound significance among the rich. Unsurprisingly, then, Anthony's proclamation caused horror and commotion. When called upon to explain himself, the saint turned to scripture, quoting the Gospel of Luke (12:34): *ubi enim thesaurus vester est ibi et cor vestrum erit*, 'for where your treasure is, there your heart will also be.' Taking Anthony's turn of phrase as literally as Santa Chiara's fellow nuns, the onlookers promptly called a surgeon to open the dead man's chest, and, astoundingly, it was found to be totally empty. Only then did Anthony reveal to the assembled officials that they should pay a visit to the rich man's safe, a chest hidden beneath his bed, where they would find the missing organ nestled comfortably among his piles of gold. Sure enough, it is there that the heart was discovered, and the ungenerous miser was dragged by a cart along a nearby river and buried unceremoniously at its edge, double-crossed by his own body.

Later Italian literature continued to place the heart at the centre of similar gruesome stories of good and evil. The Tuscan author Giovanni Boccaccio (1313–1375), writing in his famous *Decameron* – a collection of stories told by a group of young men and women sitting out a nearby plague in a Florentine countryside villa – included several hearty twists among his tales of trysting lovers. In one story, that of Ghismonda, daughter of the prince of Salerno, the princess tries to resist the well-bred husbands chosen for her by her father. When she enters into an illicit affair with a lover, her father has him killed and his heart sent to his daughter in a goblet. In true melodramatic style Ghismonda cries enough tears to fill the goblet, mixes them with poison and drinks the entire concoction to end her own life. In another of Boccaccio's tales a knight discovers that his wife has been unfaithful to him with another man. He promptly kills the lover in a joust and cuts out his heart, but he does not stop there. Giving the organ to his chef, he orders that it be made into a ragout for his unknowing wife:

Il cuoco gli mandò il manicaretto, il quale egli fece porre davanti alla donna, sé mostrando quella sera svogliato, e lodogliele molto. La

donna, che svogliata non era, ne cominciò a mangiare e parvele buono, per la qual cosa ella il mangiò tutto.

Come il cavaliere ebbe veduto che la donna tutto l'ebbe mangiato, disse: 'Donna, chente v'è paruta questa vivanda?'

La donna rispose: 'Monsignore, in buona fé ella m'è piaciuta molto'.

'Se m'aiti Iddio', disse il cavaliere 'io il vi credo, né me ne maraviglio se morto v'è piaciuto ciò che vivo più che altra cosa vi piacque'.

La donna, udito questo, alquanto stette, poi disse: 'Come? che cosa è questa che voi m'avete fatta mangiare?'

Il cavalier rispose: 'Quello che voi avete mangiato è stato veramente il cuore di messer Guiglielmo Guardastagno, il qual voi come disleal femina tanto amavate. E sappiate di certo che egli è stato desso, per ciò che io con queste mani gliele strappai, poco avanti che io tornassi, del petto!'

The cook set the ragout before him but, feigning that he wished to eat no more that evening, he had it passed to the lady and highly commended it. The Lady took some of it and found it so good that she ate the dish whole.

Seeing she had eaten it all, the knight asked, 'Madam, how did you like the dish?'

The Lady replied, 'In good faith, my lord, a lot.'

'I believe it!', returned the knight. 'It is no wonder you should enjoy dead that which while living you enjoyed more than anything else.'

For a while the lady was silent, then asked, 'What do you mean? What is this you have made me to eat?'

The Knight replied, 'That which you have eaten was truly the heart of Sir Guiglielmo Guardastagno, who you, disloyal woman that you are, loved. And I know for sure: a short while before I came back, I plucked it from his breast with my own hands!'

In the rich literary tricks they played with the heart, medieval authors were harnessing the organ's vital power through metaphors

of love, but also passion, greed and vengeance. Just as beheading was a potent symbol of social control amid the Body Politic, when reaching for a body part to represent both the soaring highs and punishing lows of human existence – at once lovingly kind and viciously cruel – it was difficult to compete with the body's supreme centre, the heart's intense emotional valency assured through both medical thought and popular romance.

Looking at Love

It is within the visual repertoire that accompanies these courtly tales of love, loss and rejection that the first medieval images of the heart began to appear outside of the therapeutic realm. These literary hearts, however, do not look as we might expect.

One of the earliest is found in a French manuscript of the 1250s containing an epic poem with the peculiar name *Le Roman de la Poire*, 'The Romance of the Pear'. As a story, it is relatively simple. The pear is a symbolic and erotically potent fruit given to the author by a lady, his estranged lover. Intoxicated by its taste and full of an unquenchable desire, he searches her out in Paris, conversing en route with human personifications of several emotions and virtues – Beauty, Loyalty, Mercy – before eventually finding his beloved and singing to her his tale. The moment when the two lovers first set eyes on each other is a key juncture in many such courtly narratives, but in the *Roman de la Poire* this look is not portrayed as a literal glance. It features as yet another personification: a kneeling messenger who, much like the active Troubadour eyes of Giraut de Bornelh, scurries between the lovers. He is called Douz Regart, a punning name literally meaning 'sweet looks', and in one illustrated manuscript of the poem an artist has preserved his image within the calligraphic curve of an illuminated capital 'S'. Douz is shown kneeling before the lady offering the author's heart, holding it up to her chest as if it were communing directly with her own, the ultimate symbol of shared affection.

41. Douz Regart, a personification of the lover's gaze, holding a heart in a thirteenth-century French manuscript of the *Roman de la Poire*.

On closer inspection, though, the heart held by Douz looks more like the story's eponymous pear than anything we might today recognise as a shape symbolising love. It is no neatly curved, evenly formed, symmetrical ♥, of the likes we are used to seeing on Valentine's Day cards or bursting forth from the chests of swooning cartoon characters. Partly, this oblong heart was matching medical descriptions such as that of Ibn Sina, who described the organ as *ad pineam*, 'like a pine cone'. But this is also because for most of the Middle Ages the ♥ as a shape held no specific link with the organ of the heart. ♥s are certainly

found on all sorts of medieval objects, but simply as one decorative motif among many alongside vine scrolls, hatched lines, chequerboard patterns or circular spirals.

It is still unclear precisely how this formalised yet abstract shape actually came to stand for the organ and emotions of the heart as it does now. Perhaps it was an association with the leaves of creeping ivy or other plants thought at the time to be aphrodisiacs. Or perhaps the pre-existing ornamental ♥ shape simply grew quite naturally to fit descriptions of a bicameral organ, more pointed at one end than the other. Either way, the use of this symbol seems to have concretised only towards the very end of the medieval period, when it featured in several early European printed images. The new technology of print meant that from the 1450s onwards images could be created far more easily and spread far more quickly across different regions and audiences. This broad circulation seems to have been the thing to seal common agreement that the ♥ symbol represented the heart, especially its amorous properties. From these novel and newly abundant images, especially printed playing cards, the sign began quickly appearing on all manner of later medieval and early renaissance objects. Tokens of romantic affection like decorated boxes opened to reveal secret symbolic affections in the form of inscribed or embossed hearts. Combs gifted to one's beloved might place a heart at their centre, ensuring that a suitor would be squarely in the mind of his lady while at her toilette. And in some cases entire artworks were even crafted to fit the symbol, like a series of cordiform books, a speciality of the Netherlands, which contained within their heart-shaped pages all sorts of accumulated images, poems and courtly songs of love and romantic encounter. Few actual love letters or other literary declarations of affection tend to survive from the Middle Ages beyond the grand narratives of courtly love stories, and these heart-shaped trinkets offer us a rare glimpse into what must have been a busy and intimate network of personal affection.

In all of these cases the image of the heart helpfully gave medieval people a way of animating types of otherwise unexpressed inner feeling, the organ acting as sort of bodily spokesperson. Yet just as a

42. Six circular details from a German medallion tapestry made
in around 1360, showing various scenes of lovers. In the upper centre
a lover gives over a winged heart to the personification of courtly
love, Frau Minne, who stabs it with an arrow. In the lower right two
lovers weigh their imbalanced hearts against each other.

heart of stone might give away its miserly owner, so it was well under-
stood that exchanging affections of the heart in this way also left one
vulnerable. No matter how freely romantic affection was presented by
one party, there had to be a receptive heart to accept it on the other
side. Success in these cordial relationships was often represented by
two hearts on evenly balanced scales, weighed up as if providing defini-
tive proof of lovers' good intentions. But inevitably, in some cases, the
receiver's heart was empty, light and unresponsive. In a small circular
roundel from a German tapestry made in around 1360, a couple weigh
their hearts against each other, but the scales fall lopsided in unrequited
affection. Raising a finger weakly in objection, the man does not look
best pleased. Pointing to her heart, the lighter of the two, his partner
barely seems bothered at all.

Sadness like this could ripple outwards from the heart to be felt by the whole body, physically as well as emotionally. While feelings like anger and desire were thought to be produced by the heart's inherent heat spreading rapidly to the ends of the fingers and toes, other passions such as sorrow or envy were met with a chilling vacuum, leaving the heart hard and heavy. As one fourteenth-century Italian author, Jacopo da Milano, asked himself in frustration: '*O cor plusquam lapideum, o cor non cor, cur non accenderis ex amore*', 'Oh heart, harder than stone, oh heart which is not a heart, why are you not enflamed with love!' In such romantic metaphors, the heart itself could be just as vocal, mourning, lamenting, sighing or even taking on fully blown wounds, ensnared and broken under emotional torture. A print from Germany designed in the 1480s by the master Caspar von Regensburg, shows the figure of Frau Minne, 'Lady Courtly Love', a Venus-like personification of love to whom German artists often turned when wishing to depict the antics of the beloved. Standing defiantly in the centre of the print, stamping, slashing and piercing, Minne is surrounded by no fewer than nineteen hearts – here fully ♥-shaped – which she is in the process of violently abusing. One is burned at a stake, others pincered, hooked, sawn in two, clapped shut in a bear trap, crushed in a press and shot through by arrows, knives and a lance. There is little that Minne's helpless, miniaturised lover can do but look on. Kneeling below her with his hands wide open, he beseeches her pathetically to stop with a hopeful rhyming triplet:

O freulein hübsch und fein.
Erloß Mich auß der pein
und schleus mich in die arm dein.

Oh Fräulein, pretty and fine!
Release me from the pain
And take me in your arms!

The plea falls on deaf ears, and at the bottom of the print in a contemporary fifteenth-century hand, perhaps that of its original late medieval owner, a verdict is delivered. '*Du Narr*', they write: 'You Fool'.

43. The Venus-like Frau Minne, torturing the hearts of
her beloved in nineteen different ways, in a print by Master
Casper von Regensburg, made around 1485.

wol unterweisen ·
a amer rewsen ·

wy morde ich re... · Sy
hat mem herz man fra faß

mr frond und trost · dy
ha uff amem rost ·

Der lieser munt · hat mem
herz ser verwunt

sem · Gloß
der pem und
m die ram dem

Ich wil n siette ero loben · dy
mem herz hat n amem doben

calper

For the Love of God

As well as this seam of secular amorousness running through medieval notions of the heart, another type of love, perhaps even stronger, also emerged in the Middle Ages as a powerful force. This was religious love, an important issue for doctrinarians of all faiths. Jewish thinkers had long seen a love of God as at once a duty and a measure of spiritual mettle. As the Spanish rabbinic authority and philosopher Maimonides (1138–1204) viewed it, it was the main goal of Jewish law to improve the soul through knowledge, and the greater the knowledge, the greater the thirst of the faithful to love God with a burning intensity. Influential for parallel ideas in Christianity were the writings of Saint Augustine, who extended earlier classical conceptions of love and friendship to cover two specific types of Christian love. On the one hand stood *cupiditas*, a worldly love, a self-important love of other people and a deeply human desire to possess things. Linked to the mischievous classical Cupid – as well as to the covetous word 'cupidity' – it indicated a certain frivolousness, a profane and dangerous concern with the material world. Contrasting with this was another concept, *caritas*. This idea – from which evolved the English word 'charity' – connoted an opposite, far more nourishing, type of love, one that good folk should hold for each other and, more importantly, for God.

This theologically sanctioned love became particularly intertwined with the image of the heart. By the twelfth century the French theologian Bernard of Clairvaux (1090–1153) was the first to suggest that prayers might be addressed directly to Christ's heart itself rather than his person more generally. For Bernard, the deep wound made in Christ's side by the lance of Saint Longinus during the crucifixion did more than just pierce his chest: it carried on through the ribs to pierce Christ's very core. It was via such an aperture in Christ's heart that the secrets of his heavenly soul might be revealed to mere mortals. This focus of devotion came to be known as the Cult of the Sacred Heart and saw prayers and religious sentiment thrust with a real spiritual zeal

towards Christ's inner being. By the thirteenth century the German mystic Meister Eckhart (c.1260–1328) was writing prayers that set the faithful in conversation with the heart, and even more mainstream theologians, such as the Italian author Bonaventura (c.1221–1274), wrote that a good Christian could attempt to actually live within Christ's heart, devotionally speaking. As a spiritual tool, a concentration on Christ's core particularly appealed to the focused lives of monks and nuns, many of whom recounted miraculous or visionary experiences that can seem quite shocking to today's sensibilities. Heinrich Seuse, a thirteenth-century Dominican friar and religious author, wrote of creating what he called an everlasting 'badge of love' for God by cutting the letters IHS, a Latin abbreviation for the name of Jesus, directly into his chest above his heart. Another, Saint Catherine of Siena (c.1347–1380), laid claim to a series of miraculous levitations in which she and Christ tore out their hearts and bloodily exchanged them between their bodies.

Other religions at times thought just as literally about the heart's role in loving God. Muslim commentators, such as the eighth-century historian Muhammad ibn Ishaq (c.704–767), occasionally recounted the graphic miraculous tale from the life of the Prophet, when a young Muhammad was received by angels and had his heart removed by them, ritually washed and then replaced in his chest, rendering him theologically purified and open to Qur'anic teaching. But extreme and intimate accounts of this sort were far more common in Christianity, so potent in part because the heart of Christ and the narrative of its piercing found repeated presence in everyday life. In 1424 Sigismund of Luxemburg, then Holy Roman Emperor and ruler over much of central Europe, had his extensive collection of holy relics transferred from the imperial capital of Prague to the city of Nuremberg. Included in this group was the original lance of Saint Longinus with which Christ's side had been punctured. There were in fact several Holy Lances circulating in western Europe at the time. One was claimed to have been taken by the armies of the First Crusade in 1098 from Antioch in modern-day Turkey to Rome, where it was kept in the Vatican beneath St Peter's Basilica. Another, or perhaps the same one,

had supposedly been seen in Paris. A fourth eventually manifested in seventeenth-century Warsaw. However, the relic that was moved to Nuremberg inspired much more widespread devotion in comparison to its rivals. From the moment it set foot in the city pilgrims flocked to visit the Holy Lance at the Church of the Holy Spirit. Local residents wrote songs and poems commemorating its presence in their town, and it was exhibited publicly every year on the Feast of the Holy Lance, the second Friday after Easter, in the market-place across from the spectacular façade of Nuremberg's Church of Our Lady, the Frauenkirche.

Perhaps the most poetic witness to the relic's fame among Nurembergers is a small book of devotional texts gathered together by a historian and physician named Hartmann Schedel (1440–1514). Written in 1465, some forty years after the arrival of the relic in the town, the notebook is particularly interesting for a single sheet stuck into it, a small woodblock print pasted into the binding. It depicts a large heart, rendered in deep red with a thick black line marked through its centre. Above is a short phrase, also printed: *Illud cor transfixum est cum lancea domini nostri Iesu Christi*, 'This heart has been pierced through by the lance of our Lord Jesus Christ'. Early prints like these were known as *Speerbilder*, 'spear-pictures', spiritual tokens purchased as souvenirs in and around Nuremberg. Here the dark slash of the image is not just printed but has been literally enacted, the heart actually pierced through. Like all *Speerbilder*, this was supposedly done not with the printer's knife but by impaling the paper on the actual relic of the Holy Lance itself. These quickly printed and quickly sanctified images could be quickly sold to the visiting faithful in great numbers, imbued with the associated power of the relic's touch. Recreated on the pages of Schedel's book, therefore, is both an image of Christ's heart and a replication of the actions done unto it, a penetrating reenactment of an intensely revered sacred pain.

Personal, intricate objects like this reveal more than anything that the medieval heart was a deeply intelligent organ, a unique way of linking person to person, or person to holiness. Despite little being

known about its actual workings, it was still beating prominently at the centre of a medieval emotional world. And in both writing and imagery alike, it formed a symbol for expressing the very lowest lows and highest highs of religious and romantic life. To return to the case of Santa Chiara, the fervid search through her body for a barely tangible sanctity feels, in fact, like a fair reflection of the heart's physiological and emotional roots. If the heart was open, penetrable, sensual and spiritual, where else should Christ wish to dwell within the medieval body than in the poignant house of her soul?

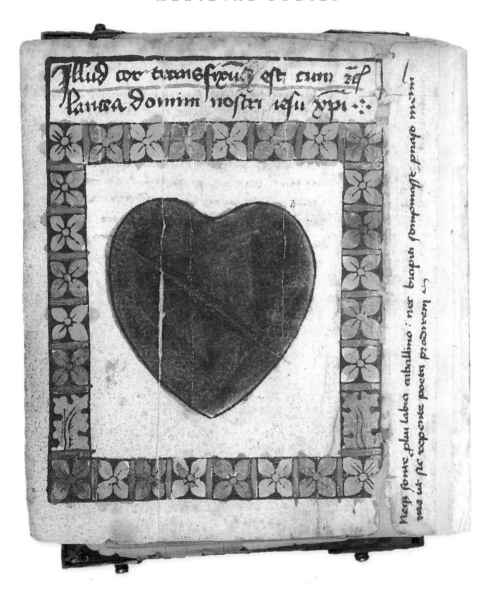

44. Hartmann Schedel's *Speerbilde*, shown from front and back.
It was pasted into his notebook in around 1465.

Deus qui nobis signatis lumine vul
tus tui memoriale tuum ad instan
ciam veronice ymaginem tuam su
dario impressam relinque voluisti
p crucem et passionem tuam tribue ut
ita mente impressam p speculum et in
enigmate venerari adorare ho
norare ipsam valeamus ut te
tuc facie ad faciem venientem iudi sup
nos iudicem secud vivo. amen.

Salue o sudarium nobile vocale
es nostrum solacium et memoriale
Esto nobis quesumus I veru adiuuamen
Dulce refrigerium et solamen.

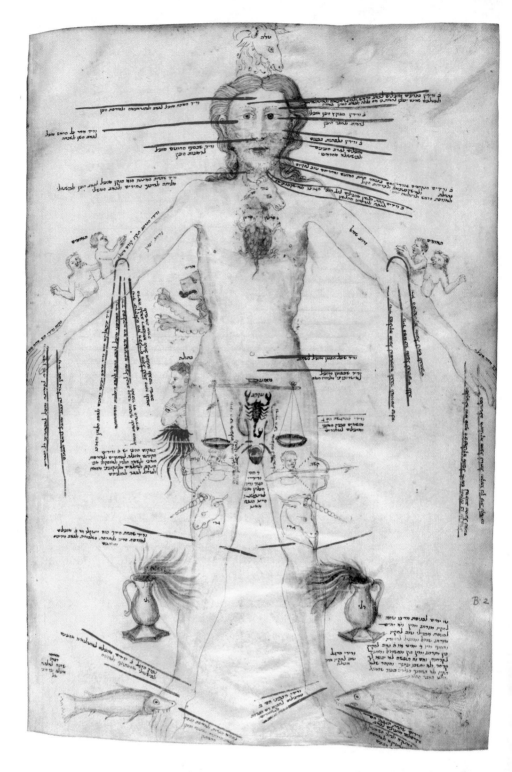

45. A blood-letting figure from a Hebrew medical miscellany, illustrated in southern France or northern Italy in the early fifteenth century.

BLOOD

This large figure fixes the reader in a wide-eyed stare from the pages of a Hebrew manuscript. His body is alarming, a tussled hybrid of man, beast and object. Red lines fire out from his face and limbs, and black dashes of Hebrew text almost seem to shout from the outskirts of his frame. He is more than a mere oddity, though. The book in which he appears was made in southern France or northern Italy in the early 1400s and is packed full of writings by a number of renowned Arabic, Catalan and Italian authors on healing the body. This skewed man-beast was not deigned to be monstrous, like the headless Blemmyae: he was a guide for medical practitioners in therapies of the blood.

Lauded above sweat or urine or *spiritus*, blood was the medieval body's most vital substance. Controlling the ebb and flow of the veins was a key way for healers to maintain the body's overall equilibrium. In particular, its mastery was important to stave off a humoral condition known by the Latin term *plethora*, a state of internal excess that could prompt ill-health. Confusingly, while the blood was a humour in its own right, it was also thought to contain the three other humours running through it. Evacuating the veins by means of small incisions with a short, stumpy, sharp knife could thus release, or at least reroute,

dangerous humoral surpluses of all kinds. Phlebotomy, as this practice of blood-letting was formally known, was a catch-all treatment. Given its quick access to the humours, it was recommended by various types of medical professionals to help with many disparate problems in adults of all ages and dispositions. It could even be administered pre-emptively when no particular condition was present. Purging the warm and wet humour that was the blood both cooled and ventilated the patient's core and was used as prophylactic insurance against illness to come: it could prepare the body for predicted future biological shifts or seasonal changes that might push it into misalignment, anything from forthcoming menstruation to the onset of a particularly hot summer.

Medieval medics had little time for the reality that letting blood would have made no actual headway in curing chronic illness or halting the spread of disease, and in fact probably did significant harm to a patient's overall health. Here, medicine of the Middle Ages again found itself caught in a feedback loop of cause and effect. Neither able nor willing to redesign their ideas about the body from scratch, the deep-rooted classical traditions that doctors were nobly perpetuating had an unshakable hold, even if it meant draining several pints of blood from a perfectly healthy person. On the contrary, the specific techniques of phlebotomy were considered something of an art among practitioners. To cure a particular illness, blood could be taken either directly in the vicinity of a painfully affected area or, alternatively, as far away from this point of root cause as possible, drawing humours instead from a theoretically correspondent part of the body. In both cases location was everything, and it is here that the lines of text like those cascading from the blood-letting figure in the Hebrew manuscript would have helped to guide a medic. Indicating particular phlebotomical points with its coloured bloodlines, the hybrid man's body is mapped topographically with different locations that ought to be bled for differing symptoms and diagnoses. The leftmost line on the figure's left arm, for example, reads:

<div dir="rtl">

וריד בסיליקא מועיל לאסטומכא ולכבד ...

</div>

Basilic vein [found just above the inner elbow], helpful for the stomach and the liver ...

Certain bloodlines held particularly strong correspondences with certain conditions. The veins in the thumb addressed aches and pains in the head, and usefully their slow-dripping rate of evacuation meant that a doctor was unlikely to over-draw the patient. The network of thick purple veins under the tongue relieved dizziness and problems in the throat, as well as sanguineous afflictions of the body more generally. Bleeding the flat vein between the heel and the ankle on each foot could help with diseases of the genitals, so long as it was followed by bleeding the related vein on the opposite upper arm. A seasoned practitioner would have probably had such treatments committed to memory, but images like the Hebraic phlebotomy man could help communicate methods from practitioner to practitioner, as well as between professionals and their customers. Surviving phlebotomy texts offer the blood-letter advice on how to manage a patient's unease over the sharp instruments involved, suggesting that being swift and professional, as well as taking up a jocular disposition, full of smiles and devoid of worry, would allay the rising fears of those in their care. Such colourful and expressive displays of medical information would also have been reassuring to those undergoing treatment if ever consulted or presented in their presence, the complex detail of the page affirming the qualifications of their doctor and perhaps even distracting them from the anxiety-provoking incisions about to be made all over their body.

The timing of such blood treatments was also thought crucial for their success or failure. Given that the human body was thought to hold a central position within the broader universe, the influence of this surrounding cosmology could be profound. Such ideas were annunciated in a concept known as melosthesia, wherein different body parts fell into particular concordance with different lunar and planetary movements. As well as blood-letting locations, the Hebraic figure also depicts this cosmic-corporeal relationship by displaying the twelve signs of the zodiac lurking atop and within the man's body. The ram of Aries (טלה), for instance, sprouts above the figure's head. A pair of Sagittarial archers (קשת) and Capricornish unicorns (גדי) rear from his upper and lower thighs. Two water vessels symbolising Aquarius (דלי) float and splash before his shins. At each arm the twins of Gemini (תאומים)

appear almost as elbow-bound, anthropomorphic growths. For the medical professional, knowledge of such correspondences between the body and the stars formed a foundational diagnostic and curative tenet. In moments when the moon inhabited a particular zodiac sign – as calculated by astrological instruments or calendar tables that often accompanied such images in medical books – planetary control was believed to draw the deliquescent humours to a corresponding bodily region like internal tides. Knowing precisely where these humours were at a particular blood-letting moment was important to avoid hazardous sites where they were pooled in large volumes and could result in patients being dangerously over-drained.

Taken together, the different elements of this illustrated blood-letting figure show how numerous scientific bodily concepts of the blood worked in unison to affect the health of a single person. And they also implicitly demonstrate just how easily these ideas could cross between different cultures in the Middle Ages. The figure in this Hebrew book represents a system of thought followed by Jews but also shared by Christian and Muslim healers, testament to the importance of blood in the multicultural medicine that often passed amicably between peoples and places. But in other aspects of medieval culture matters of the blood came to stand for the very worst forms of social separation and difference, circumstances that could grow from small injustices into fully blown international campaigns of hatred and fear.

Bad Blood

Riding through a section of Thorpe Wood, a small holt directly to the east of the busy medieval city of Norwich, a forester named Henry de Sprowston came across the body of a young boy, bloodied and dead. By this point in March 1144 such sights in the area were rare but not unknown. England was embroiled in a difficult civil conflict that had recently intensified in the vicinity of East Anglia, claiming several victims. Still, the discovery seemed unusual enough for Henry to make enquiries as to the identity of the boy. Three locals named the body as

that of a young man, William, an apprentice leatherworker and the son of a couple living in a nearby village. Henry informed the family and buried the body at the site of its discovery, apparently with little pomp and circumstance.

It is there, in Thorpe Wood, that the boy William's body would have remained undisturbed, had it not been for an intervention decades later by a monk of Norwich's cathedral named Thomas of Monmouth. Although he only arrived in the city several years after Sprowston's discovery, Thomas took a strong interest in the still unsolved murder of the dead William. By the 1160s the monk had written up a detailed account of what he saw as the boy's final movements and claimed to have identified both the culprits and their motivation. His narrative ran thus. Shortly before his death, William had been taken to the house of one of the city's wealthiest Jews under pretence of a kitchen job that failed to materialise. There he was detained against his will for several days before being set upon by a group of local Jewish men who gagged him, twisted knots of rope tight into his face and neck, shaved his head, stabbed him multiple times all over with thorns and crucified his small body on a post where he was left to bleed to death. In Thomas's mind it was specifically the boy's blood that these Jews lusted over: he had for-mulated the first case of what was to become known as 'blood libel', a poisonous accusation of ritual murder that would constantly re-emerge over the next millennium in anti-Semitic rhetoric, and is still found in some quarters even in the twenty-first century.

How exactly Thomas concocted the specifics of this tale is not clear. His writing cites as witnesses several former Jews of the city recently converted to Christianity and members of William's family, as well as his own researches in the house of the accused wealthy Jew, where he apparently gained access and discovered William's very scratches on the floor, somehow still present from the torture of several decades earlier. More than anything, Thomas was drawing on and distilling a growing racist sentiment in the city. Although only a small group, vastly outnumbered by Norwich's Christian population, the relatively recent arrival of Jews in this part of England made them unpopular, as did the large financial debts often owed them by Norwich's mercantile

class and their strong links to Norfolk's ruling Norman aristocrats. Soon after the discovery of the body, young William's uncle Godwin Sturt had publicly accused Norwich's Jews of his nephew's murder, and although a trial never took place, it seems to have been enough to spur Thomas into fictionalising a vindictive tale of remarkable depravity, setting the poor innocent William against the imagined violence of an already demonised minority.

As well as victimising the city's Jews, it was a deliberate intention of Thomas's writing to make a religious martyr of the dead boy, offering Norwich's clergy a new and potentially lucrative saintly cause. As a young Christian killed in vicious anti-Christian circumstances – an intentional mockery of Christ by the Jews, no less – William was painted by Thomas as a holy victim who was surely heavenward-bound. The boy's increasingly sacred story was embellished by the monk with all sorts of dramatic literary flourishes, describing how a fiery heavenly light flashed down from above onto the site of William's burial soon after his body was interred. Thomas also listed five full books' worth of miracles that the young martyr had apparently posthumously performed in the intervening years. Sure enough, such emotive and fantastical propagandising made its mark. William's body was hastily excavated and reburied in one of the cathedral's outbuildings, and as it grew in popularity as a shrine his bones were exhumed yet again, this time to be interred within the cathedral's high altar, from where they were recorded as working even more wonders.

The Life and Miracles of Saint William of Norwich, as Thomas's tale would become known, effectively chronicles the evolution of a nascent medieval anti-Semitic movement from its vivid foundation myth into a full-scale cult dedicated in William's name. Ultimately it was not the spiritual success its author had hoped: several centuries later, interest in William had virtually disappeared. But the repercussions for Europe's Jewish population were as long-lasting as they were tragic. In 1168 the body of a young boy named Harold was found drowned in the River Severn near Gloucester, but marks on his skin were quickly put down to his having been roasted alive on a spit by local Jews. By the 1170s several similar murders had been reported across the channel in France,

including one in 1171 in the town of Blois where no victim was ever discovered or even searched for but which still resulted in some thirty accused Jews – most of the city's community – being burned alive at the stake. In 1181 the death of a young boy named Robert in the Suffolk town of Bury St Edmunds stepped the hatred up yet another gear, prompting riots in the street, the recriminative killing of many of Bury's Jews and, eventually, the community's expulsion from the city. And in the same year similar discoveries of supposedly murdered young men in Paris, all suspiciously bearing the same hallmarks of capture and crucifixion set down in Thomas's now much-disseminated *Life of William*, saw the king of France, Philip Augustus, expel the Jews from all French territories. A century later, in 1290, England followed suit. In a matter of months the several-thousand-strong population were deported in their entirety, scattered across Europe to Spain, Germany, Italy and elsewhere. Staggeringly, this expulsion stood for some four hundred years, with Jews only being formally readmitted to England by Oliver Cromwell in 1656.

These circulating stories and political actions were accompanied by a powerful visual language which sought to make unmistakably explicit the blood libel claims against the Jews. A woodcut from an early printed book made in Germany in 1493 – written by Hartmann Schedel, the very same historian who delicately bound the slashed print of Christ's heart into his notebook – shows the fictionalised death of yet another young boy, a two-year-old named Simon from Trenta in southern Italy, who in 1475 had apparently suffered a similar fate to William. It does not make for easy viewing. Several Jews are depicted with their names floating in blocks of text above their heads, although they are made just as identifiable through the unpleasant caricatures of their Jewish clothes, hats and beards. They gather around the naked body of Simon, forcing long pins into his skin, and one figure labelled 'Moses' attacks Simon's groin with a knife in what seems to be an intentional misreading of Jewish circumcision ritual.

The existence of such an image nearly four hundred years after the events in Norwich underline how pervasive these accusations of

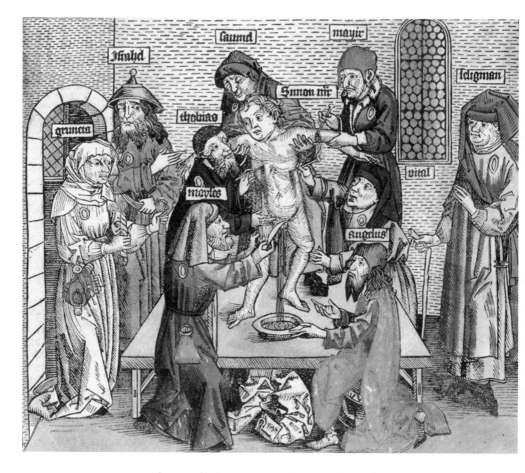

46. A print showing the ritual murder of Simon of Trenta by local Jews, included in Hartmann Schedel's *Weltchronik*, printed in Nuremberg in 1493.

ritual murder had become in Europe. And it also conveys how persistently their focus remained on the blood. The colouring of this version of the print takes particular care to stain Simon's wounds and the slowly filling dish at his feet with streaks of bright red pigment. We read in the accompanying text – which gleefully includes confessional testimonies extracted under torture from the eight Jews involved – that they planned later to use Simon's blood in religious rites that required Christian sacrifice, especially the making of matzah,

the unleavened bread baked during Passover. Further conspiracy theories even circulated that ancient Jewish prophecy foretold of their wondrous return to the Holy Land if enough Christian boy-blood be spilt. The vitality of medieval blood is here dramatically transformed by the growing fear of a diverse Europe, warped from the flowing stuff of life into fuel for racial hatred and division across the continent.

Good Blood

The greatest irony of this type of anti-Semitic persecution was that medieval Christians had themselves centuries earlier inherited from the Jews a sincere and deeply rooted spiritual reverence for Holy Blood. It played a vital role in the medieval Christian liturgy, where during the Mass bread and wine were turned through the theological process of transubstantiation into Christ's body and blood for the consumption of the faithful, a binding form of spiritual union with God. This moment in the service was the Eucharist – from *eucharisteo* (εὐχαριστέω), Greek for 'the giving of thanks' – a daily divine proof enacted through the intervention of priestly blessing. And it was not just a metaphorical act, a mere sympathetic comparison of red liquids. Prestigious international meetings of churchmen, most notably the influential Fourth Ecumenical Council, held in Rome's Lateran Palace in 1215, had made absolutely clear that this doctrine should be taken quite literally as a miraculous action of direct transformation. As the priest uttered the appropriate prayers over the bread and wine a fundamental reconfiguration of holy matter took place, the earthly stuff of grape and grain instantaneously morphing into Christ's actual corporeal essence.

The logic of this practice stemmed from a moment recounted in the New Testament, where, in front of the Apostles, Christ himself worked two elements of the Jewish Seder into twin symbols of his own body. As the Gospel of Mark narrates (14:22–24):

Jesus took bread, and blessed and broke it, and gave it to them, and said, 'Take, eat: this is my body.' And he took the cup, and when he had given thanks, he gave it to them: and they all drank of it. And he said unto them, 'This is my blood of the new testament, which is shed for many.'

This symbolism was co-opted by early Christians as a centrepiece of their religious worship, although the medieval Church clarified that it was only the officiating priest who should actually consume the bread and wine. The assembled laity would have had to make do with watching the whole affair from the pews, only receiving Communion directly maybe once a year at Easter. By the thirteenth century it had become common for the officiating cleric to turn from his prayers at the altar and hold the Eucharistic bread aloft high into the air for all to see at the point of transubstantiation. This swiftly became a climactic liturgical moment for congregations, bringing the distant historical life and death of Christ vividly into the tangible present to create a shared visual experience that tied lay communities together. The direct observation of such Masses were thought to imbue those who witnessed them with all sorts of positive miraculous powers, and by the fourteenth century we find people requesting such liturgical sights for aid in numerous circumstances, from fortune in business to the celebration of baptism to the commemoration of deceased relations.

Although the Eucharist marked the most regular materialisation of Holy Blood, it was not the only form in which the liquid could appear to the faithful. Christ's body was known from scripture to have miraculously ascended to heaven intact on his death, yet medieval theologians were quick to note that there were in theory several moments in his earthly life when he must have shed blood: at his circumcision, for instance, or the crucifixion, when his feet, hands and side were pierced. Pouncing on this holy loophole, a number of blood relics sprung up for veneration over the course of the Middle Ages. One in St Basil's Chapel in Bruges was thought to have been delivered there in the twelfth century from the Holy Land after the Second Crusade, while the cathedral of San Salvador in Oviedo, Spain,

claimed to house a blood-soaked garment taken from Christ's dead body. Another famous example was held in London, where, according to the chronicler Matthew Paris, it had been brought by King Henry III. Matthew recorded that on 13 October 1247 the king himself led a procession of devotion from St Paul's Cathedral to Westminster Abbey, all the while barefoot and with his head raised perpetually to the heavens. He carried with him a luxurious rock crystal vase full of Christ's blood, a relic that he had secured from religious authorities in Jerusalem and had delivered to England through secretive back channels by a group of crusading knights.

As Henry's lavish vessel suggests, no expense was spared on the containers of this Holy Blood. One such reliquary, housed in the abbey of Schwerin in northern Germany, had its blood relic set within a piece of jasper, the rare stone in turn lodged in the side of a small metal sculpture of Christ. Another, at the monastery of Cismar, not far along the North Sea coast, was also enclosed within a sculpted Christ, but this time his chest had a small door for hinging open on feast days to display the Holy Blood within. Such luxurious attention was also given to the chalices that held the transfigured wine of the Eucharist. In the earlier Middle Ages these could be made of elaborately crafted yet relatively inexpensive materials: wood, copper, ceramic, glass and horn. But from around 800, Church restrictions tightened to allow only the choicest metals to touch the transfigured Holy Blood. Nothing less precious than silver was permitted, and we find chalices carved from valuable stones and gilded metals, and encrusted with jewels and Roman cameos. These would have been among the most ornate and costly pieces in the treasury of a medieval church, their extravagant materials designed to match their symbolic and spiritual importance.

Outside of institutional contexts, the sacred presence of the blood of Christ could also be captured in more personal ways. A small book of prayers made in the 1480s or 1490s, probably for an unknown female devotee living in Surrey, south-west of London, prefaces its religious texts with a number of remarkable pages dedicated to Christ's blood, each one painted entirely in shades of red. One of its most vivid double pages is stained from top to bottom in a deep crimson, with darker red

47. The Tassilo Chalice, made in the late eighth century for Liutperga, wife of the Bavarian Duke Tassilo III, perhaps to celebrate the establishment of the Benedictine Abbey at Kremsmünster, where it still resides today.

pigments picking out an alternating pattern of dotted and dripping wounds that traverse across the whole of the opening. At only 12 centimetres long and 9 centimetres wide, turning the pages of this miniature devotional book to reveal a tiny rectangle suffused with blood would have provided a startling concentration of both colour and religious purpose. In giving an impossibly close view of the surface of Christ's wounded skin, it evokes a sense of his violent suffering ad infinitum, as if the wounds might continue outwards from the book's pages in a boundless river of articulated reds. This blood was perhaps also enumerating the sources of Christ's pain for a specific pursuit. Counting his bloody wounds was a popular method among devout Christians for quantifying the degree and quality of Christ's religious torture, with some texts even going to the extremes of estimating the precise number of individuated drops spilt. One Middle English poem on the subject riddles:

The numbre of the droppes of blode
That Ihu Criste shed for manhode:
Fyue hondred thousande for to tell.
And eyght and forty thousande well,
Fyue thousande also grete and small,
Here is the nombre of them all.

The number of the drops of blood
That Jesus Christ shed for mankind:
Five hundred thousand for to tell.
And eight and forty thousand as well,
Five thousand also great and small,
Here is the number of them all.

48. A page from a devotional book made for an unknown Englishwoman soon after
1480, showing a mass of Christ's blood and the individual wounds of his skin.

With totals ranging from 4,000 to over 500,000, the counting of these almost endless wounds of Christ would have given them a deliberately contemplative quality. By ruminating on such a page the reader could move from cut to cut in turn, all the while considering and amplifying the agony of Christ, like a devout accountant hunched over an abacus of blood.

Life Blood

Blood like this reveals something of a contradiction at the heart of medieval religious life. For while many individuals seem to have been quite happy, eager even, to engage theoretically with copious amounts of spiritual blood, when presented with its reality they could quickly turn squeamish. One fourteenth-century Frenchwoman spoke of finding the Eucharist at church particularly unpleasant, admitting that the transubstantiation held little spiritual appeal. The Holy Blood, she said, reminded her of:

> the disgusting afterbirth that women expel in childbirth, and when-
> ever I saw the body of the Lord raised on the altar I kept thinking,
> because of that afterbirth, that the Host was somehow polluted.
> That is why I could no longer believe it was the body of Christ.

Her issue here is not doubt, as such. Although she ends by questioning the ugliness of its results, she appears to have had no problem envision-ing the Eucharist as bringing forth actual, transubstantiated blood. On the contrary, for her the spiritual stumbling block seems to be that this Holy Blood was all too real, too much like the living, flowing stuff of her own body.

The idea that the Eucharist might be excessively vivid for some recalls deep-rooted philosophical links between blood and the very idea of being alive in the first place. As the biological engine oil of all bodies, medical and spiritual alike, blood was the purest marker of someone or something being animated or, just as often, reanimated. Several legal

texts from the late twelfth century refer to a popular belief known as cruentation: the idea that an otherwise completely inanimate corpse, stilled for days, weeks, even years, might begin to bleed afresh when in the presence of its murderer. The concept was founded on the notion that perpetrators of such crimes underwent an indelible exchange of spirits with their prey during the act of killing, the severity of their malicious intentions and mortal sins somehow conducted through the murder weapon and into the body of the victim. Even though it was dead, the corpse of someone grievously wronged in this way could briefly live again to pump blood from its wounds, seeking posthumous vengeance by identifying its enemies in a magical form of proto-forensic proof.

Bleeding could in this way mark all sorts of unexpected sentience. As early as the seventh century Byzantine icons of saints are recorded as bringing forth real blood when injured. One ninth-century Cypriot mosaic of the Virgin and Child was claimed by generations of worshipers to have once bled from the knee when hit by an arrow. Another, this time a painted image from late medieval Constantinople, bled real blood when attacked by an angry priest. And the same bloody signs of spiritual animation could hold true for other religious accoutrements, from statues to fonts to reliquaries, even relics themselves. The canonisation documents of the fourteenth-century French holy woman Jeanne-Marie de Maille speak of a relic of the True Cross in the saint's possession that bled when it was cut in half, the small red spring taken as proof both of Jeanne-Marie's inherent holiness and the authenticity of the relic, which once propped up the bloody body of Christ. Even the most mundane religious objects could be vividly brought to life through miraculous blood. In fourteenth-century Wilsnack, in northern Germany, three small Eucharistic wafers were discovered unharmed among the rubble of a burned-out church that had been destroyed by a knight, Heinrich von Bülow, enraged after a disagreement with a local bishop. The wafers' survival through such a disaster was in itself amazing. They were flat, crumbly forms baked in wax-lined metal presses, hardly stuff capable of surviving a blaze large enough to engulf a building. But these three tiny pieces were also found to have suffered in the process in a distinctly human way: each had shed at its very centre a tiny drop of real blood. Bleeding wafers like this were

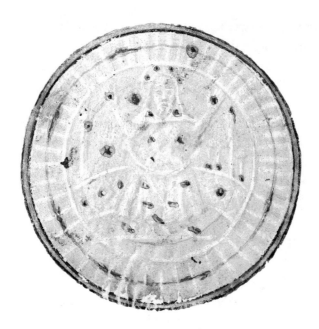

49. The miraculous Bleeding Host of Dijon, painted onto
an empty page in a Book of Hours made around 1475 in Poitiers,
France. The image shows a thin Eucharistic wafer embossed with the
raised image of Christ and speckled with the miraculous blood.

a popular miraculous occurrence, especially in Germany, where watching such events became a major pilgrimage attraction. In each case, the bloody vitality of these totally inanimate objects was taken as concrete proof of Christ's immanent presence within them. In the southern German towns of Walldürn and Weingarten, as well as Orvieto in Italy and Dijon in France, bleeding wafers were enshrined in elaborate metalwork monstrances and closely watched for repeat occurrences of their miracles, which sometimes came with daily regularity.

Examples of this phenomenon in modern times provide a more predictable explanation for the bloody tendencies of these bygone objects. One such blood wafer, observed in Utah in 2015, proved on closer investigation not to be bleeding but blooming microscopic red mould on its surface. In an Athens suburb in 2001 a painted icon of the Virgin and Child also appeared to bleed miraculously, attracting much media

hype, but upon testing its 'blood' was revealed to be nothing more than cherry juice. These modern hoaxes are useful, not because they reveal some sort of scientific truth that we can impose onto the past, but because they remind us that although observant medieval peoples attached great importance to bleeding things, they did not necessarily accept such happenings without scepticism. Faked relics and miracles were exposed often in the Middle Ages – the stuff, for example, of Chaucer's untrustworthy, lank-haired Pardoner – and the Church was careful to evaluate systematically any such claim. Panels of officials undertook close investigations of the sites of miraculous events, interviewing eyewitnesses and testing spiritual proofs before declaring something like a bleeding wafer authentic. And the laity themselves were also highly capable of observing the distinction between blood fact and blood fiction. The fragments of a surviving Anglo-Norman religious play re-enacting the life of Christ known as *La Seinte Resureccion*, 'The Holy Resurrection', noted that the dramatic impact of its narrative could be enhanced in performance through a bleeding prop. Contemporary stage directions written alongside the original text advise that, at the moment in the story when Longinus drives his lance into Christ's side, a large on-stage wooden sculpture of Jesus should be stabbed, inside of which would be hidden an inflated bladder of animal blood that, when pierced, would make the statuette appear to bleed authentically. Such inventive deception would have been impressive to medieval audiences, certainly reminding them of truly inexplicable holy occurrences like the bleeding wafers of Wilsnack. But they knew perfectly well that this was no miracle, just clever stagecraft.

Staunching and Stitching

Emerging from these miraculous events is a discerning and sophisticated spectrum of animating lifeblood spread across various areas of medieval culture. Theologians, clerics, jurists, physicians – these were professionals whose work came alive when blood started to flow. There was, however, one group concerned with stopping this red tide in its

tracks as quickly as possible. Surgeons regularly encountered the day-to-day realities of the bloody body, although from the evidence of medical diagrams such as the Hebrew blood-letting figure at the beginning of this chapter, it might at first seem that there was not much even the best trained of these healers could have done if presented with someone bleeding out. Such a patient would be haemorrhaging their vital humours at the double, and surely were not long for this world. Yet we might contrast this phlebotomical man with a counterpart image also found in manuscripts of the period who seems somewhat more hopeful that something could be done to save bleeding patients in even the most drastic of cases.

This type of picture is known as the *Wundenmann*, the 'Wound Man', a figure who, like his hybrid blood-letting fellow, stares blankly out of the page. Rather than being covered in strange cosmological symbols, however, his body instead bears a multitude of graphic wounds. His skin is covered in bleeding cuts and lesions, stabbed and sliced by knives, spears and swords of varying sizes, many of which remain in the skin, protruding porcupine-like from his body. A dagger pierces his side, and through his strangely transparent chest we see its tip puncture his heart. Even worse, his neck, armpits and groin sport rounded blue-green buboes, swollen glands that suggest he has contracted various types of disease. His shins and feet are clustered with thorn scratches, and he is beset by a rabid dog, snake and scorpion which bite at his ankles, a bee that stings his elbow and even a toad that aggravates the inner cavities of his stomach. Despite this horrendous barrage, though, he is very much alive, for scattered around him are texts that offer the individual cures that his many wounds so desperately cry out for.

The earliest known books to contain the Wound Man appeared in late fourteenth-century Germany, particularly surgical works from Bavaria associated with the renowned Würzburg surgeon Ortolf von Baierland. Blood was particularly important to empirics like Ortolf. His writings affirm the same ideas that underpinned academic phlebotomical practice, with a humoral *plethora* having multiple problematic effects on the body's total health. But, as the image of the Wound Man makes unnervingly clear, bleeding was less a theoretical concern than a matter of practical urgency to a surgeon like Ortolf, who would have regularly been presented with

50. A Wound Man from a Bavarian manuscript made around 1420,
plotting various injuries and their cures across the body.

bodily traumas caused by accident or on the battlefield. Many of these sorts of injuries are bundled together in the painted figure, who effectively functions as a human table of contents for the surgeon. By his side are numbers and phrases that indicate where in the treatise that follows a healer might find a particular helpful procedure. Next to the spider, crawling up his thigh, a piece of text reads, '*Wo eine spynne gesticht*, 20' ('When a spider bites, 20'), directing the reader to paragraph 20 of the book for an appropriate cure. Besides the figure's right hand is '10. *Boss negeli*' ('10. Bad nails'), and inside his left thigh, '38. *Ein phil do der schaft notch ynne stecket*' ('38. An arrow whose shaft is still in place'). Others focus directly on the blood. Written along the large spear piercing the figure's left side and penetrating into his stomach is the legend '*So der gross viscus wund wirt*, 14' ('If the large intestine is injured, 14'). Turning to the corresponding cure 14, we find:

> 14. Item: If the *groʒe darm* ['large intestine'] or the *magen* ['stomach'] or the *gederme* ['entrails'] are injured, you can heal it thus: sew it together with a fine thread and sprinkle *rot puluer* ['red powder'] on it. The same powder is good for all wounds, and the best can be made thus. Take 9 parts of *swartʒ win* ['black wine'] that is the very reddest and 1 lot of hematite, 1 lot each of nutmeg and white frankincense, 3 lots of gum arabic, 1 lot each of *sanguinem draconis* ['dragon's blood', sap from the *Dracaena cinnabari* tree] and *mumie* [ground mummy]. Pound that all together, make a powder out of it, and keep it as needed.

This is a recipe for a styptic, an anti-haemorrhagic powder that could be used by the surgeon to staunch the flow of liquid from particularly bloody wounds and help successfully stitch it closed.

Late medieval surgical techniques like this benefited from centuries of received professional knowledge. Al-Zahrawi, the tenth-century Arabic author whom we have already encountered dispensing dental advice, lists a number of methods for suturing bleeding wounds, from figure-of-eight threads to difficult double-needle stitching. Another author, the seventh-century Byzantine surgeon Paul of Aegina, specifies that

surgical thread should be made of fine wool and that the healer must be careful to understand the body's layers in suturing wounds, knowing the difference between cartilage, muscle and skin when knitting the surface shut. But the contents of the Wound Man's styptic powder also hark back to older, superstitious sympathies often found at the centre of medieval pharmaceutical practice. The look and feel of particular ingredients were sometimes valued as much as their rarity, expense or inherent humoral properties. It is no coincidence here that a treatment which claims to arrest the flow of the blood calls for a powder formed of conspicuously red things: a dark wine that is 'the very reddest', the stone haematite or iron oxide, which was a staple in the production of red dyes and paints, and *sanguinem draconis*, a tree sap so red that it accrued a mysterious Latin name associating it with dragon's blood.

The Wound Man, then, may well be frozen in a state of perpetual bleeding pain, but his battered body was ultimately an imaginative and arresting herald of the different types of powerful knowledge that could be channelled and dispensed through the medieval surgeon. Indeed, even in these most practical of manuscripts the mythic power of Holy Blood also rears its head, mingling with the hands-on advice. The cures written bedside the Wound Man call for all sorts of charms to be recited over the bleeding patient, the sort of prayer that might invoke the Three Kings, the Virgin or Christ himself as mediators of sacred healing. In fact, there seems a further subtle religious echo in the painted figure's pose. Seeing a man standing forlorn, arms outstretched wide to his side, bleeding all over his body, many medieval readers would have immediately recalled similar depictions of Christ's pained and holy suffering. Multiple authors at the time did, after all, describe Jesus as *ipse medicus, ipsa medicina*, 'both the doctor and the cure'. Perhaps the drops of blood falling from the Wound Man's cuts and bruises were intended to blur with those that stained the pages of devotional books or oozed from miraculous wafers. Not unlike the blood libels that so maligned medieval Jews, blood here again deeply intertwines medical and spiritual thinking, distilling religious identity with the more mundane moments of everyday life to form a single potent and sometimes disturbing concoction.

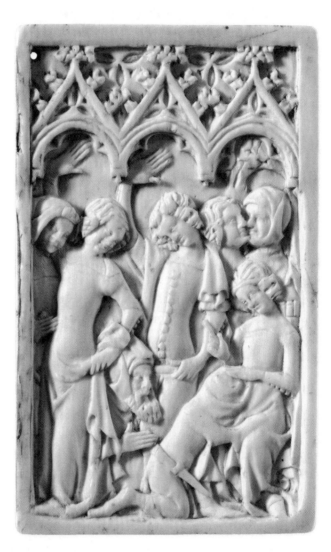

51. A small ivory carving depicting a game of Hot Cockles, probably
one half of a writing tablet, made in fourteenth-century France.

HANDS

I n the basement of the British Museum sits a small ivory plaque from fourteenth-century France. The piece is tiny, only 5 centimetres by 8, small enough to fit neatly into the palm of the hand. It would probably have originally been used as a writing tablet. Paired with another small plaque of identical size, the two halves would have hinged together in the manner of a miniature book, its sculpted surface acting as a cover while recessed spaces in its back were filled with a thin coating of wax. Short notes or calculations could be inscribed into this hardened layer with a sharp stylus by its owner to record their thoughts or figure sums, before the piece was then run over a candle to melt and reset the wax page, clearing it of writing in a single swoop like a medieval Etch-a-Sketch.

The carved image on its decorated front was more permanent. It depicts a gathered collection of men and women tightly framed within three architectural niches. These courtly figures – some standing, one seated, another two on the floor – are playing a game known in the Middle Ages as *Haute Coquille*, 'Hot Cockles', or sometimes *La Main Chaude*, 'The Hot Hand', a jaunty name that masks a rather more sexualised pastime. To play, someone is blindfolded and then spanked. In

the British Museum ivory it is a young man who finds himself kneeling at the centre of the action, his head placed inside the folds of a seated woman's skirt so he cannot see. Despite the small size of the piece his outline is delicately rendered, ghostly beneath the cloth, and we get a sense of the game's erotic potential in the silhouette of his hand, creeping up the woman's left thigh. The act of spanking itself is prefigured in the raised right arms of the two women behind, their exaggerated hands poised to strike him in a pair of flat, slapping swings. The game finished with the blindfolded figure guessing the identity of his or her slapper by the sting of their spank alone. If they were correct, they would be rewarded with a kiss, as shown at the ivory's upper-right, where a victorious couple quietly smooch among the arches.

Hands are conspicuous in this piece. They touch, slap, pat, hitch, point, grope, caress, spank. The more we look, the more of them we see. The woman whose skirt the man is under rests her left hand on his head, her right at the same time pointing with a strangely elongated finger upward to the assembled crowd. The pair of spankers hitch up their skirts with grabbing motions. The bearded figure in the lower left, who presumably is up – or should that be under – next seems to be using his hands to part the crowd, edging his way between the women with flattened palms. Even the woman at the far left of the composition, a figure so peripheral as to not be granted a whole body within the bounds of the plaque, is still given a large flapping hand, tucked centrally inside the ivory's frame. Placed in the palm of the hand, as this writing tablet often was, these details would have resonated: the ivory conveys not just the tactile extremities of the body but the sense of touch itself in action.

Medieval concepts of touch are difficult to get to grips with, full of inherent problems and contradictions. When compared with the more mystical, ethereal sensations of vision and sound, which travelled via diaphanous rays and vibrating air, or even the more tangible senses of taste and smell, touch was found right at the bottom of the sensory pile, the very basest of the five senses in the Middle Ages. Perhaps this was because it is a confusingly simultaneous sense, neither totally active nor totally receptive: in reaching out to touch something, that thing

is inevitably touching you at the same time. What is happening there? Are you touching or being touched? Or both? This haptic inelegance seemed clearly ignoble in comparison to the illusive magic of sweetening song, the soft waft of a heavenly scent or the subtle gradations of vision.

On the other hand, however, the undeniable sensual immediacy that comes with touch meant that at times it could also be presented as one of the more vital of medieval sensations. Like scent, taste, sound and sight, touch was thought to function through the animating *spiritus* flowing through the medieval body, transferring sensory information from the surface of the skin back to the brain for cognition. But unlike these other senses, touch was sturdy, hard-headed and definitive. It could give direct and tangible presence to the world around you. The fact that touch is, of course, impossible at a distance – compared with hearing far-off sounds or seeing images on the horizon – suggested a certain thrilling proximity. It could even be viewed as the most crucial sense of all. Scholars continued to acknowledge the claim made by philosophers like Aristotle that touch was the one sense absolutely necessary for life. That is to say, an organism might exist without its other senses – might be deaf, blind, anosmic or ageusic – but without any sense of touch a being must be thought of as fundamentally lifeless, must be dead. In this way touch was used as a fundamental measure of vitality and was thought of as a diagnostic tenet in its own right in the Middle Ages. Manipulating the patient's body to different degrees could ascertain their levels of pain, while tapping them at particular points was advised while listening for certain echoes or sounds, something still done by doctors today to gauge the health of the chest. Hands were described by medical authorities as the body's workmen, and employing them to test the firmness of a particular body part – its swelling, texture or moisture – was all of interest in understanding the nature of a patient's particular condition. Sickness could be keenly sensed through a doctor's fingers.

Touching Tools

A problem emerged from the importance placed on this curative touch in the medieval medical encounter. What if a medic needed to carry out their work not with their hands but with tools? What if they needed to cut, to suture, to stitch? If touch was prized for its directness in diagnosis, was it not a problem to attend to the patient at such a state of tactile remove?

To combat this, medieval surgeons began to develop a way of thinking about their tools which conceptually merged their instruments with their own bodies. In particular, authors discussed probes, scissors, knives and other tools as direct extensions of their operator's hands. Both Greek and Latin terminology preserve something of this inextricable bond in the very etymology of the word 'surgery', inherited from the Greek, *kheirourgos* (χειρουργός), or Latin, *chirurgia*, both combinations of the terms for 'hand' and 'work'. In early medieval Old English texts direct conflations were made of medical tools with the people who wielded them, the terms for surgeon and surgical instrument often interchangeable with one another. And in later Middle English writings too the language of the medical professional was caught up in everyday bodily terminology. The ring finger was often also dubbed the *leche fingir* – from the Old English for doctor, *læce* – both because it was commonly used to mix and apply medicines and because its veins were thought to lead directly to the heart. Henri de Mondeville, the French surgeon whose writings on skin we have already seen vividly illustrated by the figure of a flayed man, even went so far as to describe the iron joints and blades of his surgical knives as being like a surgeon's very own fingernails and digits. This linguistic idea could also work backwards, with surgeons writing that they themselves needed to be delicately formed in the manner of their exquisite surgical tools. The Italian medic Lanfranc of Milan (c.1245–1306) stressed the importance of a surgeon's well-shaped hands with long small fingers, while his contemporary the Flemish author Jan Yperman (c.1260–1330), spoke of surgeons needing '*vingheren ende lanc sterc van lichame,*

niet bevende', 'fingers extending long from the body and which do not tremble'.

We can begin to see what these surgeons meant when we look more closely at the complicated tools that would have been used in their surgeries. Surviving instruments from the Middle Ages are exceptionally rare, not often preserved among the precious collections of objects passed down to the modern day. Even so, elaborate images in manuscripts do exist and these give at least some sense of medieval surgical instrumentation. Perhaps the most prominent of these is an influential series of treatises by al-Zahrawi, who addressed surgery in the last volume of his thirty-part book the *Kitab at-Tasrif* (كتاب التصريف لمن عجز عن التأليف), known in English as *The Method of Medicine*). It preserves around 200 depictions of surgical tools, elongated forms slotted between passages of explanatory text. Like the illustrated skeleton of the Persian physician Mansur, whose bones are presented

52. Surgical instruments, from a thirteenth-century copy of al-Zahrawi's *Kitab at-Tasrif*.

diagrammatically rather than realistically on the page, these images of tools are not intended to convey precise shapes and dimensions to the reader. Whether in original Arabic manuscripts, Latin translations or even later printed editions, al-Zahrawi's instruments appear for the most part rather thin, wildly coloured and with toothed blades of exaggerated size or strange, feather-like softness. Nevertheless, such luxurious images still make clear just how important these objects were to the surgeons who wrote and arranged these books: careful time and attention have been taken to convey the ornate detailing of their grips and the subtle decoration of their ends, showcasing them as expensive, professionally crafted items.

Presenting instruments like this was also an acknowledgement that the tools of their trade formed an important part of surgery's public face. Possession of the right equipment for the job communicated both competence and expertise, just as today the set-up of a doctor's surgery or their impressive new diagnostic technologies might seek to tell a patient that they are in the hands of a well-trained and successful professional. Good-quality tools were so important to medieval surgeons that we frequently find them mentioned as star objects in their wills. The final testament of one Antony Copage, a surgeon in late medieval London, requested that all his steel instruments be left to his servant George on the condition that 'he be of the same craft'. Listed alongside Copage's valuable books, his finest clothes and even some personal keepsakes left to his wife, his surgical kit was clearly among his most prized possessions. Tools also allowed surgical guilds to regulate the field by sanctioning certain individuals to practise. These communal institutions could grow to substantial size and renown. In late medieval York, for instance, the barber-surgeons' guild was a pre-eminent medical force, responsible for activities as diverse as organising annual religious plays and enfranchising newly trained members. Some amateur workers seem on occasion to have slipped through the cracks: records of St Bartholomew's Hospital in London list a carpenter by the name of Galop being called to 'practyse surgery' on a patient whose limb needed amputating with a saw, obviously not for his anatomical expertise but because he simply had something resembling

the right equipment. Nonetheless, for approved professionals, being allowed by their community to wield their tools conferred both masterful status and social standing. Indeed, the guild's consent could be withdrawn just as momentously as it was granted. If found transgressing the rules – failing to keep up payment of dues or dropping below certain professional standards or moral benchmarks – a member might be forbidden to practise and have their tools confiscated. To strip them of their instruments was to strip them of their very hands to work with.

Surgical instruments from the Middle Ages were even sometimes thought to possess a kind of inherent agency in their own right. For strict followers of Aristotle, for whom the ability to touch marked the difference between the living and the dead, this made little sense: a scalpel or a saw formed of cold, hard metal should have no vitality to it at all. But in the hands of the medieval creative imagination these heavy, inert tools could come alive. The designs of surviving instruments are almost always organic and extremely animated. Patterns gravitate towards foliage, with shimmering petal-shaped gilding and vine-scroll, damascened inlay. Others sport active animal features, hawk-headed handles or frilled elephantine trunks that spiral out from the main body of the design, energising their forms. Human faces and mouths also abound, sprouting from handles and joints. Such orally fixated animation is especially fitting, given that contemporary medical treatises often rhetorically referred to surgery as a biting craft, with writers returning repeatedly to the actions of 'chewing', 'munching' or 'gnawing' in their texts to describe both the spread of diseases and the movement of tools as they worked through the body.

These active designs align too with descriptions of instruments in contemporary literature, a fictional realm where instruments could come to life even more evocatively. In Middle English poetry, a tool like a saw – used by a number of different professionals, butchers or foresters as well as surgeons – could not only look on from its animal ends and gnaw whatever its serrated teeth cut into but could also be made to speak. A fifteenth-century manuscript from Leicestershire preserves a short poem entitled 'The Debate of the

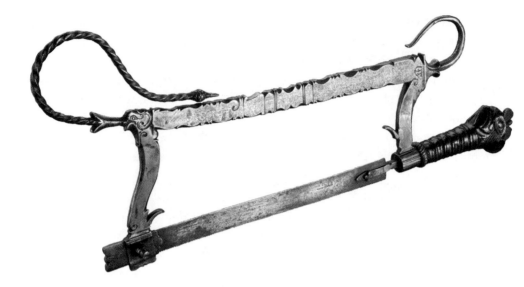

53. An early sixteenth-century surgical saw, probably made in western
Europe, that preserves many earlier medieval features.

Carpenter's Tools', in which a gaggle of animated objects from a
woodworker's bench debate the best way for their master to achieve
prosperity and, more urgently, how their furious work might keep up
with his rapacious habit for drink. After disputations from the axe,
the brace and others, the saw eagerly joins the chorus, reprimanding
the previous speaker, the compass, as an apologist for his inebriated
master:

> *It is bote bost þat þou doyst blow*
> *For thofe þou wyrke bothe dey and nyght*
> *He wyll not the I sey þe ryght*
> *He wones to nyghe þe alewyffe*

> It is but boast that you do blow
> For though you work both day and night,
> I say he will not prosper.
> He lives too near the landlady.

The carpenter's saw, just like the surgeon's saws and knives, stood for hard toil and committed craft, embodying animated loyalty and artisanal common sense. As sentient speaking beings, touching the patient all over, they morphed into eloquent commentators on the surgical world they actively witnessed. One later German surgical saw, now in Vienna, offers a short poetic verse etched onto its bow. Punning on the double meaning of the German word *spruch*, translatable both as a 'saw' and as a 'motto', it reminds readers of the simultaneous fear and hope such tools could inspire:

Spruch:
Grausam sieht mein Gestalt herein,
Mit Angst, Schwäche und großer Pein,
Wann das Werk nun ist vollendt
Mein Schmerzen sich in Freide wendt.

Saw / Motto:
Cruel looks are in my shape here lain,
With fear, weakness and great pain,
But when the work is then all ended,
My hurting into joy is rendered.

Handy Devices

Depictions of hands appear extremely frequently in the margins of all types of medieval manuscripts, medical, fictional and poetical. In fact, they feature more than any other body part. These manicules, as they are now known, consist of slender palms that sprout sets of extremely elongated fingers, one of which will point to a particular section of text. These little hands are the remnants of medieval readers, designed deliberately to draw the eye to an important phrase, the start of an especially consequential chapter or even just a place in the text to which, for reasons now forgotten, a book's owner wished to return at some point in the future. As markers, they are often appended to personalised

notes also made in the margins and might have been added by multiple people at multiple moments in the history of a manuscript, building up a layered sense of a book's pattern of use.

These marginal hands are just one of several tantalising palimpsests of the medieval act of reading, many of which suggest that the experience could have been a quite different one from our own. Letters and other correspondence are recurrently described in the Middle Ages as being read out loud by messengers to whoever was present, rather than being absorbed alone by their addressee. And the debate as to whether most everyday reading happened silently in a person's head or was actually vocalised audibly as they made their way through a book is still a live one. But more than anything, these surviving manicules affirm just how tactile an operation medieval reading could be. With readers trawling across lines of text with their fingers and thumbing back the corners of pages to turn them, some parchment books have become almost blackened through repeated handling, so much so that modern conservators' machines, known as densitometers, can be used to measure the comparative scruffiness of pages and isolate the most dirty – and therefore likely most popular – passages of a particular text, the ones to which a certain owner turned time and time again. Not that readers went unwarned against such tough treatment of these expensive objects. Florentius de Valeranica, a tenth-century Spanish scribe, reminded his readers of the pain and difficulty of writing:

> si uelis scire singulatim nuntio tibi quam grabe est scribturae pondus. oculis caliginem facit. dorsum incurbat. costas et uentrem frangit. renibus dolorem inmittit et omne corpus fastidium nutrit. ideo tu lector lente folias uersa. longe a litteris digitos tene quia sicut grando fecunditatem telluris tollit sic lector inutilis scribturam et librum euertit. nam quam suauis est nauigantibus portum extremum ita et scribtori nobissimus uersus.

If you want to know how great the burden of writing is: it mists the eyes, it curves the back, it breaks the belly and the ribs, it fills the

kidneys with pain, and the body with all kinds of suffering. There-fore, turn the pages slowly, reader, and keep your fingers well away from the pages, for just as a hailstorm ruins crops, so the sloppy reader destroys both the book and the writing. As a port is sweet to the sailor, so the final line is sweet to the writer.

Some readers, however, could not help themselves. Touching while reading was not just a quotidian action, the pages naturally accruing everyday grime: it could also mark moments of emotional pique. The names or accompanying images of wrong-doers or devils are found scraped and scratched at, stabbed and smudged out. Other images have been loved into oblivion, particularly holy figures, who are often rubbed away to a blank nothingness through repeated caresses. To avoid such accidental desecration of holy text, when reading from the Torah, Jews used a *yad* (ד׳, literally 'hand'), a short metallic pointer often tipped with an actual miniature sculpture of a hand to follow the text at a respectful distance.

As well as scuffing and dirtying them, the fingers were also useful tools for memorising information from the pages of manuscripts. The Italian music theorist Guido of Arezzo (c.991–1033) used the hand to outline his innovative techniques for learning song. Codifying a hexacord, or six-part, system of musical notation that had developed through various Greek, Roman and early medieval iterations, Guido assigned each note within this sextupled system a name: *ut, re, mi, fa, sol* and *la*, still alive today in the modern *solfège* method. He then posi-tioned each of these notes at one of nineteen points spread around the joints of the fingers. An Italian diagram of Guido's arrangement, found in a manuscript still held at its original home in the medieval abbey of Montecassino in Italy, shows the notes spread about the hand, moving in a spiral pattern from G at the tip of the thumb, down via the notes A and B to the palm, before then moving through C, D, E and F across the base of the fingers, up the little finger repeating G, A, B, and then spi-ralling across the top of the fingers back into the centre. Such a system could help an individual in the complicated memorisation of particular tunes in relation to their respective scales, and it may also have allowed

54. A Guidonian hand from a musical miscellany made
towards the end of the eleventh century in Italy.

for teachers to sign notes at their pupils across space, correcting their notation by sight as they rehearsed new hymns.

If Guidonian hands helped singers retrieve a past tune or chant from their memory or to notate it in the present, similar hands were also used to intuit future events. Chiromancy, the act of divining things to come from someone's hands, was a prominent magical practice in the ancient world and was adopted in the medieval West through translations of detailed Arabic sources, much the same route as many important medical texts. Unlike works on health, however, which advocated understanding broad humoral dispositions and the spread of diseases across the body, chiromancers drew attention only to the minutiae, tiny differences in the lines and markings on different parts of the palm and fingers. One thirteenth-century English manuscript illustrates a magical hand covered all over with text to help find the primary points of a chiromantic reading. At the palm the three main lines or creases which form something of a triangle at the centre of the hand could be read for indications of life and death, whether the hand's owner would be honourable or cowardly in battle, or if they would die by water or fire. The propensity of small mounds of flesh elsewhere on the joints of the fingers intimated that the person would have multiple children and escape illness with ease. And the length of fingers or the curved appearance of nails could be clues as to a number of other characteristics, from a susceptibility to leg wounds and a budding intelligence to copious income and a murderous temperament.

A whole system of elaborate miniature signs flourished across these hands. The appearance of cross shapes at the base of the fingers spelled unexpected doom. A symbol like a crossed-out letter 'Є' prognosticated that a man would rise to become a bishop, while a doubled 'oo' sign suggested an imminent loss of testicles for the bearer or their younger brother. How seriously medieval people took these supposed divinations was surely, as today, a matter of great variation. Some sources describe the practice simply as a silly game and misleading witchcraft, but the inclusion of palmistry points that evaluated the honour of one's advisers or the faithfulness and virginity of a future wife hint that the readings could carry with them a degree of seriousness, should they

55. A hand inscribed with chiromantic readings, from a
medical miscellany made in England in the 1290s.

be so interpreted. If inclined to look more closely, men and women would see that at the end of their arms they were carrying around tools for reading, singing and even a road map for their entire life to come plotted out on their own bodies.

Signing and Clasping

Although Guidonian singing spirals or chiromancy diagrams are valuable to us because they preserve intricate medieval systems of thought, the existence of such frameworks is bittersweet. For they remind us that there must have been countless social customs of signs and symbols once alive in the Middle Ages, entire sophisticated gestural dialects that have since completely vanished.

Some of these lost affectations are opaquely hinted at through fragments of written description. The influential Northumbrian author Bede (c.673–735), for instance, wrote in the 720s of a sophisticated method of numerating digits on the fingers which allowed different combinations of folding, closing and bending of two hands to sign individual numbers all the way from 0 to 9,999. We can imagine craftsmen or traders gesturing prices in this way across busy markets, or sailors signalling at sea across the deck. And it is not surprising either that Bede, a monk, was aware of such arrangements. Given the strict regulations placed on speech in some monastic settings, systems of gesture were integral to the smooth running of a religious institution like a monastery. Take the tenth-century monks of the Abbey of Cluny, an influential foundation in eastern France from which the hôtel of Alexandre du Sommerard, later the Musée de Cluny, took its name. These men put particular weight on the self-abnegation of religious life, advocating a new and focused form of monasticism which preferenced prayer over much other normal human behaviour. Fasting, celibacy and extremely long periods of sung devotion characterised this French tradition, as did a strictly maintained silence thereafter. Not speaking was designed to avoid sins of the tongue, as well as to channel the monks' prayers more thoroughly in imitation of the angels, who were

thought by the Cluniacs only to sing. This was easier said than done, however. Cooking, writing, tending the land, these were all things that could not stop simply because a foundation's inhabitants refused to engage in the un-angelic act of conversation. Almost as soon as the silent practice took root, a process of signalling sprang up that helped the monks go about the necessities of daily life. How this monastic finger-chatter might have worked in reality is hard to re-piece, but a rare sign lexicon preserved in a handful of contemporary manuscripts describes around 118 symbols for places, people and things that monks would have needed to know. Among others, we learn that:

> For the sign of a dish of vegetables, drag one finger over another finger, like someone cutting vegetables that he is about to cook.
>
> For the sign of a squid, divide all of the fingers from each other and then move them together, because squid are made up of many parts.
>
> For the sign of a needle, strike your fists together, because this signifies metal, and after that pretend that you are holding a piece of thread in one hand and a needle in the other and that you want to send the thread through the eye of a needle.
>
> For the sign of the Holy Virgin, draw your finger along the forehead from eyebrow to eyebrow, because that is the sign for a woman.
>
> For the sign of something good, whatever it is that you say is good, place your thumb on one side of your jaw and your other fingers on the other side and then draw them down gently to the end of the chin.
>
> For the sign of something bad, place your fingers spread out on your face and pretend that it is the claw of a bird grasping and tearing at something.

The more of this kind of distant descriptive evidence we discover, the more we see that gesticulations and hand gestures were a funda-mental aspect of medieval religious life, even for those not part of communities vowed to perpetual silence. Islamic scholars of the period

discuss the clarity that moving the hands could bring to the words of clerics when preaching, and during the observance of the Christian Mass priests were taught to raise their arms high and apart in a gesture that deliberately echoed the arms of Christ, stretched wide at the crucifixion. Folding one's hands closed in front of one's chest was an equally respected and potent movement in many religious settings, designed to accompany thoughts and prayers, and to encourage the faithful to at once rend their souls and embrace God close to their hearts.

Such symbols surface, too, in objects of popular religious culture. Touching a reliquary was a sure-fire way to mark one's presence at a shrine, as well as to physically absorb the spiritual and bodily benefits of a relic's immediate presence. But reliquaries could, in a sense, touch back. Some were formed not just as elaborately decorated boxes but in the shape of fully realised forearms, complete with hands frozen in signs of benediction. This is not necessarily because they contained within them a piece of sacred finger or arm, humerus or ulna. They could hold any holy remnant. Instead, it was their gestural potential that was prized, allowing them to be waved over the congregation as if they were the actual blessing hand of the saint themselves, spreading the holiness contained in the object's core across banks of the assembled faithful. Hand gestures could bind secular communities together in much the same way. In the legal world the raising of both hands or resting them on holy scripture to testify was, as in some courtrooms today, of equal importance to any verbal authentication that could be offered when giving testimony. Marriage contracts also hinged on the 'handfasting' of a couple, their betrothal signified by the clasping of their hands together. So popular was this gesture as a symbol of love that pairs of conjoined hands, just like hearts, became a popular feature of amorous tokens, keepsakes and rings. One extremely well-preserved fourteenth-century brooch was excavated from a field in Cheshire. Made of gold and exquisitely detailed, it is formed of two sleeved arms whose hands meet in a tight clasp at the bottom. The gold on the back of this particular piece has been left undecorated so as to show off its valuable, shiny surface, but other examples sometimes preserve details

56. A golden fourteenth-century brooch in the shape of a heart with a pair of
clasped hands, found in 2011 by a metal detectionist in a field in Cheshire.

of small flowers – perhaps, poignantly, forget-me-nots, a flower that
had considerable significance to medieval lovers – and even inscrip-
tions intended from one lover to another, often in Anglicised French:
pensez de moy, 'think of me'.

Touch also played a role in less amorous ceremonies of fealty. A
person might swear allegiance to their king or caliph by intoning an oath
of obedience, but this was only officially cemented in the conjoining of
hands between the two parties. Gestures of this sort seem to have played
a particularly prominent part in many royal customs, continuing into the
Middle Ages from earlier classical traditions. As God's representatives
on earth, rulers went through elaborate ceremonies that involved both
being touched and touching others. A third-century sculpted relief at
Naqsh-e Rostam (نقش رستم), a necropolis near the ancient city of Perse-
polis in Iran, shows an enormous image of the Sasanian King Ardashir I
grasping a symbolic ring of rule handed to him by the Zoroastrian god,
Ahura Mazda. Later Middle Eastern investitures of the Mamluk sultans
and Abbasid caliphs would see the ruler hold or be girded with a curved,
Bedouin-style sword. European monarchs too were anointed on the
forehead with holy oil by archbishops or other senior clergymen during
their coronations, recalling the biblical model of the much-revered war-
rior-king David by the prophet Samuel in the Old Testament. And by the

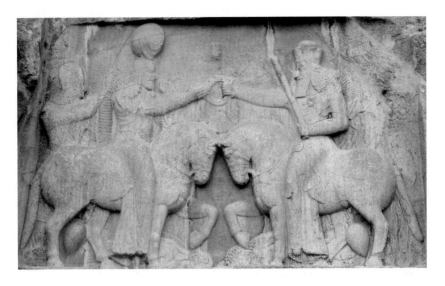

57. A third-century sculpted relief of the Sasanian King Ardashir I
grasping a symbolic ring of kingship, preserved at the ancient
necropolis at Naqsh-e Rostam (نقش رستم), Iran.

later Middle Ages the touch of a monarch themselves, especially imme-
diately after such coronation rites, had reciprocally transformed into a
much-prized thing. So charismatic was this touch that in certain cases
it was even thought to have the ability to heal various illnesses through
royal caress. Scrofula, a form of tuberculosis of the lymph glands causing
large sores and swellings around the neck, was a disease that became so
associated with this type of monarchical healing that it took the Latin
name *morbus regius*, the 'regal disease' or, sometimes, the 'king's evil'.
From the eleventh century onwards its French and English victims were
granted special audiences with their respective monarchs to receive this
miraculous cure. Records are hazy as to how precisely such healing
touches were given: some royals may have employed a lingering stroke
of the face and neck, while others may have made do with a simple pat
on the head. Either way, the hands of the king carried an intense power
to cleanse severe sickness.

Cleaning these royal hands themselves could be even more compli-
cated. A link between hands and health had long held strong currency

in the medieval Muslim world. The Qur'anic dictum that the body should be purified before prayer gave rise to regular ritual ablutions, involving the washing of the hands, feet, face and sometimes the whole body. For some this may have been a trivial point of spiritual etiquette, but for others the washing of the hands could be a site for real creativity. In around 1206 the Arabic scholar and engineer Ismail al-Jazari (1136–1206) completed his *Book of Knowledge of Ingenious Mechanical Devices* (الجامع بين العلم والعمل النافع في صناعة الحيل), the most elaborate in a series of technical manuals stretching back to ninth-century Baghdad, which outlined how to build a range of mechanical automata, functional machines often featuring moving beasts and figures. Some illustrated copies of the *Book of Knowledge* accompany al-Jazari's detailed text with colourful diagrams that bring these creations to life, labelled to correspond with his extensive notes on construction. Alongside an elephant clock, a floating four-piece musical band, an automatically locking castle gate, a model for mechanised blood-letting and many other pieces, one of these manuscripts' folios shows a machine that al-Jazari was commissioned to build by his patron, the Artuqid king Salih. The King, al-Jazari writes, 'disliked a servant or slave girl pouring water onto his hands for him to perform his ritual ablutions'. To help, the inventor created an elaborate contraption in the shape of a large canopy. When the King pulled a lever, the hydraulic power of the water stored in its hidden upper tank made a bird at the top of the device sing. Water then poured steadily into a basin from a jug supported by a hollow mechanical copper servant who also held a mirror and a comb for him to use as he washed. Another bird then drained the finished water away, before, finally, the servant automatically lowered her left hand in a finishing flourish to offer the King a towel to dry himself.

Lavishing such meticulous attention on these sovereign hands made sense. Alongside the officiating priest giving wide-armed blessing to his congregation and the surgeon feeling his way across the body of a patient with his finger-like tools, the king was among only a few medieval individuals whose appendages were invested with the awesome power to transform. Hands in the Middle Ages let the world in. Their touch gave shape to experiences and objects, people

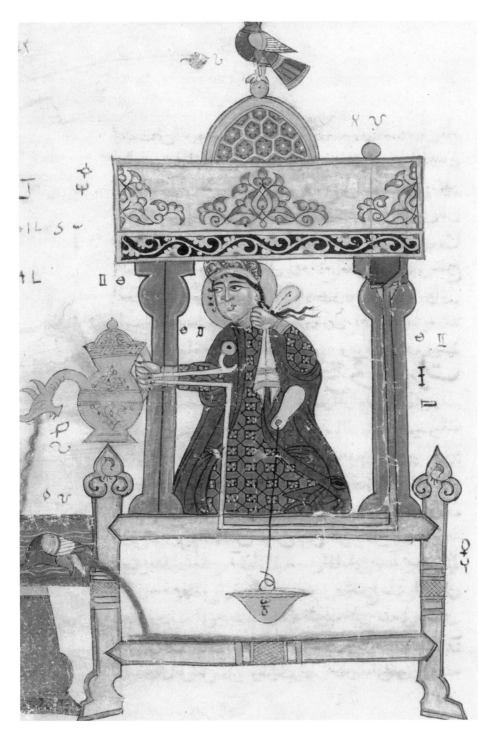

58. A folio from a version of Ismail al-Jazari's *Book of Knowledge of Ingenious Mechanical Devices* copied by the calligrapher Farruq ibn Abd al-Latif in 1315, probably in Syria. It shows a mechanical device for washing the king's hands, complete with a singing bird and automatous servant who hands the user a towel on finishing.

and places, enacting everything from the playful spank in a game of Hot Cockles to the momentous binding grasp of marriage. Writing in the fifth century, Saint Augustine theorised that the hands of men and women functioned in their own right as what he called *verba visibilia*, 'visible words'. Although no medieval hands survive today to speak this gestural language to us, we are lucky that it still lingers in artistic objects and the traces of customs: sealing contracts, scratching devils, teaching music or commanding life and death.

STOMACH

A *tufayli* (طفيلي) was a sponger and a cheeky glutton. Appearing across many stories in medieval Arabic literature, this stock character was a gatecrasher extraordinaire. Using a whole range of cunning comic strategies, he could ingratiate himself uninvited into any feast or party, posing as a guest to fool the doorman, jumping gates from nearby balconies or convincing party-goers to smuggle him in with gentlemanly good humour. One of the *tufayli*'s goals was to extract as much from his host as possible, drinking the wine and helping himself to food. Sometimes discovered and ejected, other times embraced for his ballsy wit and allowed to stay, a *tufayli* never left a party without filling his stomach to the brim.

This sort of comedic, exaggerated gluttony was a recurrent trope in writing across the Mediterranean in the Middle Ages. *The Land of Cokaygne*, a poem probably written in Ireland in the early fourteenth century, tells of a fictional monastery inhabited by sexually deviant monks whose surroundings were so abundant with food that their very buildings were constructed from delicious treats for them to eat:

Þer beþ bowris and halles
Al of pasteiis beþ þe walles,
Of fleis, of fisse and rich met,
Þe likfullist þat man mai et.
Fluren cakes beþ þe schingles alle
Of cherche, cloister, boure and halle.
Þe pinnes beþ fat podinges,
Rich met to princeʒ and kinges.

There are private rooms and large halls
All made of pies and pastries are the walls,
Of rich food, fish and meat,
The most pleasing that a person can eat.
Of flour cakes are the roof tiles all,
On the church, cloister, chamber and hall.
Their wooden beams of fat puddings,
Rich food fit for princes and kings.

Written at around the same time, an Old French *fabliau* – a popular type of bawdy, secular poem – follows the similarly gluttonous tale of *Les Trois Dames de Paris*, 'The Three Women of Paris', Margue Clouue, Maroie Clippe and their friend Dame Tifaigne. One fateful night in 1320, on the feast of the Epiphany, the three women visit a tavern to overindulge. After gorging themselves on food and ale they take their revelry to the streets, where they strip naked and dance, before promptly collapsing in a heap. Mistaken for corpses, the trio are dragged to the nearby cemetery at Les Innocents for burial, only to awake from their drunken comas to demand more food. Framed against the skulls of the charnel houses, we can imagine the terrified surprise of a nearby gravedigger who discovers them, blaming their reanimation surely as the work of '*dyables*', the devil.

Gluttony here is not only depicted as shamefully uncouth but is also aligned with more sinister devilish work. It was, after all, one of the seven cardinal Christian sins, and descriptions like that of *Les Trois Dames* drew on a conflation – common since Genesis – of an uncontrollable passion for food with predatory desire for all things, especially an

insatiable sexual lust. Dante Alighieri, describing hell in the opening book of his epic fourteenth-century poem the *Divina Commedia*, recounts a circle of reckoning reserved specifically for gluttons of all types. It is a reeking, muddy place where the congenitally greedy are punished for their sins for all eternity by being constantly pelleted with polluted rain and hail, each one constantly tossing and turning in a vain attempt to stay dry. There they are watched over by Cerberus – '*il gran vermo*', in Dante's words, 'the great worm' – a fearsome three-headed, mud-eating beast with an enormous belly and unquenchable appetite.

The Latin for glutton, *gula*, was also the anatomical term used to describe the gullet, which along with the stomach and intestines made up the fundamental elements of the medieval digestive system. After swallowing, food was understood to travel down the throat via the actions of *villi*, strips of muscle that banded the oesophagus, from where it reached the *os stomachi*, literally the mouth of the stomach. Thereafter food gathered in the stomach itself, which some authors postulated was round in shape, in order to withstand its own inward stresses and strains.

As a process, digestion was understood to happen through a triumvirate of actions occurring at three different bodily points. The first began in the belly. As food passed through the stomach and gut, it was refined by the body's digestive faculties, removing faecal matter, later to be expelled by excretion, and leaving behind a pale white liquid substance known as chyle. This liquid was in turn passed on to the second stage of digestion, which happened in the liver. There the chyle was heated by the organ's warm confines, a process Galen described as like the baking of bread or the fermentation of wine. Cooking the chyle produced blood and other humours, which, in the third and final stage of digestion, were pumped outwards by the heart to the extremities. Here they were assimilated from the veins into the rest of the body, the broader human form being fuelled by the transformation of swallowed food into a constant outward flow of moisture and heat.

For medical practitioners digestion was at once a natural process of imbibing nutrients from food and an important route for intervention and cure. Given that the humours were themselves produced during

digestion in different quantities and combinations, depending on what had been consumed, ingested medicines were an obvious way to try to balance the inner processes of the sick. This would have been one of the only practical means of treating conditions open to most ordinary people in the Middle Ages, who we presume would have had their own litany of useful humoral concoctions to be taken in accordance with the advice of unrecorded local healers, trained or untrained. Certainly, in the better-documented professional realm many texts written and read by master physicians and surgeons discuss in detail the varied curative properties of different medicinal raw materials to be prescribed for consumption. Books of this nature were normally known as herbals, a catch-all term for treatises listing curative plants that can be traced back to classical precursors. The earliest to survive is a sixth-century manuscript that preserves a text first written around the year 70 by the Greek surgeon Dioscorides on what was to become known as *materia medica*, material medicine. It records the detailed characteristics of several hundred plants alongside hundreds of small illustrations of these individual specimens. It is unclear whether these pictures were original to Dioscorides' first-century work or in fact represented a newer, medieval method of presenting herbal and botanical material. Either way, by the early Middle Ages these books were some of the few to be singled out for particularly exciting decorative treatment, a marker of their serious value among the typically plain medical literature of the day.

One group of texts, bundled together and communally entitled the *Pseudo-Apuleius Complex*, showcases the breadth and seeming eclecticism of subjects that could be included in these broad-minded manuscripts. At the heart of this group was a herbal by the eponymous Roman author Pseudo-Apuleius, which, like Dioscorides' work, lists the nomenclature and medical uses of different plants. But the *Complex* also contained far more disparate yet intriguing material, often including a text on the plant betony (modern-day *stachys officinalis*, or hedge-nettle), another on the mulberry plant (thought especially good for dysentery, toothache and menstrual pain), and a third treatise on the use of the badger in medical treatment (a beast with broad magical

59. The entries for *brassica silvatica* (wild cabbage or wild cole),
basilisca (sweet basil) and *mandragora* (mandrake), from a
twelfth-century English copy of the *Pseudo-Apuleius Complex*,
a wide-ranging work on pharmacy and medicines.

properties and which, dried and pulverised, was considered a potent
cure-all wonder drug).

An early medieval copy of the *Complex* from the twelfth century
shows just how easily these vastly disparate themes could intermingle
when presented on the page. Each section is accompanied by illustra-
tions of herbs, roots and plants, as well as miniatures of mammals,
insects and more fantastical creatures. One page shows in its upper
left an entry for *brassica silvatica*, wild cabbage or perhaps wild cole,
accompanied by an image of the herb. This is a carefully consid-
ered but not photorealistic rendering, one clearly not designed to be
brought out while combing the forest floor in search of particular

specimens. After all, this was a large and extremely expensive book, far too bulky and valuable for carrying around in such a manner. Rather, the image has a deliberately schematic quality to it: the plant's main features are enlarged for taxonomic effect – dark green horizontal leaves, tripartite purple flowers, yellowing roots and a fat, pinkish sprouting tuber beneath – all exaggerated shapes intended to form a visual touchstone for finding the *brassica* among the busy book's myriad herbs.

Real plants, though, also jostle on the page with more folkloric elements. Below the *brassica* writhe three spine-tongued basilisks, mythical serpent-like creatures that nested in the roots of the depicted *basilisca* plant, sweet basil, to which they lent their name. To their right is the deadly *mandragora*, or mandrake, a plant whose chunky, flesh-like twisted roots lent it the fairy-tale reputation of being half-plant and half-person. Upon being unearthed, it was said to scream so loud that the plant could deafen any person who heard its cry: hence two men are here using their dog to harvest it from the ground by a chain, the beasts unaffected by the mandrake's ear-shattering shriek.

These extraordinary additions are a reminder once again that conceptions of medicine and the body in the Middle Ages were always fluctuating between the tangible and the fantastic. On the one hand, they are discussed in their herbal's accompanying text as real, usable ingredients, happily recommended for the healing of numerous diseases. Sweet basil is enumerated as having three different varieties of three different colours, each with different medical properties to help nerve pain and swellings. The mandrake too is treated like any other tuber, its dried bark, roots and leaves making a serviceable headache cure and particularly good sleeping powder. Yet, on the other hand, even in its discussion of these most fundamental raw ingredients, medieval healing seems caught between what we would view as clearly defined science and something far more abstract. It happily conflates thinking from the philosophical and religious realms with input from the artistic imagination, an infinitely more creative and fluid world of health than our own.

Feast and Fast

As well as medical treatises that relayed edible plants and cures, about fifty complete cookbooks survive from the Middle Ages. These take various forms: some present lavish outlines of grand meals, recorded with as much care as these luxurious illustrated herbals, while others offer only more fragmentary recipe lists or basic kitchen records of noble households. In both cases their contents can be pretty cryptic. The *Liber de coquina*, written in Latin in early fourteenth-century Naples, draws on a whole host of regional cuisines for its dishes, listing Italian recipes from Lombardy to Campania to Sicily, and even others marked 'ad usum Anglie' (English) or 'ad usum Francie' (French). Clearly, local culinary fashions had long been formed by this point in the 1300s, yet their recipe details are still rather vague. Take one for *limonia*, a chicken dish with lemons:

> *Ad limoniam faciendam, suffrigantur pulli cum lardo et cepis. Et*
> *amigdale mundate terantur, distemperentur cum brodio carnis et*
> *colentur. Que coquantur cum dictis pullis et speciebus. Et si non haben-*
> *tur amigdale, spissetur brodium cum uitellis ouorum. Et si fuerit*
> *prope horam scutellandi, pone ibi succum limonum uel limiarum uel*
> *citrangulorum.*

> To make *limonia*, fry chickens with fat and onions. And crush washed almonds, moisten with meat broth, and strain. Cook this with the chickens and spices. And if you have no almonds, thicken the broth with egg yolk. When it is almost time to serve, pour on it the juice of lemons or limes or oranges.

A modern cook used to modern cookbooks might run into trouble here. How many chickens? How much fat, and what type? What is 'meat broth'? How long until the chicken is cooked? These medieval recipes, though, rarely list quantities or measures, techniques or timings, suggesting that they were mostly prompts for methods and dishes

already well known among chefs. Whether a trained professional in the pay of a wealthy lord or just the head of a small farmhouse kitchen, a cook wanting to follow these recipes would have had to build on their bare bones, improvising according to the ingredients available. Whether this recipe turned out to be lemon chicken, lime chicken, orange chicken or, for that matter, garlic chicken or onion chicken depended on both what was at hand and, of course, the tastes of those eating.

In some cases, we can still read between the lines to find faint traces of the culinary craft itself. Take a recipe for crêpes found in a French house guide from 1393 titled *Le Ménagier de Paris*, 'The Parisian Household Book':

> *Crespes.*
>
> *Prenez de la fleur et destrempez d'œufs tant moyeux comme aubuns, et y mettez du sel et du vin, et batez longuement ensemble: puis mettez du sain sur le feu en une petite paelle de fer, ou moitié sain ou moitié beurre frais, et faites fremier; et adonc aiez une escuelle percée d'un pertuis gros comme vostre petit doit, et adonc mettez de celle boulie dedans l'escuelle en commençant ou milieu, et laissez filer tout autour de la paelle; puis mettez en un plat, et de la pouldre de succre dessus. Et que la paelle dessusdite de fer ou d'arain tiengne trois choppines, et ait le bort demy doy de hault.*

> Crêpes.
>
> Take flour and mix with eggs, both yolks and whites, and add salt and wine, and beat together for a long time: then put some oil on the fire in a small iron skillet, or half oil and half fresh butter, and make it sizzle; and then have a bowl pierced with a hole about the size of your little finger, and then put some of the batter in the bowl beginning in the middle, and let it run out all around the pan; then put on a plate, and sprinkle powdered sugar on it. And let the iron or brass skillet hold three measures, and the sides be half a finger tall.

Like a French crêpe today, this recipe contains both flour and eggs, while wine – which would have been more diluted than modern

vintages – acts as a sterilised substitute for water or milk. But we also here pick up a sense of the medieval kitchen in action, from the varied warmths of the cooking fire to specialised bowls and skillets, and even a sense of the chef themselves, whose fingers form a basic measure and whose ears and nose are relied on to pick up the precise moment the cooking butter sizzles.

Most of these early books inevitably present the more exclusive of medieval cuisines, recording a pan-European culinary style intended largely for the upper classes. After all, to follow such recipes the user would have needed to be able to read, not often an option for lower-class cooks. And many of these dishes would have required substantial funds and a sizeable kitchen staff to recreate. One English manual, *A Boke of Kokery*, lists the contents of an elaborate feast held to celebrate the ordination of John Stafford as Archbishop of Canterbury in 1443. The dishes are extensive, to say the least. For the first course: venison, beef, capons, pheasant, swan, heron, bream and custards. A second followed: more capons, crane, more venison, rabbit, partridge, curlew, carp and fritters. And then a third: flavoured cream, jelly, broth, melon, plover, marrow cakes, rail bird, quail, dove, more rabbits and even more fritters. To top it all off, each of these gut-busting courses was followed by an intricate sugar sculpture known as a *sotelte*. The first was formed into a large throned Saint Andrew, the second a Trinity with Saints Thomas and Austin, and finally, to finish with a flourish, another Trinity, this time adorned with a semi-decapitated Saint Thomas, John the Baptist and four surrounding angels. For the Archbishop's guests consumption was intended to be as ornate as it was conspicuous.

Food habits of the lower classes are almost entirely omitted from these official narratives and therefore somewhat harder to puzzle out. Imported products such as luxury fruits, expensive spices and sugar would have been beyond the means of most tables, and meals instead revolved around more immediately available ingredients. Grains were a prime staple, used in soups or processed into flours of varying quality. Preserves also provided an inexpensive way of counteracting the rise and fall of seasonal produce, especially in times of famine. Meat and fish could be smoked or salted, and fruit and vegetables could be

pickled, although it is unclear whether recipes like that for a German pickle from the 1350s, found in *Das Buoch von guoter Spise* ('The Book of Good Food') – which suggests preserving beetroot with caraway, anise, vinegar and honey – would have ended up as a thick preserved souse or a smoother, silky style of condiment. Ultimately, standards of living would have varied widely, but even so a peasant might still occasionally be able to feast on the same type of partridge found at Archbishop John's table. Living near a forest would have meant a more regular supply of fresh game for many, likewise with the sea and fresh fish. And by the same token a lord could perfectly well have enjoyed a chunky chutney, should he ever have wished for the lowly stuff to be served at his table.

That said, crossing these culinary class lines was not without a degree of risk, at least in the view of medieval medicine. The quality of food and drink had long been listed as one of the so-called six 'non-naturals', external factors that held sway over standards of human health, and which also included air and atmosphere, motion and rest, sleep, the retention and elimination of the humours via excretion, and movements of the spirit, one's emotional or mental state. From the eleventh century, dietary treatises began to collect and codify information on healthy living according to these principles, in particular the ways that food related to the body's overall humoral balance. Given that different types of people were thought to have different humoral dispositions and temperaments, each man and woman was thought to have a fundamentally different gustative capability and constitution, which were also linked to their position in society. Workers of the land – caricatured by their profession as earthbound, the feet in John of Salisbury's Body Politic – would find diets of humorally cold and wet foods more balancing and appropriate: fish, cabbage, rosewater, leeks and so on. On the other hand, different physiologically distinct individuals needed warming up, such as the aged or the congenitally cowardly, as well as the furnace-like bodies of important royalty, whose constantly stoked heat reflected and maintained their high social rank. These people should instead seek nourishment from humorally warming and dry foods: nutmeg, cinnamon, lemon, venison and red wine, among many others.

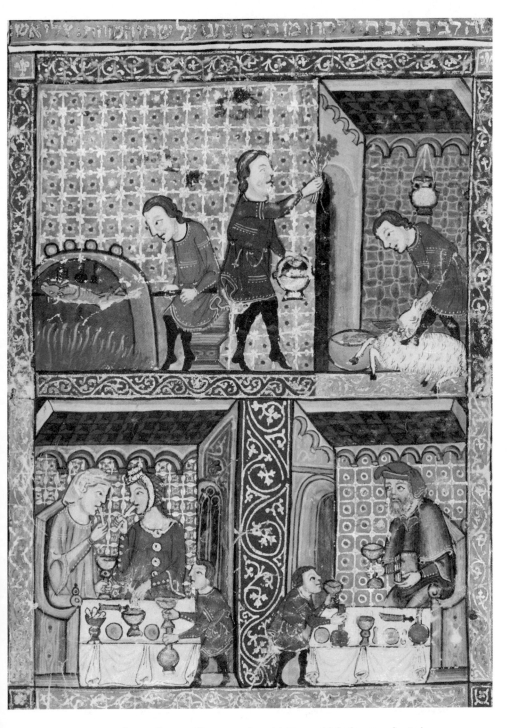

60. A page from a fourteenth-century Spanish Haggaddah showing the Seder meal, the central event in the Jewish celebration of Passover. Above, a lamb is slaughtered and roasted, while the herb hyssop is used to paint the symbolic mark of blood on the lintel of the house. Below, the meal is celebrated.

Equally important, especially spiritually speaking, was what one did not eat. As today, the Jewish laws of kashrut (כשרות) or the Islamic designation of certain foods as halal (حلال) allowed individual religious denominations to cultivate a sense of community through shared diets. And the act of fasting was also interpreted as a way of directly encountering the divine, what the thirteenth-century Spanish Kabbalist and mystic Moshe ben Shem-Tov referred to as the ultimate way 'to know one's Creator'. This was thought especially potent in matters of penance or remembrance and, due to the strict segregation of the genders in most religious roles, it was one of the only routes of spirituality open to women in the strongly patriarchal faiths of the Middle Ages. In Christianity fasting was at the heart of monastic living, with both monks and nuns regularly breaking off from eating to focus their human desire away from matters of earthly contentment and towards spiritual contemplation. These were restrictive social surroundings for women: although female mystics from these communities might gain significant spiritual renown and their abbesses could rise to positions of real political power, nuns still relied on male priests to undertake the Mass, which they could only observe. Food, therefore, was a valuable means through which to take more immediate control of their environment, and in particular, these women found an extreme spiritual reflection in the complete denial of the appetite.

In these cases medical concepts of rounded good health and balanced diet were jettisoned in favour of the obsessive extremes of religious life, something again best exemplified in the dramatic lives and deaths of the saints. Margaret of Hungary (1242–1270), daughter of the Hungarian king Béla IV, fasted so intensely throughout her life that she is recorded as looking desperately thin and pale. Yet, rather than being frowned on, this practised devotion saw her canonised almost immediately after her death. The Frenchwoman Colette of Corbie (1381–1447) similarly fasted from an extremely young age, preferring to fall into ecstatic spells enraptured by thoughts of Christ than to eat a meal, yet her kiss was rumoured to miraculously cure the sick. The foundational and perhaps most extreme story of religious

61. A wall-painting showing the emaciated Saint Mary of Egypt, made to decorate the church of Panagia Phorbiotissa at Asinou in Cyprus in the early 1100s.

starvation was that of the early saint Mary of Egypt (c.344–421). We are told in narratives of Mary's life that she was a prostitute in Alexandria for nearly two decades before a pilgrimage to the Holy Sepulchre in Jerusalem made her see the error of her moral ways and convert to Christianity. Wanting to repent these former sins, Mary crossed the River Jordan to live in the desert as an ascetic hermit dedicating her life only to God. She took with her nothing but three loaves of bread, and her *vita* goes on to tell us she lived this way for forty-seven years, fasting throughout much of this time to the point of total emaciation. Images of Mary were made throughout the Middle Ages, from wooden carvings to painted decorations on the walls of churches, all of which show her with wild long hair. Her tiny frame is often angular and gaunt, her chest, back and cheeks all rendered hollow, with her skin stretched impossibly tight over a visible skeleton beneath, almost a living version of Alice Chaucer's alabaster corpse. Yet for those who might wish to pray to Mary, this was a sign not of mania but of dedication: good Christian thoughts were sustenance enough for this stick-thin figure, who wandered hungry throughout the Levant for half a century.

Entrails

In January 1475 a notary in Paris named Jean de Roye recorded that an archer had been found guilty of larceny. After being detained in the city's prison, the man had been sentenced to hang at a large gibbet erected outside the capital's walls, but on the day of his proposed punishment a petition had been submitted to King Louis XI by a group of physicians and surgeons of the city. These professionals, Jean testified, believed that the body of the condemned was of some greater use. Invoking various common conditions – bladder stones, burning colic and other painful internal maladies – the practitioners suggested it would be of great help for them in their diagnoses to see the very sites where these diseases were formed inside the human body, and that the best way of doing this was to cut open a living man. The petition

was successful, and Jean goes on to record the opening of the man's stomach, the inspection of his insides by the doctors and, amazingly, that afterwards his entrails were happily returned back into his belly before being sewn up again. Given the finest recuperative care, at the king's expense no less, Jean writes that the archer made a full recovery within a fortnight, had his sentence of death pardoned and was compensated handsomely for his troubles.

Much of this account seems bizarre to a modern reader: the royal petition by an interrogative band of physicians and surgeons, the archer's speedy and seemingly untroubled recuperation from a stomach trauma that should surely have killed him and, especially, his gruesome public vivisection. Such violent invasion of the body was certainly not the norm in Jean's Paris. Unlike in the Italy of Mondino, who by 1316 had begun to make examinations of the body beneath the skin, in France religious and social restrictions still tightly controlled anatomies, so much so that it was not until the 1500s that observational dissections were regularly undertaken by Paris's medical faculty. Perhaps, though, turning to historical context to understand Jean's strange story is only half the answer. We know by now that tales of the medieval body often had all sorts of meanings and metaphors at work under the surface. Could the archer opened at the stomach be a way of expressing something else, a broader French fascination with the body's interior?

Today, technology has afforded us a real familiarity with our deepest innards in ways that pre-modern peoples would never have thought achievable. For most medieval men and women the sight of one's own entrails was the clearest possible sign that something had gone very wrong indeed and that death was imminent. Such fears, however, did not stop them from imagining what the interior of the body looked like. This certainly seems to be what is happening in a page from a fourteenth-century philosophical manuscript also from Paris. Pretty typically for a relatively large and luxurious edition of a popular text – a commentary on Aristotle's classic zoological treatise *De animalibus* ('On Animals') – the parchment is thoroughly embellished with pen flourishes, illuminated initials and even occasional

marginal scenes, framed with floral motifs and inhabited by the text's
eponymous creatures feeding, fighting and rutting. But on one folio,
beneath the introduction to a chapter on the internal parts of living
creatures, sits an enlarged gathering of internal organs arranged as if
within a living human form. We are able to follow the long trachea
downwards towards the lungs and intestines, atop of which sit the liver,
heart, stomach, bladder and kidneys, while at the base of the entire
system a tubular colon and anus morph seamlessly into twin branches
of floral decoration. There is a real sense of revelation here, in which,
like Jean's archer, the skin has disappeared, allowing us to look directly
at what lies beneath. The body is even flanked by a crowd of six physi-
cians, deliberately identifiable by their doctoral gowns and bonnets, all
staring up at the gigantic innards with frantic and awed gesticulations.
The scene seems to show what the poet Francesco Petrarca — that god-
father of the term 'medieval' — once described as physicians' 'obsessive
seeing', always straining 'to see that which lies within, the viscera and
tissues'.

62. A group of physicians examining a large accumulation of guts, from an illustration in a commentary on Aristotle's zoological treatise *De animalibus* made in Paris in the late fourteenth century.

Contemporary events just outside Paris show just how obsessive this interest in innards could become. Take the medieval abbey of Maubuisson, just a few hours' ride north of the capital. By the thirteenth century the area had come some way from the bandit hideaway which had earned it a name derived from *buisson maudit*, literally 'bad bush'. The Queen of France, Blanche of Castile (1188–1252), and her son King Louis IX (1214–1270) had built a substantial royal complex here, complete with outbuildings, nuns' quarters and a large church to serve as a necropolis for their Capetian dynasty. Yet unlike the English tombs at Westminster or the caliphs' memorials in Cairo, this was not a space for the burial of French royal bodies in their entirety. Well aware that prayer at the site of the corpse could act as a conduit to end purgatorial suffering, the Capetians alighted on the idea of splitting their bodies in two in order to double their spiritual potential. Alphonse of Poitiers, King Louis's brother, died in 1271 en route to France while returning from the Crusades, but had strictly stipulated that in such an event his entrails should be separated from his body and sent to Maubuisson for individual burial. Robert II of

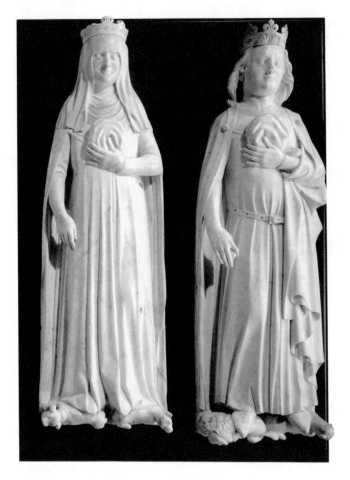

63. Effigies of Charles IV and Jeanne d'Évreux
holding bags filled with their entrails, sculpted in marble by
Jean de Liège around 1370 for Maubuisson Abbey.

Artois, another prominent royal nobleman, followed suit, asking for his
innards to be removed and interred in the foundation's church, placed
there on his death in 1302. Nearly thirty years later, Blanche's great-great-
grandson, and by then king of France, Charles IV (1294–1328), earned
specific permission from the pope to have his body split into easily vener-
ated pieces, his entrails sent to Maubuisson for burial. And fifty years after
that, Charles's wife and long-time widow, Jeanne d'Évreux, requested

identical treatment to that of her husband on her death in 1371, as did one of Charles's successors as king, Charles V, in 1380. Over the course of a century Maubuisson had become a dynastic memorial built on coils and coils of intestine.

The interred entrails of these French royals were given a leading role in their tombs at the abbey. Shortly before her death Jeanne d'Évreux commissioned the famed Flemish sculptor Jean de Liège to create a double tomb for the entrails of herself and her husband, King Charles, the upper sections of which still survive intact. They show two small marble effigies of the couple, around half life-size, both crowned and dressed in delicately sculpted royal robes. They would look perfectly normal were it not for the small leather bags they each clutch to their chest, the soft curves of the pouches betraying neat shapes of intestine spiralled within. Carved in unsettling detail, they appear winding and twisted as if alive inside a sculpted stomach, curled up like links of miniature sausages. Charles V seems to have liked them so much that he commissioned Jean de Liège to make him an entrail tomb as well, yet another bundle of French guts set in stone at Maubuisson.

These burials were particularly cherished by the foundation's nuns, who saw the remains as a marker of their abbey's continuing importance to the crown. They prayed beside them in their church, wishing for the safe purgatorial repose of their queens, princes and kings beyond the grave. And, as time went by, the royal stomachs occasionally offered back heavenly responses of their own. Abbey records from May 1652 show major renovations to Maubuisson's church, during which a wall was breached by builders to reveal unexpectedly an unmarked, lead-lined box. Upon opening, it was found to contain Robert II of Artois's 300-year-old viscera. Witnesses described the innards as totally undecayed, 'fresh, vermilion and full-bloodied', despite not appearing to have been specially preserved or embalmed. To mark the occasion they were displayed fully exposed for ten weeks, all the while never dulling in colour and exuding a soft, sweet perfume throughout the church, miraculous entrails gutted from the abbey's very walls.

Anal Arts

Maubuisson's venerated intestines were an exception. Far from sweet smells and holy remembrance, when arriving at the stomach on their head-to-toe narratives of the medieval body, medical authors knew they were in fact poised to encounter some of the body's basest and most unpleasant parts. Far from the primacy of the head and the second important group of organs clustered around the heart in the chest, the belly and the gut were ranked an unpleasant third. This lowly stomach was made even more off-putting by its occasional unfortunate byproducts, a whole host of spontaneous rumblings and grumblings, hiccups and belches. For all its links to pharmacy, diet and spiritual nourishment, the process of digestion had a tendency, when malfunctioning, to reverse itself awkwardly. Vomiting, when not being induced by a doctor with purgatives to balance the humours, was to be taken as a sign of serious abdominal issues and could even be a physical manifestation of intellectual or moral repulsion. Take Egill, the tenth-century heroic protagonist of one of the oldest medieval Scandinavian sagas, who in a scene of his story is presented as truly disgusted by the poor hospitality of a man he meets on his travels, Ármóðr; so much so in fact that, instead of speaking words of thanks to his host, Egill takes him by the shoulders and throws up violently in his face:

> sér spýju mikla, ok gaus í andlit Ármóði, í augun ok nasarnar ok í munninn; rann svá ofan um bringuna, en Ármóði varð við andhlaup

> a huge vomit that gushed over Ármóðr's face, and inside his eyes and nostrils, and into his mouth; it poured down over his breast so that Ármóðr approached suffocation.

Controlling these gut instincts was not always so easy, and perhaps this is why some of the more vilified figures in the medieval canon had something of the belly about them. Eve, harbinger of original sin, tempted Adam into an act of eating that was to cast all of mankind

into perpetual repentance. The wolf Ysengrimus, always outwitted in medieval French poems by his nemesis, the cunning fox Renard, is driven in his villainous actions by his rapacious appetite and raging belly, not unlike the character of the cheeky Arabic *tufayli*. And, more seriously, in penance for the ultimate betrayal of Christ, Judas Iscariot not only hanged himself in shame – suicide itself a serious sin by Christian law – but, according to one biblical account, upon falling, his hanged body burst open at the stomach, his guts gushing out all over a field.

Even worse than this hazardous third zone was where the stomach was known to lead: the fourth and very lowest of the bodily quartet, comprising the genitals and the anus. Stereotypes of the medieval return time and time again to the period as a scatalogical moment, where people both lived in filth and relied on it as their one and only source of comedy. Perhaps this is because historical humour of the bottom resonates much more easily through time than the Middle Ages' more complex satires, political caricatures and local lampoons, all of which relied on the subtleties of contemporary context, much of which is now inevitably lost. But to presume that all medieval humour therefore revolved around the bottom, or indeed that this humour could not in itself be sophisticated, again does the era a disservice. This Anglo-Saxon riddle, for instance, seems on the surface really to revel in the anus:

Question: How do you make an asshole see?
Answer: By adding an o.

Look closer though, and we realise this is not just a smutty joke about the sphincter, it is a pun. Add an 'o' to the Latin for 'asshole', *culus*, and you get *oculus*, the Latin for 'eye'. Language, as well as the bottom, is the joke's foundation.

The same was true of medieval performance, in which the bottom also sometimes reared its cheeks. The court of Henry II boasted one Roland the Farter, paid handsomely for amusing the royals with a dance that included a simultaneous jump, whistle and fart. Abbasid caliphs,

too, kept such flatulists alongside singers and fighting dogs in their entourage. But keeping jesters in their pay to parp on command did not exclude aristocratic patrons from also appreciating more complex bottom-bound satire. One French play, the *Farce Nouvelle et Fort Joyeuse du Pect*, commonly translated as 'The Farce of the Fart', was performed in 1476 for the extremely wealthy Count René of Anjou. It stars a woman named Jehannette who is particularly prone to farting around her house, and in the play's opening scene she lets forth so violently while doing the laundry – the fart picked out in loud sound effects from off-stage – that her aggrieved husband, Hubert, takes her to court. The device of putting a farter on trial, however, not only mocks the anus: it allows for a cutting pastiche of the courtroom, which duly chooses to take this whole affair extremely seriously. Mixing gross-out delight with legal satire, the leeching lawyer who persuades the couple to sue each other and the pompous judge who ultimately rules that Hubert simply has to put up with his gassy wife are both just as much the butt of the joke as Jehannette.

An object of simultaneous disgust and amusement, the anus could also be a lucrative arena for healers. This was the case for one surgeon in particular, the fourteenth-century Englishman John Arderne, who by the 1340s had built up an excellent reputation and successful practice in Wiltshire and Nottinghamshire. Arderne stands out from many English medical men of the era through both his high rate of successful cases and a series of popular surgical treatises that survive written under his name. Unlike his contemporaries, who tended to concern themselves with more generalised compendia of diseases and pharmaceuticals, Arderne achieved substantial renown through his publication of a single innovative surgical procedure: the treatment of anal fistulae.

Fistulae are abnormal tubular erosions of the flesh caused by unhealed abscesses, which form unhealthy connections between organs or simply holes that burrow themselves deeper and deeper into the body from the surface of the skin. They appear frequently in medieval texts, mentioned as often as kidney stones and haemorrhoids, and they were a common complaint among the horse-riding knights and nobles of the period, for whom perianal abscesses could

64. Four images of an operation to close an anal fistula, from
a copy of John Arderne's *Practice of Anal Fistula*, written and
illustrated in England in the early fifteenth century. We see in turn
the surgeon probing, threading and closing the fistula.

easily appear during long days riding in a wet saddle. Fistulae presenting this way were notoriously difficult to treat, often with tragic results: before Arderne it is estimated that more than half of the patients who sought such treatment died during the aggressive surgical procedures designed to cure them, which often prescribed etching away at the problem with acidic substances and had a relatively poor level of aftercare. His new treatment was a serious departure for the condition, recommending that the fistula instead be carefully cut into before being repeatedly cleaned and dressed. Comparatively efficacious and highly sought-after, the technical elements of this surgery remain in their essence the same today. Arderne's writings boast both raised survival rates and famous patients, who doubtless lined his pockets in the process.

Not only was Arderne an innovator in the surgical treatment of the condition, but he also pioneered new ways of presenting his anal advances on the page. These are the very first medieval books actually to illustrate the individual stages of a surgical operation, unfolding for the reader alongside the text of the treatment's detail. It was a novel illustrative scheme: across four small figures we are taken through the narrative of the surgical action step by step, each freeze-frame showing the disembodied hand of the healer working through a different major moment in the process for which Arderne was famed, probing, cutting and then closing the fistula. Like the entirety of the medieval digestive system, these anuses seem to hold something of a contradiction within them. On the one hand, they are deeply serious and rather disgusting things, naked, scatalogical, uncontrollable, the subjects of dangerous, embarrassing, probing operations. But on the other, for all the earnestness of the operation on display they still have something of the carnivalesque about them. Their manipulated lower halves create a real visual spectacle, whirly-gigging in cartwheels as they flip and spin across the page, all the while dressed in the long stockings and expensive shoes of Arderne's high-class patients. However mucky the route from throat and stomach down to intestines and backside may have seemed, it was still praised as the site of carefully balanced class-based diets, sacred self-abnegation, venerable entrails and transformative moments

of surgical intervention like this one. This is the medieval body at its most topsy-turvy, pivoting between extremes. It is as if, in the words of the poet John Lydgate when once describing his own stomach, we are being presented with a world refreshingly '*tournyd vp-so-doun*'.

65. A German Shrine Madonna, sculpted
around 1300 in the Rhine region.

GENITALS

On the surface this sculpture of the Virgin and Child seems no more remarkable than any other small-scale object to survive from the Middle Ages. Mary's pose is tranquil and iconic, staring impassively into the distance with her painted grey-blue eyes as she feeds the infant Christ. If anything, it is a rather static portrayal of a deeply symbolic maternal embrace. The small child feels almost like an afterthought, welded to her left arm beside a rather awkwardly positioned breast. The piece is also not in the best condition. Despite the odd moment of subtle shading that still lingers around Mary's rosy red cheeks, the sculpture's paint and gold have in many places fallen away. Once vivid details like the crown on the Virgin's head or her outstretched right hand have been snapped off, reduced to brownish stumps, exposing the grain of the untreated wood beneath.

There is, though, something more interesting afoot. A thick line ruptures the scene, a black gap running from the bottom of Mary's neck straight down her chest, right to the bottom of her skirt. Unusually, a series of small hinges subtly concealed within the side panels of her throne allow the sculpture's front to be thrown open in two, revealing a more opulent world within. Like a medieval matryoshka doll,

the Virgin's previous picture of still calm in fact contains a complex visual scheme. Her body is the busy stage for multiple animated figures, including a central carving of God the Father and painted scenes from the lives of both Christ and Mary on its newly formed wings. With the flip of a hand the sculpture's skeleton bisects to expose a set of unexpected holy interiors.

This type of opening figurine from the Middle Ages is known as a Shrine Madonna. Few of these novel sculptures survive today, but we can tell from the visual splendour and elaborate detailing of those which do that they were important objects for the communities who commissioned them. First and foremost, they were tools for individual and communal prayer, acting as anthropomorphic altarpieces around which people could gather. Accounts of one religious foundation in northern France record an even larger, life-size Shrine Madonna, sadly now lost, which was placed on the high altar of its church to form the primary focus of daily devotions. A nun from this same community, one Sister Candide, noted in her diary that the sculpture would be opened up during times of crisis, especially in moments of drought, when the revelation of the Madonna's internal panoply of scenes was thought to amplify the pleas of the faithful and bring rain to feed their crops. Such an opening was a truly wondrous event for people like Candide. As she wrote:

> Quand'elle estoit ainsi ouverte, ce n'estoit une Vierge, mais un monde et plus qu'un monde ... petits mondes enfermez dans le corps de cette monstrueuse figure.

> When she was open she was not a Virgin but a world and more than a world ... little worlds enclosed inside the body of this monstrous figure.

This image of Mary as a series of self-contained worlds was a common refrain of theologians. In extolling the virtues of the Virgin Birth they often turned to elaborate metaphors of enclosure when describing the holy womb. It was a saintly oven in which Christ had been incubated,

66. German Shrine Madonna (open view).

a treasured ark protecting precious cargo or a doorway through which Christ entered the world. By hinging apart the wings of the Shrine Madonna, its communities were daily re-enacting a fundamental moment of Christian salvation, opening the Virgin's heavenly body to see Christ, their saviour, growing inside at the miraculous behest of God.

Mary was, of course, unique in conceiving through such complex heavenly means. Yet even ordinary medieval pregnancies were still thought to follow a highly complicated anatomical process. Competing

and sometimes clashing notions of birth were put forward by different medical authorities, but they all agreed that the womb formed a central part of a larger sexual system working within a woman's body. This included the cervix, vagina, ovaries and clitoris, although the last of these was an organ seldom mentioned in medieval accounts. Following classical thinkers, the male and female sex organs were presented as something of a mirror to one another, each inverted versions of similar genitals that on the surface suggested a certain similarity between the sexes, at least in terminology: the ovaries were discussed as a pair of female testicles and their emissions were seen as equally vital to conception as the male sperm. But for virtually all medical authorities, inevitably themselves men, this mirroring also served to emphasise the difference between the conspicuously external nature of the penis and testes and what they saw as the vacant interiority of the vagina and uterus, masculine presence contrasted with feminine absence. Of the two types, it was still the female body that received by some distance the greater attention in such theorising, made so intriguing to this male audience through its ability to menstruate and bear children. Even so, their writings all still espoused distinctly male-oriented notions of reproduction, where women served as a receptacle for an all-singing-all-dancing masculine seed.

The specifics of this union were relatively well plotted out. The ancients had conceived that male ejaculate was the product of the brain via the spinal column, but by medieval times most theorists recognised this to be the role of the testicles, their winding veins thought to form spermatic substance from the concoction or cooking of blood. During sex this male sperm made its way via the vagina to the womb, where it combined with female sperm that had been released from the ovaries and drawn to the uterus through two thin cords. The two sperms together formed a mass, which through the womb's actions of heat and compression slowly solidified into the beginnings of an embryo. Some leftover transmuted essence conjoined to the uterus to become the placenta, a network of veins and arteries whose ligaments suspended the foetus and nourished it with vital spirits drawn from the mother. This child first developed a liver to create its own blood flow and was then imbued with a soul, specified by medieval churchmen as happening

after forty days for a male and eighty days for a female. Once the baby was born, growth continued through the nourishment of its mother's milk, a substance thought to be concocted in the breast from the same maternal blood that had once fed the foetus *in utero*.

Contemporary medical authors were quick to explain the entire process of conception in terms of metaphor, although they were rather less imaginative than theologians describing the Virgin Birth. The thirteenth-century Italian author Giles of Rome chose a rather unceremonious workaday comparison, writing that the sperm might be seen as a carpenter acting on the wood of menstrual blood to create a foetus. In his *Canon of Medicine* Ibn Sina wrote even less romantically that generation might be compared to the manufacture of cheese, with the clotting agent of the male sperm acting on the milk of the female sperm to coagulate together into a child. More eloquent, perhaps, is the interior of the sculpted Shrine Madonna, which also conveys something of the contemporary understanding of female anatomy. Its internal system is split into seven sections which appear to echo the common medieval description of the uterus as divided internally into seven cells, each of which could nurture a child. A foetus generated in three of these cells would birth a boy, three more would birth a girl, and a single final cell would birth a hermaphroditic child. Subtly mirroring a real body within its sculpted wooden forms, this Shrine Madonna co-opted the detail of contemporary gynaecological medicine to signal just how exceptional the birth of Christ had been: Mary had supposedly circumvented this entire complex sexual system with nothing more than the miraculous words of an angel.

Secrets of Women

Written into these medieval concepts of sexual medicine was an unapologetic imbalance between the genders that was to have dramatic impact on both the nature and quality of women's lives throughout the Middle Ages and beyond. On a fundamental level, the female body was believed to be biologically subordinate to the male. This was in part

due to a basic humoral distinction between the sexes. It was men who formed the true ideal for mankind, especially in terms of the much-vaunted bodily heat at the heart of anatomical understanding. Men's bodies were thought to produce this vital nourishing warmth with ease and in abundance, meaning that they grew larger and produced more hair, as well as having no trouble dispersing any humoral excesses naturally built up within the hot body through the production of sperm or sweat. Women, on the other hand, inhabited bodies that were far colder, and in some cases were even described as closer in type to the bodies of children than those of fiery, fully grown males. Following this logic, female growth was inevitably slower and they were on the whole thought to be smaller and smoother, tending towards physical weakness and a sedentary fragility. For these inferior bodies, too frigid to evacuate the humours through sweat or concoction, the only option for purging accumulated excess was menstruation.

It was to this unique function of women's bodies that the male medical academy repeatedly returned in order to decipher both women's physiology and their psyche. The texture, colour and frequency of a woman's menstrual blood might all be used to make various judgements as to her constitution, casting her as either careful or irrational, hardy or contrarian. As with any other manifestations of humoral effects on the body – hair colour, skin colour, the size and shape of the nose or forehead or chin or ears – medical frameworks were set up to suggest that these details revealed certain inner truths of character or temperament. And the divining of mentality or morality from blood flow was so ingrained and apparently logical that it was even espoused by female authors themselves, when given the rare opportunity to write about their own bodies. In her twelfth-century treatise *Causae et curae*, 'Causes and Cures', Hildegard of Bingen outlined four general types into which the various constitutions of men and women fell. Men are arranged by her in order of vitality, fertility and character, from a hardy ideal with reddish skin and fiery blood through to more vapid and infertile types with weak veins and a pale complexion. Her four types of women, by contrast, are defined by their menstrual flow. A large woman with heavy, reddish menses would prove prudent

and chaste, a woman with a heavy flow of bluer blood tended towards inconsistency and would be happier without a husband, while other types with different patterns of menstruation might have either a good memory or an inactive, sluggish mind.

It is hardly comforting that these formal medical stereotypes were consistent with biological ideas about the humours, but there was at least some internal logic to them. In other areas, however, little need was felt for such deduction, and thinkers brandished these accepted humoral inferiorities and patterns of menstruation as a blunt tool for an unbridled and blatant misogyny. Catholic theology, for instance, viewed childbirth as womankind's share of the punishment for Original Sin, and religious discourses equating blood with uncleanliness in both Judaism and Islam also provided complicated superstitious grounds for the demonisation of menstruating women. Among other ideas, even supposedly learned treatises circulated the notion that menstrual blood could turn bronze objects black, perish crops or drive animals mad, and that menstruating women might be able to transmit their problematic feminine temperaments onto innocent men through an evil, witch-like, sideways glance. One thirteenth-century Latin text, *De secretis muli-erum*, 'On the Secrets of Women' – originally a manual for teaching clergy about reproduction but soon popularised as a foundational philosophical argument for medieval and early modern misogyny – even suggested that one could:

> *Capiantur capilli mulieres menstruosae et ponantur sub terra pingui ubi iacuit simus tempore hyemali tunc in vere sive aestate quando calescent calore solis generabitur serpens longus et fortis*

> Take the hairs of a menstruating woman and place them in the fertile earth under manure during the winter, then in spring or summer when they are heated by the sun, a long, stout serpent will be generated.

Another clear sign of these male thinkers' fascination with menstruation and birth is that many more medieval images of wombs survive

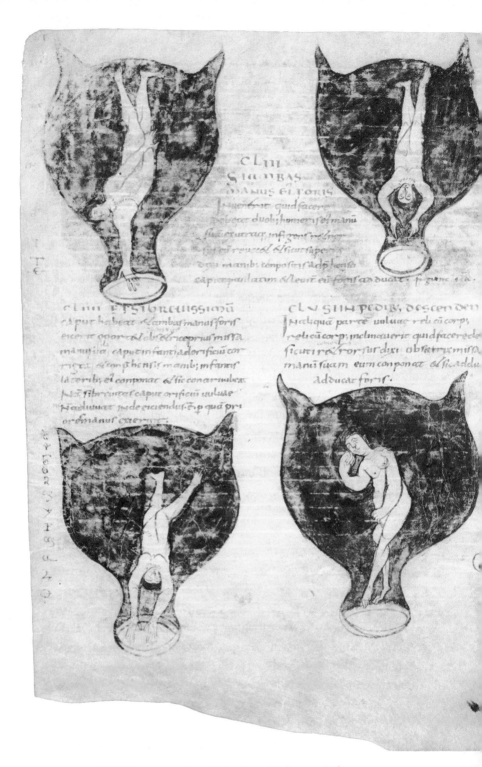

67. Eight presentations of the foetus in the womb, from a
ninth-century gynaecological manuscript.

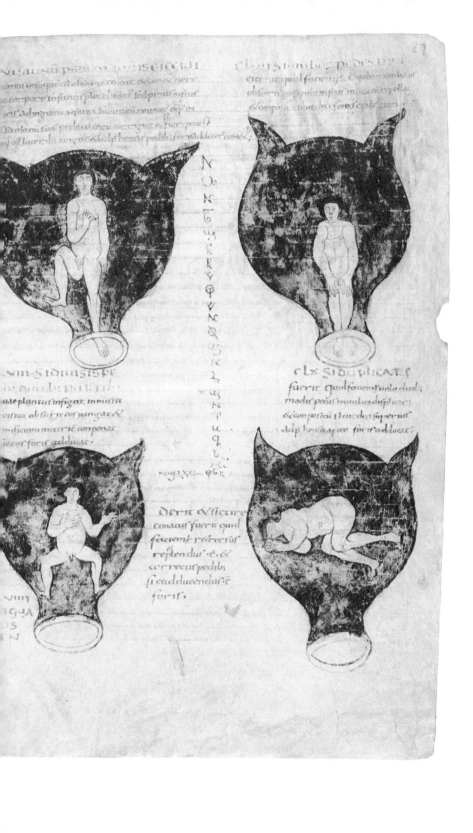

than of penises. Most that do occur feature as part of a long-standing illustrative tradition accompanying treatises on gynaecology and obstetrics, especially an influential text known as the *Gynaikeia*. Based on the first- or second-century texts of the Greek physician Soranus of Ephesus, the treatise was known in Europe through a Latin translation made three or four centuries later by an author known only as Muscio, a writer perhaps from north Africa about whom we know little. Copies of this text can depict up to seventeen presentations of unborn foetuses in the womb alongside instructions as to their best methods of delivery. In pictures like this a tiny, perfectly proportioned figure symbolises the unborn foetus, normally floating within a stylised circular outline representing the womb. The earliest-known such series is found in a ninth-century manuscript in the Royal Library in Brussels, where foetuses are shown in a variety of combinations and positions: twins, triplets, quadruplets, more complicated breach and compound births, and even a monstrous womb containing eleven children. Throughout, the organ is clearly rendered with a circular funnelled opening to the bottom and two horns to the top, presumably intimating the direction of the ovaries, the whole affair rendered with a light red, semi-transparent wash as if it were blown from fragile glass.

Like other luxurious illustrated medical books – lavish herbals or surgical manuals – it is doubtful that expensive tomes such as this would actually have been used by medieval healers, at least not in the sense that they were casually browsed for solutions at the bedside of a woman going into labour. Leaving aside the unhelpful distortions of its diagrammatic images, the strips of text offer only cursory advice to the practitioner in short phrases: *Si ambos pedes foris eiecerit* ('If both of the feet are extending out'), *Si genua ostenderit* ('If the knees present first'), *Si plures ab uno fuerint* ('If there is more than one child') and so on. Other texts, though, offered more directly helpful guidance, advising that women close to birth be bathed often, their bellies anointed with various oils, and that they eat only easily digestible foods. Some followed humoral logic to suggest a more specific diet in the lead-up to the birth. Michele Savonarola (c.1385–1468), an Italian humanist and physician, wrote in his *De regimine pregnantium*, 'On the Regimen

of Pregnant Women', that the patient should avoid fried fish and cold water, sticking instead to bran bread, fruit and (worryingly, from a modern perspective) red wine. As was common elsewhere in healing, theoretically sound academic treatments intermingled in gynaecological treatises with far more folkloric medicines, especially when it came to advice for women who did not wish to get pregnant in the first place. Contraceptives tended towards the superstitious, like these four examples included in the Salernitan text the *Trotula:*

> If a woman does not wish to conceive, let her carry against her nude flesh the womb of a goat which has never had offspring.
>
> Or there is found a certain stone, named *gagates*, which if it is held by the woman or even tasted prohibits conception.
>
> Otherwise, take a male weasel and let its testicles be removed and let it be released alive. Let the woman carry these testicles with her in her bosom and let her tie them in goose skin or in another skin, and she will not conceive.
>
> If she has been badly torn in birth and afterward for fear of death does not wish to conceive any more, let her put into the afterbirth as many grains of caper spurge or barley as the number of years she wishes to remain barren. And if she wishes to remain barren for ever, let her put in a handful.

The *Trotula* also offers advice on dealing with the uterus. A highly sensitive organ, if it was not regularly purged through either sex or menstruation then most medical authorities agreed with ancient theorists like Hippocrates that it might either begin to give off deadly fumes or could itself rise up within the body towards the chest and head. This condition, known as uterine suffocation, was thought to cause the patient to swoon or faint, feel choked by the fumes, swell in the neck and throat, and in extreme cases even die. It was up to practitioners to attempt to wrangle the womb back to its original position. More pragmatic healers turned to practical medicines, including making foul smells under the nose by burning feathers, wool and linen in order to drive the womb from the head, or correspondingly sweet-smelling

spices and herbs to suffumigate the vagina, tempting the womb back downwards to its correct position. Healers also turned to more superstitious means to address the malady, which some believed to be caused by demonic possession. Charms were designed to be intoned over the sick woman as a form of exorcism, like this tenth-century example, now in Switzerland, addressed to help a maid known only by the initial N:

> To the pain in the womb ... O womb womb womb, cylindrical womb, red womb, white womb, fleshy womb, bleeding womb, large womb, nervous womb, floated womb, O demoniacal one! ...
>
> In the name of God the Father ... Stop the womb of Thy maid N. and heal its affliction, for it is moving violently ... I conjure thee, O womb, by our Lord Jesus Christ ... not to occupy her head, throat, neck, chest, ears, teeth, eyes, nostrils, shoulder blades, arms, hands, heart, stomach, spleen, kidneys, back, sides, joints, navel, intestines, bladder, thighs, shins, heels, nails, but to lie down quietly in the place which God chose for thee, so that this maid of God, N., be restored to health.

That we might find such theories nonsense today is fair, although a formal diagnosis of 'hysteria' – a uniquely feminine illness deriving from the term *hystera* (υστερα), the word used for 'uterus' in the very same ancient Greek medicine that spawned the wandering womb – was only excised from some modern professional psychiatric guidelines as late as the 1950s.

For guidance in understanding these wildly diverse layers of medieval advice on birth, some pregnant women would have turned to a midwife. This is a complicated group of practitioners to pin down, not least because beyond the sparse collections of academic treatises and magical fragments the act of birth was rarely documented in detail in a formal sense. At the beginning of the period the number of professional midwives seems to have declined significantly from their once prominent position in the late Roman world, where they would have attended pregnant women and helped with delivery, inspecting the genitals and offering massage to the stomach or advice on

breathing. By the early Middle Ages we get only a fleeting mention of their work in occasional legal proceedings or fictional narratives. Births at this point were mostly overseen by local healers and older female family members, whose expertise was grounded in practical experience rather than academic knowledge. But by the twelfth century midwifery as a profession appears to have been on the up once more. Islamic commentators began to write of the intense pains and difficulties of birth and mention a number of areas of obstetrical specialism, both in methods of delivery and the complicated after-care of mother and child. And in Europe the rise in midwives was met by attempts from university doctors, the state and the Church to take increased control over the practice. For the academy, writing theoretically about women's medicine was designed, at least in part, to bring a previously largely female profession to heel, subsuming midwives' work within what they saw as their own superior intellectual understanding of the body. Local governments, on the other hand, were more concerned with a broader development of public health, enforcing certain legal frameworks that eventually included some sensible egalitarian measures: for example, that midwives, once licensed by local regulating bodies, should be mandated to treat the poor as well as the wealthy.

The Church's interest in the matter was less bureaucratic. It addressed instead a serious concern for the spiritual health of the many children that did not survive birth. Accurate maternal mortality figures are difficult, if not impossible, to come by, certainly when generalising across the whole of the Mediterranean. But if, from existing records, we can estimate that at certain points in the Middle Ages as many as one in five medieval women died from complications either during or after birth, and also that they might have given birth to an average of five or six children, we can imagine how genuinely dangerous and fraught an experience pregnancy must have been for many. One poem, gathered in the thirteenth-century German anthology *Carmina Burana*, evocatively describes the whispers a pregnant woman might perceive around her as she walked down the street: '*Cum vident hunc uterum / alter pulsat alterum, silent dum transierim*' ('when they see this womb / they tap each

other and pass by, silent'). Churchmen were clear that a midwife would be needed if these fears were ever realised, intervening to perform the medieval equivalent of a Caesarean section. In the pre-modern era these were procedures undertaken only after the death of a woman in labour, described as *sectio in mortua*, the 'cutting open of the dead woman'. They were not intended to save the life of a child, rather to allow for an emergency baptism of its soul before it too passed away.

Perhaps because of this extreme danger, the successful birth of a child was something to be celebrated with real gusto. This was often marked through a variety of elaborate gifts to new mothers, a host of hopeful objects wishing both her and her baby good health: painted ceramics, cutlery, sweets or expensive clothing. In Italy, from around 1300 onwards, traditional offerings began to include elaborate birthing trays given to women either just before or just after birth and presented laden with carefully chosen things for her to eat. These *deschi da parto*, as they were known, are particularly interesting for the actual images they present of the birthing scene itself, often illustrated in painted vignettes on their top or bottom. In a tray from 1428, decorated by the Florentine artist Bartolomeo di Fruosino (c.1366–1441), we see a detailed depiction of a new mother sitting up in bed, perhaps during what was known as the 'lying-in' period, a term of around four to six weeks where postpartum women were kept relatively secluded for recovery. Dressed in a cap and red cloak, likely special birthing wear, she is attended by a variety of women. Some sit beside the bed washing and tending to the newborn child, one of whom might be a *balia*, a wet nurse, and outside, to the left, small figures queue to enter the room, birth gifts in their hands. The mother herself is turning to another woman, who, fittingly, is presenting her with a birthing tray just like the one on which this entire scene is painted.

On the reverse of Fruosino's tray, an inscription confirms its good intent: 'May God give health to every woman who gives birth ... May the child be born without fatigue or danger.' Perhaps to lighten the mood further, he also includes the image of a playful young boy, who proudly boasts: 'I am a baby who lives on a rock, and I urinate silver and gold!' The birthing scenes on such trays are clearly an idealised

68. A *desco da parto*, or birthing tray, made in Florence in
1428, painted by the artist Bartolomeo di Fruosino.

picture of an elite event, set in a grand house full of expensive gifts and
multiple helpers, some distance from the everyday realities of childbirth
for the vast majority of medieval women. Still, they give us a glimpse
into an almost totally unrecorded world. Notably, no male physician
is present. This is an all-female sphere, the women exchanging gifts,
playing music and gesturing to and fro in animated conversation.

A Second Sex

What impact did all these ideas about pregnancy and birth, menstruation and inferior humours have on the actual lives of medieval women? Certainly the outlook was in many ways bleak. Women's secondary status carried through into almost every institutional context possible, all of which were fundamentally geared towards the men who had dominated such arenas for centuries. Religious hierarchies, at least those incorporating major positions of political control, were run exclusively by men. The universities in which women's theology, philosophy and, of course, biology were discussed were male-only domains. And most surviving medieval laws use male pronouns with such frequency as to suggest that the female sex held virtually no autonomous status within certain legal frameworks: court records mostly invoke women via their husbands and fathers in an unpleasant and proprietary fashion. In many ways the Middle Ages can be seen as a deeply troubling time, where anatomy cast half of the population almost as a lower form of human being.

All this is patently true. Yet, as always, the detail of these situations was far more nuanced. The boundaries of medieval women's lives were, for instance, just as often conditioned by geography as by biology. Compare statistics for marriage at the opposite ends of Europe. From the fragmentary evidence we have, it seems that in the south – Italy, Spain or southern France – most women would have been married by a pretty young age. Many were in their later teens at the time, taking husbands on average a decade or so older than them, and in the rare case of high-status diplomatic brides it could be even younger than this: Blanche of Castile, founder of Maubuisson Abbey and its entrail necropolis, was only twelve when she was made to marry the soon-to-be King Louis VIII of France, himself also twelve at the time. In Europe's north, however, in London or the Flemish cities of Ghent or Bruges, women appear to have married somewhat later in life. Most only took husbands when in their early twenties, perhaps after a period of employment earning their own wage. Likewise, in both north

and south a minority of women married only in their forties and fifties, entering into unions of companionship based on shared comfort, not on the speedy bearing of children. What emerges is a range of marriage models across different cultures, each of which would have impacted on a woman's quality of life in quite different ways. Some were quickly co-opted without choice into union with a man and the potentially dangerous process of motherhood, while others were able to live out very different existences, entering into the world of work and forging a more independent path. Even the apparently fixed universals of married status could themselves change quickly. A widowed woman might, after the death of her husband, enjoy substantial financial prosperity and independence compared with her younger, married daughter. Partial records found in the storeroom of the Ben Ezra Synagogue in Old Cairo – the largest trove of information we have on medieval Jews, housing more than 300,000 fragmentary texts – suggest that divorce was far more common in Jewish communities than in Christian ones, where the Church had made it almost impossible to dissolve a marriage. Jewish women, on the contrary, could instigate divorce proceedings themselves without their husbands' permission, and were also allowed afterwards to remarry into more personally or socially advantageous partnerships should they wish.

In the Muslim Middle East and north Africa the situation was different again. The familiar caricature of the medieval harem, in which groups of women might be coupled to a single man through marriage, gives way to more complicated readings in reality. Under Islamic law men could in theory take more than one wife, but this seems not to have happened particularly often. And likewise, while social structures of Muslim marriages were, like their European counterparts, often highly restrictive – wives were described as ideally submissive and demure, and were generally kept to particular parts of the home, with their bodies always fully covered when out in public – these conditions, while overwhelmingly stifling, could also, contrarily, enable certain unique opportunities. Muslim women were able to partake of female-only spaces in a way almost entirely denied their European counterparts. We get a sense of this in an image from a thirteenth-century manuscript

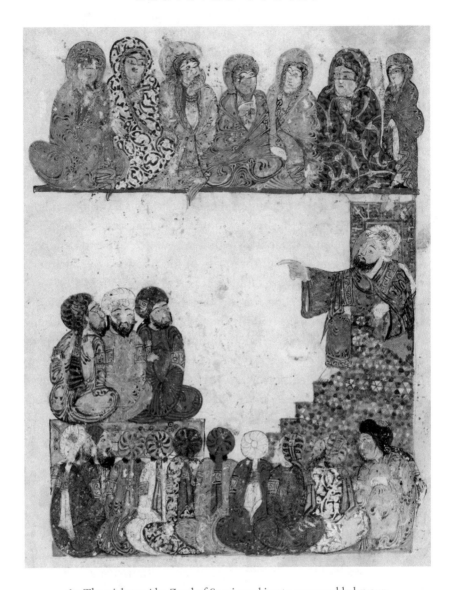

69. The trickster Abu Zayd of Saruj speaking to an assembled group
of men and women, from the *Maqamat* (مقامات), or compendium of
tales, by the Iraqi author Muhammad al-Hariri. This version of the
book was illustrated by a scribe named Yahya al-Wasiti in 1237.

showing a gathering of people listening enraptured to a speech by Abu Zayd of Saruj, the main character in a literary work of the Iraqi author Muhammad al-Hariri (c.1054–1122). Here a group of women are present at the top of the scene, perhaps on a balcony overlooking the action. They are shown wrapped in colourful clothes, swirling textures of multi-patterned textile enveloping their bodies. True, they all wear veils, exposing virtually none of themselves save the upper or lower portions of the face. But, separated from the men, they turn and gesture to each other as if in far more engaged conversation than their silent, static male counterparts. Their world is reminiscent of the busy atmosphere depicted in Fruosino's birthing tray, except that, rather than being a rare moment of exclusively feminine celebration, for these Muslim women speaking with one another outside of male earshot is presented as a typical daily experience.

Like geography, matters of class could also serve either to exacerbate or to mitigate biological preconceptions of gender. The arranged, socially advantageous marriages of the rich would have seen many wealthy women pressured into a destiny they had not chosen for themselves, something felt far less acutely the lower one got down the social ladder. Yet, unlike the poor, such women were often still able to use family money in the service of personal or social good in the same way as their husbands, free to spend on whatever they wished, from the commissioning of specialised artisans to the foundation of religious or civic institutions. In these upper echelons women could even rise through familial connections to the most serious positions of power possible. One can imagine that Arwa al-Sulayhi (c.1048–1138), the eleventh-century queen of Yemen, would not have been nearly as restricted by her gender as an ordinary Yemeni woman when conducting various important diplomatic missions and making political peace on behalf of her country. Nor do we suppose that the earlier, eighth-century Byzantine empress Irene (752–803) felt quite as oppressed as the women she would rule over from Constantinople after seizing the throne from her twenty-six-year-old son Constantine VI, whom she promptly had arrested and violently blinded, to ensure that he could never retake power. A formidable tactician, Irene's reign saw her crush theological heresies, found an elite personal guard, and pay

for the building of enormous churches that were decorated with lavish schemes in just the same manner as those of male rulers past. Indeed, she sometimes went so far as to take the title *Baslieus* (βασιλεύς): 'Emperor', not Empress.

Opportunities for medieval women wishing to side-step altogether the seemingly tough shackles of their patriarchal societies were few, although for some in Europe one option was to enter into a marriage not with a man but with Christ. Becoming a cloistered nun within a church and devoting oneself to an exclusively holy existence hardly feels like a substantial emancipation. But its celibate nature would have at least appealed to women in search of a life without the dangers of childbirth. Just how passionately some desired the protection of the Church comes across forcefully in the *vita* of an unusual saint named Wilgefortis, who was much venerated in northern Europe from the ninth century onwards. Her name is a corruption of the Latin *virgo fortis*, 'strong virgin', although she was sometimes known by several other remarkable names: Uncumber, Kümmernis, Liberdade and Eutropia. She was, so the story goes, the daughter of a pagan king due to be married off to a neighbouring ruler as part of a peace treaty. Wilgefortis, however, firmly rejected the idea. In her mind she owed spousal devotion only to the crucified Christ, and no amount of coercion would convince her otherwise. For this refusal Wilgefortis was swiftly imprisoned, where she prayed that her appearance might be transformed so as to be found repulsive by all men, leaving her in peace to live out her days chastely in a convent in the service of God. Sure enough, when she was later fetched from her cell, in the words of one source: 'They found that all her beauty was gone, and her face overgrown with long hair like a man's beard.' She was now doubly estranged from her father – both an evangelised Christian and a miraculous hermaphrodite – and in an enraged state he had her tortured and crucified. A horrible death like this was unlikely to have been preferable to marriage for most women, yet the pious example of such saints showcases how seriously many took the alternative religious life of a nun. These were holy women who pushed back against a masculine status quo, their model of pious liberation sanctioned by divine intervention.

70. St Wilgefortis on the cross, from a Book of Hours
made in Ghent around 1420.

Tales like that of Wilgefortis make clear too that it is not quite right
to see the Middle Ages as a time in which gender was conceived of only
as a binary, with powerful men set against weak women. Her image is
found sculpted and painted with frequency in the period, and it sug-
gests that the apparently fixed attributes of the sexes could on occasion
become blurred: she wears a woman's dress yet has a man's bearded
face, she was seen as somehow strange through her 'unnatural' doubled

gender and yet when crucified was venerated as a perfect archetype of holiness. It is almost as if somewhere along the way Wilgefortis's femininity was suddenly weaponised, an idea we see expressed in the works of several other late medieval women. The fifteenth-century Welsh poet Gwerful Mechain, for example, clearly felt empowered enough to write witheringly of her counterpart male authors, whom she felt shied away from gender as a subject for high art. For her a woman's body was no site of shame, it was aggressive poetic fuel. As she wrote in one poem, *I'r cedor*, 'To the vagina':

Gerddau cedor i gerdded.
Sawden awdl, sidan ydiw,
Sêm fach, len ar gont wen wiw,
Lleiniau mewn man ymannerch,
Y llwyn sur, llawn yw o serch,
Fforest falch iawn, ddawn ddifreg,
Ffris ffraill, ffwrwr dwygaill deg,
Pant yw hwy no llwy yn llaw,
Clawdd i ddal cal ddwy ddwylaw.
Trwsglwyn merch, drud annerch dro,
Berth addwyn, Duw'n borth iddo.

All you proud male poets, you dare not scoff.
Let songs to the quim grow and thrive
Find their due reward and survive.
For it is silky soft, the sultan of an ode,
A little seam, a curtain on a hole bestowed,
Neat flaps in a place of meeting,
The sour grove, circle of greeting,
Superb forest, faultless gift to squeeze,
Fur for a fine pair of balls, tender frieze.
A girl's thick glade, it is full of love,
Lovely bush, blessed be it by God above.

Sexualities and Penis Trees

In the darker moments of medieval life women were overwhelmingly the victims of men. It is hard to say precisely whether sexual crimes were committed more or less frequently in the Middle Ages than the present, but structures of accountability were certainly far less reliable. Legal records and civic accounts record rape as not an infrequent occurrence, especially in large cities, and we get a sense that punishment for such crimes, enforced by an entirely male legal system, were rarely enacted to their fullest extent. Even when they were, prosecution was typically based on the degree to which a crime had transgressed shared male codes of honour and the limitations they placed on a woman's social appeal to other men. If a man raped a virgin, despoiling her for potential future unions, he might be forced to marry her himself or at least continue to support her financially as he would a wife. If the victim was already married, the punishment could be significantly more severe, depending on the specifics of the crime and her husband's background, from a hefty fine through to hanging. A concern for the physical and psychological well-being of the women involved is largely absent.

In the world of fiction and folklore, by contrast, the responsibility for sexual aggression was just as often reversed. One of the many contradictions at the heart of contemporary attitudes towards women was that the womb – and by extension a woman herself – was viewed both as extremely placid, a simplistic vessel waiting to be filled, and at the same time dangerously aggressive, a siren-like, greedy void. The latter prompted severe castration anxiety among medieval men, something frequently brought to the fore in romance narratives. Here male authors voiced fears that mischievous women might wish to do violent harm to their suitor's penis by various means, inserting sharp iron into the vagina in order to ensnare his member or simply slicing off the penis cleanly from his skin. Stories like this range from genuinely fearful tales to more playful visualisations seen on love tokens, cast into fertility badges, carved evocatively into the lids of small treasure boxes and painted in the margins of medieval manuscripts. One such illustration decorates a

71. A pair of nuns plucking penises from a tree in the
margins of a manuscript of the *Roman de la Rose* made
in Paris in the mid-fourteenth century.

famous thirteenth-century French epic poem, the Roman de la Rose, with
a pair of nuns comically stuffing their pockets with large penises plucked
from a sprouting tree, a masculine equivalent to the kind of floral meta-
phors used by Gwerful Mechain. This is a simple enough comedic device,
found in a number of medieval stories: the cloistered celibate life of a
nun was, in theory, as far away from this kind of libidinous plucking as
it got. Yet there might be a more reactionary message at work here too.
Unusually, this manuscript was not the product of a typical, exclusively
male illustrator's workshop. It was made by the much-esteemed hus-
band-and-wife team Richard and Jeanne de Montbaston, whose atelier
in fourteenth-century Paris produced a number of these luxury books.
It is even possible that this particular image is the work of Jeanne alone,
who continued to write and illustrate independently after Richard's death

in the 1350s. We are left to wonder whether these nuns are painted conforming to masculine stereotypes of female sexual aggression, pocketing penises left, right and centre, or are instead shown being more genuinely rebellious, trying to overturn a phallocentric world in an almost proto-feminist mould.

For its part, the penis could end up serving as an important organ of identity for medieval men. We find, for instance, a familiar bragging equation of codpiece size with manliness laced throughout masculine self-image in the Middle Ages. That a man might be openly mocked for the smallness of his penis is shown in a passage from a thirteenth-century Icelandic saga, where a maid comes across the story's romanticised outlaw hero, Grettir Ásmundarson, naked. Although Grettir was known as a fearsome presence, the maid exclaims to her sister rather disappointedly:

Svá vil ek heil, systir, hér er kominn Grettir Ásmundarson, ok þykki mér raunar skammrifjamikill vera, og liggr berr. En þat þykki mér fádœmi, hversu lítt hann er vaxinn niðr, ok ferr þetta eigi eptir gildleika hans ǫðrum.

Bless me, sister, Grettir Ásmundarson is here, and he seems to me well built indeed, and lying here naked. But it seems to me extraordinary how small he is down below. It doesn't go with his bigness in other respects.

Alternatively, for medieval Jews and Muslims, rituals of circumcision – the *brit milah* (ברית מילה) or *khitan* (ختان) – elevated the penis as a marker of belonging. While Islamic scholars debated whether the practice was obligatory or simply traditional, for Jews it followed directly in the model of Abraham, a marker of the covenant of the Jewish people with God and an important moment of initiation. This was a time when a young boy might be named, and, unlike the 'uncontrolled' blood of menstruation, the officially sanctioned blood of circumcision was theorised by rabbis as having spiritually potent properties, sometimes poured during the ritual onto the ground in front of a synagogue's Ark. Given that Christ had been born to a Jewish family, some Christians

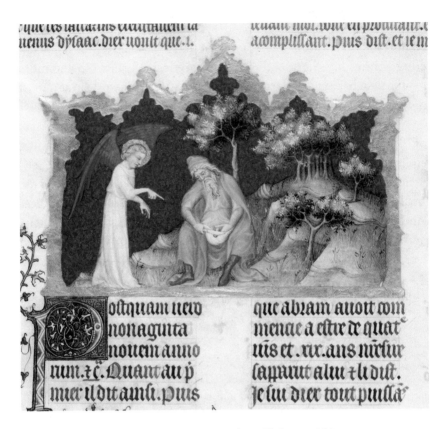

72. Abraham circumcising himself, from a richly
illustrated Bible made in France around 1355.

too noted it was technically possible that, although his body had been assumed miraculously to heaven, his foreskin may have remained on earth as a holy relic. This was a controversial claim rebutted by theological critics but was nonetheless embraced by some: the holy woman Catherine of Siena even spoke of a wedding ring for her spiritual marriage to Christ that was formed from the holy prepuce itself. Several Holy Foreskin relics appear in the medieval record, with suspicious frequency given there should have been only a single one to go round. One was venerated in the city of Antwerp, another was displayed in the Spanish pilgrimage capital of Santiago de Compostela, a third was in the eastern French city of Metz, and yet another was in the possession of the

Holy Roman Emperor Charlemagne. This last foreskin even claimed a complicated ancestry from the Virgin herself, who had kept it in a small bag after the circumcision before giving it to Saint John. The pouch had then apparently been passed to an angel, who had conveniently deposited it in the imperial court at Aachen, where it was proudly displayed.

These medieval religious traditions of the penis managed to take what was fundamentally a sex organ and turn it into a public and distinctly de-sexualised object of brotherhood or sacred veneration. Other groups, however, were pressed into doing the reverse: hiding overtly eroticised male subject matter from society in a far more coded way. Sexual love between two men was viewed within the conservative bounds of the Middle Ages as a corruption of God-given gender norms. Male homosexuals were framed as sodomites, after the inhabitants of the supposedly depraved and promptly destroyed biblical city of Sodom, and we find their existence largely absent from official accounts apart from records of their punishment. Depending on where and when one lived, sentences for sodomitical crimes varied dramatically, from those of the German Empire, whose law codes barely mention such perceived misconduct, through to those of the Venetian Republic, whose fourteenth-century *Signori dei Notti*, or 'Night Watch', would sentence gay men to death by burning at the stake. Some small homosexual communities do seem to have existed during the Middle Ages, although even these remain recorded in only the most derogatory of ways. Richard of Devizes' twelfth-century chronicle of life in England during the reign of Richard I mentions a number of what he saw as sexually deviant characters amid London's medieval nightlife: alongside *farmacopolae* ('drug pedlars') and *crissariae* ('prostitutes'), he lists *glabriones* ('effeminate boys'), *pusiones* ('rent boys'), *vultuariae* ('witches') and *mascularii* ('man-lovers').

Leniency for such sodomitic crimes might in fact depend on the degree to which a gay man strayed outside regular sexual roles. The most unpleasant homophobic rhetoric was reserved for the passive homosexual, whose penetration meant his experience of sex was transformed into an unacceptably feminine mode. By comparison, the active penetrator was thought at least to be dispensing something of the typical male sexual responsibility, albeit with a moral wrong-headedness. Following

a similar gendered logic, gay women were recorded even less frequently in the Middle Ages than gay men. Lesbians were members of society who were by definition twice as inferior, both by their homosexual orientation and their secondary female gender. They only very rarely feature in literary stories of the era, and even then they tend to exchange mostly non-physical affection. A tale found in the tenth-century *Jawami' al-ladhdha* ('Encyclopedia of Pleasure'), by the little-known author Ali ibn Nasr al-Katib, tells of two princesses named Hind and al-Zarqa who fall in love and found a monastery together. But theirs is an amorousness of a particularly chaste variety, presented as a model of female loyalty and certainly not praise for open sapphic love itself.

Reading Piss

One aspect of the genitals united all people, female and male, Jewish and Christian, homosexual and heterosexual alike: eventually, everyone needs to urinate. Within the modes of humoral medicine everything that was expelled from the body – sweat, vomit, saliva, faeces – could be pored over for its quality and quantity by a knowledgeable healer for signs of underlying internal imbalance, and urine was no exception.

Texts from as early as the seventh century offered detailed guidance for physicians in uroscopic readings. We agree today that urine colour can be an indicator of levels of hydration within the body as well as various other measures of health, but this earlier medicine took urological divining to extremes. So focused were some physicians on reading urine that the round-bottomed flasks in which patients' samples were presented to them quickly became a prominent part of their visual culture. Much like a modern white coat, a person in a medieval manuscript depicted peering at such a flask instantly identified himself as a physician, although this was not necessarily a reifying gesture of respect. In the fifteenth-century stained-glass windows of York Minster, monkeys rather than men inspect urine bottles, a bawdy pastiche of the active medical scene in the city. In theatrical plays, too, bungling doctors also offered light comic relief through the bladder.

In the so-called *Croxton Play of the Sacrament*, a rare surviving piece of English religious theatre, a character called Master Brownditch of Brabant – whose name already suggests a certain coprological obsession – is described in particularly urine-laden terms:

> *The most famous phesycyan*
> *That ever sawe uryne!*
> *He seeth as wele at noone as at nyght,*
> *And sumtyme by a candelleyt*
> *Can gyf a judgyment aryght*
> *As he that hathe noon eyn.*

The most famous physician
That ever saw urine!
He sees as well at noon as at night,
And sometimes by a candlelight
Can give a judgement just as well
As one that has no eyes at all.

Urine is both Brownditch's badge of honour and his failing, the proud marker of his trade and the basis for a backhanded compliment that his urological pronouncements are no better than those of a blind man.

These colourful characters of the stage could be matched medically with equally colourful images. A beautiful tree complete with flowering roundels of piss sounds like something of a paradox, and yet this is how several medieval texts on uroscopy chose to frame their contents. A wheel of samples from a manuscript made around 1420 in Germany shows the detail that went into such prognoses, the culmination of many different theories on micturition. A circle of flasks are shown graded by colour around a flourishing, seven-branched tree, a style of illustration that simultaneously echoes contemporary philosophical diagrams of virtues and vices, religious family trees mapping the genealogy of Christ and, in a way, the penis tree of the *Roman de la Rose*. Each branch suggests a different broad diagnosis, ranging from indigestion to imminent death, while an outer layer offers abstract colorific descriptions picked up

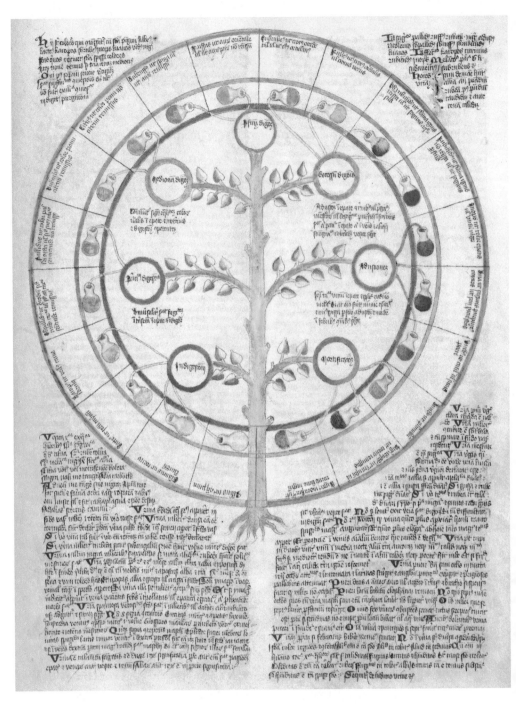

73. A wheel of urine sprouting from a tree, from a German
medical manuscript made around 1420.

by the corresponding sample's shade. Lowest on the scale we find *albus* ('white'), with the explanation that such urine is 'as clear as well-water'. The circles then move through various grades of yellow – *karopos* (likened to camel's hair or skin), *subpallidus* (like unreduced meat juice), *rufus* (like a fine gold or saffron) – before turning to different reds – *rubicundus* (like a low flame), *inops* (like an animal's liver) and *kyanos* (like a darkened wine). Finally, after covering ever deeper greens – *plumbeus* (like the colour of lead) and *viridis* (like a cabbage) – the wheel finishes with two ominous shades of black, one described as being like ink and the other the colour of a darkened animal horn.

These vivid descriptions of urine show just how sensory a task physicians were undertaking when inspecting patients' samples, with uroscopy texts encouraging all sorts of behaviour at the bedside: testing the viscosity of the urine and any particles suspended within, grading its smell or evaluating its sweetness or bitterness. Shaken, stirred, sniffed, even tasted, urine was reified in such flourishing trees, turned from effluvia to a careful diagnostic tool. In fact, just like the topsy-turvy medieval ideas of the anus, the notion of elevating some-thing base to something extremely sensitive is a good model for how the Middle Ages seem to have viewed the genitals in general. We are often encouraged to look back on their views of gender and sexuality as rather blunt, switching robotically between only two modes. On the one hand, there is the coyness of courtly love or religious celibacy, a chastity that separated the genders and saw sex as sin, something best avoided or at least uncomfortably repressed. On the other, there is the overstimulated titillation of something like Jeanne's penis tree, a raw eroticism that could demonise both genders and tip all too easily into sexual danger and violence. Yet the work of authors and makers at the time shows that neither stereotype was strictly uniform. Medieval sex organs do not seem to have been discussed all that much more or less than in our own sexual lives today. But their genitals were certainly more momentous: no other part of the medieval body played such a defining role as the womb or the penis in plotting the bounds of how a person's life might unfold.

FEET

By the middle of 1493 the Holy Roman Emperor Friedrich III's left foot had turned almost completely black. His doctors had begun to worry some weeks earlier, when it first started slowly shifting from a healthy pink towards a shade of darkened blue. The late medieval compendia to which they might have turned for guidance spent little time on this final extremity of the body, only really discussing what to do in the case of surface issues such as boils, blisters or swellings. So in the absence of further advice the doctors were left to think instinctively. Some declared Friedrich was lacking humoral warmth and should be prescribed fiery medicaments to remedy the situation. Others insisted that the malady was down to the Emperor's near-constant consumption of melons, in which he apparently took excessive pleasure. Either way, something had to be done. A coterie of medics was assembled from far and wide to converge on the Austrian city of Linz, where the emperor was attempting to convalesce and shake the creeping blackening of his limb. Friedrich's son, the future Emperor Maximilian, sent his Portuguese physician, Matteo Lupi. The monarch's brother-in-law, Duke Albrecht IV of Bayern-München, sent the Jewish surgeon Hans Seyff to Friedrich's bedside. And they were joined there by four more German

physicians who had been summoned: Heinrich von Cologne, Heinz Pflaundorfer von Landshut, Erhard von Graz and Friedrich von Olmutz. After mulling over the Emperor, the learned group decided reluctantly that his worsening foot necessitated medieval medicine's last resort: amputation.

What followed cannot have been pleasant. While some anaesthetic would probably have been made available to Friedrich – numbing plants and opiates, hemlock, poppy or meadowsweet, applied to a sponge or burned for inhalation – the repertoire of pain relief in the Middle Ages was minimal and not particularly effective. As the five physicians steadied the patient, Seyff and another surgeon, Larius von Passau, cut through the leg above the affected area, severing skin and soft flesh with sharp knives before sawing through what remained in order to remove the foot. They then applied powders to staunch the bleeding and bandages to keep the wound as clean as possible. One hopes for the patient's sake that the procedure was at least quick. It is hard to believe he underwent it with quite the grace shown in an image of the operation preserved in a manuscript in Vienna. Friedrich appears blank-faced and in a mood of drooping calm, sitting relaxed and stretched wide in Christ-like repose as the surgeons work away at the coal-black foot. The attending physicians are shown behind him daintily supporting his arms, although they were far more likely to have been pinning the struggling Emperor down as the saw's teeth worked its way through skin and muscle to the bone.

We know an unusual amount about this foot amputation because of an account written after the fact by the surgeon Seyff himself. Why exactly he felt compelled to put pen to paper is unclear. Perhaps it was the immense pressure of operating on an emperor in the presence of his personal doctors, as well as various lords, knights and barons of the court who, he anxiously notes, were also keenly observing. Perhaps the surgical narrative was intended as some sort of personal insurance for Seyff against his patient's yo-yoing condition: the operation to remove the foot went exactly as planned (success), but Friedrich still died some weeks later (failure). Or perhaps the account was designed to immortalise Seyff's encounter with the most revered body in the land. The

personage of an emperor, like all other medieval rulers, was more impressive than any other in society. It was the head of the towering Body Politic, fed with distinct humoral diets and venerated after death even when split into different pieces in different places. But more than that, the blackened foot Seyff found himself holding was one of the emperor's most pivotal parts, a vital point of contact between the sovereign and his people.

Feet had long been identified as a place for elaborate displays of loyalty to the Crown. Kneeling before a ruler to kiss their shoes or toes was thought the ultimate mark of fealty and respect, and while Muslim leaders at the time tended to swear off the practice as frivolous and vulgar, western leaders were extremely keen. Popes had reportedly required the custom ever since the eighth-century pontiff Hadrian I had insisted his feet be ritually kissed as a symbol of allegiance by the Holy Roman Emperor Charlemagne, the centuries-old predecessor of black-footed Friedrich. Certainly by the twelfth century kissing the pope's foot was a regular part of the coronation ritual of the emperors, who were expected to genuflect before the pontiff and embrace his feet before the pope in turn placed the crown on their head. And in other cultures too the social dance of kissing feet could be equally complex, sometimes even laced with cunning political oneupmanship. The *Gesta Normanorum*, an eleventh-century history of the Normans, records that the Viking leader Rollo (c.846–930) was required to kiss the foot of the Frankish king Charles the Simple after losing to him in battle. When offered the foot, however, Rollo supposedly refused to stoop. He demanded that one of his kinsmen lift the limb up to his lips, rather than the other way around, toppling Charles from his throne in the process. Rollo had adroitly, and somewhat literally, turned the symbolic politics of the situation on its head.

More painstakingly elaborate than any other were the foot-kissing traditions of the Byzantine emperors, for whom the subtle gradations of the practice were even more finely tuned. Many long-standing and convoluted civic procedures had been slowly accruing in the court of Constantinople since the city's foundation as the empire's capital, and we are lucky to have several preserved in a unique fourteenth-century

treatise entitled *On Dignities and Offices*. The book records various multifaceted acts of *proskynesis* (προσκύνησις), bowing to the emperor to kiss and venerate his person. Evidently there was a complicated social etiquette involved. Some courtiers are ordered to remove their headwear when they prostrate themselves before the ruler, while others may keep their hats on. Some more important figures might be allowed to kiss the emperor's right cheek or hand, while others could hope for no higher than his foot. Take the subtle differentiation in the way the representatives of the city's Italian communities were expected to venerate their imperial host on Easter Sunday:

Εἰ δέ, ἐν ᾧ τόπῳ εὑρίσκεται τότε ὁ βασιλεύς, ἔνι καὶ ποτεστάτος τῶν ἐν τῷ Γαλατᾷ Γεννουΐτῶν, εἰσέρχεται καὶ ἀσπάζεται καὶ οὗτος μετὰ τῶν σὺν αὐτῷ τὸν βασιλέα, καθὰ καὶ οἱ ἄρχοντες, ὡς δεδήλωται, ἤτοι τὸν πόδα, τὴν χεῖρα καὶ τὴν παρειὰν αὐτοῦ ... Ὅταν οὖν ἔλθῃ μπαΐουλος, καθ᾽ ἣν μὲν πρώτην ἡμέραν προσκυνήσειν μέλλει, γονατίζει μόνον οὗτός τε καὶ οἱ μετ᾽ αὐτοῦ, ἀσπάζονται δὲ τὸν τοῦ βασιλέως πόδα οὐδαμῶς.

If the leader of the Genoese also happens to be at the place where the Emperor is, he too enters and with his companions kisses the Emperor in the manner of the court title holders, as was indicated, namely his foot, his hand and his cheek ... As for the Venetians, since the Emperor had wanted to make war with them ... when their leader comes, on the first day and he is to perform *proskynesis*, both he and his companions kneel only, they do not kiss the Emperor's foot at all.

Here we see that the Genoese, who appear particularly cordial and perhaps somewhat toadying to the emperor, are invited to show the fullest deference and kiss the foot. The Venetians, on the other hand, remain untrusted after recent political fractiousness and are only permitted to go as far as a neat curtsey.

Even if you were a simple layman, medieval authors and artists were on hand to make these deferential practices accessible through evocative prayers and paintings. The Netherlandish author and clergyman Willem Jordaens (c.1321–1372) was one of many writers who mused imaginatively on the nature of such interactions. In a series of instructions almost as laborious and detailed as the protocols of the Byzantine court, Willem advocated mentally throwing yourself on the floor in front of Christ, in order to access a deep spirituality:

Valt dan tot sijnen voeten. Dwaet met uwen tranen den slincken voet der waerheyt, ende claghet … Droeghet desen voet met uwen hare, dats met eenen leetsijn ende met eenen mishagen ws leuens. Custene met uwen monde, dat is: begeert met inneghen luste v leuen te regeren na die regelen der waerheyt … Hier-om moettij den rechten voet der ontfermicheyt gods dwaen met inneghen mynlijcken tranen, dat sij v gheue gracie ende sueten lust na die waerheyt te leuene … Siet mijn erme ziele, dese ij voeten ons heren moetij cussen met oetmoedeghen minlijcken luste, ende niet den eenen sonder den anderen.

Prostrate yourself at his feet. Moisten the left foot of truth with your tears and lament … Dry this foot with your hair, that is, with sorrow and dissatisfaction over your life. Kiss it with your mouth, that is, yearn with inner desire to lead your life in accordance with the rules of truth … You must then moisten the right foot of God's mercy with inner, loving tears, so as to receive his grace and a sweet desire to live according to the truth … Look, my poor soul, you should kiss these two feet of our Lord with humble loving desire, and you should never kiss one without the other.

In Italy it was the visual arts that took up this charge. The Sienese artist Duccio di Buoninsegna shows just the same sort of podiatric longing in a small but intricate panel painting of the Virgin painted at some point in the 1280s, known as the *Madonna dei francescani*.

74. Duccio di Buoninsegna's *Madonna dei francescani*,
probably painted in the 1280s.

We see a long flowing image of Mary holding Christ, dressed in a robe of deepest blue and flanked either side by angels that waft a piece of continuous patterned fabric behind her broad throne. Small enough that you might miss them, in the painting's lower left-hand corner there is a group of Franciscan monks, prostrating themselves before the Holy Mother. Fanned out as if the descending freeze-frames of a single stooping figure, the lowest is just about to bring his face to touch the Virgin's slipper, his mouth puckering to kiss the holy foot, wide-eyed and smiling.

Talon Toes and Bared Soles

Were we able to mimic Duccio's monks and take in our hands the type of soft slippers worn by the Virgin Mary, we would be holding an unusual survivor. Shoes fall into a long list of everyday objects that are understandably, if frustratingly, not the type of thing medieval people generally thought to preserve for posterity. Just like textiles, shoes have an obvious tendency to degrade and break in the wear and tear of daily use, and quite specific archaeological conditions are required for historical examples to make it to the present day. Made predominantly of leather, tawed using organic and mineral techniques rather than those of modern chemical tanning, shoes are particularly vulnerable to natural drying, shrinkage and break-up over time. Only those found in sufficiently wet environments – riverbanks, bogs, excavated latrines – have been able to stave off extensive decay, thereby giving us a glimpse of the fashionable footwear of the past.

From what survives, the majority of shoes from the Middle Ages appear to have been relatively simple in manufacture. Even Mary's pair that so beguile the trio of monks with their aura of beautified sanctity are only plain black moccasins. Earlier in the period, distinctions between men's and women's styles were slight, if they existed at all, and more commonly shoes were tailored to particular uses or climates. In the warmer landscapes of southern Europe, north Africa or the Middle East, simple flat leather or hemp-cord sandals might have sufficed for

75. Three medieval leather shoes. The uppermost is a long-toed *poulaine*, considered particularly fashionable in fourteenth-century England.

most activities, sometimes elaborated with gilding or decorated straps. In colder regions a more practically minded labourer working the field in rain and snow would have found a hardier, wooden-soled clog handy for protecting the feet. The most common technique among cobblers was the self-explanatory turnshoe method, where a soft piece of leather, known as the upper, was formed into the top of a shoe by placing it skin-side-down over a foot-shaped mould, known as a last. Stitched to an equally soft reversed sole, the whole affair was then turned inside out, presenting a sock-like shoe with a continuous neat seam. These delicate wares were often worn beneath pattens, a thicker wooden or sometimes hardened leather sole that strapped around the shoe itself to provide support when walking outdoors.

By the middle of the twelfth century cobblers had developed the technology to incorporate further leather layers within sections of a shoe to make its sole waterproof, and through these sorts of inventive changes later medieval shoes started to become far more individualised and unique. They took on more consistent and complicated styles based on a flurry of regional fashions. Terminology alone suggests a widening

in the range of uses, with people clad in buskins, ankle-shoes, boteaux, galoches, trippes, all with the possibility of decoration through scoring and patterning their leather, embellishing them with embroidery panels or detailing their drawstrings and buckles. Accounts of everyday life attest to this diversity too. The author John Garland, writing in thirteenth-century Paris, spoke of his neighbour selling shoes on the streets in a broad variety of laced styles with pointed toes, buckled shoes, boots with longer legs and what he tantalisingly describes only as styles exclusively 'worn by women and monks'. Around the same time a specialist market for shoes was flourishing across the Mediterranean, with makers competing to work in increasingly exclusive materials. The London Company of Cordwainers, for instance, was founded in 1272 and took its name from a literary corruption of the Anglo-Norman *cordewan*, a particularly prized and expensive type of cordovan leather imported from southern Spain, which they transformed for their clients into the very latest fashions.

One shoe excavated from a dig at the site of Baynard's Castle, a thirteenth-century palace that once stood in central London, shows just how outlandish these footwear styles could become. Formed of patterned leather, simply incised with thick stripes and thin cross-hatching, its most remarkable feature is an extremely exaggerated pointed toe, stretching out to almost double the length of the foot. These long shoes were a status symbol, particularly popular in aristocratic circles following the fashion of the wife of King Richard II, the young and stylish Anne of Bohemia (1366–1394). Her Polish origins gave these long pieces their nicknames, *poulaines* or *crakowes*, and some were even stuffed with clumps of hair or moss packing to maintain their remarkable and ever-lengthening shapes. The longest were wilfully impractical, prominently displaying that their wearer was of a class of person unlikely to have to work particularly hard or walk particularly far. And the low-slung bridge between their heels and their fronts also suggests they were designed to show off the bright colours of the wearer's hose beneath, part of a growing move to coordinate one's whole outfit into a snappy ensemble. Styles this extravagant were quick to catch the attention and derision of traditionalists, especially from those in the Church

who saw fancy shoes as nothing more than a flagrant demonstration of wild morals. One chronicler writing in the early 1360s described these pointed toes as more like 'the talons of a demon than the ornaments of men', and opined that their pride-fuelled wearers were nothing short of waifish posers: 'In the hall they are lions but in the field they are rabbits.' Better to be rabbits on points, some argued back, than to wear the blunt *kuhmhal* or 'cow's mouth' shoes that followed these *poulaines* in the fifteenth-century, bringing toe fashion flat-endedly full circle.

For all that a demon-talon toe was over the top and the cow's mouth a bit bland, both would have been favourable to no shoes at all, especially given a common medieval association of bare-footedness with crime. Stripping prisoners of their shoes was a common tactic used by authorities to slow a runner down should they ever shed their chains and try to flee. And it also featured heavily in the performance of a criminal's punishment. Men and women might be ordered to walk without shoes for vast distances across the countryside, sometimes carrying heavy objects and wearing their bared feet down to bloody stumps. Jews, in particular, were singled out for barefooted shaming, especially in northern Germany, where legal records testify to them being forced to stand without shoes on the stretched skin of a pig while swearing oaths in court. Such humiliation equated the Jews, in fact all barefoot condemned, with more general forms of unclean living. The Egyptian theologian and legal thinker Ibn al-Hajj (c.1250–1336) wrote with horror about the dirty feet of food sellers in his native Cairo. The streets of most large medieval cities were cleaned more regularly than we might expect, but could still at times become extremely unpleasant, filling with detritus and horse manure from passing wagons. Mamluk bakers, to al-Hajj's dismay, were apparently perfectly happy to walk to and from work with no shoes at all, returning to their ovens without washing, their feet caked in grime and surely polluting their wares.

In other contexts the shameful potential in bare-footedness could actually be quite useful. It was the marker of a particularly penitential mindset. Just as the elongation of elaborate shoes to some critics exhibited a certain moral recklessness, so the removing of one's shoes could mark a particular moral seriousness. Should the same rulers who were

so keen to have their feet kissed ever wish in return to perform public pious acts for their subjects, they could turn to a number of useful shoeless biblical narratives for ideas. Several European kings annually tried to recreate a Christological model of humility by following the Gospels' description of Christ washing the feet of the Apostles at the Last Supper. In a ritual not dissimilar to their miraculous curing of the scrofulous sick through the touch of their royal hands, on the Thursday of Holy Week these sovereigns could take it upon themselves to wash the feet of beggars. For some this seems to have been a genuinely honest act of penitence, with the ruler divesting themselves of their royal garb and soaping up the feet of the poor. But, predictably, for others it was more gesture than gospel, choosing only the cleanest paupers for the ritual, their feet having been carefully pre-washed before meeting with the monarch's semi-sacred hands.

Royal acts like this were matched in a more humble way in monasteries and convents, where groups of monks and nuns also undertook to wash the feet of the poor and each other, a gesture of spiritual equity among those cloistered together. The records of Syon Abbey, founded just west of London in 1415, suggest that the community there gathered at important moments in the religious calendar to sing prayers and watch their abbess wash her nuns' feet, a performance that we are told was '*kepte for a perpetual memory*' by the sisters. Christ himself had, after all, carried the cross to Calvary barefoot, and saintly models had long equated wearing no shoes with a divestment of material things in favour of divine truth. Franciscan monks, like those painted kneeling in front of Duccio's Virgin, would traditionally have walked barefoot in imitation of their order's founder, Saint Francis of Assisi (1181/2–1226), the group known colloquially in German lands as the *Barfüsser*, the 'barefooted'. Even people not normally taken by regular shoeless penance could be convinced to swear it in return for holy help. Beuve de Hantone, the swashbuckling hero of a popular thirteenth-century Anglo-Norman romance poem, is at one point in his epic narrative captured by his ruthless enemies and clad in shackles. Appealing to God, he cries out in the hope of being miraculously cut loose from his chains, vowing that he

will undertake a spiritual journey to the Holy Land in return for his freedom:

> *He dieus!... par la vostre bonté,*
> *Glorious sire, et cor me delivrés!*
> *Au saint sepulchre u vos fustes posés*
> *Vous requerrai nus piés et san sollers.*

> Oh God! … through your goodness,
> Glorious sir, and heart deliver me!
> At the Holy Sepulchre where you were placed
> I will seek you with bare feet and without shoes.

The chains, of course, break: physical proof of the sanctity that could be conjured up by something as simple as a barefoot promise.

By Foot, By Horse, By Sea

The poetic tale of Beuve de Hantone does not tell us whether our hero ever actually took a moment off from slaying giants, evading pirates and searching out his beloved horse Arondel to visit the Holy Sepulchre and enact his pilgrimage. In fairness, if the records of real medieval people are anything to go by, such a journey would have been a substantial and difficult undertaking. Reaching Jerusalem to see its miraculous sights was extremely time-consuming, expensive and treacherous. From a major western seaport such as Venice it could take anywhere between two weeks and several months to arrive at the Levantine coast, where a pilgrim might alight in the port cities of Acre, Caesarea or Jaffa. And from there Jerusalem was, as the twelfth-century Archbishop William of Tyre estimated, 'still some twenty-four miles inland', nestled high up in rolling hills.

Clearly, William thought this to be some stretch away from the sea, although exactly how far his 'miles' measured is hard to say now. Terms for distance, both big and small, were not standardised in the

Middle Ages and could vary significantly from place to place. A Swiss *toise* was nearly but not quite the same as a Danish *rode*. An Arabian *mil* (الميل) was based on distance, but a Persian *farsang* (فرسنگ) was based on time travelled. A Portuguese *legoa* was about half a kilometre either shorter or longer than a Spanish *legua*, depending on where in Spain you asked. Most measures at least tried to come back to the universal of the body, specifically the feet. Latin geometrical handbooks which emerged around the eleventh century list a 'half-foot' (*demi-pes*), 'foot' (*pes*), and 'step' or 'pace' (*passus*) as units, with many others derived from this bodily basis: a 'mile' was a thousand paces, while a 'land league' was theorised as the distance covered in an hour by a man walking consistently at an average speed. These helpfully tallied with some earlier classical names for measures, but, more importantly, they also mapped onto the most common mode of medieval travel. Finding a horse, keeping it fed and watered, purchasing a carriage, repairing it after a bumpy ride: these were expenses well beyond the means of all but the most wealthy. Instead, the vast majority of journeys would be undertaken by foot.

In the Roman world, the stability brought by having continuous lands under the same imperial rule had coupled with a strong civic infrastructure to ensure a network of well-kept, safe roads for walking and riding across the Mediterranean. With the break-up of this empire and a return to a more fractured and rural mode of living, it was not hard for grey spots to emerge in both the maintenance of highways and their protection under the rule of law. Travellers' accounts from the Middle Ages warned of the ease with which a cart's wheels or axels could crack in the divots of an unsuitable street. And they often lamented the perils of being held up by highwaymen when travelling by horse or on foot. Furious letters written to ruling kings and nobles report being robbed at knife-point of their possessions, and local laws sometimes even called for roadside trees and bushes to be kept pruned a distance back from thoroughfares to remove any convenient hiding places from which bandits might be able to ambush.

Travel by river or sea was often speedier over longer distances, but not necessarily any safer, especially given the potential for choppy

waters, storms and shipwrecks. It is no coincidence that the Venetian Republic, a city-state that thrived on its cross-continental shipping trade, contained both Europe's largest shipyards and some of its earliest banks, who innovated the first monetary mechanisms of insurance and credit to support the extreme risk of traders' world-hopping ventures. Sailors were the travellers whose lives were at the whim of nature's very fiercest elements. Consider the terrifying language used to describe a ferocious moment on the Irish Sea in one Old Gaelic poem, perhaps written by the eighth-century Ulster poet Ruman mac Colmáin:

Anbthine mór ar muig Lir
a dána dara a h-ardimlibh
at-racht gæth, ran-goin gem garg
cu tét dar muir mórgelgarb
dos-árraid ga garggemrid

Ó do-chuir an gæth atúaid
co dúthracair tuinn temen-crúaid
co m-bad fri domun an-des
fri fithnem ro ferad tres
ró ésted fri elechdúain

Ra lá tonn trén a trethan
dar cach inber íarlethan
da-rócht gáeth, ran-goin gem gel
im Cend Tíre, im Tír n-Alban
silid drib lán slíabdreman

Mac Dé athar, adblib scor
rom-ain ar gráin garg-anfod!
Fíadu fírén na Flede
acht rom-ain ar anside
ar h-iffirn co n-ardanfod!

A great tempest upon the plain of the sea,
Bold across its high borders.
Wind has arisen,
Fierce winter has slain us.
It has come across the sea.

When the wind sets from the north
It urges the dark fierce waves
Towards the southern world,
Surging in strife against the white sky
Listening to the song.

The wave has tumbled with mighty force
Across each dark broad river-mouth.
Wind has come, white winter has slain us,
Around Cantire, around the land of Scotland.
Sliab-Dremon Mountain pours forth a full stream.

Son of God the Father, with vast hosts,
Save me from the horror of fierce tempests!
Righteous Lord of the Feast,
Only save me from the horrid blast,
From Hell with high tempest!

Those who had to take the risk of long-distance travel were at least aided by several long-standing navigational technologies. The compass was reliably manufactured in Europe from the thirteenth century onwards, and a busy local knowledge of traditional routes of passage over land and sea would have been passed down by mountaineers and sailors from generation to generation. More archaic yet still accurate mechanical means had also been around for a millennium or so in the form of the classical astrolabe, a circular clinometer that enjoyed particularly widespread use on all sides of the medieval Mediterranean. It was constructed of a flat disc or tympan which had marked upon it concentric altitudinal measurements, on top of which sat a

76. A Persian brass astrolabe, made around 1000 and inscribed on the
reverse with the names of its makers, 'Ahmad' and 'Muhammad'.

more elaborate moveable framework of pointers known as a rete. By
hanging the small machine in front of the eye and aligning its constitu-
ent parts, travellers could measure their location with relative accuracy
by calculating the positions of celestial bodies, triangulating themselves
using local time and latitude. These useful instruments could be made
simply out of paper or parchment: Geoffrey Chaucer wrote a short
text addressed to a boy named Lewis, probably his son or godson,
showing in detail how this might be done. But most astrolabes which
survive attest to a far greater level of professional craft and skill. Made
of carefully decorated metal, they were less travellers' aids than tech-
nological statements in their own right. One surviving Persian piece,
made around the year 1000, is particularly delicate. Formed of brass,
it is covered in aesthetic flourishes from its shell-patterned handle to

its intricate rete, while on its reverse an inscribed signature hints at a once thriving community of specialist instrument-makers: 'Ahmad and Muhammad, sons of Ibrahim, maker of astrolabes from Isfahan'. These large and expensive objects flaunted the easy possibility of movement for the elite, while at the same time presenting the advanced cosmological and geographical knowledge of their age in the most elaborate way possible.

All this is not to say that medieval people without money permanently stayed put. True, an average man or woman might have only occasionally strayed beyond the immediate confines of their native towns and cities. But there were still certain opportunities that they could take to explore more of the world. Soldiers marched on foot over vast distances in the employ of the army, and perhaps the biggest motivator of long-distance travel was not privilege or politics but piety. Pilgrimages like those promised by Beuve de Hantone were a significant draw for rich and poor alike, and accounts survive which suggest that the Middle East attracted aspiring religious travellers from the very furthest extremes of the inhabited world. The Holy Land itinerary of the twelfth-century Christian pilgrim Sæwulf, whose Anglo-Saxon name suggests an English origin, tells of his journey to Jerusalem from the far north-west of Europe. And accounts by Muslim travellers such as the Moroccan explorer Muhammad ibn Battuta (1304–1368/9) or the Chinese diplomat Zheng He (鄭和, 1371–1433) attest to even further travel from north-west Africa and the extreme Far East.

These few written accounts, though, are rare, and we are mostly forced to trace the droves of pilgrims descending on foot to the Levant through the material markers they chose to leave behind. The Church of the Nativity in Bethlehem is one such example. This was one of the very earliest large-scale Christian basilicas to be built, constructed in 326, during the reign of the emperor Constantine, over the supposed site of Christ's birth. Throughout the Middle Ages it was regularly reformatted, suggesting a busy pilgrimage presence: the emperor Justinian renovated the site around the year 530, it was redecorated again in the twelfth century, and fitted with a new roof in the fifteenth. Today, too, changes continue. The control of the building is split between

77. A photographic negative from the 1930s showing the interior of the Church of the Nativity, Bethlehem, including its columns with their fragmentary pilgrimage paintings.

a number of different Christian denominations – Roman Catholic, Armenian Orthodox, Greek Orthodox – each of whom practise their claims to administer, clean and worship in the space with subtle distinctions. Petty differences have sometimes erupted into outbreaks of serious aggression between the parties and even mass brawls involving scores of monks. But despite this daily tension, and what is getting on for two millennia of refurbishment and violence, the church still preserves a faded testament to the diversity of the medieval Holy Land's visitors.

It is hard to see them through the bright light streaming in from the high windows, and beneath its layers of accumulated grime, but at the top of around half of the building's twenty-two columns is a network of paintings. Appropriately for their hallowed surroundings, each column boasts a frontal figure of a saint or the Virgin paid for by a different pilgrim visitor, probably all made at some point while Bethlehem was under Crusader rule. The Latin Kingdom of Jerusalem, as this Crusader state was known, was founded after the successes of the First Crusade in 1099 but was only relatively short-lived, shrinking from a once substantial strip of territory across the eastern Mediterranean to just a few cities a century later, and to virtually nothing by 1300. Surviving remnants such as the Bethlehem columns, however, prove just how important this territory was to these western invaders. Some of these paintings are of figures closely identified with the Holy Land that the Crusaders had striven to recapture. Sketched in an imported western style we find John the Baptist who had blessed Christ in the nearby River Jordan, Saint Sabas, the founder of several fifth-century Levantine monasteries, and the hermit Saint Onuphrios, who had spent all of his spiritual life fasting in the nearby Egyptian desert. But we also find paintings that represent the far-off Byzantine world, iterations of Mary in various iconic guises, from the Virgin *Glykophilousa* (Γλυκοφιλούσα, 'of the Sweet Kiss'), showing the mother and child exchanging a tender embrace, to the more dramatic Virgin *Hodegetria* (Ὁδηγήτρια, 'pointing the way'), where Mary gestures towards Christ, intimating with bittersweet irony his role as the saviour of mankind. On two more columns we even find Saint Olaf and Saint Knute, tenth- and

eleventh-century Norwegian and Swedish kings, testimony to patrons who had travelled to Bethlehem from as far afield as Scandinavia. That these diverse peoples all came together to invest spiritually in the decoration of this building – commemorating their distant homelands in the process – tells a vivid a story of the church as a place of passionate remembrance for pilgrims from far-flung lands who had all thrown caution to the wind and braved the elements to congregate in a single sacred spot.

Opposite Feet

A pilgrimage across continents to imbibe the spiritual aura of sacred spaces would be a once-in-a-lifetime event for most people, the furthest their medieval feet would ever carry them. Some travellers, though, took up a sense of adventure as a professional obligation. These medieval explorers and authors preserved some of their more spectacular journeys in a series of remarkable travelogues which still survive today in various versions. They recorded with wonder the extraordinary cultures they came across and the strange architecture of cities they visited. Some even spoke of lands so distant that they described them as *antipodes*, literally 'opposite feet', a world of peoples who lived so dramatically far around the globe they stood on an earth completely inverted.

The work of someone like Benjamin of Tudela (c.1130–1173), a Jewish author born in northern Spain, gives a sense of the richness of these surviving stories. In his *Travels of Benjamin* (מסעות בנימין) the author records a fantastically wide-ranging journey. Beginning in Spain, he travels north-east through southern France, down along the western coast of Italy via Rome and across Greece to Constantinople, all the while recording a snapshot of European peoples and places. We hear rich descriptions of the turreted houses of Pisa, the imperial palaces of Greece and the shining flagstones of the Byzantine capital. Geography is vividly brought to life too, from mountain ranges and rivers to islands and vast beaches. And he recounts an array of cultural

events: vicious mule and bird fights in Rome, community enterprises to feed the sick in Montpellier, and meetings with hundreds of rabbis, lawyers, physicians and other intellectuals en route. But Benjamin did not stop at Constantinople. Continuing southwards through the Holy Land, he then turned east and journeyed to Mosul and Baghdad, travelled south again deeper into the desert and then north to Basra. He admired the fact that in Okbara, a city on the Tigris, there were some 10,000 Jews compared with only 300 in a western city like Marseilles. And after nearly eight years of wandering the globe, Benjamin chartered a ship around the entire Arabian Peninsula to tour Egypt, before finally sailing westwards to Sicily and returning to his native Iberia to publish his travels. Perhaps appropriately for such a well-voyaged man who had searched out Jewish communities across large stretches of the globe, he ends by reiterating a plea from Deuteronomy, asking God to 'return and gather the People of Israel from all nations whither he has scattered thee. Amen. Amen. Amen.'

Other travellers, such as the thirteenth-century Venetians Niccolò and Marco Polo, or early Arab explorers such as the adventurous Muhammad al-Muqaddasi (c.946–991), shed even greater light on the criss-crossing routes that could be taken across the medieval Mediterranean and even further afield. More than anything, they narrate a bewildering multitude of cultural exchanges. As these virtual strangers stumble into worlds previously completely unknown to them, they inevitably take on a distinct tone of wonder, marvelling at the distant fruits of the earthly antipodes. So vivid were these authentic accounts that they inspired a market for more fantastical books written somewhat closer to home. A text like the popular *Travels of John Mandeville* claims to offer an account by its eponymous fourteenth-century English knight who covers, in his own words, the 'many diverse manners of folk, of diverse laws and shapes' stretching from Europe and the Middle East across China and Africa. For all it is presented as fact, however, this piece is almost certainly a work of the imagination. For one, the historical figure of John Mandeville appears nowhere in contemporary sources. And even more suspiciously he records both far-off cultures and fantastical beasts of a variety of shapes and sizes.

In fact, the routes John takes and sights he comes across seem to have been cribbed exclusively and sometimes verbatim from both available accounts of earlier explorers and from classical writings. What we have here are two completely different medieval approaches to geographical knowledge. On the one hand, someone like Benjamin is presented as painstaking in his accuracy. A Hebrew preface to his narrative states clearly that 'after strict inquiry, Benjamin's words were found to be true and correct, for he was a true man'. Mandeville's *Travels*, on the other hand, are tales spun by an armchair traveller. The medieval reader is left to decide whether to see him as duplicitous, working his creative brain and not his travelling feet, or simply playful, writing in inventive ways within a new genre of literary travel fiction.

Lying somewhere between these two registers of real and mythic travel is the complicated testimony of medieval maps. In the Middle Ages these were rarely documents that voyaging pilgrims or travel writers could have used to plan their routes, neatly plotting out future journeys in measures of feet and paces across their decorated surface. Instead, they were things far more concerned with principles than practice. Theories of cartography had thrived in the Arabic-speaking world from its earliest days, producing foundational works attributed to thinkers like the Central Asian writer Abu Zayd al-Balkhi (c.850–934) or the Persian geographer Muhammad al-Istakhri (d.957). Far from the much-propagated idea that people in the Middle Ages believed they inhabited a flat earth, ancient Greek geographers had long before proven not only that the globe was a complete sphere but that the regions of Europe, Africa and Asia – what they called the *oikumene* (οἰκουμένη), the inhabited world – constituted only around a quarter of the planet's total surface. Building on these theories, early Arabic thinkers like al-Balkhi and al-Istakhri wrote extensive treatises in a tradition later known as the *Kitab al-masalik wa-al-mamalik* (كتاب المسالك والممالك), 'The Book of Routes and Realms'. These manuscripts both discussed the world's size and shape, and offered abstract visualisations of vast areas of the globe through a series of up to twenty-one detailed maps. These included, among others, plans of

78. A colourful thirteenth-century rendering of
Sharif al-Din al-Idrisi's World Map.

the Arabian Peninsula, the Indian Ocean, north Africa, regions of
Iran, and various seas and rivers, as well as a grand, richly coloured,
totalising image of the entire known world shown as a complicated
circular whole.

Advanced geographical knowledge like this was soon being
exported out from the Arabic world, sought by all sorts of medieval
elites. It was an intellectual interest that could cross traditionally strict
cultural and religious boundaries. The Muslim Moroccan geographer
Sharif al-Din al-Idrisi (c.1100–1165) was commissioned in the 1150s to
create a complete atlas of the known world by the Christian king of
Sicily, Roger II. Copies of this book still survive, although at first glance
the opening image from al-Idrisi's text does not look like anything we
would describe as a map. A version now in Cairo, painted in 1348,
seems more of a constructivist jungle of abstract shapes and patterns:
the circular world is enshrined by a band of blue water, the uncoloured
lands punctuated by bright curved spots of mountain ranges, lakes and

the thin lines of rivers. But the placement of these details is far from random. Unlike the modern decision that north should sit at the top of a map – an idea which, after all, comes from a totally arbitrary historical consensus – these early Islamic maps are instead oriented with south at the top of the page. It is as if they visually echo the antipodean wonder expressed in contemporary travellers accounts: flip the whole scheme 180 degrees and you soon begin to recognise the dots of the British Isles and western Europe, a broad Eurasian land mass and an enlarged Arabian Sea merging into the Indian Ocean, bounded by an unusually curved African coastline. Plotted by medieval theorists over a millennium before such images could actually be seen from space or verified by precise satellite mapping technologies, they present a geographical picture of the world at once staggeringly accurate and playfully colourful, familiar yet strange.

It is interesting to compare these Arabic images with another map made at almost precisely the same time as the colourful image from Cairo. The Catalan Atlas, as it is now known, was drawn and painted in 1375 by a mapmaker from Majorca named Abraham Cresques. Here cartography again had no trouble crossing cultural boundaries: Abraham was a Jew, commissioned by the king of Aragon, Pedro IV, to make the map for King Charles V of France, both Christian rulers. Yet, just like the contrasting styles of the travel accounts written by Benjamin of Tudela and John Mandeville, this map seems to be interested in something slightly different from al-Idrisi and his Arabic forebears. It is certainly accurate. Across its eight leaves, this time oriented with north at the top, we see the whole of Europe, north Africa and Asia, their precise coastlines derived from complicated compass points plotted onto the map in a web of thin black lines. But at the same time Abraham also insistently presents a far more fantastical view of the world. As well as geographical features – the Red Sea, literally rendered red, or the Atlas Mountains running across north Africa, realised as a thin band of humps drawn out like a giant chicken-leg – the map is populated by animals, peoples and historical events that float in both space and time. The Three Kings happily pass by an elephant en route to Christ's nativity. Mansa Musa, the late medieval king of Mali, sits in

79. The eight map leaves of the Catalan Atlas, made by
Abraham Cresques in 1375.

the centre of Africa holding an enormous gold coin, a reference to the
wild tales circulating of his almost inconceivable levels of wealth. And
in the Far East a shimmering archipelago of red, green, blue and golden
islands is interspersed with naked figures eating fish and a double-tailed
mermaid, symbols at once of both the paradisiacal bounty and fearful
monsters lurking at the world's edge.

These distorted bodies included by Abraham bring us back to the
very beginning of this book and the headless figure of the Blemmyae.
They too parade their unnatural forms up and down the coast of Africa
on these wild world maps alongside troops of other-worldly monstrous
races, one of whom even seems to refer knowingly to the absurdity of
living at the 'antipodes': as if to signify the upside-down ground on

which they walked, the men of a mythic country named Abarimon are shown with feet growing in the wrong direction, protruding behind them from their calves so that they in effect walk backwards. But as well as revelling in the strangeness at the extremes of the medieval world, by reducing the glorious bounty of the globe so that it could be held in the hand, such maps were, at least in part, designed to inspire. Those lucky enough to see these rich documents might well have felt compelled to take to their feet: rulers to set aside the political pageantry of foot-kissing and voyage afar to conquer new lands, pilgrims to don their leather shoes and search out the promise of distant holy cities, or explorers to grab their pens and journey for years in search of never-before-seen wonders.

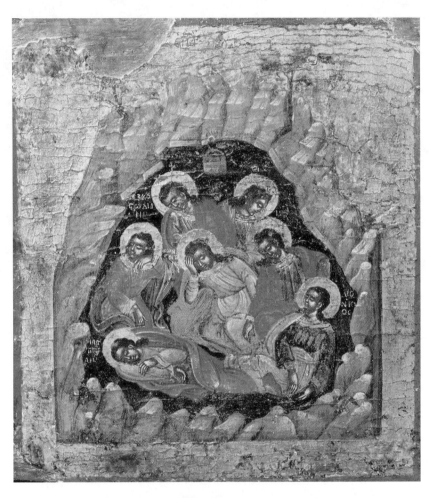

80. The Seven Sleepers of Ephesus, depicted with a shimmering gold background in a sixteenth-century icon painted in Crete.

FUTURE
BODIES

There will always be more to say about the medieval body. Like bodies today, the more closely we look, the more we realise that all sorts of patterns are appearing before our eyes. This book has only scratched the surface of the different ways in which people of the past saw themselves. Their human forms were at once a place for debating and developing the complicated theories of the ancients, a conduit for sensual engagement with the world around them, a stage for performing a cacophony of different sexual, religious and racial identities, and a canvas for aesthetic ideas, from ugliness and pain to the most ecstatic beauty. The body was everything to everyone.

Throughout the Middle Ages people tried to predict what would happen to their own bodies in the future. Spiritual thinking supplied various solutions to the perilous uncertainty of times to come. Eschatological prophecies both biblical and contemporary promised thunderous revelation, moral judgement and the revival of corpses for either fearsome damnation or salvation in an eternal messianic age. Secular literature similarly dreamed of parallel futures: in the fantastical, almost sci-fi tale of the Seven Sleepers of Ephesus, retold across

Europe and the Middle East from the sixth century onwards, a group of men seal themselves in a cave overnight, awaking only to discover that they have somehow slept for three hundred years. Medieval philosophers, too, grappled with abstract questions of the world to come. Can we ever truly know the nature of change? Is the future handed down to us by fate, divine or otherwise? If so, do we ever really have any freedom, any choice in our actions? Or can we somehow bend this ordained true path to point in any direction we want it?

By the beginning of the sixteenth century this medieval world was indeed poised to change significantly. A whole host of ideas that had been unshakable for centuries were on the turn. In 1492 Spanish ships crossed the Atlantic, bringing back news of an entirely new continent. Between 1497 and 1499 Portuguese sailors rounded the southern tip of Africa, reshaping centuries-old maps and forging vital new sea routes to the Far East. And in 1522, some two thousand years after the idea began to be floated by the ancient Greeks, the first maritime circumnavigation of the planet proved for certain that the earth was a sphere. All sorts of other fixities were likewise flipping and tumbling. From 1512 the reigns of Selim I and Suleiman the Magnificent saw the Ottoman Empire grow with speed, unifying vast swathes of eastern Europe, Anatolia, the Middle East and north Africa for the first time in centuries. Meanwhile, in western Europe, religious and political allegiances were being completely redrawn after Martin Luther's publication in 1517 of his 'Ninety-Five Theses', effectively kick-starting the Reformation and setting the Catholic Church on the road to schism. Medicine, too, expanded in this era of new horizons. Ingredients available from the New World were combined with novel forms of experimental chemistry espoused by the dynamic and controversial Swiss physician Paracelsus (c.1493–1541), leading to a shift away from the four classical humours towards a broader array of pharmaceutical cures. And a new wave of exploratory anatomists, among them the Italian Jacopo Berengario da Carpi (1466–1530), the Frenchman Charles Estienne (c.1505–1564) and the Netherlander Andreas Vesalius (1514–1564), began to open the body with revived interest, intent on observing afresh what they actually saw beneath the skin.

81. An anatomical diagram of a man and a woman, probably printed in London in 1559. The figures are presented with folding flaps of anatomical details that the viewer could peel back layer by layer to uncover the interior beneath. The woman holds a small sign bearing the Latin dictum *Nosce te ipsum*, 'Know thyself'.

Few medieval thinkers had divined any of these things in their future, and perhaps as a result they are often swept away in the wake of the sixteenth century's narrative of dramatic change. I began this book by thinking about how our view of historical moments like the Middle Ages can end up saying as much about the present as it does about the past, but this is equally true of the early modern era that followed it.

Just as the term 'medieval' tends today to be conflated with a certain muddiness or backward way of thinking, so too have we set the 'renaissance' up to be nothing but a success. In its very name it is presented as a rebirth, a period of life following a period of death, in Francesco Petrarca's words the moment 'when the darkness has been dispersed'. We admire this generation for their quick turnover of ideas because that is what we, at least for the last century or so, have admired the most in ourselves, in our own change-driven modern society. They seem to be asking the questions we would ask, rolling back boundaries, pushing for the new and the innovative. The argument for the Middle Ages rests on a different set of far less glamorous standards: continuity, consistency, reflection, an ability to keep an idea alive come good times and bad. But we must not forget that looking back and looking forward are complementary things. Without medieval people preserving the classics in their copies and commentaries from Baghdad to Constantinople to Salerno to Paris, early modern people would have been left with little of substance to so dramatically rethink.

What, then, is the future of our understanding of medieval bodies? This, I think, also hinges on looking simultaneously backwards and forwards, keeping one eye on the past and the other on what is coming up ahead. Our world is evolving more quickly than at any time in history, even by the seemingly chaotic pace of the sixteenth century. And we are now able to combine the slow, meticulous process of research into the past – careful readings of art, poetry, religious texts, folk stories, medical cures – with rapidly developing technologies to push our discoveries in all sorts of unforeseen directions.

We also have more and more medieval bodies to hand. The Museum of London's Centre for Human Bioarchaeology holds the partial skeletons of over 20,000 people from various periods that have been revealed from the capital's core, and similar finds continue all the time in the most inauspicious of places. In 2015 excavations in the basement of a Paris supermarket turned up some 200 medieval bodies at the site of a former hospital. In 2016 planned extensions to Aberdeen's Art Gallery revealed at least 92 bodies, probably buried on the site when it was a thirteenth-century friary. In 2017 excavations were completed in

82. A plague pit containing 48 medieval skeletons, discovered on the site of a
fourteenth-century monastery hospital at Thornton Abbey in Lincolnshire.

Rome on a group of 38 graves, part of a small medieval Jewish cemetery
found after renovation work to the new headquarters of an insurance
company. And this is more than just an urban phenomenon. After a
particularly stormy winter in the Irish town of Collooney, in County
Sligo, strong winds toppled a 215-year-old beech tree which dragged
with it from the ground the body of an eleventh- or twelfth-century
boy whose skeleton had become entangled in its growing roots.

If properly catalogued and cleaned, a wealth of information can
be found just by looking at these medieval remains. Most obviously,
abnormal bones tell a rich tale. Unexpected breaks, fractures and other
damage might point to a severe bodily trauma, suggesting particu-
lar and often violent causes of death. And more benign deformities
of fused or worn bone could indicate that an individual had lived for
some time with certain categories of joint problem or congenital issues
that warped the bones, telling us something of the conditions that they
enjoyed or endured in life. More recently, however, developments in

increasingly sophisticated types of technical analysis mean that we can learn even more detail of past medieval lives. Since the 1980s, bioarchaeologists have been getting better and better at searching the densest, best-protected parts of skeletons, like the pulp of the teeth or the temporal bone located in the skull behind the ear, for preserved samples of ancient DNA. This aDNA, as it is known, can be extracted, amplified, sequenced into the correct order and compared with other historical and modern examples to present a unique profile of the skeleton sampled. Even from the most fragmentary of remains we can now tell a person's sex, their likely geographical or ethnic background and whether or not they suffered from certain genetic diseases such as cystic fibrosis or anaemia. Studies can even run similar tests on the aDNA of the microscopic bacteria that once inhabited the fibres of these historical bodies, a process that has revealed a range of historic strains from plague to tuberculosis to leprosy.

Such groundbreaking techniques are not only at work on skeletons either. Methods like this can help us uncover new stories about every type of object mentioned in the chapters of this book. The parchment pages of manuscripts or the leather of historic shoes can be tested to discover what kind of animal they were formed from and where they were bred. The cloth of ancient textiles or the wood of holy relics can be traced by their dyes or plant matter to particular times and individual regions of the medieval world. Sometimes in these researches objects are even treated just like bodies. In 2007 the large thirteenth-century casket reliquary of Saint Amandus, a seventh-century bishop of Maastricht, underwent investigation in the technical department of its current home at the Walters Art Museum, Baltimore. To find out more about the piece, the gloved hands of conservators cut away small sections of the reliquary's copper skin from its wooden core with blades and scalpels. Its metal plaques were investigated microscopically, in the manner of skin or blood samples. And the entire work was then transported to the nearby University of Maryland Medical Center, where it was placed inside a Computed Tomography X-ray scanner, a machine normally reserved for living Baltimore citizens. The results were analysed for clues about the reliquary by both the Walters conservation

83. The twelfth-century casket reliquary of Saint Amandus being scanned in a
Computed Tomography X-ray scanner at the Maryland Medical Center, Baltimore.

team and a group of diagnostic radiologists from the Medical Center
itself, doctors and historians in dialogue.

This is the future of medieval bodies. Like centuries-old patients,
we examine objects and human remains alike with care. We search out
their case histories, trawling through the archives to find fragments
of information that help us begin to build up a picture of their past
lives. We send their samples to the lab for analysis, using sophisticated

processes to help us draw the net tighter. And then, pooling together all of this expertise, we diagnose them: sixth-century, Arabic, female, silver, painted, German, thirteenth-century, male, Egyptian, alabaster and so on. Like the Seven Sleepers of Ephesus, these are bodies that have not been roused for centuries. Now they are awake and chattering like never before.

ACKNOWLEDGEMENTS

I would like to thank my careful and extremely generous editors Cecily Gayford and Kirty Topiwala; Taylor McCall, Jocelyn Anderson and Jessica Barker for casting their expert eyes over some or all of this manuscript; the production and design staff at Profile Books and Wellcome Publishing; Sophie Scard, Lisa Toogood and Caroline Dawnay at United Agents; Rania Jaber, Roland Betancourt and Maggie Breidenthal for their advice on translation; my many inspiring colleagues and students at The Courtauld Institute, Columbia University and the University of East Anglia; and lastly my family and friends, especially Anne Chmelewsky for her constant love and support, without which this book would never have been written.

BIBLIOGRAPHY

The ideas explored in this book have been informed by the work of researchers from many different academic fields, writing in various languages, who focus their attention on multiple topics, regions and moments within medieval culture. The bibliography below provides a brief, selected list of further reading, all in English, drawn from this diverse scholarship. It first surveys the general themes of medieval history, medicine and art, before then giving more specific references relating to material from each of the book's bodily chapters in turn. Some of these resources tend towards the academic, but where possible I have listed introductory works for a general reader which themselves include their own extensive bibliographies.

Although what follows can only begin to scratch the surface, I hope it gives a flavour of this busy field and offers you a chance to investigate medieval bodies even more closely in a number of different directions.

General Reading

Several works offer a useful outline of the medieval period from its beginnings through to the renaissance. For broad handbooks and encyclopedias, each with individual entries on numerous topics, see: A. Classen (ed.), *Handbook of Medieval Culture* (2015); R. A. Johnston, *All Things Medieval: An Encyclopedia of the Medieval World* (2011); R. E. Bjork (ed.), *The Oxford Dictionary of the Middle Ages* (2010); J. W. Meri (ed.), *Medieval Islamic Civilization: An Encyclopedia* (2005); N. Roth (ed.), *Medieval Jewish Civilization: An Encyclopedia* (2003); and A. Vauchez (ed.), *Encyclopedia of the Middle Ages* (2000). For more narrative histories see: M. Rubin, *The Middle Ages: A Very Short Introduction* (2014); C. W. Hollister and J. M. Bennett, *Medieval Europe: A Short History* (2005); and R. W. Southern, *The Making of the Middle Ages* (1993). For a view of medieval everyday life see: R. Gilchrist, *Medieval Life: Archaeology and the Life Course* (2012); J. Gies and F. Gies, *Daily Life in Medieval Times* (1999); and J. Le Goff, *The Medieval World*, trans. L. G. Cochrane (1997). For the pitfalls of coming to the Middle Ages from a modern perspective see: S. Harris and B. L. Grigsby (eds), *Misconceptions about the Middle Ages* (2007).

Medieval medicine has also been outlined through several introductory studies, each of which offers an engaging overview of medical thought in the Middle Ages. For long, broad histories of medicine from antiquity onwards see: M. D. Grmek (ed.), *Western Medical Thought from Antiquity to the Middle Ages* (1999); and L. I. Conrad et al., *The Western Medical Tradition: 800 BC to AD 1800* (1995). For a more specific focus on the medicine of the Middle Ages see: L. Kalof (ed.), *A Cultural History of the Human Body in the Medieval Age* (2014); L. Demaitre, *Medieval Medicine: The Art of Healing, from Head to Toe* (2013); P. E. Pormann and E. Savage-Smith, *Medieval Islamic Medicine* (2007); T. F. Glick, S. J. Livesey and F. Wallis (eds), *Medieval Science, Technology, and Medicine: An Encyclopedia* (2005); and N. Siraisi, *Medieval and Early Renaissance Medicine: An Introduction to Knowledge and Practice* (1990). For a diverse collection of various original medieval medical texts, translated into English see: F. Wallis, *Medieval Medicine: A Reader* (2010).

The same is true of medieval art and architecture, with many works offering detailed overviews of different aspects of medieval visual culture. For general introductions see: R. Ettinghausen, O. Grabar and M. Jenkins-Madina,

Islamic Art and Architecture 650–1250 (2003); L. Nees, *Early Medieval Art* (2002); N. Coldstream, *Medieval Architecture* (2002); V. Sekules, *Medieval Art* (2001); R. Stalley, *Early Medieval Architecture* (1999); J. Lowden, *Early Christian and Byzantine Art* (1997); and M. Camille, *Gothic Art: Glorious Visions* (1996). For medieval art and its relation to medicine in particular see: J. A. Givens, K. M. Reeds and A. Touwaide (eds), *Visualizing Medieval Medicine and Natural History, 1200–1550* (2006); P. M. Jones, *Medieval Medicine in Illuminated Manuscripts* (1998); and J. Murdoch, *Album of Science: Antiquity and the Middle Ages* (1984).

Medieval Bodies

French Half-Man P. Charlier et al., 'A Glimpse into the Early Origins of Medieval Anatomy through the Oldest Conserved Human Dissection', *Archives of Medical Science* 10:2 (2014), 366–73.

'Getting Medieval' K. Biddick, *The Shock of Medievalism* (1998).

Medievalism D. Matthews, *Medievalism: A Critical History* (2015).

Francesco Petrarca V. Kirkham and A. Maggi (eds), *Petrarch: A Critical Guide to the Complete Works* (2009).

Parallel Medieval C. Benn, *China's Golden Age: Everyday Life*

Histories *in the Tang Dynasty* (2002); T. de Bary et al., *Sources of Japanese Tradition, Volume One: From Earliest Times to 1600* (2001); P. Frankopan, *The Silk Roads: A New History of the World* (2015); B Avari, *India: The Ancient Past* (2007); R. Pankhurst, *The Ethiopians: A History* (2001); N. Levtzion, *Ancient Ghana and Mali* (1973); A. Kehoe, *America before the European Invasions* (2002); J. Lee, *The Allure of Nezahualcoyotl: Pre-Hispanic History, Religion and Nahua Poetics* (2008).

Inheritors of Rome C. Wickham, *The Inheritance of Rome: A History of Europe from 400 to 1000* (2009); B.

	Ward-Perkins, *The Fall of Rome and the End of Civilization* (2005).
Byzantium	J. Herrin, *Byzantium: The Surprising Life of a Medieval Empire* (2007); C. Mango (ed.), *The Oxford History of Byzantium* (2002).
Early Medieval Europe	R. Collins, *Early Medieval Europe, 300–1000* (2010); M. Innes, *Introduction to Early Medieval Western Europe, 300–900: The Sword, the Plough and the Book* (2007); J. M. H. Smith, *Europe after Rome: A New Cultural History, 500–1000* (2005).
Islam	V. O. Egger, *A History of the Muslim World to 1405: The Making of a Civilization* (2004); I. M. Lapidus, *A History of Islamic Societies* (2002).
Demography	M. Kowaleski, 'Medieval People in Town and Country: New Perspectives from Demography and Bioarchaeology', *Speculum* 89 (2014), 573–600; D. A. Hinton, 'Demography: From Domesday and Beyond', *Journal of Medieval History* 39 (2013), 146–78.
Climate	B. M. S. Campbell, *The Great Transition: Climate, Disease and Society in the Late-Medieval World* (2016).
John Lydgate	D. Pearsall, *John Lydgate (1371–1449): A Bio-Bibliography* (1997).
Lincolnshire Skeletons	T. Waldron, *St Peter's, Barton-upon-Humber, Lincolnshire: A Parish Church and its Community, Volume 2, The Human Remains* (2007).
Black Death	M. H. Green (ed.), *Pandemic Disease in the Medieval World: Rethinking the Black Death* (2014).
Classical Humours	V. Nutton, *Ancient Medicine* (2013).
Balance	Joel Kaye, *A History of Balance, 1250–1375: The Emergence of a New Model of Equilibrium and its Impact on Thought* (2014).
Man and the Cosmos	A. Akasoy, C. Burnett and R. Yoeli-Tlalim (eds), *Astro-Medicine: Astrology and Medicine, East and West* (2008).

Early Islamic Baghdad	A. K. Bennison, *The Great Caliphs: The Golden Age of the Abbasid Empire* (2009); D. Gutas, *Greek Thought, Arabic Culture: The Graeco-Arabic Translation Movement in Baghdad and Early Abbasaid Society* (1998).
Bimaristans and Hospitals	A. Ragab, *The Medieval Islamic Hospital: Medicine, Religion, and Charity* (2015); B. S. Bowers (ed.), *The Medieval Hospital and Medical Practice* (2007).
Universities	H. De Ridder-Symoens (ed.), *A History of the University in Europe: Universities in the Middle Ages* (1992); W. J. Courtenay and J. Miethke (eds), *Universities and Schooling in Medieval Society* (2000).
Surgeons	M. R. McVaugh, *The Rational Surgery of the Middle Ages* (2006); E. Savage-Smith, 'The Practice of Surgery in Islamic Lands: Myth and Reality', *Social History of Medicine* 13 (2000), 307–21.
Guilds	G. Rosser, *The Art of Solidarity in the Middle Ages: Guilds in England 1250–1550* (2015); G. C. Maniatis, *Guilds, Price Formation, and Market Structures in Byzantium* (2009); A. Cohen, *The Guilds of Ottoman Jerusalem* (2001).
Civic Health	C. Rawcliffe, *Urban Bodies: Communal Health in Late Medieval English Towns and Cities* (2013).
Religion	D. Nirenberg, *Neighboring Faiths: Christianity, Islam, and Judaism in the Middle Ages and Today* (2014); J. H. Arnold (ed.), *The Oxford Handbook of Medieval Christianity* (2014); K. Armstrong, *Islam: A Short History* (2000); T. L. Steinberg, *Jews and Judaism in the Middle Ages* (2007).
Magic	D. Collins (ed.), *The Cambridge History of Magic and Witchcraft in the West* (2015); S. Page, *Magic in the Cloister: Pious Motives, Illicit Interests and Occult Approaches to the Medieval Universe* (2013).

Head

Monstrous Races	J. B. Friedman, *The Monstrous Races in Medieval Art and Thought* (2000); A. Bovey, *Monsters and Grotesques in Medieval Manuscripts* (2002); L. Daston and K. Park, *Wonders and the Order of Nature: 1150–1750* (1998); J. J. Cohen, *Monster Theory: Reading Culture* (1996).
Galen	C. Gill, T. Whitmarsh and J. Wilkins (eds), *Galen and the World of Knowledge* (2009); R. J. Hankinson (ed.), *The Cambridge Companion to Galen* (2008).
Ibn Sina	L. E. Goodman, *Avicenna* (1992).
The Brain	E. Clark, K. E. Dewhurst and M. J. Aminov, *An Illustrated History of Brain Function* (1996).
Mental Disability	I. Metzler, *Fools and Idiots?: Intellectual Disability in the Middle Ages* (2016); S. Katajala-Peltomaa and S. Niiranen, *Mental (Dis)Order in Later Medieval Europe* (2014); W. J. Turner, *Care and Custody of the Mentally Ill, Incompetent and Disabled in Medieval England* (2013).
Charles VI of France	R. C. Famiglietti, *The Madness of Kings: Personal Trauma and the Fate of the Nations* (1995); V. Green, *Royal Intrigue: Crisis at the Court of Charles VI, 1392–1420* (1986).
Layla and Majnun	M. W. Dols, *Majnun: The Madman In Medieval Islamic Society* (1992); R. Gelpke (ed.), *Niẓami Ganjavi's Layla and Majnun* (1966).
Hair	L. Demaitre, *Medieval Medicine: The Art of Healing, From Head to Toe* (2013); R. Milliken, *Ambiguous Locks: An Iconology of Hair in Medieval Art and Literature* (2012).
Chaucer	D. Gray (ed.), *The Oxford Companion to Chaucer* (2003).
Beheading	G. Geltner, *Flogging Others: Corporal Punishment and Cultural Identity from Antiquity to the Present*

	(2014); A. Traninger, B. Baert and C. Santing (eds), *Disembodied Heads in Medieval and Early Modern Culture* (2013); D. Westerhoff, *Death and the Noble Body in Medieval England* (2008).
John of Salisbury	C. Grellard and F. Lachaud (eds), *A Companion to John of Salisbury* (2015).
Llywelyn ap Gruffudd	J. Smith, *Llywelyn ap Gruffudd: Prince of Wales* (2014); H. Fulton (ed.), *Urban Culture in Medieval Wales* (2012).
Jean Froissart	P. F. Ainsworth, *Jean Froissart and the Fabric of History: Truth, Myth, and Fiction in the Chroniques* (1990); G. Brereton (ed.), *Froissart's Chronicles* (1978).
Saints	R. Bartlett, *Why Can the Dead Do Such Great Things? Saints and Worshippers from the Martyrs to the Reformation* (2015); P. Brown, *The Cult of the Saints: Its Rise and Function in Latin Christianity* (1981).
Relics and Reliquaries	C. Hahn, *Strange Beauty: Issues in the Making and Meaning of Reliquaries, 400–c.1204* (2012); C. Freeman, *Holy Bones, Holy Dust: How Relics Shaped the History of Medieval Europe* (2011); P. Geary, *Furta Sacra: Thefts of Relics in the Central Middle Ages* (1990).
Theatre and Performance	J. Enders (ed.), *A Cultural History of Theatre in the Middle Ages (1000–1400)* (2017).
Johannisschüsseln	B. Baert, *Caput Johannis in Disco: Essay on a Man's Head* (2012).

Senses

Cluny Tapestries	E. Taburet-Delahaye, *The Lady and the Unicorn* (2007).
Senses	M. Bagnoli (ed.), *A Feast for the Senses: Art and Experience in Medieval Europe* (2016); R. G. Newhauser, *A Cultural History of the Senses in the*

	Middle Ages, 500–1450 (2016); C. M. Woolgar, *The Senses in Late Medieval England* (2006); G. Rudy, *Mystical Language of Sensation in the Late Middle Ages* (2002); W. F. Bynum and R. Porter (eds), *Medicine and the Five Senses* (1993).
Sensory Archaeology	J. Day (ed.), *Making Senses of the Past: Toward a Sensory Archaeology* (2013).
Sight	M. A. Smith, *From Sight to Light: The Passage from Ancient to Modern Optics* (2014); R. S. Nelson, *Visuality before and beyond the Renaissance: Seeing as Others Saw* (2000); D. C. Lindberg, *Theories of Vision from Al-Kindi to Kepler* (1976).
Roger Bacon	B. Clegg, *The First Scientist: A Life of Roger Bacon* (2003); J. Hackett (ed.), *Roger Bacon and the Sciences* (1997).
Eye Anatomy	F. Salmón, 'The Body Inferred: Knowing the Body through the Dissection of Texts', in *A Cultural History of the Human Body in the Medieval Age*, ed. L. Kalof (2014), 77–98; L. Demaitre, *Medieval Medicine: The Art of Healing, from Head to Toe* (2013).
Blindness	E. Wheatley, *Stumbling Blocks before the Blind: Medieval Constructions of a Disability* (2010). M. Barach, *Blindness: The History of a Mental Image in Western Thought* (2001); F. Malti-Douglas, 'Mentalités and Marginality: Blindness and Mamluk Civilization', in *The Islamic World from Classical to Modern Times*, ed. C. E. Bosworth et al. (1989), 211–37.
Quinze-Vingts	M. P. O'Tool, 'The *Povres Avugles* of the Hôpital des Quinze-Vingts: Disability and Community in Medieval Paris', in *Difference and Identity in Francia and Medieval France*, M. Cohen and J. Firnhaber-Baker (eds) (2010), 157–74.
Disabled Persecution	I. Metzler, *A Social History of Disability in the Middle Ages: Cultural Considerations of Physical*

	Impairment (2013); J. R. Eyler (ed.), *Disability in the Middle Ages: Reconsiderations and Reverberations* (2010).
Margery Kempe	B. A. Windeatt (ed.), *The Book of Margery Kempe* (2004); J. H. Arnold and K. J. Lewis (eds), *A Companion to The Book of Margery Kempe* (2004).
Smell	S. A. Harvey, *Scenting Salvation: Ancient Christianity and the Olfactory Imagination* (2006); J. Drobnick, *The Smell Culture Reader* (2006); C. Classen, D. Howes and A. Synnott, *Aroma: The Cultural History of Smell* (1994).
Metalwork	J. Cherry, *Medieval Goldsmiths* (2011); R. Ward, *Islamic Metalwork* (1993).
Saint Irene	J. O. Rosenqvist, *The Life of Saint Irene Abbess of Chrysobalanton: A Critical Edition* (1986).
Smelling Paradise	A. H. King, *Scent from the Garden of Paradise: Musk and the Medieval Islamic World* (2017).
Astrology	S. Page, *Astrology in Medieval Manuscripts* (2002); R. Rashed (ed.), *Encyclopedia of the History of Arabic Science* (1996); R. French, 'Astrology in Medical Practice', in *Practical Medicine from Salerno to the Black Death*, (eds) L. García-Ballester et al. (1994), 30–59.
Teresa de Cartagena	D. Seidenspinner-Núñez, *The Writings of Teresa de Cartagena* (1998).
Deafness	I. Metzler, 'Perceptions of Deafness in the Central Middle Ages', in *Homo debilis Behinderte – Kranke – Versehrte in der Gesellschaft des Mittelalters*, ed. C. Nolte (2009), 79–98; A. de Saint-Loupe, 'Images of the Deaf in Medieval Western Europe', in *Looking Back: A Reader on the History of Deaf Communities and their Sign Languages*, (eds) R. Fischer and H. Lane (1993), 379–402.
Music and Sound	E. Dillon, *The Sense of Sound: Musical Meaning in France, 1260–1330* (2012); M. Everist (ed.), *The Cambridge Companion to Medieval Music* (2011); T. Christensen (ed.), *The Cambridge History of*

	Western Music Theory (2002); R. Strohm and B. J. Blackburn (eds), *Music as Concept and Practice in the Late Middle Ages* (2001); F. Shehadi, *Philosophies of Music in Medieval Islam* (1995).
Boethius	J. Marenbon (ed.), *The Cambridge Companion to Boethius* (2009).
Hagia Sophia	R. Mark and A. Ş. Çakmak (eds), *Hagia Sophia from the Age of Justinian to the Present* (1992).
Echoes	B. Blesser and L.-R. Salter, *Spaces Speak, Are You Listening?: Experiencing Aural Architecture* (2006); M. Bull and L. Back (eds), *The Auditory Culture Reader* (2003).
Hildegard of Bingen	B. M. Kienzle, D. L. Stoudt and G. Ferzoco (eds), *A Companion to Hildegard of Bingen* (2014).
Bells	J. H. Arnold and C. Goodson, 'Resounding Community: The History and Meaning of Medieval Church Bells', *Viator* 43:1 (2012), 99–130.
Exultet Rolls	T. F. Kelly, *The Exultet in Southern Italy* (1996).
Speech	I. R. Kleiman (ed.), *Voice and Voicelessness in Medieval Europe* (2015); K. Reichl (ed.), *Medieval Oral Literature* (2011) .
William of Rubruck	W. W. Rockhill (ed.), *The Journey of William of Rubruck to the Eastern Parts of the World, 1253–55* (1900).
Anthony of Padua	F. Lucchini, 'The Making of a Legend: The Reliquary of the Tongue and the Representation of St. Anthony of Padua as a Preacher', in *Franciscans and Preaching*, ed. T. J. Johnson (2012), 451–84.
Kissing Books	K. M. Rudy, 'Kissing Images, Unfurling Rolls, Measuring Wounds, Sewing Badges and Carrying Talismans', *The Electronic British Library Journal* (2011).
Taste	P. H. Freedman (ed.), *Food: The History of Taste* (2007); C. Korsmeyer (ed.), *The Taste Culture Reader: Experiencing Food and Drink* (2005).

Omne Bonum L. F. Sandler, *'Omne Bonum': A Fourteenth-Century Encyclopedia of Universal Knowledge* (1996).

Al-Zahrawi M. M. Spink and G. L. Lewis, *Al-Zahrawi's On Surgery and Instruments: A Definitive Edition of the Arabic Text with English Translation and Commentary* (1973).

Skin

Henri de Mondeville M.-C. Pouchelle, *The Body and Surgery in the Middle Ages*, trans. R. Morris (1990).

Flaying L. Tracy (ed.), *Flaying in the Pre-Modern World: Practice and Representation* (2017).

Dissections and Autopsy K. Park, *The Secrets of Women: Gender, Generation and the Origins of Human Dissection* (2006); E. Savage-Smith, 'Attitudes toward Dissection in Medieval Islam', in *Islamic Medical and Scientific Tradition*, ed. P. Pormann (2010), 299–342.

Fasciculo de Medicina J. J. Bylebyl, 'Interpreting The *Fasciculo* Anatomy Scene', *Journal of the History of Medicine and Allied Sciences* 45:3 (1990), 285–316.

Skin K. L. Walter (ed.), *Reading Skin in Medieval Literature and Culture* (2013); A. Paravicini Bagliani (ed.), *La Pelle Umana/The Human Skin* (2005); S. Connor, *The Book of Skin* (2004); C. Benthien, *Skin: On the Cultural Border Between Self and the World*, trans. T. Dunlop (2004).

Plastic Surgery S. L. Gilman, *Making the Body Beautiful: A Cultural History of Aesthetic Surgery* (1999).

Leprosy E. Brenner, *Leprosy and Charity in Medieval Rouen* (2015); T. S. Miller and J. W. Nesbitt, *Walking Corpses: Leprosy in Byzantium and the Medieval West* (2014); L. Demaitre, *Leprosy in Premodern Medicine: A Malady of the Whole Body* (2007); C. Rawcliffe, *Leprosy in Medieval England* (2006).

Race and Racism D. Nirenberg, *Communities of Violence: Persecution of Minorities in the Middle Ages* (2015); L. T. Ramey, *Black Legacies: Race and the European Middle Ages* (2014); S. C. Akbari, *Idols in the East: European Representations of Islam and the Orient, 1100–1450* (2009); D. Strickland, *Saracens, Demons and Jews: Making Monsters in Medieval Art* (2003); J. Devisse and M. Mollat (eds), *The Image of the Black in Western Art* (1979).

Cosmas and Damian K. Zimmerman (ed.), *One Leg in the Grave Revisited: The Miracle of the Transplantation of the Black Leg by the Saints Cosmas and Damian* (2013).

Crusades N. Morton, *Encountering Islam on the First Crusade* (2016); A. V. Murray (ed.), *The Crusades: An Encyclopedia* (2006); C. Hillenbrand, *The Crusades: Islamic Perspectives* (1999).

Luttrell Psalter M. Camille, *Mirror in Parchment: The Luttrell Psalter and the Making of Medieval England* (1998).

Paper J. M. Bloom, *Paper before Print: The History and Impact of Paper in the Islamic World* (2001).

Manuscripts V. Tsamakda (ed.), *A Companion to Byzantine Illustrated Manuscripts* (2017); M. Epstein (ed.), *Skies of Parchment, Seas of Ink: Jewish Illuminated Manuscripts* (2015); G. N. Atiyeh (ed.), *The Book in the Islamic World: The Written Word and Communication in the Middle East* (1995); J. J. G. Alexander, *Medieval Illuminators and Their Methods of Work* (1994).

Law E. Conte and L. Mayali (eds), *A Cultural History of Law in the Middle Ages (500–1500)* (2018); J. A. Brundage, *The Medieval Origins of the Legal Profession: Canonists, Civilians and Courts* (2008).

Textiles S.-G. Heller, *A Cultural History of Dress and Fashion in the Medieval Age* (2016); C. Browne, G. Davies and M. A. Michael, *English Medieval*

	Embroidery: Opus Anglicanum (2016); F. Pritchard, *Clothing Culture: Dress in Egypt in the First Millennium AD* (2006); T. Ewing, *Viking Clothing* (2006); G. R. Owen-Crocker, *Dress in Anglo-Saxon England* (2004).
Sumptuary Laws	C. K. Killerby, *Sumptuary Law in Italy 1200–1500* (2002).
Prostitutes	G. Leiser, *Prostitution in the Eastern Mediterranean World: The Economics of Sex in the Late Antique and Medieval Middle East* (2016); J. Rossiaud, *Medieval Prostitution*, trans. L. G. Cochrane (1988).
Nudity	S. C. M. Lindquist (ed.), *The Meanings of Nudity in Medieval Art* (2012).
Vestments	M. C. Miller, *Clothing the Clergy: Virtue and Power in Medieval Europe, c.800–1200* (2014); W. T. Woodfin, *The Embodied Icon: Liturgical Vestments and Sacramental Power in Byzantium* (2012).

Bone

Bones	F. Wallis, 'Counting all the Bones: Measure, Number and Weight in Early Medieval Texts about the Body', in *Was zählt: Ordnungsangebote, Gebrauchsformen und Erfahrungsmodalitäten des 'numerus' im Mittelalter*, ed. M. Wedell (2012), 185–207.
Bathing	C. Kosso and R. M. Taylor (eds), *The Nature and Function of Water, Baths, Bathing and Hygiene from Antiquity through the Renaissance* (2009).
Veterinarians	H. A. Shehada, *Mamluks and Animals: Veterinary Medicine in Medieval Islam* (2013); L. H. Curth, *The Care of Brute Beasts: A Social and Cultural Study of Veterinary Medicine in Early Modern England* (2010).

Animals C. Heck and R. Cordonnier, *The Grand Medieval Bestiary: Animals in Illuminated Manuscripts* (2012); J. E. Salisbury, *The Beast Within: Animals in the Middle Ages* (2010); B. Resl (ed.), *A Cultural History of Animals in the Medieval Age* (2009); D. Salter, *Holy and Noble Beasts: Encounters with Animals in Medieval Literature* (2001).

Hunting R. Almond, *Medieval Hunting* (2003).

Death J. Rollo-Koster (ed.), *Death in Medieval Europe: Death Scripted and Death Choreographed* (2017); S. M. Butler, *Forensic Medicine and Death Investigation in Medieval England* (2015); P. Binski, *Medieval Death: Ritual and Representation* (1996).

Burial S. C. Reif, A. Lehnardt and A. Bar-Levov (eds), *Death in Jewish Life: Burial and Mourning Customs among Jews of Europe and Nearby Communities* (2014); L. N. Stutz and S. Tarlow (eds), *The Oxford Handbook of the Archaeology of Death and Burial* (2013); P. Geary, *Living With the Dead in the Middle Ages* (1994); F. S. Paxton, *Christianizing Death: The Creation of a Ritual Process in Early Medieval Europe* (1996); J. I. Smith and Y. Y. Haddad, *The Islamic Understanding of Death and Resurrection* (1981).

Apocalypse M. A. Ryan (ed.), *A Companion to the Premodern Apocalypse* (2016).

Purgatory J. Le Goff, *The Birth of Purgatory*, trans. A. Goldhammer (1984).

Thomas Aquinas J.-P. Torrell, *Saint Thomas Aquinas: The Person and His Work*, trans. R. Royal (2005).

Sicily S. Davis-Secord, *Where Three Worlds Met: Sicily in the Early Medieval Mediterranean* (2017).

Alice Chaucer J. A. A. Goodall, *God's House at Ewelme: Life, Devotion and Architecture in a Fifteenth-Century Almshouse* (2001).

Dance of Death	E. Gertsman, *The Dance of Death in the Middle Ages: Image, Text, Performance* (2010).
Ivory	S. M. Guérin, 'Meaningful Spectacles: Gothic Ivories Staging the Divine', *The Art Bulletin* 95 (2013), 53–77; P. Williamson, *An Introduction to Medieval Ivory Carvings* (1982).

Heart

Chiara da Montefalco	K. Park, 'The Criminal and the Saintly Body: Autopsy and Dissection in Renaissance Italy', *Renaissance Quarterly* 47:1 (1994), 1–33.
Heart	L. Demaitre, *Medieval Medicine: The Art of Healing from Head to Toe* (2013); S. Amidon and T. Amidon, *The Sublime Engine: A Biography of the Human Heart* (2012); H. Webb, *The Medieval Heart* (2010); E. Jaeger, *The Book of the Heart* (2000).
William Harvey	J. Shackelford, *William Harvey and the Mechanics of the Heart* (2003).
Emotion	S. Broomhall and A. Lynch (eds), *A Cultural History of the Emotions in the Late-Medieval, Reformation and Renaissance Age (1300–1600)* (2017); P. King, 'Emotions in Medieval Thought', in *The Oxford Handbook of Philosophy of Emotion*, ed. P. Goldie (2009), 1–23.
Moses Ben Abraham Darʿi	J. J. M. S. Yeshaya, *Medieval Hebrew Poetry in Muslim Egypt: The Secular Poetry of the Karaite Poet Moses ben Abraham Darʿi* (2011).
Troubadour Poetry	W. D. Paden and F. F. Paden, *Troubadour Poems from the South of France* (2007); E. Aubrey, *The Music of the Troubadours* (2000).
Courtly Love	P. J. Porter, *Courtly Love in Medieval Manuscripts* (2003).
Giovanni Boccaccio	T. G. Bergin, *Boccaccio* (1981).

Heart Shapes P. J. Vinken, *The Shape of the Heart: A Contribution to the Iconology of the Heart* (2000); D. Bietenholz, *How Come This ♥ Means Love? A Study of the Origin of the ♥ Symbol of Love* (1995).

Love Tokens M. Camille, *The Medieval Art of Love: Objects and Subjects of Desire* (1998).

Early Printing D. S. Areford, *The Viewer and the Printed Image in Late Medieval Europe* (2010).

Maimonides K. Seeskin (ed.), *The Cambridge Companion to Maimonides* (2005).

Bernard of Clairvaux J. Leclercq, *Bernard of Clairvaux and the Cistercian Spirit*, trans. C. Lavoie (1976).

Nuremberg S. Brockmann, *Nuremberg: The Imaginary Capital* (2006).

Blood

Hebrew Medicine L. García-Ballester, *Medicine in a Multicultural Society: Christian, Jewish and Muslim Practitioners in the Spanish Kingdoms, 1222–1610* (2001); J. Shatzmiller, *Jews, Medicine and Medieval Society* (1994).

Phlebotomy P. Gil-Sotres, 'Derivation and Revulsion: The Theory and Practice of Medieval Bloodletting', in *Practical Medicine from Salerno to the Black Death*, (eds) L. García-Ballester et al. , (1994), 110–56.

William of Norwich E. M. Rose, *The Murder of William of Norwich: The Origins of the Blood Libel in Medieval Europe* (2015).

Anti-Semitism S. Lipton, *Dark Mirror: The Medieval Origins of Anti-Jewish Iconography* (2014); I. M. Resnick, *Marks of Distinction: Christian Perceptions of Jews in the High Middle Ages* (2012); M. Merback (ed.), *Beyond the Yellow Badge: Anti-Judaism and Antisemitism in Medieval and Early Modern Visual*

	Culture (2008); R. Chazan, *Medieval Stereotypes and Modern Antisemitism* (1997).
Schedel's Weltchronik	A. Wilson, *The Making of the Nuremberg Chronicle* (1976).
The Eucharist	A. W. Astell, *Eating Beauty: The Eucharist and the Spiritual Arts of the Middle Ages* (2006); M. Rubin, *Corpus Christi: The Eucharist in Late Medieval Culture* (1991).
Fourth Lateran Council	J. C. Moore, *Pope Innocent III (1160/61–1216): To Root Up and to Plant* (2009).
Blood Relics	N. Vincent, *The Holy Blood: King Henry III and the Westminster Blood Relic* (2001).
Counting Christ's Blood	L. H. Cooper and A. Denny-Brown (eds), *The Arma Christi in Medieval and Early Modern Material Culture* (2014); A. A. MacDonald et al. (eds), *The Broken Body: Passion Devotion in Late-Medieval Culture* (1998).
Life Blood	B. Bildhauer, *Medieval Blood* (2006).
Cruentation	S. M. Butler, *Forensic Medicine and Death Investigation in Medieval England* (2015).
Blood Miracles	C. W. Bynum, *Wonderful Blood: Theology and Practice in Late Medieval Northern Germany and Beyond* (2007).
Bleeding Icons	M. Vassilaki, 'Bleeding Icons', in *Icon and Word: The Power of Images in Byzantium*, A. Eastmond and L. James (eds) (2003), 121–29.
Fake Miracles	K. Brewer, *Wonder and Skepticism in the Middle Ages* (2016); M. E. Goodich, *Miracles and Wonders: The Development of the Concept of Miracle, 1150–1350* (2007).
La Seinte Resurreccion	K. Kopania, *Animated Sculptures of the Crucified Christ in the Religious Culture of the Latin Middle Ages* (2010); D. M. Bevington (ed.), *Medieval Drama* (1975).
The Wound Man	J. Hartnell, 'Wording the Wound Man', *British Art Studies* 6 (2017).

Surgical Technique — P. D. Mitchell, *Medicine in the Crusades: Warfare, Wounds and the Medieval Surgeon* (2004); M. McVaugh, 'Therapeutic Strategies: Surgery', in *Western Medical Thought from Antiquity to the Middle Ages*, ed. M. D. Grmek (1998), 273–90; M.-C. Pouchelle, *The Body and Surgery in the Middle Ages*, trans. R. Morris (1990).

Hands

Games — S. Patterson (ed.), *Games and Gaming in Medieval Literature* (2015); C. Reeves, *Pleasures and Pastimes in Medieval England* (1995); J. M. Carter, *Medieval Games: Sports and Recreations in Feudal Society* (1992).

Touch — C. M. Woolgar, *The Senses in Late Medieval England* (2006); C. Classen (ed.), *The Book of Touch* (2005); F. Salmón, 'A Medieval Territory for Touch', *Studies in Medieval and Renaissance History* 3:2 (2005), 59–81.

Surgical Instruments — J. Hartnell, 'Tools of the Puncture: Skin, Knife, Bone, Hand', in *Flaying in the Pre-Modern World: Practice and Representation*, ed. L. Tracy (2017), 1–50; J. Kirkup, *The Evolution of Surgical Instruments: An Illustrated History from Ancient Times to the Twentieth Century* (2006); M. M. Spink and G. L. Lewis, *Al-Zahrawi's On Surgery and Instruments: A Definitive Edition of the Arabic Text with English Translation and Commentary* (1973).

Reading — S. Reynolds, *Medieval Reading: Grammar, Rhetoric and the Classical Text* (2004); P. Saenger, *Space Between Words: The Origins of Silent Reading* (1997).

Densitometers — K. M. Rudy, 'Dirty Books: Quantifying Patterns of Use in Medieval Manuscripts

Using a Densitometer', *Journal of Historians of Netherlandish Art* 2:1/2 (2010).

Florentius de Valeranica — C. Brown, 'Remember the Hand: Bodies and Bookmaking in Early Medieval Spain', *Word & Image* 27:3 (2011), 262–78.

Guido's Hand — A. M. B. Berger, *Medieval Music and the Art of Memory* (2005); C. Berger, 'The Hand and the Art of Memory', *Musica Disciplina* 35 (1981), 87–120.

Memory — M. Carruthers, *The Book of Memory: A Study of Memory in Medieval Culture* (2008).

Chiromancy — C. Burnett, 'The Earliest Chiromancy in the West', *Journal of the Warburg and Courtauld Institutes* 50 (1987), 189–95.

Bede — G. H. Brown, *A Companion to Bede* (2009); P. H. Blair, *The World of Bede* (1990).

Cluniac Sign Lexicon — S. G. Bruce, *Silence and Sign Language in Medieval Monasticism: The Cluniac Tradition, c.900–1200* (2007).

Hand Reliquaries — C. Hahn, 'The Voices of the Saints: Speaking Reliquaries', *Gesta* 36:1 (1997), 20–31.

Jewellery — C. Entwistle and N. Adams (eds), *Intelligible Beauty: Recent Research on Byzantine Jewellery* (2010); M. Campbell, *Medieval Jewellery: In Europe 1100–1500* (2009); M. Jenkins and M. Keene, *Islamic Jewelry in The Metropolitan Museum of Art* (1983).

Sasanian Iran — T. Daryaee, *Sasanian Persia: The Rise and Fall of an Empire* (2009).

Morbus Regius — M. Bloch, *The Royal Touch: Sacred Monarchy and Scrofula in France and England* (1973).

Ismail al-Jazari — D. R. Hill, *The Book of Knowledge of Ingenious Mechanical Devices by Ibn al-Razzaz al-Jazari* (1974).

Stomach

Arabic Literature G. Schoeler, *The Genesis of Literature in Islam: From the Aural to the Read*, trans. S. M. Toorawa (2009); *Cambridge History of Arabic Literature*, various volumes (1983–2006); R. Irwin (ed.), *Night and Horses and the Desert: An Anthology of Classical Arabic Literature* (1999).

Gluttony S. E. Hill, 'The Ooze of Gluttony: Attitudes towards Food, Eating and Excess in the Middle Ages', in *The Seven Deadly Sins: From Communities to Individuals*, ed. R. Newhauser (2007), 57–72.

The Land of Cokaygne H. Pleij, *Dreaming of Cockaigne: Medieval Fantasies of the Perfect Life*, trans. D. Webb (2003); G. Claeys and L. T. Sargent (eds), *The Utopia Reader* (1999).

Old French Fabliaux *The Fabliaux*, trans. N. E. Dubin (2013).

Dante Alighieri R. Kirkpatrick (ed.), *Dante's The Divine Comedy* (2013): R. Jacoff (ed.), *Cambridge Companion to Dante* (2007).

Digestion L. Demaitre, *Medieval Medicine: The Art of Healing, from Head to Toe* (2013).

Pharmacology and Herbals P. Dendle and A. Touwaide (eds), *Health and Healing from the Medieval Garden* (2008); M. Collins, *Medieval Herbals* (2000); J. Stannard, *Herbs and Herbalism in the Middle Ages and Renaissance* (1999).

Fantastical Creatures E. Morrison, *Beasts: Factual and Fantastic* (2007).

Food and Cooking M. Montanari (ed.), *A Cultural History of Food in the Medieval Age* (2015); M. W. Adamson, *Food in Medieval Times* (2004); T. Scully, *The Art of Cookery in the Middle Ages* (1995).

Le Ménagier de Paris G. L. Greco and C. M. Rose (ed.), *The Good Wife's Guide (Le Ménagier de Paris): A Medieval Household Book* (2009).

Religious Diets	E. Baumgarten, *Practicing Piety in Medieval Ashkenaz: Men, Women and Everyday Religious Life* (2014); D. M. Freidenreich, *Foreigners and Their Food: Constructing Otherness in Jewish, Christian and Islamic Law* (2011); C. W. Bynum, *Holy Feast and Holy Fast: The Religious Significance of Food to Medieval Women* (1988).
Jean's Archer	V. Nutton and C. Nutton, 'The Archer of Meudon: A Curious Absence of Continuity in the History of Medicine', *Journal of the History of Medicine and Allied Sciences* 58:4 (2003), 401–27.
Blanche of Castile	L. Grant, *Blanche of Castile, Queen of France* (2017).
Louis IX	J. Le Goff, *Saint Louis*, trans. G. E. Gollrad (2009).
Vomiting	L. Demaitre, *Medieval Medicine: The Art of Healing, from Head to Toe* (2013); R. Waugh, 'Word, Breath and Vomit: Oral Competition in Old English and Old Norse', *Oral Tradition* 10 (1995), 359–86.
Scandinavian Sagas	T. M. Andersson, *The Growth of the Medieval Icelandic Sagas, 1180–1280* (2006); H. O'Donoghue, *Old Norse-Icelandic Literature: A Short Introduction* (2004).
Comedy and Obscenity	N. F. McDonald (ed.), *Medieval Obscenities* (2014); J. R. Benton, *Medieval Mischief: Wit and Humour in the Art of the Middle Ages* (2004); M. Jones, *The Secret Middle Ages* (2002).
Roland the Farter	V. Allen, *On Farting: Language and Laughter in the Middle Ages* (2007).
The Farce of the Fart	J. Enders (ed.), *The Farce of the Fart and Other Ribaldries: Twelve Medieval French Plays in Modern English* (2011).
John Arderne	P. M. Jones, 'Staying with the Programme: Illustrated Mansucripts of John of Arderne, c.1380–c.1550', in *Decoration and Illustration in Medieval English Manuscripts*, ed. A. S. G. Edwards (2002), 204–36.

Genitals

Shrine Madonnas E. Gertsman, *Worlds Within: Opening the
 Medieval Shrine Madonna* (2015).

Women K. M. Phillips (ed.), *A Cultural History of Women
 in the Middle Ages* (2013); J. Herrin, *Unrivalled
 Influence: Women and Empire in Byzantium* (2013);
 S. Joseph et al. (eds), *Encyclopedia of Women and
 Islamic Cultures* (2007); M. Schaus (ed.), *Women
 and Gender in Medieval Europe: An Encyclopedia*
 (2006); A. Grossman, *Pious and Rebellious: Jewish
 Women in Medieval Europe*, trans. J. Chipman
 (2004).

Gynaecology M. H. Green, *Making Women's Medicine
 Masculine: The Rise of Male Authority in Pre-
 Modern Gynaecology* (2008).

De Secretis Mulierum H. R. Lemay, *Women's Secrets: A Translation of
 Pseudo-Albertus Magnus' De Secretis Mulierum
 with Commentaries* (1992).

Trotula M. H. Green, *The Trotula: An English Translation
 of the Medieval Compendium of Women's Medicine*
 (2002).

Midwives F. Harris-Stoertz, 'Midwives in the Middle Ages?
 Birth Attendants, 600–1300', in *Medicine and
 the Law in the Middle Ages*, ed. W. Turner and
 S. Butler (2014), 58–87; M. H. Green and D. L.
 Smail, 'The Trial of Floreta d'Ays (1403): Jews,
 Christians and Obstetrics in Later Medieval
 Marseille', *Journal of Medieval History* 34:2
 (2008), 185–211.

Caesarean R. Blumenfeld-Kosinski, *Not of Woman Born:
 Representations of Caesarean Birth in Medieval and
 Renaissance Culture* (1990).

Deschi da parto J. M. Musacchio, *The Art and Ritual of Childbirth
 in Renaissance Italy* (1999).

Ben Ezra Synagogue A. Hoffman and P. Cole, *Sacred Trash: The Lost
 and Found World of the Cairo Geniza* (2011).

Wilgefortis	D. A. King, 'The Cult of St. Wilgefortis in Flanders, Holland, England and France', in *Am Kreuz – Eine Frau: Anfänge, Abhängigkeiten, Aktualisierungen*, S. Glockzin-Bever and M. Kraatz (eds) (2003), 55–97.
Hermaphrodites	L. DeVun, 'Erecting Sex: Hermaphrodites and the Medieval Science of Surgery', *Osiris* 30 (2015), 17–37.
Gwerful Mechain	K. Gramich and C. Brennan (eds), *Welsh Women's Poetry 1460–2001: An Anthology* (2003); D. Johnston, *The Literature of Wales* (1994).
Sex and Sexuality	R. Evans (ed.), *A Cultural History of Sexuality in the Middle Ages* (2012); R. M. Karras, *Sexuality in Medieval Europe: Doing unto Others* (2005); V. L. Bullough and J. A. Brundage (eds), *Handbook of Medieval Sexuality* (1996).
Penises	L. Tracy (ed.), *Castration and Culture in the Middle Ages* (2013).
Roman de la Rose	F. Horgan (ed.), *The Romance of the Rose* (2009).
Grettir's Saga	D. Zori and J. Byock (ed.), *Grettir's Saga* (2009).
Foreskins	L. B. Glick, *Marked in Your Flesh: Circumcision from Ancient Judea to Modern America* (2005).
Homosexuality	R. Mills, *Seeing Sodomy in the Middle Ages* (2015); N. Giffney, M. M. Sauer and D. Watt (eds), *The Lesbian Premodern* (2011); G. Burger and S. F. Kruger, *Queering the Middle Ages* (2001).
Uroscopy and Urine	F. Wallis, *Medieval Medicine: A Reader* (2010); M. R. McVaugh, 'Bedside Manners in the Middle Ages', *Bulletin of the History of Medicine* 71 (1997), 201–23.
Croxton Play of the Sacrament	J. T. Sebastian (ed.), *Croxton Play of the Sacrament* (2012).

Feet

Holy Roman Emperors	P. H. Wilson, *Heart of Europe: A History of the Holy Roman Empire* (2016).
Foot-Kissing	L. Brubaker, 'Gesture in Byzantium', *Past & Present* 203:4 (2009), 36–56.
Charlemagne	J. Fried, *Charlemagne*, trans. P. Lewis (2016).
On Dignities and Offices	R. Macrides et al. (eds), *Pseudo-Kodinos and the Constantinopolitan Court: Offices and Ceremonies* (2013).
Willem Jordaens	R. Van Nieuwenhove et al. (eds), *Late Medieval Mysticism of the Low Countries* (2008).
Duccio's Madonna	J. Cannon, 'Kissing the Virgin's Foot: *Adoratio* before the Madonna and Child Enacted, Depicted, Imagined', *Studies in Iconography* 31 (2010), 1–50.
Shoes	Q. Mould, 'The Home-Made Shoe, A Glimpse of a Hidden but Most Affordable Craft', in *Everyday Products in the Middle Ages: Crafts, Consumption and the Individual in Northern Europe c. AD 800–1600*, ed. G. Hansen (2015); F. Grew and M. de Neergaard, *Shoes and Pattens* (2001).
Anne of Bohemia	T. Alfred, *Reading Women in Late Medieval Europe: Anne of Bohemia and Chaucer's Female Audience* (2015).
Pigs	C. Fabre-Vassas, *The Singular Beast: Jews, Christians and the Pig*, trans. C. Volk (1997).
Beuve de Hantone	R. B. Herzman et al. (eds), *Four Romances of England: King Horn, Havelok the Dane, Bevis of Hampton, Athelston* (1997).
Travel	J. B. Friedman et al. (eds), *Trade, Travel and Exploration in the Middle Ages: An Encyclopedia* (2000).
Pilgrimage	E. Tagliacozzo and S. M. Toorawa, *The Hajj: Pilgrimage in Islam* (2015); B. Whalen, *Pilgrimage in the Middle Ages: A Reader* (2011); K. Ashley and M. Deegan, *Being a Pilgrim: Art and Ritual on*

	the *Medieval Routes to Santiago* (2009); J. Stopford (ed.), *Pilgrimage Explored* (1999).
Jerusalem	B. D. Boehm and M. Holcomb, *Jerusalem, 1000–1400: Every People under Heaven* (2016); S. S. Montefiore, *Jerusalem: The Biography* (2012); J. Wilkinson et al. (eds), *Jerusalem Pilgrimage, 1099–1185* (1988).
Irish Poetry	M. O'Riordan, *Irish Bardic Poetry and Rhetorical Reality* (2007); O. Bergin, *Irish Bardic Poetry* (1970).
Crusader Painting	J. Folda, *Crusader Art: The Art of the Crusaders in the Holy Land, 1099–1291* (2008).
Travel Writing	S. A. Legassie, *The Medieval Invention of Travel* (2017); C. Thompson (ed.), *The Routledge Companion to Travel Writing* (2016); M. B. Campbell, *The Witness and the Other World, Exotic European Travel Writing, 400–1600* (1991).
Benjamin of Tudela	M. A. Signer et al. (eds), *The Itinerary of Benjamin of Tudela: Travels in the Middle Ages* (1993).
Mandeville's Travels	A. Bale (ed.), *John Mandeville's The Book of Marvels and Travels* (2012).
Maps	K. Pinto, *Medieval Islamic Maps: An Exploration* (2016); J. B. Harley and D. Woodward, *The History of Cartography: Cartography in Prehistoric, Ancient and Medieval Europe and the Mediterranean* (1992).

Future Bodies

Science Fiction	C. Kears and J. Paz (eds), *Medieval Science Fiction* (2016).
The New World	F. Fernández-Armesto, *1492: The Year the World Began* (2009); P. C. Mancall (ed.), *Travel Narratives from the Age of Discovery: An Anthology*

(2006); S. Greenblatt, *Marvelous Possessions: The Wonder of the New World* (1991).

Ottoman Empire — C. Finkel, *Osman's Dream: The Story of the Ottoman Empire, 1300–1923* (2005); C. Imber, *The Ottoman Empire, 1300–1650: The Structures of Power* (2002).

Martin Luther — D. K. McKim (ed.), *The Cambridge Companion to Martin Luther* (2003).

Paracelsus — C. Webster, *Paracelsus: Medicine, Magic and Mission at the End of Time* (2008); P. Elmer (ed.), *The Healing Arts: Health, Disease and Society in Europe, 1500–1800* (2004).

Renaissance Anatomy — S. Kusukawa, *Picturing the Book of Nature: Image, Text and Argument in Sixteenth-Century Human Anatomy and Medical Botany* (2012); R. K. French, *Dissection and Vivisection in the European Renaissance* (1999); A. Carlino, *Books of the Body: Anatomical Ritual and Renaissance Learning*, trans. J. Tedeschi and A. C. Tedeschi (1999).

Bioarchaeology and aDNA — M. Jones, *Unlocking the Past: How Archaeologists Are Rewriting Human History with Ancient DNA* (2016); C. S. Larsen, *Bioarchaeology: Interpreting Behavior from the Human Skeleton* (2015); T. A. Brown and K. Brown, *Biomolecular Archaeology: An Introduction* (2011).

Amandus Reliquary — J. Hartnell, 'Scanning Saint Amandus: Medical Technologies and Medieval Anatomies', *postmedieval* 8:2 (2017), 218–33.

LIST OF
ILLUSTRATIONS

INDEX